CHRISTINA RIGGS

TREASURED

How Tutankhamun
Shaped a Century

PUBLICAFFAIRS

New York

PublicAffairs
Hachette Book Group
1290 Avenue of the Americas, New York, NY 10104
www.publicaffairsbooks.com
@Public_Affairs

Printed in the United States of America

Originally published in hardcover in Great Britain in 2021 by
Atlantic Books, an imprint of Atlantic Books Ltd.
First US Edition: February 2022

Published by PublicAffairs, an imprint of Perseus Books, LLC, a subsidiary of Hachette Book Group, Inc. The PublicAffairs name and logo is a trademark of the Hachette Book Group.

The Hachette Speakers Bureau provides a wide range of authors for speaking events. To find out more, go to www.hachettespeakersbureau.com or call (866) 376-6591.

The publisher is not responsible for websites (or their content) that are not owned by the publisher.

Library of Congress Control Number: 2021945662

ISBNs: 9781541701212 (hardcover), 9781541701229 (ebook)

LSC-C

Printing 1, 2021

Contents

Discoveries

THE PROJECTOR DRONED a dead buzz as we waited, desks abandoned. We were gathered in our plastic chairs at one side of the classroom, turned towards the pull-down screen where a white square promised a window to another world. If only Mrs Williams would thread the filmstrip and begin.

At last the square changed colour, and a set of shaky words appeared. *Life in Ancient Egypt*, or *Land of the Pharaohs*, perhaps. Beginnings always scroll by unremarked. With a thwack of its lid, Mrs Williams shut the cassette player and signalled us to silence. The tape squeaked into life and settled into the sonorous tones we knew from other filmstrips we had watched at Sanderson Elementary School in rural Ohio. In 1983, the authoritative voice of knowledge was deep, male, and often out of sync with the images before our eyes. Teachers – even young and pretty ones, like Mrs Williams – tended to miss the tone that told them to advance the projector to the film's next frame. The voiceover moved on to George Washington's harsh winter at Valley Forge, or the effects of chlorophyll, while we were still watching Paul Revere's midnight ride or staring at the yellow sun.

Today was life and death: we were about to embark on ancient Egypt. On wan winter afternoons, we had already been to Mesopotamia, 'Cradle of Civilization', between the Tigris and Euphrates. I had stared at two blue rivers in the textbook map,

afraid someone would see that the dots along them – Nineveh, Babylon, Ur of the Chaldees – were already familiar ground. My cheeks burned as my separate worlds, of school and church, were forced to meet. In class, Mesopotamia was the land of ziggurats and Hammurabi. In church, where my family spent long Sunday mornings, Mesopotamia was the land of Abraham, whose God was ours.

If Mesopotamia seemed too close, would ancient Egypt be too far? The filmstrip took us swiftly to the Nile, a blue line snaking north and opening like a flower. Life-giving waters, the voiceover intoned. Mighty pharaohs, and the pyramids appeared. Cranes hauled a temple piece by giant piece into the air. A beep, and we were in the Valley of the Kings, waiting for Mrs Williams to catch up. Death was on the way.

Another beep, another frame. A boy who had been king but died too young. His name, the voice as deep as God's announced, was *Toot-ankh-a-MOON*. His tomb was a time capsule found intact, his life preserved at the moment it had ended. Everything had been left just as it was more than 3,000 years ago. There was even an old photograph to prove it, as photos seem to do. The beep again, and something wonderful shimmered into view. A miniature coffin, a *can-oh-pick*, according to the soundtrack syllables. But I was not listening. I was looking. Its surface alive with jewel-like colours, the *can-oh-pick* container filled the filmstrip square in defiance of its small size. Above the intense blues and blood-rich reds of its feather-patterned body, a little gold face, set seriously towards the future, wavered on the screen. My skin tingled. I willed Mrs Williams to forget to advance the film this time.

When the recording beeped, however, Mrs Williams pressed the button. The projector hummed; the filmstrip shuddered forward. No matter: the golden face was fixed now in my mind.

Toot-ankh-a-MOON. Ten years old and miserable, I had never seen anything so splendid and surreal. I had to know more about this Tutankhamun and his tomb in the Valley of Kings, not knowing, not able even to imagine, how it would change my life.

* * *

Tutankhamun at ten years old had a better idea of where his life was heading. Born a prince, perhaps he grew up knowing that he might be king of Egypt one day, even if becoming king at nine or ten years old was premature. One thing he could not have known was that he did not have long to live – nor could he have imagined that death, and a quickly finished burial, would take him from his world into ours.

It's difficult now to imagine the past century without Tutankhamun and the discovery of that time-capsule tomb. Had Howard Carter's crew of Egyptian archaeologists been less thorough and overlooked the rock-cut stairwell to the jam-packed set of four small rooms back in November 1922, history would have overlooked Tutankhamun. Instead, this long-lost king, buried before he was out of his teens, found more fame and influence in the twentieth century than he had ever known in his own lifetime. Without this little-known ruler, Howard Carter, a self-taught and temperamental British archaeologist, might have died a failure, not a heroic household name. His sponsor, the 5th Earl of Carnarvon, might have died of old age instead of an infected mosquito bite in his Cairo hotel room. There would have been no media frenzy of Tut-mania and mummy curses to kick-start the jazz age, and no surge of corresponding pride in the newly independent nation-state of Egypt, where Tutankhamun was a ready-made symbol of the country's longed-for resurrection.

From the moment the beds and boxes and burial trappings in his tomb reversed their journey up those stairs, Tutankhamun

began to shape the politics of the Middle East – and the global popularity of ancient Egypt, like no other archaeological find before or since. The modern world would never be the same, not only for the events that surrounded the 1920s discovery of the tomb, but also because that proved to be only the pharaoh's first rebirth. A Tutankhamun revival in the early 1960s helped the United Nations' cultural arm, UNESCO, keep the temples of Nubia from disappearing beneath the backed-up waters of the Aswan High Dam, as the ancient source of the pharaoh's gold (the *noub* of Nubia) was sacrificed to hydroelectric power. In his second career as a cultural ambassador, Tutankhamun – or at least, a selection of objects from his tomb – toured the United States and Canada to draw attention to the Nubian temples' plight, then travelled to Japan to raise the funds that saw the rock-hewn sanctuaries of Abu Simbel winched to higher ground. The miniature coffin that had dazzled me on screen once gazed up in golden calm at Jacqueline Kennedy, who opened the first 'Tutankhamun Treasures' exhibition at the National Gallery of Art in Washington in November 1961. It was the gilded start of the Kennedy presidency, when hopes for a fairer society and American leadership were high and culture was the kindest weapon the Cold War had at its disposal.

By the 1970s, when I was born, hopes had lowered and culture had been sharpened to a point. As the Middle East peace process and free-market economics entangled Egypt with America, Tutankhamun did the diplomatic work of presenting his homeland as a friendly face and worthy ally. 'Every American should know more about Egypt and the Middle East,' declared a catalogue of educational media published by the United States Office of Education in 1977.[1] Filmstrips like those we watched in my small-town school were part of a concerted effort to educate Americans about the region and cultivate a positive attitude

towards Egypt and the Arab world, the source of the oil on which the American way of life depended. A new tour of Tutankhamun's treasures in the late 1970s had a similar effect. Mrs Williams had been to see it, returning to Ohio inspired and well supplied with books, posters, and a teacher's guide from the museum shop. Only later would I realize how much this coincidence had shaped my ten-year-old self, and only later still would I see that it wasn't much of a coincidence after all. Ancient Egypt was not on school curricula by chance, nor had Tutankhamun permeated American culture by force of personality. On the contrary, he was a blank, a wide-eyed icon – and all the more powerful for it, as a symbol of luxury, might, and ultimate command. All that gold, which defied time, made it seem as if the lost young man in the middle of it all had defied death itself.

He hadn't, of course, but in the hundred years that have passed since the discovery of his tomb, Tutankhamun has found an afterlife far different than anything intended by the ancient priests who oversaw his burial. In 2022, museums and the media around the world are marking the centenary of the discovery with a focus on the triumphant tale of 1922 and the treasured status of the tomb and its objects today. This book tells the story of what happened in between and why it matters. The history of Tutankhamun in the twentieth and now twenty-first century shines a light on several things we take for granted (celebrity archaeologists, UNESCO's World Heritage scheme, blockbuster exhibitions) and several more we need to challenge (systemic racism, global inequalities, climate change). All of these are linked. The archaeological heroes of movie plots and TV documentaries descend from excavators whose work was an integral part of Western colonialism and empire-building in the nineteenth and early twentieth centuries – systems that relied on racism through and through. As colonized countries demanded independence

in the wake of two world wars, UNESCO emerged as an international body that promoted peace through culture, yet its early efforts at protecting heritage sites turned a blind eye to the forced migration of 100,000 Nubians in Egypt and Sudan – and the idea that places matter more than people has been difficult to shift. The museum blockbusters that grew up around Tutankhamun's treasures went hand in hand with capitalist excess, Cold War politics, and the dizzying, detrimental heights reached by weapons sales and fossil fuel extraction in the Middle East. Tutankhamun did not create the climate crisis, or invade Iraq, but his story helps us see how deep and intertwined are the roots of cultural, political, and social phenomena we usually treat as separate plants. They have grown in the same soil, and to understand and change them, we must start from there.

By covering a century of Tutankhamun's history, between 1922 and now, this book departs from conventional accounts of the great discovery and the golden treasures to offer quite a different take on this ancient Egyptian ruler, whose short life yielded such a surprising afterlife. Amid growing awareness of the need to challenge historical biases and their implication in contemporary prejudices, it is time to take a more rounded look at how the tomb was located, cleared, and studied; what happened to the objects and the excavation records; and why 'King Tut' has been headline news for several generations. In researching and writing my account of Tutankhamun, I have tried to give priority to stories, and storytellers, that have been ignored, overlooked, or even erased from Egyptology. Here you will find the Egyptian archaeologists, poets, politicians, curators, and many others who have been looking after Tutankhamun's legacy for a hundred years. You will learn (if you didn't know already) that Tutankhamun and his family are a long-standing part of Black heritage for African-American and other African diaspora communities.

And you will read about the often unknown and little-recognized women without whom Tutankhamun would not have stepped back into the limelight in the latter half of the twentieth century.

It is a human story and, I hope, a humane one. It draws on personal history as well, for Tutankhamun shaped my life in ways Mrs Williams could not foresee: I became an expert on ancient Egypt and have spent thirty years studying and working at universities, delving into archives and museum storerooms, even turning up as a talking head on television documentaries now and then. But with its determined focus on the ancient world, at the expense and exclusion of the modern, Egyptology did not live up to my childhood dreams. Mid-career, I took a sideways step to rethink, retrain, and refocus my attention on how different people, at different times and places, have imagined ancient Egypt, and why. In this book, I weave together memoir, travel, art, and archaeology in order to write a history that is revisionist in the best and truest sense of that word: to revise an accepted or established version of events. Its Latin root, *re + videre*, means to look again, and it is by looking over new evidence, or from a new angle, that we can see the past, the present, and ourselves with fresh eyes.

Tutankhamun's own unblinking eyes gazed out from a poster Mrs Williams hung behind her desk and from the cover of the exhibition catalogue she brought for us to leaf through, carefully, in class. Saturated colour photos gleamed between the covers: the gold-and-blue-striped mask, the alabaster vases that seemed to glow with their own light, and the graceful, gilded figure of a goddess with a fat scorpion perched incongruously atop her head. The words that poured across the pages enchanted me as well, and even the strange silvery tones of old photographs that showed the objects still in the tomb, stacked every which way like the boxed-up Christmas ornaments, camera equipment,

and jigsaw puzzles that jostled in the cupboard underneath the stairs at home.

I beamed inside with pride when Mrs Williams let me borrow the catalogue for one precious weekend. I slid it gently into my school bag with what was left of my paper-sack lunch and long-division homework. In my house we respected books but rarely bought them, much less left them lying around to browse at will. My mother's historical romances fought for space with folded sheets in the linen closet, and volume by volume she was acquiring a Funk & Wagnalls encyclopaedia for the family, with saving stamps from the Big Bear grocery store. Above his desk in the damp half-basement room we called the den, my father kept a trusted Strunk & White and a paperback of *Nineteen Eighty-Four*, the year that was so ominously on its way. A dark, forgotten bookcase held my parents' musty college yearbooks, which I leafed through on wet afternoons, seeking out my mother in her cats-eye glasses, and my father, shoulders padded out beneath his football jersey. Sometimes the past seemed very long ago.

Upstairs, inside a cabinet in the living room, were two books that needed my mother's permission to peruse: a family medical encyclopaedia and a similarly weighty *Reader's Digest* tome, an illustrated history of the world with the ambitious title *The Last Two Million Years*.[2] Cross-legged on the floor, my back against our green tartan sofa, I pulled the book onto my lap and opened its marbled covers on my knees. The spine's stiff glue gave a satisfying crackle, the pages crisp with underuse. I flipped past a naked, hairy caveman skinning a deer ('man masters fire') and stopped briefly at a drawing of the four races of man (all shown, indeed, as men). Mesopotamia I had already exhausted ('among the Sumerians, civilized society takes shape'). What I wanted now was Egypt.

And there it was. The river Nile, the gods and kings, the stone solidity of temples, pyramids, and statues. This was a better Egypt than the Bible offered, with its sinister magicians, evil pharaoh, and drowned army. After supper, I smoothed a sheet of poster-sized paper across the kitchen table. In neat rows, I drew a dozen Egyptian deities for Mrs Williams' class, labelling each with unfamiliar names (Osiris, Thoth, Isis) and divine responsibilities (death, writing, motherhood and magic). My own mother hovered anxiously. God had forbidden graven images, but I sat quietly colouring them in as she dried saucepans. 'You aren't getting . . . involved in those things?' she asked, as if I might be starting to believe in winged women and bird-headed men. I didn't believe in her God, which I think she sensed. She worried about my teenaged brothers too, convinced that satanic messages had been embedded, backwards, in their Led Zeppelin albums. 'It's for extra credit,' I offered by way of an answer. I didn't believe in Isis or dark jackal-headed Anubis, no, but I found it reassuring to know that other people had. It was proof that there were other ways of living, thinking, being, even dying.

To reject God was to face damnation. But that was exactly what a pharaoh named Akhenaten had done, according to *The Last Two Million Years*. Breaking with the old religion that honoured a god named Amun, this king and his queen, Nefertiti, had created a new way of worshipping the sun disc, known as Aten. Unlike the gods in hybrid human forms, shown with animals on their heads or in place of them, Aten was a perfect circle with rays of light beaming down to bless the royal couple and their daughters. In some respects, Aten worship paralleled and prefigured the monotheism of Judaism, Christianity, and Islam. There was only one sun, after all. A hymn to Aten, said (on slim evidence) to have been written by Akhenaten himself, reminded me of the sing-song rhymes and soaring refrains that were the

best part of Sunday services. 'You rise beautiful from the east-
ern horizon,' it praised Aten at dawn. Yet sunset always followed.
'You rest in the western horizon,' it mourned, 'and the land is in
darkness like death.'

Flipping the page on Akhenaten, I came face to face with
Tutankhamun. The boy king was credited with returning Egypt
to its old gods, for the better. He changed his name to mark
the restoration, from Tutankh-*aten*, 'living image of Aten', to
Tutankh-*amun*, the living image of the god Amun, a creator
whose own name meant 'the hidden one'. I pored over photo-
graphs that showed more of the exquisite objects from the tomb.
They were in colour, like my favourite photographs in Mrs Wil-
liams' catalogue, except for one small shot in grainy shades of
black and white. Boring by comparison, like Kansas before the
vibrant Land of Oz in the Judy Garland film that I watched
eagerly on TV each year. I was sceptical of too much monotone
intrusion of twentieth-century life between myself and ancient
Egypt. Why couldn't I get straight there, in full colour, to the facts?

I looked at the dull picture again. A man, two men, or more,
peering into some kind of doorway. Light streamed past like
Aten's rays, leaving them in shadows. I read the text nearby,
which informed me that Lord Carnarvon and Howard Carter
had opened the tomb of Tutankhamun in 1922. Were these the
men in the photograph, I wondered, and what was a Lord if
not the Lord? I pushed my heavy eyeglasses back up my nose.
The text was short, the typeface tiny. It told a story we seemed
already meant to know: at the bottom of a flight of steps, before
a bricked-up opening covered with ancient seals, Carter chisels
out a hole just wide enough for a torch beam and his peering eyes
to pierce. 'Can you see anything?' this Lord Carnarvon asks, and
Howard Carter has to reply. 'Yes,' he says. 'Wonderful things.'

* * *

Except he didn't say it, nor was that a photo of the fateful moment when Carter and Carnarvon first breached the sealed doorway of the tomb in November 1922. A century on, these details have been lost in all the tellings and retellings of the tomb's discovery. I found that out much later. First I had to make my own discovery about happenstance and history. What survives, and what is lost. Who tells the tale, and who slips through unnoticed, unnamed, disregarded, overlooked.

I fuelled my passion for the past by scouring books, acquiring facts, and immersing myself in a vividly imagined 'Ancient Egypt'. I wanted a story that was whole, unfractured, and for that I needed more than those few pages in *The Last Two Million Years* or Mrs Williams' catalogue could give me. Fortunately, every other Saturday was for the public library. My mother had been taking me since I was small, when the library was upstairs in the town hall, a fortress of Indiana sandstone whose blocks had travelled to Ohio by a system of canals that had long ago run dry. By the time I was ten, the library had moved to a new red-brick building, its gambrel roof blending into the grid of downtown streets, between the steepled churches, stolid banks, and columned porches of historic houses. An entire floor housed children's books, where I could spot familiar favourites on the unfamiliar shelves.

Egypt was elsewhere, I soon discovered. A kind librarian showed me how to find it. I slid a drawer out of the card catalogue, as she had done. Its brass pull, curved over my fingers, felt snug and protective. The cards inside brushed by my fingertips as I flipped through subject headings. Each card a book, and there were dozens, hundreds, of them. EGYPT, ANCIENT, was on the ground floor, in ranks of non-fiction organized by Dewey decimals, a system we had learned about in school. Non-fiction: the world of the real, but no less an escape for that.

I checked out as many books as I could carry. My schoolmates

already took me for a four-eyed geek, a freak who had skipped a grade and could not name the members of Duran Duran. Books were a retreat. I liked the squared-off stillness of Egyptian statues, the symmetry of carved friezes, and the colourful wall paintings, each figure precisely distanced from the next. In the ancient Egypt I had started building in my head, everything lined up in ordered rows of images and neat blocks of printed text. Lists of kings formed tidy timelines, too, although the reigns each side of Tutankhamun trailed off in question marks. I wondered why. His name was near the end of the 18th Dynasty, which had lasted for 250 years (around 1550 to 1300 BC) and seemed to be Egypt's golden age, in every sense, as the kings amassed wealth through military conquest and savvy trade deals. My books referred to the last few decades of the dynasty – Tutankhamun's era – as the Amarna period. Amarna, I read, was where a king who came before him, Akhenaten, had established a new city in a sheltered bay of cliffs. It was set back from the Nile as if its residents could thrive on sun alone, without water to quench their thirst or let them sail away.

Unlike Egyptian rulers who had been known for centuries in Western Europe, thanks to Greek and Roman writers and the Bible, the famous names of the Amarna age – Akhenaten, Nefertiti, Tutankhamun – were fresh discoveries in the late nineteenth and early twentieth centuries. Their stories have been filtered not through the literary imaginings of the Renaissance (Shakespeare's Cleopatra) or Romantic era (Shelley's Ozymandias, who was Ramses II, 'the Great'), but through the mass media and popular culture of European empire. In other words, modern history determines what we know about this period, and excavating the layers of our own past is the only way to tell what can, and can't, be said with any certainty about the life of Tutankhamun and his relationship to other Amarna rulers.

Amarna itself was excavated in the 1880s, around the time that Britain invaded and occupied Egypt. The remote site excited scholars and the public alike because it yielded an archive of diplomatic correspondence, impressed in clay tablets using the wedge-shaped cuneiform script that was common in ancient Syria and Iraq. Written in Akkadian, the letters name places and rulers that correspond to some Old Testament accounts, which captured the imagination of devout Victorians eager to map the Bible on to the Middle East. Amarna also stood out because it was an urban settlement, rather than the usual tombs and temples found in Egypt. Tutankhamun probably spent part of his childhood in the city's palaces, but Egyptian kings and their entourages were often on the move, making appearances, holding court, and taking luxurious trips to hunt prey out in the desert or fat wildfowl among the Nile marshes.

In the early 1890s, influential British archaeologist Flinders Petrie excavated at Amarna – with young Howard Carter to help him. Petrie used lectures, exhibitions, and the illustrated press to publicize his finds and raise money for future work. He made Akhenaten and the royal family fit the domestic ideals of late Victorian Britain, the king a proud *pater familias* who tended the garden in his spare time and dandled his six daughters on his knees as their mother, Nefertiti, looked on and smiled indulgently. But there were soon several Akhenatens circulating. When American academic James Henry Breasted – an observant Christian who had first trained to be a Congregationalist minister – published a bestselling history of ancient Egypt in 1906, his Akhenaten was a Protestant reformer, a monotheist ahead of his time whose life and rule collapsed in opposition from the idol-worshipping, papist priests of Amun. In this version of events, Amarna was a utopian interlude that could not last, and Tutankhamun was a child manipulated into restoring the old gods.[3]

A more avant-garde and edgy Akhenaten emerged on the eve of the First World War, when German excavations at Amarna uncovered several limestone and plaster portrait heads in what appeared to be a workshop for making sculpture. With their unfinished edges and exquisite forms, they might have come right out of a contemporary sculptor's studio, works in progress for the modern age. The most remarkable was a painted bust identified as Nefertiti, discovered in 1912 in excavations led by the German Egyptologist Ludwig Borchardt and funded by Berlin-based cotton magnate James Simon. For several decades, the French-run antiquities service in Egypt allowed excavation sponsors to keep a portion of what they found, based on an agreement reached at the end of each winter digging season. That year, the French official who visited Amarna to agree the division made a cursory inspection and ceded the stunning sculpture to the German team, rather than claiming it for the Egyptian Museum in Cairo.[4] James Simon kept the bust with the rest of his art collection at home in Berlin until 1920, when he donated it to the city's Neues (New) Museum, together with other Amarna finds. The museum waited to put the bust on public display until 1923, after Howard Carter found the tomb of Tutankhamun. Queen Nefertiti became an instant icon, a pale-skinned beauty equally as enigmatic as her husband Akhenaten and the boy king who came after them. Before his death in 1932, Simon wrote to the Prussian minister for culture (the regional authority for Berlin), supporting calls for the bust to be returned to Egypt. Times were changing, as were German politics: when Hitler's National Socialists came to power the next year, a large plaque at the museum in honour of Simon – like Borchardt, a Jew – was taken down and all references to his donations expunged.[5]

Nefertiti, Akhenaten, Tutankhamun. Firm facts about these ancient individuals are as dry as an Ohio canal, compared to the

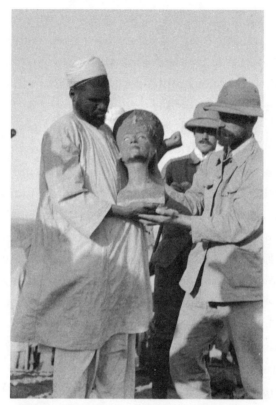

Ra'is *Mohammed es-Senussi holds the bust
of Queen Nefertiti, which he and his team
excavated at Amarna, 6 December 1912*

soap opera psychodramas that have been woven around them. Tutankhamun was part of Akhenaten and Nefertiti's family, but specialists still disagree on the specifics, including who his parents were.[6] Analyses of ancient DNA have lately claimed to offer firm solutions, but they are a house of cards built on a shaky table. For a long time, scholars like Petrie and Breasted assumed that Akhenaten and Nefertiti had only daughters, because the six princesses appeared so often with their parents and never with any princes present. The logic hasn't held up, however. In this period, the 18th Dynasty, the conventions of Egyptian art meant

that a reigning king was not shown together with his male chil-
dren. Tutankhamun may therefore have been Akhenaten's son,
either by Nefertiti or by a different wife.

Other theories have proposed that Tutankhamun was Akhen-
aten's younger brother or half-brother, or most recently that he
was Akhenaten's grandson, born to one of Akhenaten and Nefer-
titi's older daughters.[7] It's a puzzle with a hundred pieces, many
of them missing; hence the question marks around the line of
succession between Akhenaten and Tutankhamun, too. After
Akhenaten's death, a woman described as 'beneficial for her hus-
band' and 'beloved of Akhenaten' took over for a year or two. She
may have been his daughter Meritaten or his widow Nefertiti,
taking on new names as every pharaoh did. Either before or after
this 'beloved' came a ruler named Smenkhare, whose identity is
even less clear. Perhaps he was Tutankhamun's older brother or,
in a recent reconstruction of the family tree, his father. One Tut-
ankhamun specialist believes that Smenkhare was a new name
for Nefertiti as her independent rule developed. Whatever the
case, Smenkhare reigned a short time too, leaving only the boy
still known as Tutankhaten to take on the rule of Egypt.

Two pieces can be anchored into place in the jigsaw of Tut-
ankhamun's origins and family life. First, he married the third
daughter of Akhenaten and Nefertiti, a princess named Ankhesen-
pa-aten who, like him, changed the last portion of her name in
honour of Amun, becoming Ankhesen-*amun*. Whether she was
his sister, half-sister, or aunt, and what the difference in their ages
was, remains unknown and probably unknowable. The figure
and name of Ankhesenamun appear on many of the best-known
objects from Tutankhamun's tomb. On the backrest of the gilded
chair known as his throne, she is clad in silver and lays a hand
on her husband's body, anointing him with scented oil.[8] In the
gold leaf covering a small wooden shrine, he pours water into her

cupped hand to drink.[9] Male and female went together in Egyptian thought, and every king needed his counterpart in a queen who could balance, define, and refuel his masculinity.

The second puzzle piece to fix in place is this: Tutankhamun was born a prince and recognized as such in childhood. On a carved limestone block later used as building rubble, his slender, dangling legs appear alongside the royal formula that identifies him as 'the king's son of his body, whom he loves'.[10] History has little use for love, however, and it makes scant room for women, children, and the dispossessed.

Whoever Tutankhamun's mother was, the absence of her name or image anywhere in his tomb, or on any monument from his reign, probably indicates that she had died before he became king. Rulers of the time with living mothers made those women prominent, alongside or in place of their own wives. We do know about one woman who cared for Tutankhamun in his younger years. Her name was Maia, and her privileged role as the prince's wet-nurse gave her the social status and financial means to build a large and lavishly decorated tomb in the cemetery of Saqqara, west of Cairo.[11] She had earned the right to represent the king inside her tomb as well, and on one wall, Tutankhamun sits on Maia's lap, depicted – according to convention – as if he were a miniature adult in her embrace. Prince and king, child and man, at once.

By the time this orphaned boy came to the throne around 1332 BC, Akhenaten's palaces at Amarna had been abandoned in favour of older royal residences, such as those at Memphis, near Cairo, and Thebes – the name Egyptologists use for the ancient site that lies beneath and among the streets of modern Luxor, as if a different name were all it took to separate the past and present into discrete parts. In Tutankhamun's childhood, a turn back to the old gods was already under way, and no surprise. The

specific form of Aten worship that Akhenaten had promoted, with himself and Nefertiti in star roles, was not sustainable once both were dead. Tutankh-aten quietly became Tutankh-amun, and both those names appear on a handful of objects in his tomb. More important for Egyptians was the new name he adopted on becoming king: Neb-kheperu-re, which identifies him with the visible forms (*kheperu*) of the sun god, Re.

Becoming king may have meant leaving childhood behind, but some traces of that childhood, and of the family who predeceased him, were set aside for safekeeping. When Tutankhamun died, aged around eighteen or nineteen, these keepsakes joined him in the tomb. A single linen glove, sized for a child's hand, was folded up in a delicately painted box, one of the 'wonderful things' that Carter spotted in his initial glimpse of the tomb's first room (the Antechamber, as he called it).[12] Nearby, a child-sized ebony chair was tucked neatly under a gilded bed carved like a lioness, probably used to support the wrapped-up, embalmed body of the king in funeral rites.[13] Draped over the body of the jackal figure that kept watch over Tutankhamun's burial shrines was a linen tunic, freshly pressed and marked in ink with what looks like the name of Akhenaten and 'year 9', perhaps the date in that king's reign when the garment had been made.[14] A slender ivory writing case, with wells for six different shades of paint or ink, lay between the jackal's forelegs, lined up with precision.[15] The hieroglyphs incised upon its surface name Princess Meritaten, Akhenaten and Nefertiti's eldest daughter. Depending on how you fill the gaps in your Amarna puzzle, Meritaten may have been the wife of Smenkhare, the woman who briefly ruled before or after him, and the mother of the young man whose body had been secreted away inside those burial shrines.

Meritaten, or another woman who ruled as king, is a silent presence elsewhere in the tomb as well. The miniature coffin that

had sent goosebumps up my arms had not been made for Tut-
ankhamun but for a royal woman.[16] Tutankhamun's names are on
the lid, spelled out with inset slivers of coloured glass and car-
nelian. But on the inside of one lid, chased in the beaten gold,
are faint outlines of the hieroglyphs that wrote out 'beneficial for
her husband', a phrase that imbued the queen with the qualities
of a goddess. Gold workers had begun to craft a set of these con-
tainers for this woman's burial, to hold the corpse's embalmed
viscera. For some reason (speed? convenience? family ties?), the
craftsmen repurposed the four coffins, each around 40 cm high,
for her successor – and perhaps son – instead. Shimmering in
blue, turquoise, and red, the feathered body distracts the eye
from the reworked name. Whoever the queen of these so-called
canopic coffins was, she is no more than a shadow beneath the
outer shell, or what historians call a palimpsest – a surface that
has been erased and written over, rubbed almost smooth to start
again. It makes a useful metaphor for history itself, with a gentle
warning and an urgent plea. To see the past and its endurance
in our present, we have to turn time's mute survivors towards
the light.

* * *

Emptied cities, orphaned children, faded names. History finds
gaps through which to slip. Buildings, artefacts, and bodies are
always tending towards decay, no matter how we try to stave it
off. Not everything from the past can survive in physical form.
But something more than physical survival determines how his-
tory manifests itself in school curricula, museum displays, and
television shows. The old truism is still too true: history is often
written by the winners, or at least by those with enough power to
shine its spotlight where they choose. The history of Tutankha-
mun's tomb and its discovery is no exception.

When he stepped into the first chamber of the tomb, Howard Carter felt that he was stepping back into the ancient past. Three thousand years had vanished like a time-travel tale come true, and like a time traveller, Carter described his initial shock and sheer bewilderment in the journal he began to keep, its self-conscious prose a practice run for future publications. 'Yes, it is wonderful,' he recollected in its pages, as his reply to Lord Carnarvon's anxious query.[17] What, if anything, was visible beyond the stifled corridor they had followed underground? Only one person at a time could see through the hole Carter had made in the blocked-up opening at the corridor's end, and only by the light of an electric torch that shone into utter darkness. 'The first impression' of the space they saw, wrote Carter, 'suggested the property-room of an opera-house.' He crossed out the last two words and moved a different phrase there from two lines above: the property-room of 'a vanished civilization', the sentence became, as if the past had staged itself for Howard Carter to find.

In some respects, the tomb of Tutankhamun was, indeed, a staging place, prop room, and storage cupboard all at once. Burying a king was busy work. So was finding him. Howard Carter had been working for the Earl of Carnarvon for fifteen years by the time they stood at Tutankhamun's threshold. After the fact, Carter characterized the tomb's discovery as the culmination of a personal quest, and histories of archaeology have continued to oblige, embroidering an adventure tale with Carter as a lone hero battling against the odds and Carnarvon's dwindling funds. But writing history means looking forward in time, not back. Since resuming work in 1917, Carter and his Egyptian team, led by Ahmed Gerigar, had progressed from one end of the two-pronged Valley of the Kings towards its centre, clearing built-up debris down to bedrock. A tourist site already in Roman times, more recent visitors had searched the valley high and low for decades, yielding the

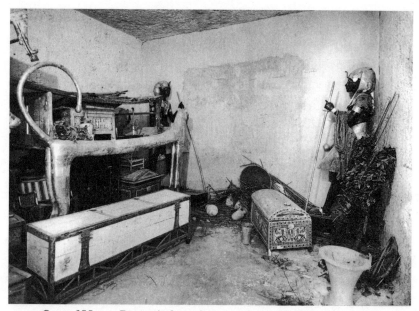

One of Harry Burton's first photographs inside Tutankhamun's tomb, showing the plaster-covered entrance to the Burial Chamber, taken in December 1922

entrances to sixty-one tombs. Some were cut into the rock faces of the valley, its geology carved millennia ago by a long-vanished river; others were cut into its floor – like Tutankhamun's, which became tomb sixty-two. The later, larger tomb of Ramses VI, with a vertical opening, dwarfed the area where Tutankhamun's burial lay. Over time, layers of rockfall, earth, and everyday detritus covered the spot further, until a pick, shovel, trowel, or broom wielded by one of the Egyptian excavators revealed the contours of a stony step. Sixteen steps led underground, in a stairwell that measured barely an arm span and forced grown men to crouch until they were halfway down it. At the foot of the stairs was a blocked-up doorway, then a rubble-filled corridor sloping steadily underground for more than 7 metres, and finally the second blocked doorway that stood, in Carter's mind, between present and past. Between him and the wonderful things.

The first room that Carter glimpsed by torchlight proved to
be one of four and the largest at 8 metres long and 3.6 metres
wide, with a comfortable clearance overhead. Carter may have
imagined himself in the property-room of a vanquished civili-
zation, at that first impression, but he had not yet imagined the
full extent of the tomb and its contents, nor the rationale for its
creation in antiquity. The other three rooms leading off from the
first were probably hacked out of the bedrock after the phar-
aoh's unexpected death at a young age, around 1323 BC. With no
tomb ready for him in the Valley of the Kings, where other rul-
ers of the 18th Dynasty had been buried, the officials in charge
of Tutankhamun's burial seem to have adapted a tomb created
for a lesser royal, which consisted of a single chamber at the end
of a staircase and corridor.[18] Carter came to call that room the
Antechamber. In its back wall, an opening about 1 metre high
gave access to a second, much smaller room that was quarried out
to serve as one of the ritual storerooms required for royal burial
equipment. Carter understood the ritual purpose of this space,
which he called the Annex and saved for clearing last, more than
five years later. Archaeology is slow work.

What grabbed the excavators' attention first was the
plastered-over wall at the short, right end of the Antechamber.
This proved to be the blocked opening into a third room whose
generous dimensions (6.4 metres long, 4 metres wide, with a
3.6 metre ceiling) were obscured by its stunning contents, for
this was the Burial Chamber where Tutankhamun's embalmed
body lay deep within a thick cocoon of gilded wooden shrines, a
linen-covered tent (or pall), a quartzite and granite sarcophagus,
and three coffins, each also shrouded in cloth. The head of this
ensemble lay at the west end of the space, so that the dead would
catch the first rays of the rising sun on his face. The foot end of
the burial led into the fourth and final room, at a turn to the

right. Carter first called this 'the storeroom', but then changed his mind to Treasury. It is another ritual space essential to the efficacy of Tutankhamun's burial – but the line between storage and sanctity is faint. There are no rites without the paraphernalia that goes with them. Folding something away, boxing it up, labelling the crate, and sweeping clean the floor: those are care-taking activities, too, even if the priest who spoke the prayers and wafted around the incense has long gone home for lunch.

No one knows how Tutankhamun died, only that he was eighteen or nineteen years old – a grown man by the standards of his day. Unexpected as his death probably was, a well-established procedure would have kicked in to prepare his body, tomb, and burial goods. The ideal period required to embalm and wrap a corpse was seventy days, the length of time that one of thirty-six constellations identified by Egyptian astronomers as circling the southern sky would spend out of sight before it reappeared on the horizon. Once wrapped up, in hundreds of metres of pure linen, the embalmed body could be kept aside indefinitely while the tomb, coffins, sarcophagus, burial shrines, and other ritual goods were prepared. Other objects that were part of a royal burial – jars of fine wine, preserved food, sacred statues, and *shabti* figures that stood in for the deceased – could be placed into the tomb once its rooms were ready, and those were among the first items moved into the Annex and the Treasury. The coffining, funeral procession, and further rites performed near the tomb marked the moment when the body, in its coffins, could be lowered into place in the sarcophagus and the rest of the tomb filled up around it. It will have taken several days, at least, to put everything in place, manoeuvre the lid onto the basin of the sarcophagus, and build the four gilded wooden shrines around it, one by one. The largest, which almost filled the chamber, was put together from pieces inked with assembly marks ('south rear') by carpenters who must

have held their breath and hoped. Priests needed to perform additional prayers and actions at certain junctures, too, such as positioning objects (symbols of the god Anubis, oars, perfume vases) around and just inside the outermost burial shrine. These protected the dead king and helped him on his never-ending cycle of divine rebirth.

In the Burial Chamber itself, four magical figures were sealed up into niches in each wall, and artists had to finish painting the walls as well, before scrambling through a narrow hole left in the blocking for their exit.[19] The other rooms, and all the ceilings, were left bare. Once the Annex was filled and sealed, it was the Antechamber's turn. Three ceremonial couches were lined up against its far wall, and the last of Tutankhamun's personal items – furniture, clothes, weapons, sticks and staves of his high office – could be fitted in around, on top, and under them. Dismantled chariots were placed in last, leaning to the left of the entrance. A drinking bowl carved from a single piece of creamy yellow alabaster, in the form of a white lotus blossom, was left standing on the floor on the way out.[20] Around its rim, valuable blue pigment fills the incised hieroglyphs that wish the drinker an eternity spent 'sitting with your face to the north wind, your eyes beholding happiness'.

Finally, the time had come to block, plaster, and seal the doorway through which, some 3,200 years later, Howard Carter would have his 'wonderful' view. The ancient workmen filled the corridor with limestone chips and rubble and then repeated the blocking, plastering, and sealing process to close off the entrance at the bottom of the stairs. They next filled the stairs in, too, and that was Tutankhamun buried.

As Howard Carter and his team reversed these ancient processes and began to clear the tomb, they noticed signs of rushed work, hasty adjustments (the biggest coffin had its projecting

feet cut back to fit into the sarcophagus, for instance), and what some scholars have derided as slapdash carelessness. Humans are human, however, and many of the workers who fitted out the tomb were not as well versed in, or attached to, theological minutiae as today's Egyptologists seem to be. If the statue of a goddess wound up on the 'wrong' side of a shrine, according to the cardinal points, it was not the end of their world, or ours. Other signs of messiness, disorder, and damage in the tomb point to opportunistic thieving, done either while the burial was being finished off or during an illicit entry after it was sealed, given that the two outer entrances had been plastered and stamped over twice. Some objects might have gone missing, and Carter found that the contents of many storage boxes had been scrambled, with their lids knocked off or set askew.

In the millennia after Tutankhamun's tomb was sealed, time, moisture, and microbes went to work inside the crowded space. Some two-thirds of the objects buried with the king were made in whole or part of organic materials, that is, substances that had once, like him, been alive. Wood, ivory, textiles, leather, feathers, plant remains, all are organic materials and especially vulnerable to decay. Moisture made the ancient wood expand and contract, loosening its painted plaster and gold leaf. Veneers and inlays came loose from boxes, furniture, and jewellery. Textiles were brittle, and cloth sagged into shreds around the statues it had once wrapped, as part of the rituals the ancient priests performed. Gilded leather fittings for the king's chariots and horse harness had cracked with time, and the chariots themselves were placed in the tomb in pieces, a puzzle within a puzzle to sort out. Treasures they may have been when they were buried with Tutankhamun, and treasures they would be again once the world got sight of them. In between, a mystical transformation had to occur, wrought not by prayers and incense this time, but

by catalogue cards, cameras, and chemicals – the science that the twentieth century took on faith.

The task was huge. Depending on how you count them, since objects like the miniature coffins are part of larger wholes, Carter and his colleagues found between five and six thousand objects in the tomb by the time their work was done a decade later. At a minimum, each object had to be catalogued and cleaned, using ammonia, acetone, benzine, or even stronger solvents, some of them now banned as health hazards. A sprayed-on coat of paraffin wax was standard, in an attempt to arrest further decay and keep surfaces pristine. Many objects required extensive repairs and reconstruction to make them suitable for study, transport, and display. Paraffin injected into crevices helped stabilize artefacts that should long ago have disintegrated into dust, the same as the human hands that had once made, packed, and transported them for deposit in the tomb.

Even objects made of solid gold, like the miniature coffins, had substantial help to make them ready for the modern world. 'Canopic' is a nineteenth-century term for containers like these, which held internal organs (lungs, stomach, liver, and intestines) removed during the embalming process that we call mummification – a ritual that made the dead bodies of elite Egyptians divine. In the most elaborate form of this ritual, embalming priests removed the organs, desiccated them, infused them with resin-perfumed oils, and wrapped them with linen into tight bundles. Each of the four canopic coffins from Tutankhamun's burial had these bundles placed inside, still oozing oils, and each coffin was then itself secured with two knotted strips of linen. The coffins stood upright in four deep wells drilled out of the solid alabaster shrine designed to take them, while more of the anointing oil was poured over the top, sticking them fast inside the wells.[21] Next, a carved alabaster stopper, carved into the form

of a royal head, sealed the opening of the wells before the shrine's own lid was set on top and draped with a dark-dyed cloth.[22]

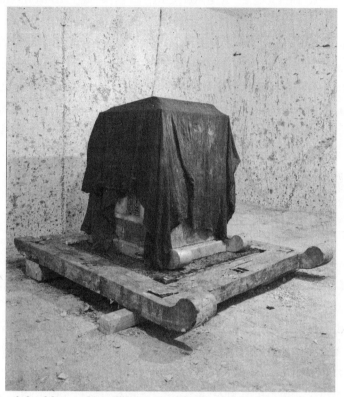

A dyed linen shroud draped over the alabaster canopic chest, which stood inside a gilded shrine in the Treasury; photograph by Harry Burton, autumn 1927

If this process of anointing, wrapping, and sealing seems like an elaborate and unexpected way to treat objects that today look almost worthy of Fabergé, it was entirely normal for Egyptian rituals, which worked by concealing potent objects like these from human sight. Some things are only for the gods to see. Turning the little coffins into artworks fit for a museum vitrine, or an educational filmstrip, meant prising them out of the stone shrine, removing their wrappings, emptying them of their sacred

bundles, and cleaning off the resin-sticky oils that adhered to them. The gold interiors, where the lost queen's name was hidden, had to be cleaned with pyridine (a type of benzine), and the exteriors, with their intricate inlays of blue and turquoise glass and red carnelian, were carefully checked over and made sound with wax. At least one had lost the white stone inlay either side of its obsidian pupil, which someone painted in to fill the gap – perhaps Howard Carter, who had an artist's skilled and steady hand.[23] Whichever of the four canopic coffins have gazed past visitors from a display case over the years, or past my younger self from celluloid, they are pristine not because time stopped for them, but because archaeology has shifted time into reverse.

* * *

My own discovery of Tutankhamun spurred me forward. In the books on ancient Egypt that I found in the public library, or bought with carefully saved allowance funds, I spotted a word for what I wanted to be when I grew up: an Egyptologist. It was used to describe Howard Carter, the man who found the tomb of Tutankhamun, and that seemed good enough to me. I went back to the library to search through a reference book on college courses and find out where to go to study this strange subject that no one of my personal acquaintance considered viable or real. It worked, and half a career and lifetime later I shifted into reverse, too. I went back to have a closer look at Tutankhamun – not in his time, but in mine.

In a coincidence of the coronavirus pandemic in spring 2020, much of this book was written in the bedroom where I filled out my applications for college admission, financial aid, and scholarships. Now emptied to a desk and chair ('sale pending', reads the sign out by the road), it sports the same pink walls and plum carpeting I chose when the house was rebuilt in my penultimate

year of high school. Fire had destroyed the old one, taking with it all the photo albums, childhood toys, and modest heirlooms that define a family to itself. Little survived but the acrid smell of smoke, which clung to the charred pages of my books, diaries, and drawings before they were shovelled to the county dump. Where there had been photographs of distant digs and famous pharaohs, or pencil portraits I had worked over for days, there was now a stubborn smudge of ash on my numb fingers. At night, in borrowed shelter, my mother wept over the memory of her wedding dress and the ivory frets of a Gibson polished by her dead father's country chords. We buried what was left of the guitar on the hill behind the house, next to the dog who had been trapped inside. The flesh of these once-living creatures fell away as the bones of the new structure went up that winter.

The rebuilt house was nearly ready by the time a cold Midwestern spring crept forward. My parents wanted us to have a choice in the interior, to help us feel at home again. They proffered paint cards and carpet samples. I pointed my approval to oblige. But when we moved back in, manoeuvring our way around doorways that were in different places, the shades were brighter than the old room's faded lilac. It was an early lesson that went unheeded: you cannot recreate the past.

Eighteen months later, I moved to the East Coast to study archaeology, and recreating the past was all we tried to do. We learned how to discover it, a bit like Howard Carter had, with trowels and paperwork and Munsell soil charts. We pored over the ground plans of major sites, drew stratigraphies, and memorized a canon of ancient art. What struck me was the phrase that a professor used to caution against reading too much into the buildings and objects that happen to endure through time. They were 'accidents of survival', she said. By then, I felt a bit like one myself.

Her point was that not everything can last. The challenge is to sift for absence. On a summer excavation in Greece, I sifted dirt instead. A smooth potsherd painted centuries ago slid silk-like through my fingers, and I watched a marble Venus lifted up from where it fell in Roman times. Time never disappeared for me, however. I sensed no slippage between centuries, like Carter claimed to feel inside Tutankhamun's tomb. Having seen first-hand how fragile objects are, I knew that what survived was just one fragment of a larger picture, too large for us ever to see. Archaeology looks for long-gone people in what they leave behind, but it is hard to get at why and how those things and places mattered long ago. A guitar is only a guitar, if you do not know who brought its strings to life.

That Venus face down among the hypocausts of an abandoned bath was ice-cool to the touch, an exile from her own time, caught out in ours. I wound up an exile of sorts in the life that I had chosen from the library guide. Studying at an Ivy League university meant learning a social landscape that I had not known existed. Each spring, the Faculty Club hosted a dinner for the few students like me who benefited from a generous scholarship scheme. My first year, I stared anxiously at the cloth napkin, three glasses, and four sets of silverware that faced me. My second year, someone took me for a Riggs from the Washington DC banking family, as if I were a donor, not the recipient of largesse. My third year, I declined the invitation; selective participation is an option for the immigrant in her new country. My final year, I recanted and went along to say goodbye, reconciled that this world was now my home. But like the new house erected on the foundations of the old, I was not quite the same inside. My doors had been rearranged; my windows looked out on different views.

At university, I put aside my interest in Tutankhamun and

his treasures, which in any case weren't covered by my classes in archaeology or Egyptology. I pursued my studies with dogged determination, relieved to have a focus in a life that felt otherwise unmoored. The university library was a refuge, as were the jobs I took to make ends meet, filing slides in the archaeology department and answering the rare phone calls that jangled in the Egyptology office on sticky summer days. My professors at undergraduate level and in graduate school had lived through, and even worked on, the 1970s exhibitions that had toured the United States and enthused my sixth-grade teacher. Perhaps they'd had enough of the boy king. All that gold glittered too much for serious academia, and my childhood wish to apprehend an ancient Egypt inside out, with every puzzle piece in place, now seemed naïve.

In retrospect it was, but I am not alone in that. What many of us want from archaeology and ancient history are hard facts softened by familiarity. Something tangible to anchor ourselves to an idealized past. There are pleasures to be had in such a take on history, to be sure. But there are problems, too – not least of which the fact that both conventional and more sensationalized accounts of Egyptian archaeology (think mysteries and aliens) pay scant attention to how antiquity has been made, and remade, in more recent times. Understanding this is crucial, all the more so because it means confronting difficult histories and their legacies today. Colonial expansion, military force, and systemic racism made Egyptology possible in the nineteenth and early twentieth centuries, and Egyptology returned the favour by serving up an ancient Egypt stamped in that likeness. Once modern history comes into view, the deep past no longer offers such a comforting escape.

In the wake of a pandemic that has laid bare global inequalities and seen a resurgent movement for racial justice under the

banner of Black Lives Matter, it is more crucial than ever to understand the context in which the discovery of Tutankhamun's tomb took place – a context in which ugly histories are embedded as surely as the polished stones and lustrous glass in the little coffin that inspired my ten-year-old imagination. The centenary of Howard Carter's first, fabled glimpse of the wonderful things will see the Tutankhamun industry kick into high gear, with television programmes, museum exhibitions, glossy picture books, and media coverage to rival the original 'Tut-mania' of the 1920s. But amid those celebrations is an opportunity to reconsider outmoded assumptions about Egypt, then and now, and to reflect on the fate of its well-travelled, slightly weary, and most gilded son.

Archaeology was an imperial project at its heart, something the next chapter makes clear as we follow Howard Carter to Egypt and to Tutankhamun's door. Although empires crumbled in the course of the twentieth century, the fate of a find like the tomb of Tutankhamun shows us that some of their old ideas and influences have stubbornly endured, or simply changed tack. No pure and unassailable ancient Egypt exists, or ever will. More and less accurate versions of it can be argued over endlessly, but each is a model reconstructed from data that will always be incomplete, imperfect, and indebted to contemporary value systems. The story of Tutankhamun's tomb is no exception. As this book traces the tomb's history through the Second World War and an unexpected 1960s revival, and beyond, we see that it has as much to do with geopolitics, post-war utopias, and consumer capitalism as it does with priceless treasures, thrilling discoveries, or hidden burials. Death and loss should figure in Tutankhamun's story, too, but they rarely get much mention. We are blinded by the promise of eternity in all that ancient gold and by the legend that now goes with it, where the lone hero gets to break the sacred

seal unscathed. We would do well to look beneath our reworked surfaces and sieve our dust and ash instead.

This book recounts my own discovery of Tutankhamun, a reckoning with what I've learned, and unlearned, since that jewel-like little coffin flickered into view upon a classroom screen. Like any writer, I can speak only from my own position, or what academic lingo calls being 'situated' in a time, place, and perspective. What that means is that I do not claim to offer the kinds of universal truths or voice taken for granted by many books about the ancient world and its lauded 'discovery' by the West. In particular, I do not speak for the many and diverse Egyptians whose points of view have often been misrepresented, stifled, or simply ignored in making Tutankhamun into a cultural phenomenon. By drawing attention to Egyptian roles in the 1920s discovery of the tomb, and its rediscoveries between the 1960s and today, I have tried to point towards different histories that could and should be told. In that spirit, the book concludes with chapters that consider our indifference to the ancient dead and our responsibilities to the living. Who narrates their own story, and who fulfils their childhood dreams, are determined in part by a past that has shaped the present. Only a rebalanced, less bombastic, approach to Tutankhamun can yield a future where more voices can be heard and more dreams realized.

In my own sifting of Tutankhamun's tale, I have seen his treasures close enough to touch – his gold collars, gilded chariots, and spotless linen underwear. I have leafed through Howard Carter's photo albums, walked his teenage streets, and visited museums and archives on three continents. I have blinked back pointless tears over letters, receipts, and photographs where the nonchalant cruelty of colonialism, and the inevitability of death, seemed overwhelming – and I have smiled, or raised an eyebrow, at the small details and sarcastic asides that bring archival documents to

life. Along the way, I have met dozens of people whose lives, like mine, were touched or changed forever by an encounter with the boy king. There have been unexpected turnings and occasional dead ends. But tracing the trajectory of Tutankhamun since 1922 has let me lift into the light the unexpected and unsung in the history of this remarkable excavation – and weigh up its continued impact on our world today. After a century shaped by Tutankhamun, what a wonder it would be to see his story used to tell, more honestly, our own.

I

Creation Myths

IN AN OLD folk tale, a pedlar from the town of Swaffham in Norfolk dreams that if he goes to London, he will find his fortune on London Bridge. He walks a hundred miles to the capital and stands on the bridge all day, then a second, feeling a fool. On the third day, a shopkeeper asks what the man is doing. Following a dream, the pedlar says, and the shopkeeper tells the pedlar about his own strange dream, that a pot of gold lies buried beneath an oak tree in a Swaffham garden. The pedlar recognizes it as his own home and heads there, chastened. With the treasure he discovers beneath the ancient oak, the pedlar helps the poor and pays for repairs to Swaffham's church, his lesson learned. Go out and search the world for treasure, if you will, but you may find that it was always in your own backyard.

Swaffham has fared better than some market towns in Norfolk today, where rural poverty rubs up against second homes and country houses still in private hands. Tucked away in its Georgian and Victorian buildings are a boutique hotel, a good bookshop, and several options for afternoon tea. Above the wide marketplace the name Rasputin blazes over a Russian restaurant – a sign of Eastern European immigration to the region, which is always in need of agricultural and healthcare workers. But many storefronts wear the pinch of penny-counting, and in 2016, the Breckland district voted by 64.2 per cent to leave the

European Union. A benefactor with a pot or two of gold would not go amiss.

Perhaps a similar divide between well off and poor, old-timer and newcomer, marked the town when Howard Carter lived there as a boy. Both sides of his family had deep Swaffham roots, and Carters live there still. A second cousin once or twice removed runs a tapas restaurant called Tutankhamun's, right on the marketplace. On the walls hang paintings based on photographs, with a portrait of Carter himself in pride of place behind the bar. Ask about the family connection and the owners will unfold a complicated family tree. Swaffham should do more to honour him, they say. A statue, a display of replicas from the tomb, something, anything, to bring Tutankhamun tourists here.

Two doors down, the town museum does its best to remember the Carter family and their famous son, on its shoestring budget as an independent charity. Swaffham Museum was one of the first places I visited after moving to Norfolk, and one of the last when the time came to move away, a decade later; little had changed in between. The Carter Connection Gallery on the ground floor is the museum's most heavily used space. It tells the story of Howard Carter's early life and Swaffham ties, alongside activities and displays designed for children 'doing ancient Egypt' at school, as I once did.

Gilt-framed oil portraits introduce us to the Carter family; they are by Howard's older brother William, who followed their father Samuel into a painting career. Beyond them is the star attraction: a scaled-down recreation of the moment, in February 1923, when Howard Carter and Lord Carnarvon broke through the dividing wall between the Antechamber and the Burial Chamber. You climb a set of wooden steps and peer into a recreation of the tomb, built in what might have been a broom cupboard. Press a button and the lights go up on the scene, as

an actor voicing Howard intones the inevitable words. Yes, wonderful things.

Unlike the Swaffham pedlar, Howard had not found his fortune there but in the Middle East, where the old English folk tale seems to find its origin, or at least its twin. The thirteenth-century Persian poet Rumi, a Sufi scholar, told of a man in Baghdad who dreamed of finding wealth and renown in Cairo, and a Cairo man who did the opposite. Dorothy and the Good Witch in *The Wizard of Oz* said more or less the same: dream of being elsewhere, and you may miss where treasure lies.

* * *

Tutankhamun made Howard Carter famous. For a time, at least, he was almost as interesting to the public as the boy king whose tomb he had found – and as inscrutable. Among his papers at Oxford University are a number of incomplete memoirs and autobiographical notes in which Carter revisited, and rewrote, his past.[1] He painted his Swaffham youth and childhood with soft edges, a fair copy from a Victorian picture book idyll. Whether it was is difficult to say.

Born in Earl's Court, London, in May 1874, Carter was sent as a baby to live in his grandfather's household on the edge of town, where the woodland began. Country air was better than the famous London fog, and Carter's mother had her hands full with several other children. Howard was the youngest of eleven, ten sons and one daughter; three of his older brothers had died before his birth. In Swaffham, Grandfather Carter was gamekeeper for the estate of the Hamond family and lived in a tied house on their estate. Still known by the name Keeper's Cottage, the house is built of brick and the gnarled flint nodules that fill the Norfolk fields, like the stone bones of long-dead creatures.

Young Howard was looked after by two unmarried aunts.

Other family members joined him when they could: his brothers Verney and William, the portrait painter; his sister Amy, to whom Carter remained close throughout his life; and their parents, Martha and Samuel. Samuel Carter was an artist of some success, known for his skill at painting animals. In London, his work had been shown in the Royal Academy's Summer Exhibitions, and he was the animal illustrator for the *Illustrated London News*, a weekly newspaper that would play a significant role in Howard's life. By the time Howard was in his early teens, his parents divided their time between London and Swaffham, where Samuel continued to paint commissions for country clients. Favourite horses, pampered pets, and hunting themes offered steady and respectable work.

In one of his unpublished autobiographies – *An Account of Myself*, he had titled it – Carter claimed to have been 'debarred from public school life and games' due to physical weakness, as if these proving grounds for the military and civil service had ever been an option in his family circumstances. Although two of his older brothers briefly attended Hamond's grammar school in Swaffham, which was sponsored by the same family for whom their grandfather worked as gamekeeper, there is no record of Howard having gone there. Perhaps he received his schooling at home with his aunts, or by informal arrangements elsewhere. Whatever the reason, in later life, Carter must have been aware that a lack of formal education set him apart from many of the gentlemen archaeologists, wealthy art collectors, and aristocratic patrons with whom he worked and socialized. Soon after I moved to England, I heard British Egyptologists offer a single criticism of Carter: that he had copied the Earl of Carnarvon's manners of speech and dress. After several years of living and working in Britain, I came to understand how barbed the observation was, by English standards. To ape one's social betters is to

flout a system in which everyone is meant to know their place and stay there.

The teenaged Howard Carter had plenty of contact with his social betters when he helped his father Samuel with painting commissions. Like his brothers and sister before him, Howard had studied drawing and painting with Samuel, with a focus on closely observed birds and animals; the family kept a menagerie at their Swaffham home. His skills with pencils and water-colour brushes would serve Carter well in later life, not least in the recording of Tutankhamun's tomb. Helping out his father also brought him into the ambit of the landed gentry – and his first encounter with ancient Egypt, courtesy of a country house.

Since the 1850s, Samuel Carter had done regular commissions for the Amherst family at their estate some eight miles west of Swaffham.[2] William Amherst (or Tyssen-Amherst, to give one spelling of the family name) was just twenty years old when he inherited from his parents, who died less than two years apart. They are buried in a sturdy church of Norfolk flint that can now be reached by footpath across a field, its square tower hunkered down near the ruins of what was once Didlington Hall. Part of the estate's wealth came from the timber forests planted in the sandy-soiled Brecks, which helped build industrializing Britain. Amherst spent his income in lavish style. He turned the brick-built Georgian hall into an Italianate mansion said to have boasted a chimneypiece from St Peter's Basilica in Rome. Outside were landscaped gardens, boating lakes, and a well-stocked deer park that attracted royal visits. Inside, Amherst's library was a book collector's dream. His rarities included sixteen volumes printed by William Caxton, who set up the first press in England in the 1470s.

But it was Amherst's passion for Egyptian antiquities that changed Howard Carter's life. In 1865, Amherst purchased the

entire 600-strong collection of Egyptian antiquities formed by
Dr John Lee, a noted astronomer who had spent time in Egypt
during the Napoleonic Wars.[3] The most striking objects in
Lee's collection were seven statues of the lion-headed goddess
Sekhmet ('the powerful one'), carved in a hard, dark stone and
standing nearly 7 feet tall. They had been in England for several
decades by then. Lee acquired them after they failed to sell at
Sotheby's auction house in 1833, rescuing them from the damp,
dark arches beneath Waterloo Bridge, near the quayside where
they had been unloaded after the long journey out from Luxor,
Egypt. With a woman's body, a lion's mane, and the disc of her
father, the sun god Re, upon her head, each Sekhmet sits in calm
stillness on a simple throne, but like a purring cat, she could flip
into aggression. War and disease were her weapons, punishments
for those who disobeyed the cosmic order known as *maat*. Chaos
has a kinder side in ancient Egyptian thought, at least, and after
the devastation Sekhmet wrought came the healers and physi-
cians who worked in her name.

Amherst placed his seven Sekhmets in the open air outside
Didlington Hall, where their dark stone bodies could warm up
in the weak English sun while they kept watch over the neat
lawns and Norfolk fields beyond. He liked to say that there was
one statue for each of the seven daughters that he and his wife
Margaret had welcomed at one- or two-year intervals since their
marriage. They had no sons, and at his elevation to the peerage
in 1892, as the 1st Baron Amherst of Hackney, Amherst ensured
that the title would pass through the female line. Sekhmet –
strong-willed daughter of the sun god Re – proved a more apt
symbol of his able daughters than the new Lord Amherst might
have anticipated.

In 1871, the Amhersts took their eldest daughter Mary
(known as May) with them on the first of many trips they made

*The seven statues of Sekhmet at Didlington Hall, Norfolk,
in a photograph from the late 19th century*

to Egypt, travelling by rail and river in style. They took in the
sites that were by then part of a tourist trail, and the family inev-
itably brought home more artefacts, whose sale and export was
licensed by the Antiquities Service of the Egyptian government.
Back in Norfolk, Amherst added a single-storey extension to
Didlington Hall to house what had become one of the largest
collections of Egyptian artefacts in private hands. Known as the
Museum, its elongated windows cast natural daylight on the open
shelves and glazed cabinets filled with the family's ancient treas-
ures. In addition to the Sekhmet statues, the collection boasted
amulets, scarabs, pottery, sculptures, and stelae carved with offer-
ing prayers for the dead. Amherst owned several papyrus sheets
and scrolls as well, including one that proved to have historical
importance. Joined to its other half, which had been purchased
by Leopold II of Belgium, it recounts a series of tomb robberies

in the Valley of the Kings, 300 years after Tutankhamun's bur-
ial. By then concealed from view underneath later structures, his
tomb escaped the worst incursions that the scrolls described for
other royal burials.

Hidden tombs were far from Howard Carter's mind when
he began to accompany his father to work at Didlington Hall
in the late 1880s. By then, the Carters and the Amhersts had
struck up a social friendship of sorts – enough for the owners
of Didlington to take an interest in the future of the Carters'
youngest child. They supported a charitable organization called
the Egypt Exploration Fund, founded in 1882 by their some-
time guest at the Hall, the novelist Amelia Edwards. When the
Fund announced that it was looking for a young artist to train
for work in Egypt, the Amhersts thought Howard Carter would
be perfect for the job. He was seventeen years old with no other
serious prospects, and his modest background meant that the
£50 salary for a year's work – about average in the UK at the
time, for a skilled labourer or junior clerk – would be welcome.
Mrs Amherst assured Mrs Carter that it was a sound opportu-
nity, or as she wrote to the young scholar, Percy Newberry, with
whom Carter would be working: 'I told his mother that he ought
to try and improve himself by study as much as possible during
his leisure time.'[4]

Howard Carter went to London in the summer of 1891 to
train for his new job. This involved studying drawings in the
manuscripts department of the British Museum, made by trav-
ellers like Robert Hay on their own Egyptian journeys some
seventy years earlier. Egyptology was young as an academic
discipline, but it gave itself a genealogy stretching back to the
Napoleonic invasion of Egypt and the French general's subse-
quent defeat by a British and Ottoman alliance. Hand-copying
the scenes and inscriptions that covered the surfaces of ancient

Egyptian monuments was somewhere between a pastime and an obsession for many European visitors anxious to take their visual impressions of the country home with them. The Nile and its riverbanks, the pyramids and half-buried temples, all thronged this visual repertoire as well, an ancient Egypt filtered through Romanticism and the picturesque. Carter tried his hand at inking drawings and made his own copies from British Museum objects, which satisfied the Egypt Exploration Fund that they had found their man.

Carter left England for Egypt in October 1891. His father Samuel saw him off at Victoria Station, handing over newspapers and a tin of tobacco for the journey down to Southampton and across the Mediterranean. The young man, green as a bowling lawn, still knew little about ancient Egypt or its myths, and perhaps it was just as well. Had he consulted the seven Sekhmets at Didlington Hall, they might have warned him: death is never far from life, and destruction paves the way, painfully, for rebirth.

* * *

Carter's voyage took him by sea to Alexandria, then by rail to Cairo, where he stopped for a few days before taking the train south to the small town of Beni Hasan in central Egypt, where Percy Newberry was waiting for him. Five years older than Carter, Newberry was a budding Egyptologist and amateur botanist. He knew the Amherst family well, having stayed at Didlington Hall to make a close study of the scarabs in their collection and enjoy the estate's walled gardens. Newberry would prove to be a friend and professional ally throughout Carter's life.

At Beni Hasan and a nearby site called Deir el-Bersha, Newberry and Carter lived and worked in the bluffs above the Nile, where rows of tombs built around 2200 BC look out over

a floodplain lush with crops in the winter months. Carter was
there to help Newberry copy the painted decoration inside the
tombs.[5] There were charming representations of ancient Egyp-
tian life, with wrestlers and dancers alongside workmen, traders,
and farmers. Drawing everything by hand was the gold stand-
ard for recording hieroglyphic inscriptions and tomb scenes,
and Newberry wasn't very good at it. His method was to hang
tracing paper over the walls and pencil the outlines; these were
then taken back to England and inked in as solid forms. As an
artist, Carter knew that only copying by eye could capture both
the spirit and the specifics of the original paintings, with their
carefully applied colour, fine outlines, and delicate details. But
as the junior person in a four-man team, most of Carter's work
had to follow Newberry's system. The copies he made in his own
way, using the skills he'd learned from his father, were met with
pleasant surprise.

This Archaeological Survey, as the project was called, was
meant to make an accurate and permanent record of as many
tombs and temples as possible, at a time when a new genera-
tion of British (and other European) scholars considered them
under threat from the modernization of Egypt – the very mod-
ernization that Western European interests had been promoting
to their own financial benefit for decades. In the wake of Napo-
leon's invasion of Egypt in 1798, and his subsequent defeat, the
ethnic Albanian strategist Muhammad Ali had become governor
or *wali* of Egypt, a post he held for nearly four decades until his
death in 1849.[6] The sultanate in Istanbul granted him a degree
of independence that was unusual in the Ottoman Empire, as
well as making his post hereditary. Egyptology dates some of its
earliest and best-known heroes to Muhammad Ali's reign; how-
ever, many of them were not there to 'discover' some entity called
ancient Egypt but to render diplomatic, engineering, or military

service to an influential and reform-minded potentate within an Ottoman territory. To discover something in any case implies that monuments like the pyramids, tombs, and temples of antiquity were utterly unknown. They were not: local people living near, on, or even within these sites had their own ideas about them, as did Arabic scholars who for generations had contemplated the pyramids and hieroglyphs with awe.[7]

Muhammad Ali encouraged and even equipped several European expeditions that set out to explore and record the ancient sites of his adopted country, giving permission for them to commandeer local labour and supplies and to take back to their home countries some of the wondrous objects that they found. Between the 1810s and 1840s, men like Giovanni Belzoni, Henry Salt, Giovanni d'Athanasi, Jean-François Champollion, and Karl Richard Lepsius helped fill the museums of London, Paris, Turin, Leiden, and Berlin with Egyptian antiquities. The *wali* started his own collection too, in Cairo's Citadel, and in 1835 he instituted the first law banning the export of antiquities from Egypt without a licence – a law that was easier to institute than to enforce.[8]

It should go without saying that the nineteenth- and twentieth-century history of Egypt is crucial to understanding the development of Egyptology and the context in which archaeological work, like that of the Egypt Exploration Fund, took place. However, Egyptology remains quite attached to its own creation myth of conquering heroes, romantic adventurers, and earnest, innocent scholars set on saving ancient Egypt from its modern inhabitants. Most mainstream books, television programmes, and museum displays either skip the subject altogether or gloss over the entwined relationship between creeping colonization and Egyptian archaeology. A timeline in Swaffham Museum illustrates the point: it leaps from Queen Victoria's

accession in 1837 (two years after Muhammad Ali's antiquities law), to the discovery of Tutankhamun's tomb in 1922. But quite a lot happened in between.

The successors of Muhammad Ali had a complicated relationship with European powers, in particular the old rivals Britain and France. To Britain, Egypt was too strategic to ignore for commercial reasons; Egypt also gave access along the Red Sea route to Britain's colonial territories on the Indian subcontinent. To France, Egypt was a lucrative sphere of influence and a means to counter British power in the region; it was also a crucial cultural reference point, all the more important for being a lost piece of France's North African empire. Egyptian antiquities became a symbol of the French nation, and an obelisk gifted to the country by Muhammad Ali stands on the Place de la Concorde in Paris in place of the revolutionary guillotine. Many of Muhammad Ali's male descendants were educated in France, and one of his sons and successors, Said *pasha* (the highest Ottoman honorific rank), invited former Louvre curator – and antiquities smuggler – Auguste Mariette to establish an Antiquities Service, the *Service des Antiquités*, in Egypt in 1858. Around the same time, engineer Ferdinand de Lesseps, whose father had been French consul in Muhammad Ali's time, began construction of the Suez Canal, part-funded by French shareholders.

During the reign of Ismail *pasha* – Said's nephew, who was given the title viceroy, or *khedive*, by the Ottoman sultan – foreign investment poured into Egypt thanks to the Suez Canal project. Railway construction made use of British expertise, and British textile mills caused a short-lived cotton boom in Egypt when their supplies from the southern United States dried up during the American Civil War. Ismail lavished funds on the 1869 inauguration of the Suez Canal and the expansion of Cairo, which he constructed in Parisian style. But the boom turned bust. Egypt's

foreign debt ballooned like a bustle skirt, with half of it in the hands of British banks and bondholders. When Egypt defaulted on repayments in 1876, Britain and France stepped in to manage the country's finances and force Egypt to repay the debt – which it continued to do for decades to come. It was all the more humiliating for Egypt given that Britain had bought out Ismail's shares in the Canal only a year before. Stocks and bonds, the building blocks of capitalism, built colonialism as well.

The people who had benefited most from Egypt's boom years were the ruling class, of Turkish and Circassian descent, and thousands of foreigners who had been drawn to Egypt by opportunities in commerce or the military. Five-star general William Tecumseh Sherman – born in my Ohio home town – recommended former officers from both sides of the American Civil War to Ismail, to improve training in the Egyptian army; Ismail sent Sherman's daughter a diamond *parure* for her wedding day, in thanks. Most of Egypt's population had lives as far removed from diamonds as a lump of coal. Farmers worked land that was increasingly not their own, factory workers were under pressure to spin ever finer cotton, and the Suez Canal, like other major works, was built with conscripted labour, known as the *corvée*. An emerging middle class was stymied, too. Young men with European-style educations found the best professional opportunities always out of reach in a system that favoured foreigners and the Turkish elite. One of these men, General Ahmed Urabi *pasha*, emerged as leader of a movement that sought to even out the inequities of colonialism in Egypt. Urabi's persuasive voice in the Egyptian government and widespread support within the military had both the *khedive* and European powers worried. With Egypt's finances and the Suez Canal Company under their control, the last thing they wanted was a revolution.

In July 1882, the British navy bombarded Alexandria in

response to an Egyptian uprising the previous month which had seen shops in the city's European quarter ransacked, hundreds of people injured, and at least fifty Europeans killed. A tense summer ended with a land invasion, planned in strict secrecy, which devastated Urabi's forces at Tel-el-Kebir, on the eastern edge of the Nile delta. The lead British general, Garnet Wolseley, was a veteran enforcer of the British Empire, from India to the Northwest Territories of Canada to the Gold Coast of West Africa – wherever its unwilling subjects sought the kind of self-determination the British themselves enjoyed. After the invasion, the British army set up vast barracks and parade grounds in central Cairo, next to Ismailia Square – named after the former *khedive*, who had been forced from power by France and Britain in 1879, in favour of his son Tewfik. The square is better known by its current name, Tahrir: Liberation, to mark the 1952 revolution that finally won Egypt its independence. In early 2011, Tahrir Square was the site of protests watched around the world when the Arab Spring began to bloom.

Howard Carter's generation of archaeologists were children when Britain took control of Egypt in all but name. Since the country was still part of the Ottoman Empire, it had to be a 'veiled' protectorate, a phrase associated with its first consul-general, Evelyn Baring of the Baring banking family.[9] Baring ran Egypt for twenty-five years, an imperialist who considered Egyptians racially inferior and suppressed state-funded education. As it happens, Baring was a Norfolk man as well. When his service to Britain was rewarded with an earldom, he styled it after his family seat at Cromer on the county's North Sea coast. Empire was not something that happened elsewhere. Empire was where Britain was, and felt, at home.

How much Howard Carter had followed British politics and the Egyptian question is difficult to say. Thirty years in the future,

when British control in Egypt started to unravel, and Tutankha-
mun started to reappear, Carter's politics leaned to the right,
against Egyptian independence. When he arrived in 1891, he
probably accepted the Empire – and its advantages to him – as
a given. The only conflict he had to worry about was infighting
in the Archaeological Survey camp, which had moved on to the
site of Deir el-Bersha. A self-interested intervention by Amh-
erst saved Carter from an awkward situation, again by fortunate
timing. The soon-to-be Lord Amherst had decided to donate
the comfortable sum of £200 to the cost of an excavation taking
place not far away, at Amarna – the palace city of Akhenaten and
Nefertiti, which Flinders Petrie had been excavating on behalf of
the Egypt Exploration Fund. If Amherst paid for further work
on the site, the Fund assured him, Didlington Hall could add to
its Museum a share of whatever was found. As a protégé of the
Amherst family, Howard Carter benefited from this largesse with
a transfer to Amarna.

Petrie was on the brink of a towering career. He had worked
for the Egypt Exploration Fund at its outset then struck out on
his own, helped by the patronage of Amelia Edwards. Her death
in 1892 bequeathed to University College London her collec-
tion of Egyptian antiquities and funding for a chair in Egyptian
archaeology, which Petrie held until his retirement. He was a vig-
orous proponent of scientific racism, whose repugnant but widely
accepted theories suffuse his writing.[10] In his archaeological
fieldwork, Petrie was known for two things: first, a rigorous set
of excavation and recording techniques, and second an approach
to camp life that a Spartan would find gruelling. When How-
ard Carter joined Petrie at Amarna on 2 January 1892, one of
the first things he had to do was build his own living shelter out
of mud bricks. Meals were scrounged from whatever battered
tins Petrie had brought out from England, unless passing British

visitors (of whom there were many) invited them to dine aboard their boats.[11]

At first, Petrie summed up his new companion as 'a good-natured lad, whose interest is entirely in painting & natural history; he only takes this digging as being on the spot & convenient to Mr Amherst, & it is of no use for me to work him up as an excavator'.[12] Petrie had brought with him to Amarna a team of Egyptian excavators from the Fayum, with whom he had worked for years; he did not need another pair of hands or eyes. But as he got to know Carter, the two began to confer over finds and strike out on long walks into the desert, looking for ancient sites. On one walk, ten miles out, Carter spotted the nest of a great vulture, 9 feet across: 'The bird flew up & C. secured an egg of monstrous size.'[13] On site, there were prizes of a different kind. Among the artefacts Petrie's team uncovered that spring were sherds of pottery from the shores of Greece and fractured statues of Akhenaten and Nefertiti, made of crystalline limestone that shimmered in the sun. They were packed up for Didlington Hall, along with some of the ring moulds and bezels of shiny blue, green, and yellow faience. On one of these inscribed for Tutankhamun, Petrie spotted an unusual feature, because the names of both Amun and Aten appeared side by side.[14] Perhaps the name of Tutankhamun lodged itself in Howard Carter's memory then.

Carter's skill as a draughtsman proved useful to Petrie, who made regular reports about his work to the British press with an eye on fundraising for future work. Carter had drawn a funeral scene carved inside the royal family's tomb, up in the cliffs beyond Amarna; the sketch was published with a Petrie article in the *Daily Graphic* on 23 March 1892. It was some bright news for the Carter family back in England, whose letters to Egypt had kept Howard informed of the stroke his father Samuel had suffered

that spring, and the poor progress of his recovery. Towards the end of the excavation season in May, Flinders Petrie handed his apprentice a cablegram that had just reached the site.[15] Samuel Carter had died on 1 May, days before his youngest son turned eighteen. Howard Carter wrote years later of the 'inexpressible sadness' that overcame him at the news. Petrie jotted only a few words in his diary to sum up those weeks, with no mention of Carter's loss.[16] The men had work to do to close up the site and head back to England before the summer heat. There were 125 wooden packing cases to fill with all the artefacts they had found at Amarna, waiting to be shipped to Cairo down the Nile's steady northward stream.

* * *

A life looked at backwards can seem to tell a story of smooth forward motion, but even in his rosy-hued memoirs, Howard Carter recognized the role that serendipity had played along the way – and the setbacks he had faced, including his father's death. From these bumpy and by-chance beginnings, Carter wound up making a career. He must have been one of those people who come into themselves when they can cut, or at least loosen, the ties that bind them to family and home. Some people take root more easily in different soil.

Transplanted to Egypt, Howard Carter flourished. Like many young men, and women, born at the centre of the British Empire, he found opportunities abroad that he would never have had in Britain itself – a decent salary, a diverse social mix, and a hint of adventure, under the safe umbrella of a British passport and the financial and legal privileges that foreigners in Egypt enjoyed. By the 1880s, the foreign population in Egypt comprised about 100,000 people, mainly Europeans and North Americans, with courts, clubs, and other facilities to serve their needs and interests.[17]

The Egypt Exploration Fund had started its work in Egypt at a propitious time, just as the British military occupation began in 1882. Under the British administration, the Antiquities Service of the Egyptian government continued to be run by French scholars, as it had been from its start under Auguste Mariette.[18] But it had to adapt to changed political circumstances and drastic funding cuts. Organizations like the Fund or wealthy individuals like Amherst were the only way the Antiquities Service could afford to pay for large-scale excavations and site maintenance. It offered a share of any artefacts discovered as an inducement and reward. Private collectors and sponsoring museums kept objects for themselves, while the Fund and Flinders Petrie either sold them outright or awarded them to paying subscribers.

The Fund soon realized that its Archaeological Survey of monuments in Egypt was financially unsustainable, because it did not offer antiquities as a subscription gift. The Survey was scrapped, but the Fund kept Carter in its employ. In 1893, he became the lead artist attached to its excavations at Deir el-Bahri, a terraced temple built by the 18th Dynasty queen Hatshepsut, who ruled as the full equivalent of a male pharaoh. The temple sheltered in a bay of cliffs on the west side of the Nile at Luxor. The Valley of the Kings lay behind it, reached by a series of ancient paths, and overhead was the pointed peak identified in ancient Egypt with Meretseger, a goddess whose name meant 'she who loves silence'. This landscape at the desert edge would be the centre of Howard Carter's world for the next forty years.

Carter set to work hand-copying the finely carved and painted sequences of relief sculpture that sheltered under the temple's colonnaded terraces. His surviving pencil, ink, and watercolour copies are works of art in their own right, created through close observation and freehand, without any sign of tracing or using a transfer grid. The Deir el-Bahri reliefs were as historically

important as they were visually fascinating. Boats with unfurled sails ventured to the land of Punt on the Horn of Africa (most likely modern Eritrea or Djibouti), where they were met by the queen of Punt and her retinue. The boats returned to Egypt loaded with exotic plants and animals, resin to use as incense and perfume, and ebony wood for fine furniture and sculpture. The river beneath the boats teems with carefully distinguished types of fish, and the gods themselves weigh up gold ingots against fat cattle.[19] The riches equipped Hatshepsut's temple and symbolized the pharaoh's power in Egypt and beyond. Photographs could not make the lively scenes legible, but Carter's copies turned the rounded contours and surviving colours into crisp inked outlines, which were published in proud academic folios by the Fund. A few of his striking watercolours became colour plates, as well.

Carter worked at Deir el-Bahri for several years, becoming more interested in archaeological work than in his work as a draughtsman. By 1899, he was competent enough to be put forward for a new opportunity with the Antiquities Service, which had created two posts earmarked for British archaeologists. In a compromise designed to placate the British administration, the Service would continue to be run by a Frenchman – at that time, the pragmatic and charismatic Gaston Maspero – but British archaeologists would serve under him, one supervising the northern part of the Nile valley and delta (Lower Egypt), and one the southern region, including Luxor (Upper Egypt). Maspero, who had run the Service with flair a decade earlier, had come across Howard Carter's work before. Carter was 'obstinate', Maspero thought, but that could have its uses, besides which, Carter was new enough to Egypt that he hadn't yet made any enemies or partisan allegiances in the small world of archaeology. At the age of twenty-five, Carter became Chief Inspector of Antiquities for Upper Egypt.

Carter took to his role with gusto. His patch extended from around Beni Suef, south of the Fayum, down to Aswan, where preparations were under way for a British-built dam that would moderate the annual Nile flood. The role of inspector was as old as the Antiquities Service itself, and the title reflected the idea of monitoring, even policing, archaeological sites and work. Carter was responsible for every excavation being carried out by the Service or by licensed foreign teams, and he oversaw a team of inspectors who were increasingly drawn from the Egyptian middle class, or *effendiya* (so called because they could use the honorific title *effendi*).[20] These educated men spoke European languages, wore tailored suits, and reflected the diverse ethnic mix of Ottoman Egypt, with Egyptian Muslims, Coptic Christians, Turks, Syrians, and Armenians among their number.

Much of the work Carter had to coordinate was practical in nature, from the maintenance of ancient temples to security measures designed to protect archaeological sites and the tourists who visited them. Egypt had become a popular winter resort for Europeans; by the early 1890s, Thomas Cook steamers took some 6,000 visitors up the Nile each year, and numbers continued to rise.[21] From his Swaffham youth Carter kept an attachment to both wild and domesticated animals, and he was proud of erecting a shelter for the donkeys, and their drivers, who carried tourists up the winding road to the Valley of the Kings. Letters home to his mother ('Dear Mater') recounted these accomplishments, sometimes with drawings or square photographic prints. One showed his favourite horse, a muscled stallion named Sultan who carried him around the Luxor region, where he had made his base in a house provided by the Antiquities Service.

Carter had time to pursue his own passion for excavation, too. In front of the temple where he'd worked at Deir el-Bahri, he discovered an underground passageway leading to a chamber

that he named 'the tomb of the horse', crediting Sultan's hooves with hitting upon the opening beneath the drifted sand. It turned out to be the ritual deposit of a Middle Kingdom statue, a burial of sorts but a disappointment for Carter. Hoping it was a royal tomb, he had notified Lord Cromer himself of the find.[22] Maspero passed over the miscalculation and encouraged Carter to help with – and keep an eye on – an excavation that a wealthy American businessman named Theodore Davis was carrying out in the Valley of the Kings, where some actual royal burials might turn up.

Howard Carter on horseback at Deir el-Bahri in the 1890s
– the mount may be his favourite horse, Sultan

Davis had been a shady figure in his professional dealings in New York, but he was rich enough that no one cared. As a young attorney, he had defended political fixer William 'Boss' Tweed in the Tammany Hall corruption scandal, and Davis went

on to make a robber baron's fortune in real estate as Manhattan grew. Wealth also meant people overlooked the fact that Davis travelled not with his wife but with his long-term companion, Emma Andrews, the daughter of a wealthy Columbus, Ohio family, who became Davis's mistress after her own husband was institutionalized.[23] Davis and Andrews escaped East Coast winters by spending the time abroad, between Tuscany and Egypt. In Florence, they were part of the Anglo-American social scene that Henry James and E. M. Forster dissected in fiction. In Egypt, they had their own staffed sailboat, a *dahabiya* that could be moored anywhere along the Nile. They were networkers before the term existed, and they would be important figures for Carter in the years to come.

After five years based at Luxor, surveying the southern reaches of the country, Carter swapped Chief Inspector roles with his counterpart in the north, the Oxford-educated and Petrie-trained English Egyptologist, James Quibell. The change had been planned with Maspero from the start. Carter took charge of a portfolio covering the Nile delta, the Fayum lake basin (rich in Greco-Roman ruins), and the pyramid fields that dominate the desert escarpment west of Cairo. In early January 1905, newly arrived in his role, Carter ran into a controversy that went all the way to Lord Cromer's ears. He was working at the Saqqara office of the Antiquities Service when a verbal and then physical fight broke out between the Egyptian guards, called *ghaffirs*, and a large party of French tourists, about fifteen young men who had been drinking. The tourists first refused to buy admission tickets, then grudgingly bought a few. They became belligerent when a *ghaffir* asked to see each man's ticket before allowing him into one of the main attractions: the vaulted catacombs known as the Serapeum, where Egyptian priests had buried the sacred Apis bulls. Perhaps the French party considered it their right to visit, since it was a

Frenchman, Auguste Mariette, who had located the Serapeum in 1850, dug it out, and shipped crates of antiquities to the Louvre. It had been headline news in France, and although the work had been done without permission, Said *pasha*, grandson of Muhammad Ali, later dealt with Mariette's deception by hiring him to set up the Antiquities Service.

In the thirty-five-page report compiled by the British-run police force, Carter gave evidence of what happened when the *ghaffirs* directed the French tourists to the inspectors at Saqqara, that is, the Antiquities Service officials who answered, in turn, to Carter. One of the tourists punched a *ghaffir*, Carter reported, and the situation escalated from there. Carter personally gave the inspectors permission to defend themselves and the office, which was government property. Furniture splintered, fists flew, and once they had dusted themselves off, and sobered up, the party of French tourists complained to the Antiquities Service and the British authorities about the fracas. Carter cabled Lord Cromer the same day with his own account of the 'affray' and was called in to Cromer's office to explain himself. Norfolk ties were no help, nor was Maspero's attempt to smooth things out in Carter's favour. To satisfy the French party, Cromer wanted Carter to apologize. He refused, and Maspero sent him to a remote site in the delta to cool his heels.

Humiliated for doing what he felt was his job, Carter resigned the Chief Inspector post in October 1905. He was thirty-one years old, an unschooled country boy who had polished himself up well enough to meet the Earl of Cromer eye to eye. Maspero wished him well. Carter moved back to the west bank of the Nile at Luxor, where the land of the living met the land of the dead in a sandscape of silence that he – like Meretseger – had grown to love. He scraped a living by selling his watercolours to winter tourists and preparing illustrations for old acquaintances,

like Theodore Davis. He kept a sharp eye on the Luxor antiquities dealers too, and started to earn commission, or turn his own profit, by matching good-quality, undervalued pieces to high-paying collectors, Davis included. Davis also introduced Carter to members of the new expedition that the Metropolitan Museum of Art in New York was setting up a little further up the road, with a purpose-built excavation house paid for by J. P. Morgan. Carter's present circumstances must have seemed precarious at times, but over dinner on the Davis *dahabiya* or on his solitary rides and walks across the rough terrain of the Luxor hills, his future was already taking shape.

* * *

George Edward Stanhope Molyneux Herbert liked fast horses and faster cars. Fortunately, he married a woman rich enough to keep him in both. The wedding took place on the 5th Earl of Carnarvon's twenty-ninth birthday in 1895, and his bride was Almina Wombwell, a young woman as attractive as her £500,000 dowry (with a buying power worth a hundred times that much today). Banking was on both sides of her family tree: her French mother, Marie Boyer, was married to the son of a British baronet, but Almina's presumed, yet unacknowledged, father was banker Albert de Rothschild.[24] To this international mix could be added the best man, Prince Victor Duleep Singh, an old friend of Carnarvon's since their days at Eton. Prince Victor's father was the last maharajah of Mysore, a Sikh ruler who was deposed at the age of ten and exiled to Great Britain on the orders of the East India Company.[25] Mysore was the last state to fall to this rapacious, and well-armed, venture capitalist outfit, which subdued the Indian subcontinent before handing it over to Queen Victoria as a ready-made empire. Brought to London in 1854, the young maharajah was feted by Victoria and Albert and adopted,

at least for a time, the life of an English aristocrat. He married a German-Ethiopian woman, Bamba Müller, whom he had met in Cairo, and Prince Victor was one of their six children. The elder Singh built an estate named Elveden, ten or twelve miles across the Norfolk Brecks from the Amhersts at Didlington Hall. The shooting was fine at both.

After Eton, Carnarvon – then Lord Porchester – earned a degree at Trinity College, Cambridge, without too much trouble or distinction. Carnarvon inherited the earldom at the age of twenty-four, and with it a country seat called Highclere Castle, in Berkshire, where he had been born in 1866 and would be buried in 1923. His marriage to Almina brought a welcome injection of cash and produced two children: a son, a new Lord Porchester, later to be the 6th Earl, and a daughter named Evelyn, on whom Carnarvon doted. The rest of his attention focused on horse racing and early automobiles, the speedier the better – until an accident in Germany nearly killed him in 1901. Pain and difficulties with movement troubled Carnarvon for the rest of his life. On his doctors' advice, he spent the winter of 1903–4 in Egypt, trying to warm his newly knitted bones. Something about the country and its antiquities caught his imagination, and he returned each winter to feed his new interest. Family legend had it that Lord Cromer himself advised Carnarvon to take up archaeology – and with Gaston Maspero's approval, he did.

Maspero gave Carnarvon an excavation permit to work a stretch of ground near Deir el-Bahri known as the Dra Abu el-Naga. Beginner's luck – or the expertise of the Egyptian team who did the work – left Carnarvon with so many artefacts, from a series of burials, that he needed someone to help catalogue them for the Antiquities Service, as his permit required. Only then could the finds be divided between the Cairo Museum and Carnarvon's growing collection back at Highclere Castle. Maspero

saw a solution. He suggested that Carnarvon hire Howard Carter, and perhaps to their own surprise, the Cambridge-educated aristocrat and the self-made Norfolk lad found that they got along quite well together. So began the partnership that would bring them to Tutankhamun's door fifteen years later.

After five years of work, Carter and Carnarvon published the results of their excavations in 1912, in a handsome volume whose costs were underwritten by Carnarvon. Some insight into their relationship with each other and with the Egyptians working for them can be gleaned from the preface that Carnarvon wrote. He praised Carter for 'his unremitting watchfulness and care in systematically recording, drawing, and photographing everything as it came to light' – the skilled and systematic approach that even Carter's later critics would have to acknowledge were his strength.[26] Carnarvon's comments on the Egyptian men in his employ were less complimentary: they were 'a willing and hardworking lot', he wrote, and 'no more dishonest than other Egyptian *fellahin* [peasant farmers]'.[27]

Let's be crystal clear: such offhand insults were endemic to the practice of archaeology in Egypt and other parts of the colonized world. These attitudes shaped not only the daily interactions and academic thinking of European and American ('Western') scholars; they also seeped through any artefact discovered, book or journal article published, museum display created, or public lecture delivered. Yet the bias built into this 'ancient Egypt' goes unremarked in almost every history written within the field. As a student, I was taught nothing of the political context of archaeology in Egypt, the grossly unequal conditions in which excavations took place, or the racism that was inherent to Egyptology – a racism that was, in fact, its reason for existence. Little has changed today in school or university curricula, with some encouraging exceptions and initiatives. It is slow progress, often

met with reactionary responses or, worse, silence. What Egyptians, of every social level and identity, have to say about their history remains marginalized, as are they. In Western European thought that emerged over the eighteenth century, the modern inhabitants of Egypt were deemed incapable of understanding its ancient past, much less appreciating and caring for it.

This became part of the rationale for ever greater European involvement in Egypt. Lord Cromer had finally resigned in 1907, the year before Carter and Carnarvon began their work together. He could not survive the fallout of an incident at Dinshaway, in the delta, which saw twenty-one Egyptians sentenced to death, public flogging, or imprisonment for disturbing a British hunting party that rode across their land in pursuit of pigeons. Empire does come home to roost. But Cromer's attitudes were not unique. Imperialism depended on a belief in British superiority being taken for granted, so diffuse as to be invisible even when printed, like Carnarvon's preface, in black and white.

Unusually in archaeological publications of the time, Carnarvon named the three Egyptian foremen, or *ru'asa* (*ra'is* in the singular) who worked for him over the five years in question, 'well and satisfactorily'. They were Ali Hussein, Mohammed Abd el-Ghaffir, and Mansour Mohammed el-Hishash. It fell to the *ru'asa* to hire and manage the local men and children who undertook the physical clearance work. Between 75 and 275 people were in Carnarvon's employ at any time, and Egyptian archaeological workers started young. Basket by basket, barefoot boys – and often women and girls as well – carried away the sand and soil that the adult men dug through, an orchestra of picks rhythmically removing the protective sheath of ground that covered the ancient layers below. Both the foremen and the workers came from the surrounding villages, known as Gurna. By the time Carnarvon started digging, Gurnawis had spent a century or

more helping Europeans 'discover' ancient Egypt through their own labour and local knowledge. Many of them still work, generations later, in archaeology and tourism in Luxor. They have had few other choices, and it is their home.

Carter made it his home, too. With financial support from Carnarvon, he had his own house built at the northern end of Dra Abu el-Naga and equipped it with workspace and a darkroom so that it served the needs of the excavation. Constructed using local materials and forms, it had a central dome, a roofed veranda with arched openings, and mud-brick walls left smooth and bare of any decoration. As a private joke, perhaps, Carnarvon donated some bricks to mark the laying of the foundation. They were fired at the Bretby pottery in Derbyshire and stamped with Carter's name, a date, and place: 'A.D. Thebes 1910', using the ancient Greek name for Luxor and the Anno Domini abbreviation of the Christian calendar.[28] Sunk in Egyptian soil, the bricks were a little piece of England on foreign ground.

With Carter as scout and middleman, Carnarvon also became an avid collector of Egyptian antiquities. The men used the antiquities market to help pay for their work: Carter bought low in Egypt so that Carnarvon could sell high in London, with the profits put towards the costs of excavation. During summer visits to England, Carter began to spend extended periods at Highclere Castle, where he worked on Carnarvon's antiquities collection and, now the gentleman, took part in the shooting. Grouse season opened in August, when Egypt was hot and the Nile high.

The outbreak of the First World War in 1914 saw the Middle East become a battleground between empires struggling for survival. Since Egypt was nominally still under Ottoman rule, Britain had to take the veil off its possession: it declared Egypt a protectorate, deposed *khedive* Abbas Hilmi, and placed his uncle Hussein Kamal in power as a sultan. With Egyptian men

heavily recruited for the Egyptian Labour Corps that supported the British army, there was no one to do the physical work that excavation required, and many of the foreign archaeologists who usually worked in Egypt were called up for service, too.[29] At age forty, Carter was too old for active duty, but he did contribute war work as a courier for British intelligence, in the summer of 1915. The rest of the war he spent living quietly at his Luxor home, taking the time to explore and map the location of Lord Carnarvon's new concession to excavate: the Valley of the Kings.

Carnarvon obtained the permit for the Valley after his and Carter's old acquaintance, Theodore Davis, relinquished it in 1914. Davis knew that he did not have long to live (he died in Florida in February 1915), besides which he was confident that he had found all there was left to find among the royal tombs. He even thought he had found the tomb of a minor king named Tutankhamun, back in 1907. Numbered KV (Kings' Valley) 54, according to a system devised by British traveller John Gardner Wilkinson decades earlier, Davis's 'tomb' of Tutankhamun was a plain, single chamber with a dozen large earthenware jars that had been sealed shut with Nile mud. The jars contained an assortment of linen bandages, floral collars, pottery bowls and cups, and bags of natron, the salt compound used as a bleaching agent and desiccant, including mummification. He assumed that the burial itself had been ransacked and removed.[30] When Sir Eldon Gorst – the short-statured, beak-nosed technocrat who took Cromer's place as consul-general – came to pay a visit to Davis's comfortable excavation house, Davis offered to have the jars opened in honour of his guest. The contents were disappointing: odds and ends of linen, dried food, and desiccated wreaths. Some of the linen had ink inscriptions referring to years 6 and 8 in the reign of a ruler named Tutankhamun, about whom almost nothing was known at the time. Davis eventually gave his share

to the Metropolitan Museum of Art. A minor king had been dispensed with, as after-dinner entertainment for a millionaire and an imperial bureaucrat.

By the time Carter could start work in the Valley of the Kings in 1917, he had decided on a strategy. He would have his workmen, under Theodore Davis's old *ra'is* Ahmed Gerigar, clear the valley to its bedrock floor, removing areas where previous excavators, like Davis, had made their rubbish heaps. Carter set up a light railway track to cart the refuse away, out of the valley, instead. It was slow work with little to show for it, and when the end of the war allowed Carter to resume his summer stays at Highclere Castle, he may have had a difficult time convincing Carnarvon to continue.

Carter made summer visits to family in Norfolk as well, and to the Amhersts, who had fallen on hard times. The family fortune had been near-ruined by embezzlement in 1906, although the title passed, as planned, to Lord Amherst's eldest daughter Mary, Lady Cecil, on his death in 1909. She and Carter had remained close. At the turn of the century, when he was still Chief Inspector for the south, he had helped her dabble in archaeology at Aswan, in tombs that honeycombed the hills above the Nile cataract.[31] When she faced straitened circumstances, Mary Cecil (by then Baroness Amherst) turned to Carter to help her sell her father's seven Sekhmets to the Metropolitan Museum of Art in New York, along with a few other pieces that would raise much-needed funds. At her death in 1919, the family chose to sell off all the rest, as well as the working farms and forests of the estate and finally the Hall itself. The days of royal hunting parties in the deer park were gone for good.

Carter wrote the catalogue for the sale of the Amherst collection, pricing up parts of his own past for Sotheby's clientele. There were objects he had encountered as a teenager at the Hall,

and the limestone figures of Akhenaten and Nefertiti from his first excavation in that Amarna spring when Flinders Petrie had broken the news of his father's death. At the auction in 1921, wealthy Americans were best placed to bid for the prime pieces, Europe having spent its men and money on the First World War.[32] The Metropolitan Museum of Art acquired the Amarna king and queen and several other items to add to its seven Sekhmets, six of which stand today in the glass-roofed extension over the Nubian temple of Dendur. Carter himself secured a few objects at the sale for the Cleveland Museum of Art in Ohio, whom he had been advising on its collection of ancient Egyptian art, and he acquired a sculpted face of Akhenaten, from Amarna, for Lord Carnarvon's collection, too.

The Midwest also welcomed one of the coffins Lady Cecil had brought back from Aswan, and another that her father had acquired with the Sekhmets, via the collection of Dr John Lee. Both were bought by Albert Todd, the mint millionaire of Kalamazoo – a name I can never hear without thinking of the 1950s novelty song about a train that goes 'From Kalamazoo to Timbuktu'.[33] My father, a fan of Mitch Miller's orchestra, would on rare occasions unsleeve a record and put it to spin on the turntable built into a cabinet in the living room, a hold-over from my parents' earlier married life. That was how I recognized the song he hummed in his tuneless tenor one evening when my mother, out for choir practice at church, left him to oversee bath night and bedtime. Dad, distracted (and deaf in one ear from childhood illness), had let me stay in a cooling bath until my fingertips shrivelled like Sun-Maid raisins or a mummified hand. Out, now, came the order, or he would send me packing to these exotic-sounding lands. *Toodle-ee-doo to you.* At only six or seven years old, I worried at this prospect. Who would want to go so far from home? Dad laughed, wrapped me in a towel, and reassured

me. Kalamazoo – a name derived from the language of the Potawatomi people, whose lands these once were – could be found down the highway from his mother's house in Michigan, though Timbuktu indeed would be a challenge. *Whenever we say goodbye, don't let me see you cry.* I was too young to understand what distance means, and how often things and people have to bridge it.

People like Bao-Bao, the woman once buried in that coffin from the Qubbet el-Hawa hills at Aswan, where the escarpment faces east to the sunrise and curves south to where the Nile, and the world, began. The rest of her wooden tomb goods, and the coffin of a man buried with her, 'fell to pieces when touched', reported Mary Cecil.[34] Bao-Bao's embalmed and linen-wrapped body was cut open, and discarded, by Lord Amherst's daughter, who found nothing on it but a dark green stone, no bigger than the tip of a plump thumb. With the rest of the Albert Todd collection, the coffin of Bao-Bao is today in the Kalamazoo Valley Museum. Treasure may indeed lie close to home. But how it got there is another story.

The Reawakening

PHOTOGRAPHS LURE US into little lies. I realized this with a shiver in a London gallery several years ago, looking at a framed print of a familiar photograph from the Tutankhamun excavation. Taken during Carter's second winter at the tomb, the picture shows nine (of the eleven) rowing oars laid along the floor between the painted wall of the burial chamber and the first of the four nested shrines that surrounded the young king's sarcophagus, coffins, and masked mummy. Someone, more than 3,000 years ago, had squeezed into the narrow space to set those oars floating on an invisible river. And in January 1924, someone had squeezed into the same space to set a numbered card next to each one: 183, 184, 185, and so on, interrupting their flow forever.

I had seen that photograph dozens of times. Often enough not to have looked closely until that moment in a contemporary art exhibition, where its unexpectedness made me look again. Fittingly, the exhibition was about anniversaries and remembrance. For the centenary of the Camden Arts Centre, artist Simon Starling selected works that had been part of its past exhibitions. The Tutankhamun photograph had appeared in a 1990s show themed around loss and mutability, making it fit Starling's retrospective well. *Never the Same River* turned the Centre into a palimpsest. Layers of its own past were made visible in its

century-old galleries by replacing the works where they had once been. As if a hundred years existed all at once.

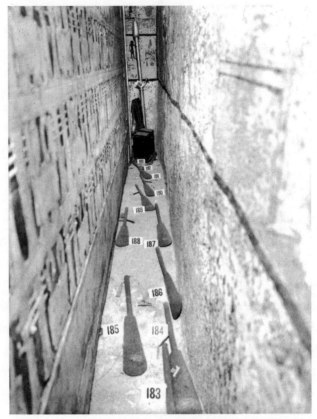

*Oars laid out between the wall of the Burial Chamber
and the outermost burial shrine; photograph by
Harry Burton, November 1923*

The oars that rowed Tutankhamun towards his rebirth could never share that fate. Once lifted from the tomb floor, taken out of their stream, their journey was diverted firmly elsewhere. In all my training as an Egyptologist, I had absorbed the tacit knowledge that photographs are objective records of the past – the ancient past. Yet the numbered cards perched by each oar spoke instead to a past that had been the present back in 1924, when

the numbers marked the first step of the tomb's transformation into an assemblage of museum objects and, eventually, touring superstars.

The camera was an essential tool for recording what Carter and his colleagues found as they emptied the tomb and brought the fabled boy king back to life. Seeing one of those excavation photos out of context, I understood at last its little lie, a placid, black-and-white conceit that time had been caught standing still. A hundred years of Tutankhamun do exist now, all at once. But that century is ours, not one of his.

Photographs were how the discovery of Tutankhamun's tomb reached the public eye – and dazzled it. Their monotones may look dull grey today, when we are so used to colour photographs and film. As a child versed in Kodachrome, Polaroids, and Technicolor, I thought them boring, and many people still do, hence the appeal of digital colourization software. But those photographs, in all their silvery shades, made Tutankhamun a global phenomenon in the 1920s, and they have continued to determine his fame and fortunes. The photographs taken inside the tomb, like the image of those oars, were the work of Lincolnshire-born photographer Harry Burton, who worked for the Egyptian Expedition (the archaeological arm, that is) of the Metropolitan Museum of Art. Five years Howard Carter's junior, and from a similarly large family and modest background, Burton also left England as a teenager and made a new life and career abroad, first in Italy and then in Egypt.

In addition to Burton's carefully composed shots, made on a large-format view camera, journalists and tourists snapped informal photographs outside the tomb, especially in the initial hectic months after the discovery. Those with a roadside view in the Valley of the Kings could watch, and photograph, the burial's reversal, as Carter, the *ru'asa*, and other colleagues brought the

dismantled chariots, the alabaster vases, the stools and chairs and boxes, one by one up to the light. Photographs look like facts, but they show only what passed before the lens, not what happened before and after, or whose interests the images might come to serve. Licensed to the London *Times*, Harry Burton's photographs skirted close to claiming ownership of Tutankhamun, in two senses: one, as legal property and two, as a product of the imagination, that is, what it was possible to say, and think, and feel, about the ancient past. For Tutankhamun was waking up into a world of mass media and consumer goods, the scars and aftermaths of war, and a hope, among Egyptians, that they might at last be free of colonial control. The river those oars had tried to row would never be the same.

* * *

Howard Carter's red-bound Letts Indian and Colonial diary for 1922 is part of the archive that his niece donated to Oxford University after his death. A year that started much like any other ended with the spectacular discovery that turned Howard Carter and Tutankhamun into household names. Most of the appointments he noted in his diary that year were as banal as the advertisements on its back and inside covers, where the business of the British Empire was meted out in Burberry trench coats, Norwich Union insurance policies, and Italian-made bandoneons en route to the tango halls of Argentina.

In the last week of October 1922, Carter was in Cairo, doing his usual round of the city's antiquities dealers, taking care of some banking matters, and fitting in a visit to his dentist.[1] On 27 October, he took the overnight train to Luxor and went on to spend the weekend with his friend Arthur Callender, an Egyptian State Railways engineer who had retired to a farm at nearby Armant. By Monday, 31 October, he was back at his home – at

some point, it had been dubbed Castle Carter – to pay the salaries of his domestic staff, and on 1 November, he was back to work in the Valley of the Kings, where lead *ra'is* Ahmed Gerigar was set to supervise the next phase of clearance work. Some accounts, after the fact, have suggested that this was the last season Carnarvon had agreed to fund. But if Carter felt the pressure more than in other years, there is only hindsight to record it. What happened next caught him by such surprise that he could only add in afterwards, writing diagonally across the diary square: 'Men found first step'. It was 4 November. A Saturday, when work resumed after Friday prayers.

'Men found first step'. By the time Carter penned those words on the diagonal across his Letts, he knew it was the first of several, but he could not know where the rock-cut steps would lead until *Ra'is* Ahmed's men had cleared as far down as step twelve. At that point, the upper portion of a blocked-up opening was visible, its surface plastered over with mud and stamped with seals about the size of a man's shoe. Carter recognized the seal impressions, which identified the group of officials responsible for the royal cemetery in its New Kingdom heyday: a recumbent jackal, ears pricked, over three rows of three subdued prisoners, on their knees with their hands pinioned behind them.[2] Where some of the plaster had fallen away at the top, Carter cleared a hole to peer through with his electric torch. There was nothing to see but rubble, but that was a good sign. Like the presence of the cemetery sealings, it suggested that an untouched tomb or a cache of reburials lay somewhere beyond. In the narrative journal Carter began to write around this time, he reports that he closed the hole 'with certain reluctance'. Under the watchful eye of *Ra'is* Ahmed, the basket boys and girls filled the staircase back up with dirt and rubble for security, standard practice in archaeology but all the more of a concern given the unusual find and its as yet unknown potential.[3]

The story of the tomb of Tutankhamun has been told so many times that fact and fiction long ago agreed to share the burden. A series of events that took place over several weeks – in fact, several months and years – have collapsed into a single moment elided into one word and act, 'discovery'. It makes for a dramatic tale but misses out the dull yet telling details that archaeological work in occupied Egypt required, as well as the confusions, uncertainties, and adaptations that any work entails. It ignores the glaring oversights of Egyptian archaeology as well: 'It was a thrilling moment for an excavator, quite alone save his native staff of workmen,' was how Carter characterized his first view of that sealed doorway at the bottom of the steps.[4] The ease with which he could dismiss *Ra'is* Ahmed and all other Egyptians as full participants in these events speaks as clearly of colonial banality as the advertisements in his Letts diary do.

Carter needed to alert two people about the find: Rex Engelbach, a British archaeologist who was then the Antiquities Service Chief Inspector for the region, and the Earl of Carnarvon, who was paying for it all. A cable Carter sent to Lord Carnarvon announced the news: 'At last have made wonderful discovery in the Valley: a magnificent tomb with seals intact; recovered same for your arrival; congratulations'. More than two weeks of waiting, planning, and further clearance work in the area adjacent to the reburied staircase followed, in what must have been an air of anxious anticipation. Carnarvon decided to travel out to Egypt with his daughter, Lady Evelyn, arriving in Alexandria on 20 November, and Carter's friend Callender came to stay with Carter and lend a hand as well. By rights, the Antiquities Service should have determined what next steps to take, and when, but no one seems to have given it much consideration at the time. Lead excavators were used to having a free hand. Later this would be remembered as one of many missteps made

by arrogant Englishmen who did not realize that Egypt was no longer theirs to run.

At the end of the First World War, with the Ottoman Empire defeated, Egypt's continued status as a British protectorate was a dilemma for the British government at Westminster. Its colonial footing had always been questioned and protested in Egypt, where a number of politicians, lawyers, cultural figures, and grassroots organizers – including Egyptian feminists – had spent decades on counter-imperialist efforts. A revolution in 1919 was put down by British troops, who still swarmed Alexandria, Cairo, and the Canal Zone as they awaited post-war demobbing. Leaders of the Egyptian independence movement, like distinguished lawyer and government minister Sa'd Zaghloul, had hoped that Egypt could send its own delegates to the Paris Peace Conference where the victorious European allies began to carve up Austro-Hungarian and Ottoman lands. When Britain overruled this, *Wafd* – 'delegation' – became the name of Zaghloul's political party, and he himself was exiled first to Malta, then the Seychelles. Britain tasked colonial secretary Lord Alfred Milner to study the situation in Egypt and recommend a way forward. Most Egyptian leaders refused to speak to him, although Howard Carter and other foreign archaeologists did.

In February 1922, Britain broke off its negotiations with Egyptian politicians, a process Milner had recommended to try to agree some form of self-rule – and Lord Allenby, decorated First World War general and special high commissioner to Egypt, had urged concessions to the nationalists. Instead, wartime prime minister David Lloyd George's government made a unilateral announcement: Egypt would be free to hold parliamentary elections and govern its domestic affairs. But Britain would maintain control of foreign affairs, the Suez Canal, its military bases in the country, and the Anglo-Egyptian colony of

Sudan. Britain would also, at the start, place one of its own civil servants in each Egyptian ministry as an 'advisor'. Nothing about the deal was ideal, and Britain's offer fell short of what Egyptian leaders had wanted. Still, it was independence of a sort. Back from exile, Zaghloul and the *Wafd* prepared for parliamentary elections to take place in 1923. What difference this moderated independence would mean for his life or work in Egypt was probably the last thing on Howard Carter's mind in November 1922, but it would shape the excavation of Tutankhamun's tomb almost from the start.

On 24 November, after Carnarvon had reached Luxor, the *ru'asa* and Egyptian workmen returned to clear the staircase once again. Rex Engelbach and other colleagues, including archaeologist Guy Brunton, stopped by to observe the removal of the final layers at the bottom of what proved to be sixteen steps, which yielded fragmentary finds of pots and broken boxes, some bearing the names of Akhenaten, Tutankhamun, and other rulers.[5] Carter could now see the entire sealed doorway, down to its base. The lower portion had two layers of mud plaster and two layers of seals, suggesting that whatever lay behind had already been breached and resealed in antiquity. The cemetery seals Carter had spotted on the upper portion covered the newer layer of plaster, while the old, untouched surface below had seal impressions that bore a single royal name: Tutankhamun. It was the first clear sign of which king might lie somewhere beyond the doorway, but it came with dampened hopes.

Tutankhamun was a name familiar to Egyptologists from small finds at the abandoned royal city of Amarna and in the Valley of the Kings, namely the cache of jars that Theodore Davis found in 1907, mistaking it for the remains of a robbed-out burial. But that was not the only evidence for Tutankhamun. Two years earlier, the French archaeologist Georges Legrain had

found an inscribed red granite slab, 2.5 metres high and almost 40 centimetres thick. The slab (or stela, the Latin term that academics use) had been drilled into at some point, trying to split it in two, and then abandoned in a corner of the great columned hall at Karnak temple, on the east bank of the Nile at Luxor. One of the columns had then collapsed over the stela, smashing it into five pieces. In ancient times, such monuments were used to record important royal statements and prayers to the gods. Erected in temples throughout Egypt, they consecrated a king's pledges for eternity, or thereabouts. What was striking about the red granite slab Legrain pieced back together was that it showed Tutankhamun praying to Amun, the god his predecessor Akhenaten had rejected. Thirty lines of hieroglyphs record that when Tutankhamun came to the throne, he restored the abandoned temples of Egypt's gods and goddesses, made a new statue of Amun in precious metal and lapis lazuli, and enriched the temples and thus Egypt itself. These were standard claims for pharaohs to make – but they took on particular significance given what scholars at the time surmised about the upheaval of the Amarna age. With Akhenaten and Nefertiti gone, had it fallen to Tutankhamun (whose exact age was then unknown) to restore the cosmic order known as *ma'at*, by restoring the old religion and the old ways? Otherwise, Tutankhamun was such a blank that it was difficult to know what to expect from his burial.

Carter spent the night under the stars beside the stairs that led into the future and the past. He spent the next morning, 25 November, taking photographs of the doorway and drawing its seal impressions, in preparation for taking it down in large chunks, trying to preserve as much of the mud plaster as possible. *Ra'is* Ahmed and the other, unidentified men and boys began the tedious work of clearing out the corridor that lay behind, filled almost to the ceiling with limestone chippings that had

been hacked out of the Valley and returned to it in this altered form. The top corner had been tunnelled through and refilled in ancient times, in keeping with the breach suggested by the doubled plaster layers. As the corridor emerged, on a gentle slope, the men found 'delicate objects' among the rubble, but Carter did not sketch, describe, or photograph these at the time.

The next day, 26 November, 9 metres (30 feet) of corridor came to an end at another doorway, plastered over and stamped with seals much like the first. In the 'excitement of the moment', as he later wrote, Carter made no notes or drawings, and it was far too dark to take a photograph. By electric torchlight, and with Carnarvon at his side, he picked a hole through the plastered surface and mud bricks behind, then used an iron rod to test for further blockages. When the rod reached only air, he enlarged the hole enough to insert a candle, testing the space for oxygen. The flame held, and by its quivering light he glimpsed what lay beyond the wall. 'Can you see anything?' Lord Carnarvon asks. And Carter has to reply, 'Yes, wonderful things.'

The dramatic phrase is courtesy of the book Carter would publish a year later with Arthur Mace, a new colleague who worked for the Metropolitan Museum of Art as a curator and on their Egyptian excavations. Born in Tasmania, where his father was an Anglican priest, Mace had been sent to school in Oxford and took his degree at Oxford University. Mace had worked on several complex archaeological finds in Egypt, and he was happy to volunteer his skills and time. He kept his own diaries and wrote detailed letters home to his wife; these were handy when it came to writing up the find for publication.[6] Mace also polished prose borrowed in part from the journal Carter had begun to keep, where he recorded his reply in terser terms: 'Yes, it is wonderful.'[7] Carnarvon wrote up his own recollections at some point, reporting his own 'trembling' words as 'Well,

what is it?' and Carter's response, 'There are some marvellous objects here.'[8]

For a better view of the wonders, Carter widened the breach still further and shone an electric torch through to illuminate the scene, which must have flickered like the newsreel film it shortly would become. What he could make out in the beam of light was a rectangular room, its walls and ceiling bare of decoration. Around its perimeter were ancient furnishings packed into every available space. The wall opposite the entrance accommodated three long gilded couches, nose to tail, since each was carved to represent an animal. From left to right, the gilded faces and inlaid eyes of a hippo, a horned cow, and a lioness bounced back the torchlight. Stacked on and under them were boxes, vases, chairs, and stools, and to the right stood two striking life-size statues in shining black and gold, either side of a plastered-over wall that Carter knew must be the opening to another space beyond. At the left, perhaps he could just glimpse the chariot wheels that leaned into the wall, their stasis a reminder or a warning: this was where motion forward had stopped dead.

* * *

There are no photographs of that moment of discovery. It was too dark for a camera lens to discern what the dark-adapted human eye could see. But photography was on Carter's mind, and Carnarvon's, too. The earl was a keen photographer, while Carter had been taking photographs in the field, and for pleasure, since his early days in archaeology at Deir el-Bahri. Before Carnarvon arrived at Luxor, Carter had tried, and failed, to photograph the layered seal impressions at the bottom of the rock-cut stairs.[9] He could not cast enough light down the stairwell and rake it across the surface to pick up the detail in the muddy, muddled wall, though he kept the quarter-plate (8×10 cm) glass negative among

his excavation archives, to the end. He knew that photographs would be essential to recording the excavation and whatever artefacts or burials they found. Even more, photographs would convey the find to a worldwide news media which had picked up pace, thanks to advances in telegraph, post, and print technologies that had emerged out of the war. Create the image and you create the story. Control the image, and that story becomes the only story anyone can tell.

On 27 November, Carter and Carnarvon supervised the removal of the wall they had peered through the day before. Engelbach had been called away to the provincial capital, Qena, but he sent a colleague named Ibrahim *effendi* Habib to carry out the inspection duties. Thanks to Engelbach and Habib, the team now had electric lamps to illuminate the bare-walled room, which Carter would refer to as the Antechamber. They could, at last, walk into the space, welcomed 'beneath our very eyes, on the threshold' by the alabaster 'wishing cup' – which Carter took back to his house.[10] Not only was there a second room or passage plastered over between the two statues that seemed to guard it from either side in the short wall to their right, but there was also a small room off at the other end of the tomb, through a low opening in the 8-metre-long back wall beneath the hippo-headed couch. This had been broken through, perhaps by ancient thieves, making it possible to peer beneath the couch and see a jumble of furniture, broken boxes, and piled-up baskets beyond. Wine amphoras and boxes of *shabti* figures were somewhere underneath. Carter would term that room the Annex and clear it last of all.

The plastered wall between the guardian statues (as they were soon dubbed) had been breached in ancient times as well, with a discreet hole at floor level 'large enough to allow of a small man to pass through'.[11] This was how the artists who painted

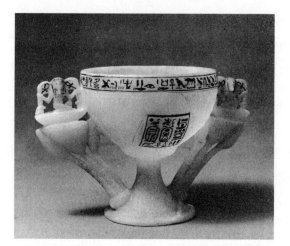

*The alabaster 'wishing cup' in the form of
an open lotus, incised with Tutankhamun's
names; photograph by Harry Burton, 1923*

the Burial Chamber had been able to get out after they finished their work. The initial inspection with Habib stopped there, and it should have been enough to allow Carter and the Antiquities Service to plan their next steps. But Carter, Carnarvon, and Lady Evelyn – presumably with the help or knowledge of *Ra'is* Ahmed – returned to the tomb in secret that night to find out more. Kept quiet at the time, the clandestine visit was an open secret in Egyptology for years, made known to a wider public only when the participants were dead. The small party used the ancient opening for the painters' exit (perhaps used by ancient robbers, too) to crawl through the blocked-up doorway between the sightless guardian statues.[12] Both the excitement and uncertainty were too great to resist. After his debacle at Deir el-Bahri twenty years before, Carter had learned not to announce spectacular finds with overconfidence.

This time, his discovery did not disappoint. The high-ceilinged room beyond was almost entirely filled by a gilded wooden

shrine 5 metres long and inlaid with plaques of blue faience, a glazed ceramic of hard-fired quartz used in ancient Egypt as an alternative to coloured stones.[13] The plaques separate repeated hieroglyphic symbols reading *tyet* and *djed*, which represented Isis and Osiris, blood and bone – and by extension, birth and death. The doors of the massive shrine were bolted shut, and laid out in front of it, extending into the open entranceway of a more modestly sized fourth room, was the jackal shrine draped in a tunic marked with Akhenaten's name.[14] Beyond that stood a gilded wooden canopy over a shrine, taller than a man and topped by a frieze of rearing cobras.[15] Surrounding the shrine were statues of four goddesses, and deep within nestled the alabaster chest and miniature gold coffins that held Tutankhamun's embalmed organs – but at that point in 1922, these were five years away from being found and opened; it would take that long for Carter and his colleagues to clear, conserve, and document the contents of the Antechamber and Burial Chamber first. More boxes were stacked on either side of the fourth chamber, later dubbed the Treasury, and on the boxes that stood to the right, an entire fleet of model boats had stopped, one with its rigged sails unfurled.

As for the royal burial itself, that could only lie somewhere inside the grand gilt and faience shrine, which the clandestine explorers had to leave untouched. With the structure filling so much of the space, they could see only part of the scenes painted against a yellow background on the chamber walls, enough to tell that they were in the distinctive style of the late 18th Dynasty. Turning to squirm their way back around the massive shrine, Carter and his companions might also have spotted eleven oars laid out by the far wall, left floating on their invisible stream for a little while longer.[16]

Carter and Carnarvon had their king. The problem now was what to do with him. The scale and nature of the find were

head-spinning, and years of labour lay ahead, more than either man realized. It was unprecedented. Royal burials had been found in Egypt before, but never intact in their original location. In 1881 and 1898, archaeologists for the Antiquities Service had cleared two extensive reburials of bodies that had been ransacked in antiquity, then rewrapped and placed in reused coffins by the priests in charge of the Valley of the Kings.[17] Carter knew the 1898 find well, since it took place while he was working nearby at Deir el-Bahri, but what he faced in KV62 was of a different magnitude and character, because Tutankhamun's burial for the most part was undisturbed.

Before work inside the tomb could start, the Antiquities Service organized security and the Ministry of Public Works (to which the Service was attached) began to rig up generators for electricity supply. Engelbach returned by train from Qena and zipped over on his motorcycle to see the tomb himself. Carter and Carnarvon had already set about staging 'a sort of official opening' to be held on 29 November, designed to announce the discovery to British and Egyptian notables, and, just as importantly, in the press ('a special report to *The Times* was sent to Luxor by runner' the same afternoon).[18] The British High Commissioner in Egypt, Lord Allenby, attended with Lady Allenby, as did the governor (*mudir*) of Qena, Abdel Aziz *bey* Yhia; the head of the Luxor police (*mamur markaz*), Mohamed *bey* Fahmy; Alfred Merton of the London *Times* and his wife; as well as the Engelbachs, Guy and Winifred Brunton, representatives of the Luxor and Qena police, the irrigation inspector of the district, the antiquities inspector Ibrahim *effendi* Habib, and unnamed others. It fell to Lady Allenby, the *mudir* Abdel Aziz, Lord Carnarvon, and Howard Carter to do the opening honours. Lunch was served at the end of the Valley, in the tomb of Seti II (numbered KV15).

The next day, the head of the Antiquities Service, Pierre Lacau, and the British advisor to the public works department, Paul Tottenham, arrived from Cairo to see the tomb for themselves. They were 'astonished' and 'enthusiastic', Carter wrote, noting that he turned away a number of Egyptian 'notables' from Luxor the same day, fearing that it was not safe to admit so many people to the small space at once.[19] Carter was in any case busy measuring up and making plans for the work that lay ahead.

He had shopping to do, as well. Having seen the tomb blocked with wooden planks and the staircase refilled a second time for security, Carter headed to Cairo in early December. There, he ordered a metal grill to cover the tomb entrance, stationery supplies, and copious lengths of muslin and cotton wool to use as packing materials for the as-yet-unnumbered objects that would be taken, one by precious one, out of the tomb where they had spent 3,200 years. Carter also saw Harry Burton on that Cairo trip, as Burton's wife Minnie noted in her diary.[20] The Burtons lived in Florence, Italy, where Burton had moved in his teens, eventually setting up a photographic studio and working for clients like the American connoisseur and art collector Bernard Berenson.[21] They spent winters in Egypt, where Harry worked for the Metropolitan Museum of Art's Egyptian Expedition, residing in its lavish excavation house on the west bank of Luxor. Carter and Burton had known each other for nearly fifteen years, through the late Theodore Davis. It was Davis who had brought Burton out to Egypt in the first place, as a friend. They moved in the same circles in Italy, and before he died, Davis recommended that the Metropolitan Museum find a place for Burton on its excavation staff.

Carter knew how skilled a photographer Burton was, and in Cairo he must have asked whether Burton could lend a hand with photography at the tomb. Burton was willing, but his employer

had to agree. Fortunately, the head of the museum's Egyptian department, Albert Lythgoe, had already telegrammed his congratulations to Carter, having seen the first announcement of the find written up in the press. Lythgoe volunteered to give whatever help he could. Carter seized the chance: could he borrow Burton? Lythgoe was happy to oblige, and the Metropolitan Museum wound up lending other Egyptian Expedition staff as well, like Arthur Mace. Behind the professional courtesy was a calculation that the museum would receive a share of the spectacular artefacts set to be discovered in the royal tomb.

Lord Carnarvon meanwhile had returned to England to make deals of his own – deals in which Burton's photographs would come to play an important role. Looking to offset the considerable costs the excavation would now face, and with the confidence of imperialism and aristocracy behind him, Carnarvon signed an exclusive contract with the London *Times*. For an upfront payment to Carnarvon of £5,000 and 75 per cent of profits from onward sales, the leading British newspaper would sell image and story rights around the world.[22] Carnarvon dreamed of film rights, too, and reserved those for himself. By agreement with *The Times*, coverage of the excavation also featured in the Saturday weekly *Illustrated London News*, the same paper for which Samuel Carter had illustrated animal subjects half a century earlier. The format and print quality of the *Illustrated London News* showed photographs to much better effect than the daily papers could, and the weekly's publisher, Bruce Ingram, had a personal interest in archaeology, which often featured in the paper. Carter must have valued these relationships, since Ingram and Harry Burton were the executors later nominated in his will.

The world had its first look inside the Antechamber of Tutankhamun's tomb on 30 January 1923, when *The Times* devoted an entire page to four photographs taken by Harry Burton just

before Christmas 1922.[23] The lag was due in part to the two weeks or so required for Burton's printed photographs to reach London by post. Those four photographs had a powerful impact on readers across Europe and North America, wherever newspapers paid the fee to reproduce them. The tattered linen hanging from the guardian statues (all that was left of their ancient wrapping); the gilded beds in their weird animal forms, stacked high with furniture and boxes; the intricate vases carved from alabaster, their perfume sealed in for an inconceivable stretch of time. Edged by sharp shadows from the electric light that Burton used, these were the first enduring impressions the public had of Tutankhamun, three years before his mummy mask made its own newspaper debut. The mask that became one of the world's most recognizable works of art still lay cocooned within layers of linen bandages and shrouds, three coffins, a sarcophagus, and the burial shrines, all their secrets shut up tight in the Burial Chamber next door.

Harry Burton tried to take two exposures for the photographs he made in the Antechamber: one with numbered cards in place, fixing a catalogue number to each object, and one without, which were the images the newspapers preferred. They made it seem as if the Antechamber had been untouched since Tutankhamun's time, allowing viewers to experience the same sensation Carter had described – as if millennia had disappeared before readers' eyes and they were standing where ancient feet had just passed by. It was one of those little lies. By the time the shutter closed on Burton's camera lens, dozens of very modern feet had been in and out of the small chamber. He himself had helped install one fixed electric bulb and rig a movable lamp, although he made sure that all twentieth-century technology stayed out of shot.

Carter had been developing a plan of work with the help of Arthur Mace and a third man, Alfred Lucas, seconded by the

Egyptian government. Lucas was a chemist with considerable expertise in analysing the materials used in Egyptian antiquities and advising on how best to repair and preserve them. Carter credited Lucas – who had courtroom experience, from his government post – for treating the Antechamber 'like a crime scene' as they tried to account for the signs of ancient disturbance.[24] It seemed clear that several of the boxes in the chamber had been opened and their contents rummaged through, although whether that was at the time of the burial or afterwards is more difficult to say. Some objects had been stuffed back into the wrong box, which Carter theorized had happened when cemetery officials came to put things right and reseal the tomb.

Although it was impossible to know exactly what went missing in any ancient robbery (or robberies, since Carter and Lucas thought there were signs of two intrusions), gold was an obvious target. They had found a piece of linen with several gold rings wrapped up inside, which Carter hypothesized a thief had dropped in haste.[25] Perfume was a rare commodity too, stored in creamy oils or fats. Near the dismantled chariots, several alabaster vases seemed suspiciously devoid of contents, and years later, in the Annex, Carter's hunch seemed to be confirmed by a perfume vase that had a trail of fingers around its interior.[26] Some long-dead hand had scooped out the scented substance – but whether for a burial rite or as petty pilfering, who could say.

Thefts from wealthy burials were an acknowledged problem in ancient Egypt, as papyri from Lord Amherst's old collection had made clear. Written about three centuries after Tutankhamun's death, they document an inspection of the royal necropolis after a security breach. But at a period of financial crisis not long afterwards, the high priests of Amun themselves took valuables from the royal tombs, to melt the precious metal and return it to commodity status. What counts as thievery depends on point of

view and motivation. It was commonplace for Western archae-
ologists and tourists to see Egyptians as tomb robbers, driven by
greed and unable or unwilling to appreciate antiquities the way
that Europeans did – thus justifying the European demand that
fuelled illicit digging and the bustling antiquities trade. Carter's
own motivation to identify ancient theft in Tutankhamun's tomb
was not only an attempt to understand its state. It also shows
his keen awareness of the terms of Carnarvon's contract with the
Antiquities Service, which specified that intact burials remained
the property of the Egyptian state. Burials that had been dis-
turbed were eligible for a division of finds between the Service
and the excavation funders. Carter, Lord Carnarvon, and the
Metropolitan Museum of Art all counted on such a division
taking place.

The clearance of the Antechamber began in earnest in early
January 1923. *Ra'is* Ahmed and three other foremen (*ru'asa*)
were on hand to work inside the tomb: Hussein Abu Awad,
Hussein Ahmed Said, and Gad Hassan, whom Carter had met
at least ten years earlier as Chief Inspector.[27] At that time, Gad
was offering some 18th Dynasty stone vases for sale from an
unlicensed excavation; in the meantime, he had become a profes-
sional archaeological worker. Near the tomb, a team of Egyptian
carpenters from the local community of Coptic Christians set up
a workshop to make wooden trays and packing crates for trans-
porting the artefacts out of the tomb and down to one end of the
Valley, where the larger, later tomb of Seti II (KV15) had been
reserved for Carter's use. There, the objects would be cleaned,
repaired, catalogued, and photographed, then packed into spe-
cially made crates for their eventual shipment on to Cairo for
safekeeping. Their final destination was, at that point, unknown.
To carry the artefacts down the Valley and undertake other work
as needed, up to half a dozen other Egyptian archaeological

workers were on hand. Add to this the indigenous antiquities inspectors responsible for the tomb, like Ibrahim *effendi* Habib; the *ghaffirs* who worked in the Valley; and the soldiers and mounted Camel Corps sent by the Egyptian government to keep guard, and one can see that a sizeable – yet largely silenced – Egyptian presence played a proud part in the discovery of Tutankhamun, too.[28]

Carter and his British colleagues referred to KV15 as the 'laboratory', in keeping with the scientific view they had of their work. Archaeology had developed in the nineteenth century as a form of field science, and the laboratory was a fitting metaphor for a space where modern technologies would turn the fragile artefacts into treasures fit for Tutankhamun – and for a museum. The tomb provided much-needed storage and workspace in its wide and level entrance corridor, some 18 metres long, 3 metres wide and with a 3-metre-high ceiling. As they were brought up from Tutankhamun's tomb by the Egyptian porters, the artefacts were laid out on a series of trestle tables inside KV15, their number cards beside them. Each object or group of objects was then recorded on 6×8-inch index cards, which Carter had stocked up on for the purpose. Carter, Arthur Mace, and Alfred Lucas together worked to clean the artefacts, carry out any necessary repairs or reconstructions, and make them stable enough for transport and display.

When that work was done, Harry Burton photographed the artefacts in the sheltered, north-east-facing bay of cliffs outside the KV15 entrance, helped by his own team of Egyptian camera assistants. Using mirrors and reflectors to aim sunlight over the surface of the objects helped avoid harsh shadows, while neutral backdrops and supports isolated them. It was all part of the scientific effect expected of such photographs, but Burton's skill, and the objects' luxurious materials and workmanship, added

The so-called 'laboratory' (tomb KV15), with Arthur Mace and Alfred Lucas working on a chariot outside; photograph by Harry Burton, November 1923

a sumptuous sheen to many of the images, making the visual argument that these were works of art. In his interviews for the London *Times* and the texts that accompanied Burton's photographs in the *Illustrated London News*, Howard Carter often emphasized the artistic qualities of the objects that were emerging as the work progressed: carved walking sticks, elegant vases, a small shrine overlaid with embossed gold leaf that showed Tutankhamun and Ankhesenamun in scenes of domestic bliss (or so he thought).[29] At other times, Carter focused on the scientific nature of the work in the tomb and at the laboratory – the work done by the Englishmen, that is. As science, this work was meant to be objective, dispassionate, devoid of commercial interest, and far removed from the grubby world of politics.

Science is never any of those things, of course, and the discovery of Tutankhamun's tomb was both commercial and political

from the start. Carnarvon's contract with *The Times* meddled in both. 'Tutankhamun Ltd.' was how a rival British paper, the *Daily Express*, characterized the excavation.[30] British newspapers wanted unfettered access to what they considered a British discovery. Some American journalists felt the same way, given the involvement of the Metropolitan Museum of Art. But the backlash from the Egyptian press cut even closer: in this new nation, just months into its hard-won independence, why should Egyptian journalists need a British paper's permission to cover what was happening in their own backyard? Carter complained about the demands of 'the local press' in his diaries, as if communicating the find to the people of Egypt would be a waste of his time.[31]

Despite the competing pressures from the media, the men working on the tomb – both British and Egyptian – kept to an astonishing pace of work, with a deadline in mind. Lord Carnarvon was set to return to Luxor in late January 1923, to be present at the opening of the still-sealed room that lay beyond the Antechamber. Leading figures from the Antiquities Service and the world of Egyptology were on hand to witness the event, which took place on 16 February. An undersecretary of state from the Ministry of Public Works, Abd El Halim *pasha* Suleman attended, as did Pierre Lacau, Rex Engelbach, Ibrahim *effendi* Habib, and a second inspector, Tewfik *effendi* Boulos, who had worked with Carter years before. The retired engineer Sir William Garstin was on hand, as well. Garstin had served in the Ministry of Public Works in Cromer's day, when he was responsible both for the construction of the first dam at Aswan and the Egyptian Museum in Cairo. Among the Egyptologists present were Herbert Winlock and Albert Lythgoe of the Metropolitan Museum of Art, James Breasted from the University of Chicago, and leading English specialist Alan Gardiner, a man of independent means.

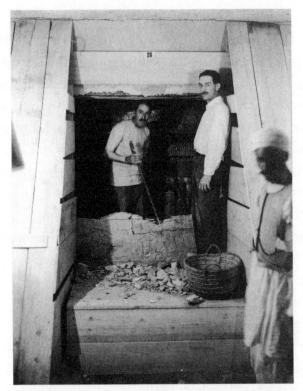

Howard Carter, Arthur Mace, and an Egyptian
colleague, breaking through the blocked opening
between the Antechamber and the Burial Chamber;
photograph by Harry Burton, 16 February 1923

By that date, the only artefacts left in the Antechamber were
the guardian statues either side of the plastered wall. To protect
them and, crucially, hide the access hole at the bottom of the
wall, the Egyptian carpenters boxed them in with sturdy planks.
Between the concealed statues, they built a set of wooden steps
to create a platform – a stage, as it were – from which Howard
Carter and Lord Carnarvon would break through the wall while
their distinguished guests watched. It took nearly two hours in
the afternoon, a time chosen because the Valley had emptied of
tourists by then. Arthur Mace wrote down his thoughts as best he

could the following week, on a break at Aswan's Cataract Hotel: 'It was no light job,' he said, with constant worry that one of the heavy stones from the blocking would fall backwards and hit the shrine wall of gilded wood and lapis-blue faience.[32]

Gardiner also tried to collect his thoughts on paper while they were fresh, confessing in a letter to his mother that he had 'a little difficulty' in getting past the corner of the shrine. Carter had opened the first shrine's doors, and they could see that another lay behind, still sealed shut with string and Nile mud. Years later Gardiner could still recall his astonishment at the burial shrines and the canopic canopy, with its goddesses 'coquettishly looking over their shoulders'.[33] He told an interviewer in the 1950s that the gold 'glittered with the greatest possible brilliancy, preserved for 3,000 years' – a shine he thought had faded in the intervening years, whenever he saw them again in their Egyptian Museum cases.[34]

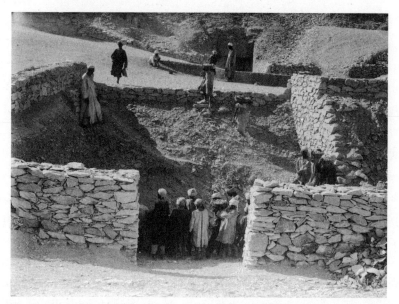

Egyptian boys with baskets of rubble for backfilling the tomb entrance between seasons of work; the man to the left may be Ra'is *Ahmed Gerigar*

For all the emotions, and the tensions, stirring behind the scenes, the opening of the Burial Chamber was the culmination of a triumphant first season. Festivities continued for two more days. Elisabeth, the Queen of the Belgians, and her son, Crown Prince Leopold, attended their own opening event on 18 February with Lord Allenby in tow, and an event for all the press took place the day after. The entire week that followed was given over to hosting visitors, before the tomb was closed and backfilled for the spring and summer months; archaeology and tourism were both seasonal, to avoid the heat. Carter estimated that the work would need two or three more years to finish. He was being optimistic, and all that gold would start to lose its lustre in the months to come. What Carter and Carnarvon had awakened was not an ancient pharaoh, but an occidental fantasy that stood in opposition to an Egyptian dream. Small wonder that the tomb of Tutankhamun was soon considered cursed.

* * *

One thing no one had anticipated was how popular Tutankhamun would prove to be. As soon as Harry Burton's first photographs were published in January 1923, a frenzy of Tutmania gripped Europe and America.[35] The world had been waiting for good news, and all the better if it came with an exotic, orientalizing flair. While modern Egypt may have presented a political problem for the British Empire, ancient Egypt tapped into tried-and-tested themes: magic, adventure, mysteries, and mummies. Destined to be as famous as Cleopatra, Tutankhamun could not help but wake up in a warm, Western embrace.

The story of the tomb's discovery shared headlines with the hangovers of the First World War. France and Germany were at odds over reparations and mining rights in the Ruhr Valley, while the Lausanne Conference was working out what to do about the

battle for independence in Turkey and the fate of the orphaned Ottoman lands around it. A new tomb in the Valley of the Kings made for an escapist read – or even offered some small comfort. Tutankhamun's exact age was uncertain until the unwrapping of his body in 1925, but the death of an adolescent boy or young man will have echoed with everyone who lost a son, brother, friend, or partner in the war. The 'bandaging' that protected the tomb objects in transit reminded *The Times* of wounded soldiers.[36] In the face of death, something had managed to live forever.

Tutankhamun, a pharaoh previously unheard of, was soon tamed into the more manageable King Tut. Jazz songs and dance crazes were churned out in his honour, and with consumer goods beginning to boom, advertisers found ancient Egyptian links for everything from lemons to cold cream. The Huntley and Palmers Biscuit Company in England – purveyors to British and European royalty – issued decorative biscuit tins inspired by the tomb. Newspaper fashion pages urged women to adopt 'Egyptian' hairstyles and experience ancient Egypt à la mode, with Tutankhamun-inspired clothes and jewellery. There were decorating fabrics, endless books, silverware, and porcelain pieces inspired by ancient Egyptian themes, and a rush of cinema building in the 1920s led to a new wave of mock-Egyptian architecture. From entertainment to clothing, foodstuffs to fiction, Tut-mania was a sales opportunity, kicking capitalism back into gear.

Tutankhamun brought tourism to Egypt back to life as well. The Thomas Cook agency, which had introduced steamboat tours to Egypt in 1869, had resumed its tours to the country only in 1920. Luxor had been a winter sun resort for decades, and any foreign tourists who had booked to visit there in 1922–23 found themselves in luck. The *Illustrated London News* reported that the Valley echoed with the 'ubiquitous click' of Kodak cameras snapping away at the activity around the tomb.[37] Hundreds more

tourists followed that winter and the next, and Carter personally welcomed British aristocrats and European royalty. Socialites and shipping magnates made their way as well, as did the celebrated British author H. Rider Haggard – another Norfolk man, whose novels *She*, *Ayesha*, and *King Solomon's Mines* had enjoyed huge success as adventure tales, and justifications for imperialism, in the late nineteenth century.

Egyptian tourists and official visitors also flocked to Tutankhamun's tomb, though they were of less interest to the Western press, or Howard Carter. A group from the Giza Polytechnic came to watch the excavation, snapped by the *National Geographic*'s reporter, and Carter hosted Sultana Melek, widow of Sultan Hussein Kamel. He chafed at other visitors sent by the Ministry of Public Works, however, seeing them as intrusions on his time. Carter seems badly to have misjudged how important the tomb of Tutankhamun was to Egyptians across the social spectrum, not least to the newly empowered middle classes and political leadership. To many Egyptians, the rebirth of the boy king was a symbol of their country's own reawakening after centuries of British and Ottoman rule. Tutankhamun was a flame of inspiration for a broader movement known as Pharaonism, so called because it looked to Egypt's ancient past as a model for modern nationhood. Naguib Mahfouz began his writing career with novels set in ancient Egypt, and poet Ahmed Shawqi limned Tutankhamun's praise in classical verse:

> *Oh, my two companions, go down to the valley, head towards the*
> *chambers of the setting suns,*
> *Pass through their stony places, pass humbly by their funereal couches,*
> *Salute the remains of glory of our Tutankhamun,*
> *And a tomb that, by its beauty and goodness, almost made the*
> *stones shine and the clay smell sweet.*[38]

Paris-trained sculptor Mahmoud Mukhtar was one of several visual artists active in the 1920s who were inspired by pharaonic visual styles and traditional materials such as red granite, quarried at Aswan.[39] Nor was Egypt's admiration for Tutankhamun limited to a cultural elite. Schoolchildren staged a play with homemade props that reveal close study of Harry Burton's photographs, and urban Egyptians followed the excavation avidly in newspapers and magazines. The monthly magazine *El-Hilal* ('The Crescent') illustrated its coverage of the find with copies of Burton photographs and images sourced from other British papers, like *The Sphere*.[40] Tutankhamun circulated freely in the Arabic-speaking world, parallel yet all but invisible to a West focused on its own claim to know and care for ancient Egypt better than Egyptians could.

Like the rest of the Egyptian press, *El-Hilal* carried the story of Lord Carnarvon's death in Cairo on 5 April 1923, his frail health unable to fight the sepsis that set in from an infected mosquito bite. Legend had it that the lights went out in Cairo at the moment he breathed his last, and that his dog back home at Highclere Castle barked for no obvious reason. The mummy's curse was already a favourite fiction, which had grown in popularity in the decades Britain kept its imperial hold on Egypt. It spoke to the moral doubts and secret fears at the dark heart of colonialism, as well as a more immediate fear of dying and the dead. What if disturbing graves was wrong, even when it counted as an -ology? Whose dead mattered, and who is left to do the haunting?

Carter was reticent about his friend and sponsor's death. He had joined the Carnarvons in Cairo as soon as he learned about the earl's illness, taking the overnight train on 20 March, but his journal entry for the day of Carnarvon's death was succinct: 'Poor Ld. C. died during the early hours of the morning.'[41]

Some newspapers had Carter prostrate with grief, or with the curse. In fact, whatever the shock and grief he felt, Carter used his unexpected stay in the Egyptian capital for transactions at the city's antiquities dealers; buying two papyri for the Metropolitan Museum of Art, earning himself a generous £200 commission.[42] Work on the tomb had to keep going, and Almina, now the dowager countess, agreed to have the Antiquities Service transfer the permit to her name. (She continued to fund Carter's work after her remarriage.) While Carnarvon's body was taken back to England for burial, Carter returned to Luxor to finish packing up the Antechamber artefacts. As many as possible would be shipped downstream to the Egyptian Museum in Cairo for safekeeping, with some unpacked to create a small display.

The transport began on 14 May in days of blazing heat.[43] *Ra'is* Ahmed organized fifty extra men to push the packing crates on flat-bed trucks that ran on a few lengths of light railway line. Each time the track ran out, four men lifted a length of scorching metal in their hands to move it from the back to the front of the slow-moving, human-powered train. It took a day and a half to cover the five or six miles between the Valley and the Nile, where a government barge was waiting. At the water's edge, the barefoot porters waded into the river that was Egypt's lifeblood. They held the crated artefacts high above their heads to carry them on board. Children stopped to watch, and from the boat, Rex Engelbach monitored the process with two Egyptian colleagues, in sharp three-piece suits and proud tarbooshes (the red felt hat, or fez, worn by government employees and middle-class Egyptian men). Tutankhamun's journey to one afterlife had been disrupted, but his next was now getting under way. A river always finds somewhere to flow.

* * *

Carter returned to Egypt in the autumn of 1923, to carry on with work at the tomb without Carnarvon. He intended to protect the Carnarvon family's interests, however, which meant supporting the exclusive contract with *The Times*. The Antiquities Service and its head, Pierre Lacau, were keen to see work on the tomb progress, but in a less fraught and hectic manner than the previous winter, when the discovery had caught everyone by surprise. Lacau reminded Carter that he needed to seek permission for any outside visitors to the tomb and informed him that there would now be an inspector from the Service on the scene each day. An Egyptian inspector. Carter was not pleased.

The next phase of work at the tomb was daunting. To reach Tutankhamun's burial, Carter and his colleagues had to find a way to dismantle the massive shrine that filled the burial chamber, and the three others that proved to be nested inside it. Like a ship in a bottle, each had been made in pieces and assembled in its final place. Since there was so little room to manoeuvre around them, the excavators demolished part of the decorated wall of the Burial Chamber, where it joined the Antechamber.

Working with carpenters from the local Coptic Christian community, Arthur Callender devised scaffolding and support beams to facilitate the disassembly work, which Harry Burton and his own assistants were on hand to document. Piece by piece, Carter, Callender, and the *ru'asa* eased the first shrine apart from its roof down, following inked marks left by the ancient craftsmen who had built the gilded jigsaw puzzle in the first place (in places, back to front). Beneath it was a linen tent or pall spangled with appliquéd stars and draped over a framework. The entire pall was rolled up with care and taken to a space outside the laboratory tomb, to await the arrival of Essie Newberry, wife of Carter's colleague Percy and accomplished head of the Embroiderers'

Guild in England. She had agreed to repair the cloth and re-stitch its stars.

Inside the Burial Chamber, working by electric light, Carter and his colleagues removed the doors of the second shrine and met another pair of doors, their ebony bolts still closed with string and mud seals stamped with Tutankhamun's name. This was a moment of discovery the camera was on hand to capture. Carter remembered the 'mystic mauve light' given off by the reflectors that Burton's assistants held.[44] With Mace, Callender, and two of the turbaned Egyptian *ru'asa*, Carter posed to peer through the golden doors, where one more sealed shrine was visible inside. It was one of these photos that I had puzzled over in *The Last Two Million Years*, wishing the men would get out of the way. They must have felt their own impatience, wondering how many more barriers lay between them and the royal body, secreted somewhere inside the golden-brown quartzite sarcophagus that the fourth and final set of shrine doors revealed. Carter posed alone before the shrines as well, the solitary hero, illuminated – or so it seemed – by the radiance of Tutankhamun, who was waiting for him on the other side.

As the four shrines were pulled apart in the early weeks of 1924, so too were Carter's relations with the Antiquities Service and the Ministry of Public Works. He had issued, as requested, regular reports to the Service and given daily briefings to all the press, not just *The Times*. But frictions about the day-to-day running of the site masked longer-term uncertainties about a division of the finds and about who now spoke for Egypt's ancient past.[45] Late in 1923, Egypt's first free elections had put the *Wafd* party into power, with Sa'd Zaghloul sworn in as prime minister in January 1924. Zaghloul's new minister for Public Works was Murqus Hanna who had, like him, been part of the Egyptian resistance struggle for many years. Hanna had been put on trial

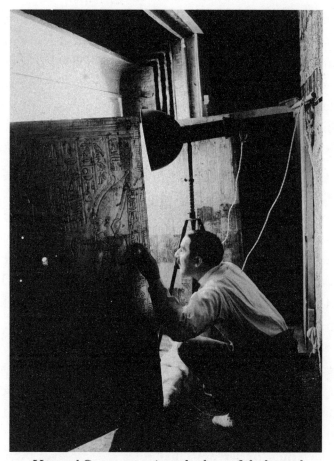

*Howard Carter gazes into the doors of the layered
burial shrines; photograph by Harry Burton,
on or before 3 January 1924*

by Britain for his actions in the 1919 revolution. The charge was
treason, which carried the death penalty. Hanna was acquitted.

Carter zipped up and down from Cairo to Luxor by train for
meetings with Hanna, Lacau, and Paul Tottenham, the British
advisor assigned to Public Works. Like the opening of the wall
into the Burial Chamber in February 1923, the idea in Febru-
ary 1924 was to hold an event for the opening of the quartzite
and red granite sarcophagus, which the dismantling of the fourth

and final shrine had revealed. Carter had promised the wives of several colleagues – Burton, Mace, and some of the other British and American men involved – that they could visit the tomb once the sarcophagus was opened. Following procedure, he submitted a list of names to the Ministry of Public Works. Permission was refused.

By this time, the red granite sarcophagus lid had been winched up by a hoist that Callender helped rig. Inside lay a shrouded coffin, the first of three that would prove to hold the mummified remains of Tutankhamun. But that was for another day. The lid was left dangling there on 13 February, when Carter snapped. After conferring with trusted supporters, including Arthur Mace and Alan Gardiner, he typed an angry notice, in English, and pinned it up for public view at the Winter Palace Hotel, Carnarvon's old haunt at Luxor. Under the impossible conditions set by the Antiquities Service and the Ministry of Public Works, he declared himself on strike. Pierre Lacau responded swiftly. Carter had broken his contract. The Antiquities Service rescinded Almina Carnarvon's excavation permit and changed the locks on the KV15 laboratory and the tomb of Tutankhamun, after gently lowering the sarcophagus lid back down over the forgotten pharaoh within.

It was no way to treat a man of science, Carter told anyone who would listen. Sa'd Zaghloul pointed out that no man of science would behave as if the tomb were his private property. The Egyptian government staged a lavish reopening event on 6 March 1924, with hundreds of local people thronging Luxor to greet the officials who arrived by train, including Lord Allenby, Murqus Hanna, and their wives. Huge crowds gathered at the riverbank, too, where ferries waited to take guests to the west bank. Prime Minister Zaghloul could not attend, but the political message was clear: Tutankhamun belonged to Egypt,

and foreign archaeologists worked for Egypt, not the other way around.

The celebratory atmosphere was bitterly reported in Egypt's main English language newspaper, *The Egyptian Gazette*.[46] To the anonymous reporter, 'the whole proceedings [...] from first to last were quite unrelated to scientific effort, being entirely in the nature of a fête'. The account derided Zaghloul's political success (he had shown the Egyptians 'the power of the mob', it read) and despaired at the number of Egyptian children present, who were being taught 'to meddle with things they cannot understand, making them the innocent and ignorant tools of political passion'. The reporter overcame enough of his disgust to follow events right through to the end. At the tomb, Engelbach was on hand to explain the work, and the Hannas hosted tea in a shelter of bright tentmakers' fabric erected for the purpose. Also in attendance were Pierre Lacau, Prince Frederick Leopold of Prussia, the Duca and Duchessa d'Aosta (the duke a cousin of the Italian king), the *sirdar*, or head of the Egyptian Army, General Lee Stack, and 'practically the entire Diplomatic Corps'. That night, there was a gala dinner at the Winter Palace Hotel, with fireworks from the opposite bank and a procession of illuminated boats upon the Nile.

The *Gazette* reporter described, in patronizing tones, the 'saddened faces' and 'unflagging fidelity and perseverance' of Carter's *ru'asa*. The account that *Ra'is* Ahmed gave to Carter tells a more professional and straightforward story.[47] The foremen were on hand when Lacau arrived with Engelbach, other Service employees (including Muhammad *effendi* Shaaban), and the head of the Valley *ghaffirs*, as well as the *mudir* of Qena, the *mamur markaz*, the head of the legal department in the Ministry of Public Works (Muhammad *bey* Riad), and 33 armed police on foot, camel, and horseback. The officials took statements in

the tomb and in KV15, and the inspection continued the next day, entering another tomb that had been used for storage in the early days of the discovery and to host white tablecloth lunches when Carnarvon was on site (tomb KV4, made for Ramses XI). In a Fortnum & Mason wine box, the Service officials found an object Carter had never fully catalogued or photographed, an unparalleled wooden head carved in Amarna style, which perhaps represented Tutankhamun himself emerging like the god Nefertum from a lotus. Flakes of paint and underlying plaster falling from its surface could not disguise the sculpture's delicate execution and unique subject. *Ra'is* Hussein passed the news to Herbert Winlock at Metropolitan House, who sent word to Carter in a coded message.[48] Carter asserted that the sculpture had been found in the entrance corridor, among the rubble, and placed in KV4 for safekeeping with other objects from the door blockings and corridor, because the tomb of Seti II had not yet been given over to the excavation. The head should have been object 8, which had a number but an otherwise blank line in the notebook Carter used to track the objects' movements. Was this an oversight or an attempted theft? It depended on one's point of view.

Carter spent the summer in North America on a lecture tour that was a resounding success and a welcome distraction. But he had hired lawyer F. M. Maxwell to file a suit on his behalf in Egypt's Mixed Courts, which had jurisdiction in cases involving both foreign residents and Egyptians. Carter lost his claim that the Antiquities Service had acted illegally to terminate his contract. Worse, his lawyer caused deep offence by accusing the Service and the Ministry of behaving like bandits, which the translator duly turned into Arabic as *haramiyya* (thieves) – a grave insult, and an echo of all the talk of ancient thieving that had occupied Carter and Lucas at the start of the excavation.[49]

Once again, Carter showed himself to be tone-deaf, arrogant, or both when it came to his position as a British subject in Egypt: Maxwell was the lawyer who had prosecuted Murqus Hanna for treason a few years before, hardly a tactful choice even for what would always have been a controversial case. Carter satisfied his pride by compiling and privately publishing a 'Statement' of his 'ultimate break with the Egyptian government' in 1924, which he distributed to friends and colleagues.[50] Carter wrote it in the third person (he is 'Mr Carter' throughout), the voice of the objective man of science.

It took a year before Carter and Lacau gingerly negotiated a return to work on site. The KV15 workspace had been boarded up and the tomb itself open only for tourists. In the meantime, Britain had forced Zaghloul's party from power after the assassination, in Cairo, of Lee Stack, head of the army in Egypt and the Anglo-Egyptian Sudan (and a former visitor to the tomb himself). A caretaker government more amenable to British interests gave Lacau more room to manoeuvre. Carter was the clear choice to continue the work he had started, and no one else wanted to commit the time, energy, or funds to Tutankhamun. Work on site resumed in 1925 with a reduced workforce and far fewer interruptions from the press. Photographer Harry Burton was on hand when needed, and chemist Alfred Lucas took leave from his normal duties to devote himself to work at the tomb. *Ra'is* Ahmed, Gad Hassan, Hussein Abu Awad, and Hussein Ahmed Said rejoined the team as well. Arthur Mace had left Egypt for the south of France, where he tried and failed to recover from damaged lungs; he died in 1928. Arthur Callender fell out with Carter over money in 1925, ending his own role in the Tutankhamun saga.[51]

Back on site in the autumn of 1925, there was one goal: the unwrapping of the royal remains, which would bring

Tutankhamun face to face with the man who'd made him famous, and vice versa. Carter and Lucas prised open what proved to be three nested coffins, each covered by a shroud and adorned with wreaths of flowers. The innermost coffin was of solid gold, with the wrapped body of Tutankhamun packed inside. Snug over the head end, laden with a beaded necklace and braided beard of gold and glass, was 'the golden mask of sad but tranquil expression', as Carter noted it in his journal. It had, he wrote, 'fallen slightly back, thus its gaze is straight up to the heavens'.[52] By that point, Tutankhamun was beyond heaven's help. The dissection and dismemberment of his body took place in November 1925, as a later chapter in this book describes. Harry Burton's photographs of the coffins and burial mask did not appear in the press until February 1926. The cover of the *Illustrated London News* introduced the world to the gold and blue glass mask that Carter had painstakingly repaired and that would, from that point onwards, be the face of Tutankhamun. Removed at the start of the unwrapping, the inlaid beard had been too heavy to reattach, its ancient wax-based adhesive long decayed. And so the pharaoh all the fuss had been about gazed out from the papers as a beardless boy with eyes wide open and the shadow of a smile across his sealed and golden lips.

* * *

Media interest moved on after 1926, but Howard Carter stayed put until 1932. He spent every winter but one living at Castle Carter and working on the tomb. There was still the room adjacent to the Burial Chamber left to clear. Initially called the storeroom, perhaps because it was so full of boxes at first sight, it became the Treasury as its contents came to light and its ritual purpose became clear. The 'sinister black chests' stacked to one side proved to be shrines containing cloth-wrapped, gilded

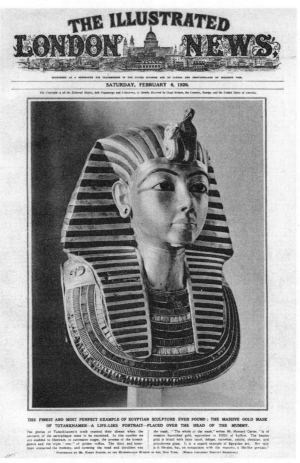

The world's first view of Tutankhamun's burial mask,
on the cover of The Illustrated London News,
6 February 1926

wooden statuettes of the king and a series of gods. On top of
them was an entire fleet of small-scale boats, one rigged with
sails and placed on top of a model granary.[53]

The main axis of the Treasury, in line with the now dismantled
burial shrines, consisted of the jackal on its own shrine, complete
with carrying poles and containing objects used in the funeral or
other rites.[54] Behind it lay the gilded head of a sculpted wooden

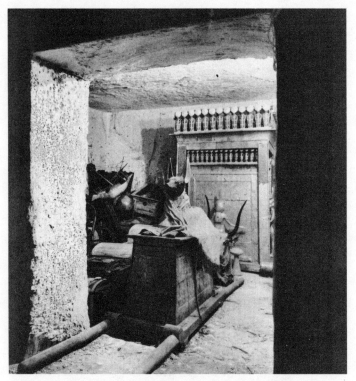

A wrapped jackal sculpture, on top of a chest of magic objects,
stood between the burial shrines and a large gilded shrine
containing the canopic chest

cow, associated with the goddess Mehet-Weret and the western
hills in which the tomb and the entrance to the netherworld both
lay.[55] Three alabaster stands, like incense burners with match-
ing lids, held traces of natron, the purifying salt used in religious
rituals, including mummification.[56] They stood in a row before
the massive gilded canopy for the canopic chest, which had
separately carved and gilded figures of four goddesses stretch-
ing out their arms protectively, one at each of its four sides.[57] A
set of decorative boxes that had been set out neatly, either side
of the jackal, turned out to hold astonishing jewellery, perhaps
used by Tutankhamun in life as well as during the funeral. One

box had a label written inside, identifying its contents as 'The gold ornaments of the procession made in the bed-chamber of Neb-kheperu-re', that is, Tutankhamun.[58] A bed-chamber was a place for sleep, but the words for sleep and death were similar in the ancient Egyptian language.

The last room to be cleared was the so-called Annex, in the winter of 1927–28. Burton came to help with the photography – there were hundreds of *shabti* figures of the king, packed into yet more boxes – but he fell ill with dengue fever. Carter nursed him for several weeks at his own home. In 1929, no work took place while Carter, Pierre Lacau, and the Ministry of Public Works drew a line under the question of dividing some of the finds from the tomb with the dowager countess, who had long since remarried but continued to fund the work. The line was drawn, but not as Carter would have liked it. The entirety of the tomb contents would stay in Egypt in recognition of the find's uniqueness and significance, not only to the world of scholarship but, just as importantly, to the new nation trying to steer its own course after decades of British domination. Space in the Egyptian Museum had been rearranged to accommodate as many items as possible on the first floor, with the rest in the basement storage magazines or still stored in the Valley. Effectively buying its national treasure free and clear, the Egyptian government recompensed the countess for her and her late husband's entire financial contribution, estimated at £36,000 – of which Almina gave Carter a quarter. He put his own money into the final seasons, as he could by now afford to do. Books and lectures about Tutankhamun, plus his commissions in the antiquities trade, had made Carter financially comfortable. He lived the life of a gentleman in Kensington, London, where his flat was furnished with oriental carpets, antique furniture, paintings, and his own collection of Egyptian antiquities.

Those last seasons were devoted to restoring the burial shrines and framework for the pall. The cloth itself had disintegrated from exposure to the elements during the year of Carter's break with the authorities. Alfred Lucas continued to work alongside Carter, assisted from time to time by Harold Plenderleith, a scientist at the research laboratory of the British Museum.[59] Between them, they effectively reconstituted the dismantled shrine walls and roof sections by injecting paraffin wax into the wood to stabilize it. Chemical adhesives helped re-adhere the fragile gilded plaster and, on the outermost shrine, the blue faience plaques inlaid between the *tyet* and *djed* symbols. Divine protection and eternal stability would have been welcome, but chemistry would have to do.

By the autumn of 1932, the shrines had been crated, carried to the Nile by Egyptian porters, sent by train to Cairo, and re-erected in the Egyptian Museum, where Harry Burton photographed them before the glass walls of the vitrines were put in place. That Christmas, Carter could survey the tomb of Tutankhamun with relief and perhaps a few regrets. It was empty apart from the stone sarcophagus containing the largest of the nested coffins. What was left of Tutankhamun's body had been rewrapped and cached inside, out of sight. At that point, Carter realized that there were no decent photographs of the sarcophagus itself, apart from incidental views taken in the tense days of 1924, as the lid was raised above it. In the intervening years, the dismantled shrines had been wrapped up and stored against the Burial Chamber walls, making for an unattractive background view and limiting the workspace. Carter visited Metropolitan House as usual during the festive period, where he saw Harry Burton and called in one last favour. If Burton could find time to photograph the sarcophagus, Carter would provide the glass negatives and pay for printing.

On 20 January 1933, Burton took his last photographs inside the tomb of Tutankhamun, twenty evenly lit exposures of the sarcophagus from every side. The same four goddesses that stood as statues around the canopic canopy here guarded each corner, their curves carved into the quartzite and their arms projecting wings around the sides. 'Today I finished the "Tut" work and dashed glad I am,' he wrote to Herbert Winlock in New York. 'I began to think I should never finish it and it seems too good to be true.'[60] Burton spoke too soon. He may have taken his last photograph of Tutankhamun's burial goods, but there was no end in sight for the reawakened king.

3

Caring for the King

WAR AND GRIEF kept Minnie Burton in Cairo in the early 1940s. Her husband Harry died in June 1940 in the care of the American Mission Hospital at Asyut, and Minnie could not travel back to their home in Mussolini's Italy, which had just declared war on Britain and France. She took refuge with friends in Cairo, serving tea to wounded troops to blunt her sorrow. In late October, as the end of Ramadan approached, Minnie received a visitor from her old life with Harry in Luxor. Hussein – she tells us only his first name – had been one of Burton's photography assistants for twenty years, including the work at Tutankhamun's tomb. He had sent a letter of sympathy to Minnie ahead of his visit and hoped she could help him find work. Harry's death meant he was out of a job, besides which the war had put an end to excavations throughout Egypt.

'I didn't know what he was fit for,' Minnie wrote of Hussein to the new head of the Egyptian department at the Metropolitan Museum of Art, Ambrose Lansing.[1] Working with her husband all that time, she assumed, had not conferred any useful skills. Still, Hussein came to pay his respects and say goodbye. He was on his way to the Canal Zone, where he'd heard that there was work. 'I gave him a pound,' Minnie explained to Lansing, as Harry had always done for the Eid al-Fitr at the end of the holy month. They spoke of Harry, moving Hussein to tears, but it

was he who offered words of comfort to his former boss's widow. 'He told me not to cry,' she wrote. 'He said, "Mr Burton is dead. I too will be dead soon, and so will you, and everyone else. Mr Burton was a good man and he is with God, and you will find him there. He knows where you are and what you are doing." Don't you think that was extraordinary?'

It is all too ordinary that the voices of Egyptians involved in the Tutankhamun discovery, like photographer Hussein, reach us only at second or third hand in the archives associated with the excavation, in Oxford and New York. Archives are compiled by those with power, not by those who landed in its path or – as Britain's grip on Egypt slowly loosened – made their way in its long wake. The years either side of the Second World War reshaped relations between Egypt and its old colonial masters. Many European and American institutions began to pull back from archaeological work in the country, and not only because money and attention had to be focused elsewhere. Balances of power and influence were shifting, and the lure of 'discovering' ancient Egypt shifted with them.

In the decade after Howard Carter finished working in the Valley, the king whom he had reawakened in 1922 went ever so softly back to sleep. Faced with an economic depression and the rise of fascism, the world had grown a little weary of the wonderful things. The *Illustrated London News* still advertised its packs of collectable postcards, using the stunning photographs Harry Burton had taken with Hussein's help. For the silver jubilee of King George V in 1935, the paper issued a colour print based on a tinted Burton image of Tutankhamun's mask, 'the most complete archaeological discovery of the reign'.[2] But commemorative supplements are where old news gives a faint gasp before becoming history.

The death of Howard Carter in March 1939 marked a turning

point in the trajectory of Tutankhamun's tomb, at least where the archives of the excavation were concerned. While the artefacts remained in Egypt, as property of the Egyptian state, Carter's notes and Burton's photographs were considered private property, as excavation records still are today. In the 1940s, after both men had died, the glass and paper records of the tomb made their separate ways to England and America, where no one knew exactly what to do with them. Interest in Tutankhamun hit a lull as the twentieth century lurched towards its mid-point, and Egyptology seemed a bit embarrassed by all the fuss the find had once created. In Oxford and New York, where the excavation archives found new homes, caring for the paper trail of the discovery became women's work for office juniors. In Egypt, meanwhile, caring for the artefacts and the tomb was a responsibility that soon fell on Egyptian shoulders, as the country strove to break its last colonial ties. In 1922, the reawakening of Tutankhamun had coincided with the nation's own, but like the journey of the sun god through the caverns of the night, birthing a decolonized country was an ongoing cycle of dark and dawn.

*　　*　　*

I found Minnie Burton's letter about Hussein while I was looking for her husband Harry in New York. The Burtons had only visited the city once, in 1924, after Carter's rupture with the Antiquities Service. But the Metropolitan Museum of Art on Fifth Avenue was Harry Burton's long-time employer, via its Egyptian Expedition, and the Egyptian department today holds thousands of his prints and negatives, as well as files of his correspondence with past curators – an archival gold mine for my research into Harry Burton's photography at the tomb. Their 1924 visit marked the start of the Burtons' cross-country trip to California at the expense of Edward Harkness, a Standard Oil

Company millionaire and patron of the Egyptian Expedition.[3] Harkness was a film buff and had been encouraging Burton to use a moving picture camera for the museum's work in Egypt. As the late Lord Carnarvon had already spotted, Tutankhamun had Hollywood potential, and Harry Burton headed there to see how film studios achieved effects that would be worthy of a pharaoh.

The Egyptian department offices and library occupy a self-contained set of rooms with its own courtyard garden in the Metropolitan Museum's north wing, part of which was redeveloped in the 1970s when an extension was built to accommodate the temple of Dendur – Egypt's gift to the United States for contributing to the UNESCO campaign to save the monuments of Nubia from the Aswan High Dam. In 1979, the same wing had hosted Tutankhamun's treasures on their second American tour. I sat at a table in the department library listening to birds chatter on a beautiful spring day as I worked forward in time through a stack of manila files, each with a typed label on its tab: BURTON, HARRY, followed by the date range of the letters inside. Burton's clear handwriting had taken me from his photographic studio in Borgo San Jacopo near the Arno in Florence in 1913, to the late 1930s, when his health began to fail; among other problems, he developed diabetes. In hospital in Linz in 1937, he was 'wretchedly thin' after a hernia operation, at 114 lbs too bony to sit comfortably on a chair.[4] A year later, in a rest home in Freiburg, he had four blood transfusions after a tonsil infection took hold. He and Minnie headed out to Luxor even though no excavations were planned, which he knew would disappoint the people of Gurna. 'The poverty gets worse and worse,' Burton reported to Lansing in New York, and he expected that many local men would be pressed into army service.

When war broke out in late 1939, the Burtons stayed in Egypt. In the spring of 1940 Harry entered the Mission hospital

at Asyut, about midway between Luxor and Cairo. I knew the end was coming. Nonetheless it gave me an archival jolt to turn a page and find a Western Union telegram, its fold lines smoothed flat and its time-darkened paper bearing pasted ticker tape with three stark words: HARRY DIED TODAY. I looked up to the windows where birdsong filtered out Fifth Avenue, embarrassed that my throat had choked on someone else's private pain. Not only Minnie Burton's, who was at his bedside to the end and whose letters filled the rest of the file ('I felt so entirely lost without him'). But Hussein's and all the unnamed, unknown others who lacked even a passing reference in Tutankhamun's modern myth, with all its gold and glory. Here, in fragile paper messages sent across buried wires or loaded on to long-lost ships, there were no heroes. Only humans and the mess we leave behind.

Although Harry Burton took his last photographs for the tomb of Tutankhamun in January 1933, his path and Howard Carter's often crossed during the few years each had left to live. With the Tutankhamun artefacts in Cairo and the tomb now just another tourist site, Carter seemed at a loss as to how to proceed. Burton thought he missed the limelight. 'He feels it dreadfully that he no longer looms so large in the public eye,' Burton wrote of Carter to their colleague Herbert Winlock. 'After all he was "it" for about 11 years which is considerably more than most "Lions" are.'[5] In another exchange with Winlock, Burton came close to disavowing Carter entirely. 'He used to have many good points but time + prosperity seems to have rubbed them down!'[6]

Carter divided his time between his London apartment and his Luxor home. He had published three bestselling books on the tomb of Tutankhamun, the last two ghostwritten by his friend Percy White, who had been professor of English at Cairo University.[7] But Carter knew that Egyptologists expected

a full scholarly publication of the tomb and its contents. Over the years, he had gathered copious notes, sought expert opinions from Percy Newberry and Alan Gardiner, and more or less completed the index card catalogue. There, he stopped. To do the whole thing properly, Carter told old colleagues at Metropolitan House, would cost at least £13,000 – money neither he nor anyone else was willing to stump up.[8]

The limelight still beckoned Howard Carter now and then, with lectures, interviews, or private tours. In 1936, he accompanied Crown Prince Farouk around Luxor and to the Valley of the Kings, where the future king – who would be forced to abdicate in 1952 – followed in the footsteps of his own father, King Fuad, to see the tomb of Tutankhamun. Carter struck one of Farouk's entourage, Adel Sabit, as a 'grumpy and rather dour man', who could turn on the charm when required. He complained to Farouk about the Antiquities Service and its treatment of him a dozen years before.[9] Perhaps it was small comfort that his former nemesis, Pierre Lacau, was finally to retire that year.

Carter might have been more circumspect about the Service had he known, or cared, how many rumours were in circulation accusing him of unethical – indeed, illegal – conduct in taking objects from the tomb to England. The eminent Egyptologist Alan Gardiner, who had tried to use his influence on Carter's behalf in the 1924 crisis, was 'very bitter' about Carter a decade later, after the archaeologist gave him an amulet that proved to have come from the tomb. Gardiner returned the amulet to the Egyptian Museum in Cairo and made sure Carter knew about it, throwing back in his face the archaeologist's assurances that it was not a Tutankhamun piece. Even Percy Newberry, Carter's lifelong friend and ally, may have distanced himself for the same reason: thefts from the tomb.[10] Taking sample material such as botanical or textile fragments for Percy and Essie Newberry to

study – that was one thing, a standard practice done without comment or controversy; like many archaeologists, the New-berrys had also acquired small antiquities in Egypt, later donated to the British Museum. The country's antiquities market was thriving, and legal until the early 1980s. But taking excavated artefacts without permission, that was something else. If true, Carter had crossed a line. Those like Winlock, who had pre-viously given him the benefit of the doubt, when Carter had protested that the concealed head-on-a-lotus sculpture was an oversight, must now have wondered if his protests of innocence had been an outright lie.

Howard Carter died at home in London on 2 March 1939, from complications of Hodgkin's disease; he was sixty-five years old. His last residence was a mansion flat at 49 Albert Court, right next to the Royal Albert Hall, where he had moved in 1932. Since enlarged into a duplex, it was offered for sale in November 2017 at an asking price of £10 million, its famous one-time resident part of the estate agent listing.[11] At the time of Carter's death, the probate valuation indicated that in addition to the reception rooms, kitchen, and bathroom, it had one bedroom, a study, and a sitting room for the housekeeper. Harold Plenderleith remem-bered visiting Carter at home, if they weren't meeting elsewhere for lavish lunches.[12] The London *Times* ran Carter's obituary, illus-trated by a Harry Burton photograph taken in February 1923, when the blocked-up doorway between the Antechamber and the Burial Chamber was dismantled. Better to remember heroes in their triumphant moments.[13]

It was by coincidence that in April, just a few weeks after Carter died, the BBC aired a fifteen-minute radio programme dedicated to the two trumpets found in Tutankhamun's tomb, one made of copper alloy, the other of silver.[14] Broadcast on a Sunday afternoon, 16 April, at 5 p.m. (it had aired on the BBC Arabic

Service the preceding Friday), the programme featured an inter-
view with Alfred Lucas, conducted in the Egyptian Museum at
Cairo by reporter Rex Keating. Lucas reminisced about his work
at the tomb, while curator Rex Engelbach – silent in the back-
ground – prepared the silver instrument for a trumpeter from
the 11th Hussars, a British cavalry regiment based in Egypt and
British-controlled Palestine in the late 1930s. Bandsman James
Tappern sounded the trumpet through a modern mouthpiece,
which split the metal, forcing Lucas back to work to repair an
object from the tomb once more. When war in Europe broke
out a few months later, some who had heard the BBC broadcast
wondered if Tutankhamun's curse had struck again.

Howard Carter's heir was his niece Phyllis Walker, the only
child of his sister Amy. Phyllis had visited her uncle in Egypt in
1931, and in his final years in London, she was his secretary and
helped to nurse him as the end approached. From Luxor a letter
of condolence reached her from the staff of Castle Carter, signed
by Hossein Ibrahim Said and Abd-el-Aal Ahmed Said. They
had heard the news from Harry Burton and wanted to express
the sorrow of their own families and, indeed, all Egyptians at
Carter's death.[15] In Carter's will, Abd-el-Aal Ahmed Said, who
had worked for him for forty-two years, received 150 Egyptian
pounds. The house itself, and all its contents, Carter left to the
Metropolitan Museum of Art. The rest of his estate, including
the London property, went to Phyllis, with Harry Burton and
Illustrated London News publisher Bruce Ingram named as execu-
tors. The will instructed Phyllis to consult the executors for advice
before selling the Egyptian antiquities in his possession. The
reason for this extra caution was soon clear: some of the items
came from the tomb of Tutankhamun.

The suspect items had been set aside by the time the auction
house Spink & Son came to draw up the probate valuation on

1 June 1939. Carter had been a client of the firm for many years. They were the source of some of the Chinese porcelain, oriental rugs, and oil paintings which furnished his London flat, as well as Egyptian antiquities that he bought and sold for clients. At the time of his death, Carter had money on account from the Detroit Institute of Arts in Michigan, whose Egyptian art collection he had been helping to develop. Harry Burton sent the museum three objects from Carter's collection in lieu of returning the funds: a cremation urn in brilliant turquoise-coloured faience, and two striking male heads of Hellenistic or Roman date, carved in a hard, dark stone reminiscent of the seven Sekhmets of Didlington Hall.

The objects that seemed to point to Carter's guilt included a silver tenon from one of the royal coffins, inscribed with Tutankhamun's name; a miniature faience vase emblazoned with the king's cartouche; amulets of coloured glass, lapis lazuli, and gold; and a stunning blue glass headrest, all of such superb quality that they could only be from the tomb. The matter weighed heavily on Phyllis Walker's conscience. To minimize damage to Carter's reputation, and avoid a potential legal tangle, she and Harry Burton sought advice from Percy Newberry, who suggested a discreet enquiry to the Foreign Office. If the artefacts could go back to Egypt via diplomatic bag, they would avoid customs scrutiny. However, the Foreign Office and the British High Commissioner to Egypt, Sir Miles Lampson, ruled this out. With Britain on the brink of war, they had more important concerns and thought the antiquities should enter Egypt by a standard route.[16]

Walker next approached Étienne Drioton, the French scholar who had replaced Pierre Lacau as head of the Antiquities Service in 1936. Perhaps helped by his training as a Catholic priest, Drioton had the tact, shrewdness, and genial nature that both Lacau and Carter seemed at times to lack. He understood what

needed to be done to absolve Howard Carter, if not in the eyes of God, then at least for the Egyptian authorities. On behalf of the Service, Drioton welcomed Walker's 'kind and delicate thought' in offering the objects to the Egyptian Museum and put a plan in place. Walker turned the artefacts over to the Egyptian consulate in London, and at the end of the war, Spink & Son saw to it that they were safely shipped to Cairo for the attention of King Farouk, who as crown prince had toured the tomb of Tutankhamun with the Englishman who found it. Drioton had become an informal advisor to Farouk on all things ancient Egyptian, and by agreement, Farouk gave some of the objects to the Egyptian Museum, covering the traces of their suspect origin; others remained in Farouk's possession after his abdication in 1952, reaching the museum at last in 1960.[17] Farouk died in exile in Italy in 1965.

Other objects that may be associated with the discovery found their way into European and American collections over the years.[18] A few can be linked to Carter's record cards from the tomb, but most have raised suspicions based on their rarity, late 18th Dynasty date, and collecting history. Carter seems to have gifted small items to certain visitors he hosted at the site in the first two seasons, such as a rosette from the linen pall and bronze tools from *shabti* figures that wound up in the collection of Queen Elisabeth of the Belgians.[19] To date, the Metropolitan Museum of Art is the only institution to have returned indisputable Tutankhamun objects to Egypt, transferring its ownership in 2010. The museum had purchased the items from Spink & Son, and although not as obviously linked to the tomb as the artefacts that Walker and Burton held back from Carter's estate, suspicions had grown over the years. Other rumoured tomb objects remain in the Metropolitan Museum's possession, including carved ivory figurines of a horse, a gazelle, and a hunting

dog with a moving mouth (all of which belonged to Lord Carnarvon), plus a miniature vase, a multi-coloured faience collar, and a pair of ivory duck-shaped dishes, bought from the Carter estate via Spink in 1940.[20] Museums in Brooklyn, St Louis, and Kansas City also own and display suspect items (to my knowledge, Egypt has made no formal request for their return), while beads and collars potentially found on the mummy continue to appear on the antiquities market today.[21]

More clear-cut in terms of legal title was the property Carter left to the Metropolitan Museum in his will: the land, building, and contents that comprised his home near Gurna. Before his own final illness struck, Burton saw to it that the contents of Castle Carter were moved to Metropolitan House for safekeeping.[22] The war helped determine the fate of both properties. Sensing the changing political wind in Egypt, many foreign expeditions hesitated to invest further funds or effort into archaeological projects. In 1948, the Metropolitan Museum sent a junior curator, Charles Wilkinson, out to Luxor to clear both houses, which it had decided to give to the Antiquities Service.[23] From Castle Carter, Wilkinson boxed up around 500 glass negatives from Burton's work on the tomb, together with a set of photograph albums that Burton had kept at Metropolitan House, documenting his Tutankhamun work. The albums, negatives, and all the Egyptian Expedition records were shipped via Cairo and Alexandria to New York, crossing the Atlantic Ocean for the first time – but not the last.

The Metropolitan Museum already had several hundred of Burton's Tutankhamun negatives in New York. As a thank you for Burton's services, which were otherwise unpaid, Carter periodically sent the museum a selection of negatives, either near-identical exposures (Burton often took two shots) or second-best views. The best shots Carter kept for himself. During the

war, Phyllis Walker stored these and all his other records of the Tutankhamun excavation in London's East End, where they were lucky to survive the Blitz. Carter's furniture, paintings, and antiques did not.[24]

Allied bombs flattened the Burtons' home in Florence in September 1943, taking with them any records of his life and work that Harry Burton kept there. The apartment on the Oltrarno had been settled on him by his one-time friend and patron Robert Cust after the two men fell out. Cust did not want Burton to work in Egypt or marry Minnie, a divorcée.[25] In that oppressive Cairo summer of 1940, after Harry's death, she saw a letter to the editor of the London *Times*, signed only 'C':

> There should still be a few among the many readers of *The Times* who, in seeing the obituary notice of Mr R.H.H. Cust, will remember the gracious hospitality which he and his housemate, Harry Burton, used to dispense in their charming flat high up in the Via dei Bardi in Florence in the early years of the nineteen hundreds. Burton was then an amateur photographer of great talent, and he afterwards became well known in his association with the late Howard Carter, and will be remembered for his exquisite work in photographing the treasures of the tomb of Tutankhamun. He predeceased Cust by less than a month, dying in hospital in Egypt after a long illness, patiently borne, on June 27th.[26]

Lives that Tutankhamun had woven together in unexpected ways, unexpectedly looped back on each other in the displacement and destruction wrought by war. Minnie Burton left Cairo for South Africa by the end of 1941, making her way back to Florence at some point after the war. She died there in 1957 and

is buried in the city's Allori cemetery with her parents. There is no word of what happened to Hussein.

* * *

Tutankhamun's treasures spent the Second World War in the basement of the Egyptian Museum – at least, as many of them as could be squirrelled away in storerooms where space was already in high demand.[27] Larger items had to stay put, notably the shrines that had been re-erected in place in late 1932 before the glass sides of their display cases closed them in for the foreseeable future. They joined the rest of the tomb artefacts on the first floor of the museum, filling the north and east sides of its square floor plan. A side room to the north, Room 3, housed the two inner coffins, the jewellery and adornments from the mummy, and the mask itself. Security gates shut Room 3 off when the museum was closed to the public, and stood wide open for visiting heads of state, from Egypt's own new king, Farouk (who succeeded his father Fuad in 1936), to Mohammad Reza Pahlavi, crown prince (later *shah*) of Iran, who married Farouk's sister Princess Fawzia in March 1939.

In the 1938 guide to the Egyptian Museum, the last edition published before the war, the artefacts from Tutankhamun's tomb filled almost a third of the book's pages. 'The details of the discovery of this now famous tomb are too well known to require recording here,' it opened, counting on visitors remembering the events of fifteen years earlier.[28] Those events influenced the order in which the guidebook listed the objects, too. They had been assigned numbers when they entered the museum in the 1920s, 'merely temporary' since at that point, their destination was not yet fixed. The anonymous guidebook author told visitors not to try to follow the numbers in any case, but to look at each vitrine as they came to it. Anyone who wanted to find a specific

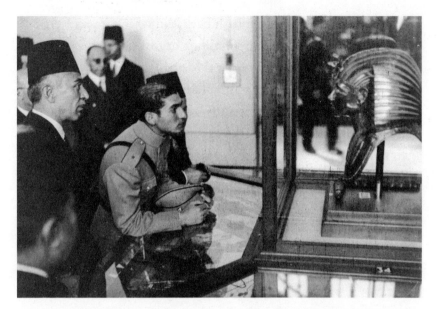

Mohammed Reza Pahlavi – future shah *of Iran – meets the mask
of Tutankhamun in Cairo, with renowned Egyptian painter
Prince Youssef Kamal (left); photograph by Riad Shehata, March 1939*

object could consult a card index mounted on a pillar where the
two long galleries met, but even those locations were considered
'temporary'. Tutankhamun was always moving, even when he
stood perfectly still.

A visitor who did read the guidebook straight through, per-
haps curious about the order in which the museum received each
object, would find that Number 1 was the gold throne from the
Antechamber, its back filled with an inlaid scene of Tutankha-
mun and his queen.[29] Number 11 was the alabaster 'wishing cup',
which Carter had assigned catalogue number 14; many objects
acquired several layers of reference numbers over the years. The
solid gold coffin, all 110kg of it, was number 219 in the guide-
book, and the mask number 220, with its heavy beard and the
three-strand choker from its neck laid out carefully alongside.[30]
Not everything was made of gold and glass. Number 644 was a

loaf of bread 'enclosed in the rush basket in which it was baked'.[31] Only at number 755 did the infamous head-on-a-lotus sculpture make its entry, with a curatorial aside about its 'curiously shaped' skull.[32] 'Similarly distorted heads may be seen in the Akhenaten exhibits,' the guidebook offered by way of explanation or advice. The Tutankhamun artefacts ran on, like a river, to the end: number 1701, one of the six chariots from the tomb, part gilded, with a display table alongside to show accessories such as a saddle and horse blinkers.[33] Number 1702 was a sample of the otherwise destroyed pall, studded with rosettes, shown with a small-scale model of how it fitted over the frame.[34] The last object was number 1703, 'part of the resinous filling of a reed torch'.[35] Treasures come in all shapes and sizes.

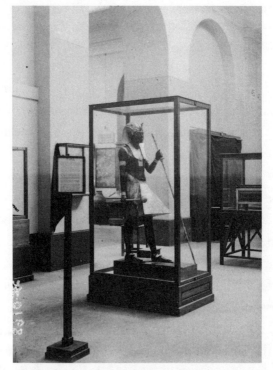

*Objects from the tomb on display upstairs in
the Egyptian Museum, Cairo, in the 1930s*

In the 1930s, chief curatorial responsibilities at the Egyptian Museum still lay with two British archaeologists: Rex Engelbach, who had been Chief Inspector for Upper Egypt when Carter found the tomb of Tutankhamun, and Guy Brunton, a former pupil of Flinders Petrie, who had excavated important prehistoric sites in Middle Egypt in the 1920s. Colonialism had erected considerable barriers to Egyptian participation in Egyptology. The British administration of Egypt under Lord Cromer cut off state-funded schooling for Egyptians and blocked efforts to establish a public university. Cromer did not consider Egyptians capable of complex thought, nor did he want an educated population that might object – as it did in any case – to British control. By the time he retired as consul-general in 1907, literacy rates had slipped to 7 per cent of the population.

European Egyptology was little better in its attitudes towards Egyptians and their interest in ancient Egypt. In the 1870s, the French scholar who set up the Egyptian Museum, Auguste Mariette, shut down his colleague Heinrich Brugsch's modest training programme for Egyptian men who wanted to study the ancient languages, history, and archaeology of their own country. The admissions criteria were daunting in any case, with knowledge of German, French, and English a prerequisite. One successful student of the programme, Ahmed Kamal, did not find a job with the Antiquities Service until after Mariette's death, and even then he had to accept a fraction of the salary his European colleagues earned. Kamal contributed to the *Catalogue Général* of the Egyptian Museum, and he later ran lecture courses in Egyptology at the Higher Teachers College and at the Egyptian (now Cairo) University, founded after Cromer's departure from the country.[36]

Two former students of Kamal's, Selim Hassan and Mahmud Hamza, were the first Egyptians appointed as assistant curators in the Egyptian Museum, in 1921, and both won Egyptian

government scholarships to pursue doctorates in Egyptology
in Europe – a competition established after the discovery of
Tutankhamun's tomb drew attention to the paltry opportuni-
ties in Egypt for Egyptians to become Egyptologists. It was an
especially auspicious leap for Selim Hassan, who came from a
village in the Delta. His father died when he was young, and his
family had struggled to pay the fees for schooling, first at home
and later in Cairo.[37] In 1923, Hassan had a tour of the tomb of
Tutankhamun with Howard Carter and wrote about the find,
and his impressions from that visit, for readers of Egypt's main
daily newspaper, *Al-Ahram* ('The Pyramids').[38]

The doctorates that Hassan and Hamza earned abroad were
only useful if there were jobs for them back in Egypt at the end
of it. Throughout the 1930s and into the 1940s, some Egyptian
politicians and corners of the Egyptian press pushed to increase
the number of Egyptian Egyptologists employed in the middle
and higher ranks of the Antiquities Service. Hassan emerged
as a favourite for the top job itself, as Pierre Lacau's retirement
approached. He had joined the faculty of Cairo University and
in 1929 began to direct significant excavations at the Giza pyra-
mids. Behind the scenes manoeuvring gave the directorship to
Étienne Drioton, with Hassan as second fiddle.[39] The arrange-
ment suited neither, and Drioton later forced Hassan to resign.

Around the time the Tutankhamun artefacts were being taken
from the museum vitrines for safety, a French excavation led by
Pierre Montet made a startling find at the site of Tanis in the
Delta – a find to rival Tutankhamun's, since it was an intact royal
tomb dating to the 21st and 22nd Dynasties, around 1000–900
BC.[40] The German invasion of Czechoslovakia pushed Montet's
discovery off newspaper front pages, however. Likewise Montet's
opening of the solid silver coffins of King Psusennes I the follow-
ing winter, which took place just as German troops entered Paris.

Egypt became an arena of war, its antiquities the least of anyone's concerns. A theft in 1941 of objects from Montet's discovery caused a small scandal, and there were accusations – fed by British archaeologists on war duty in Egypt – that the Antiquities Service was not doing as much as it should have done to police archaeological sites. Running the Service with a skeleton staff in Cairo, Drioton responded that of course its inspectors were demoralized and stretched thin. Without the usual flow of tourists and foreign archaeologists, even the Valley of the Kings was vulnerable. The world's eyes were not on Tutankhamun. At least for now.

By the end of the war in 1945, the objects were back on display. The author Penelope Lively, who grew up in Cairo, saw them one afternoon with a family friend: 'I stand looking at the great gold mask, at the chariot, at the sarcophagus, and am filled with a confused solemnity.'[41] She learned later that the day was meant to distract her from her parents' divorce hearing and her impending move to boarding school in England. That same year, the Egyptian Museum produced a slim guide dedicated solely to the Tutankhamun treasures. It sold for 10 piastres – two shillings, in British currency at the time – and included a few modest reproductions of Harry Burton photographs. The author of the guide was an Alexandrian-born Jewish Egyptologist named Joseph Leibovitch, whom Drioton had taken under his wing. Drioton created a librarianship job for Leibovitch at the Egyptian Museum.[42] Unlike the old Museum guidebook, Leibovitch organized his according to a suggested route the visitor could take through the Tutankhamun galleries. In Room 3, he described the magnificent funerary mask as it had always been displayed, with its separate beard and beaded necklace placed in the same vitrine. Within a year, Tutankhamun had a facelift: a pencilled annotation in the museum's *Journal d'Entrée* – the logbook that

recorded objects as they came in – records that the beard was
glued back in place on the young pharaoh's golden chin.[43] Tut-
ankhamun was ready for all the hope-filled potential of the
post-war era. So was Leibovitch. A communist and long-time
supporter of the Zionist cause in Palestine, Leibovitch left Egypt,
the country of his birth, in 1949 to start a new life in a new
country: Israel.[44]

<p style="text-align:center">* * *</p>

The fate of the excavation archive – Howard Carter's carefully
compiled record cards, journals, plans, and drawings, and Harry
Burton's photographs – depended on the work of several unsung
women, whose efforts fostered Tutankhamun's legacy and made
his later reanimation possible, from the 1960s onwards. During
the 1920s excavation, women had minor roles. Essie Newberry
worked on some of the textiles, including the burial pall, which
then disintegrated when it was left outside after the abrupt
closure of the tomb in 1924. Minnie Burton took a few snap-
shots one day (while Harry was filming the removal of one of the
animal-shaped biers), and she helped him with printing, accord-
ing to the diary she kept.[45] For the most part, however, even
privileged Englishwomen like Lady Carnarvon and her daugh-
ter Eve were footnotes to the find, defined by their relationship
to men.

One of the women instrumental in bringing the excavation
back to life, through its notes and photographs, had just been
born when Howard Carter began the second, stressful season
of work at the tomb in autumn 1923. Penelope Fox was not yet
twenty-five years old when she encountered Tutankhamun, but
her life had already been touched by war and loss. At the age
of eight, Penelope (known as Tiny) and her older sister Felic-
ity were enjoying a holiday on the Gower Peninsula when their

mother Olive paddled into the sea for an early evening swim. It was 19 August 1932, and a heatwave gripped southern Wales. How lovely to be on Llangennith beach when Cardiff had hit 33°C in the shade. The girls' father, Cyril Fox, planned to join his family as soon as he could; work commitments had held him up elsewhere. He was a distinguished archaeologist himself, a specialist in prehistoric Britain and director of the National Museum of Wales.[46]

A lifeboat recovered Olive's body later that night. The gifted artist, just forty-three years old, had been swept away in the undertow, the inquest found.[47] Her death notice in *The Times* appeared next to *in memoriam* messages to Rudolph Valentino, on the seventh anniversary of his own death. Within a year Cyril Fox, a man of fifty, was remarried to an archaeology student half his age. The new Mrs Fox had the family home in Cardiff redecorated and extended.[48] She moved Olive's paintings to the bedroom that Felicity and Tiny shared upstairs, when they were not away at boarding school or spending summers with their dead mother's parents in Steyning, West Sussex, where the girls had both been born. Olive was buried in the churchyard there, and part of me hopes her daughters took clutches of bright flowers to her grave. Fat roses or fresh daisies – either will do.

Tiny – Penelope – Fox turned up in Oxford after serving with the Women's Air Force Auxiliary in the Second World War; a brief wartime marriage had ended in divorce.[49] Oxford may have appealed because an aunt, Cyril Fox's sister, lived there, and Felicity had worked in the Oxford Repertory Theatre in Beaumont Street before the war. Penelope took a secretarial course and, perhaps through her father's professional contacts, in early 1948 she found an office job attached, in every sense, to the Ashmolean Museum at Oxford University.[50] She was to provide secretarial support to the Griffith Institute, whose *ex officio* director was the

Ashmolean's Keeper of Antiquities. Oxford after the war was changing, but slowly. Women had been able to earn degrees at the university since 1920, in women-only halls that received full collegiate status only in 1957. Numbers of female students were capped to keep it a man's world, and female academics could only teach in the women's colleges, a world that Dorothy L. Sayers depicted in her 1935 novel *Gaudy Night*, based on her former college (and mine), Somerville. But in the museums, libraries, and offices of the university, a small army of women kept this elite institution running from their typewriters, filing cabinets, and telephones. Penelope Fox joined their ranks.

The Griffith Institute occupied a brick-built annex that had been tacked on to the back of the Ashmolean Museum library in the 1930s. It had been set up by the will of its eponymous bene-factor, Oxford's first professor of Egyptology, Francis Llewellyn Griffith. The Archaeological Survey that took Howard Carter from Swaffham to Beni Hasan had in fact been Griffith's project, at the start of a distinguished career. On his death in 1934, Griffith left his personal library, archives, and considerable investments (he had inherited his first wife's wealth and had no children) to Oxford University, to establish an institute promoting the study of Egyptology. His widow Nora, an Aberdeen-born Egyptologist who had studied under and worked alongside her husband, added her own wealth to the donation when she died three years later.[51] Named in their honour, the Griffith Institute opened in January 1939 as a research centre with reading rooms, office space, and a sense of purpose. Like other imperial sciences, Egyptology had encyclopaedic dreams. Where the goal of empire was total control over a territory, the goal of science was total knowledge – and control of it. Hence the Griffith Institute planned to create an exhaustive scholarly resource: a bibliographic record of every hieroglyphic inscription in existence, organized by

geographic origin, with each published source about it indexed alongside.

Tutankhamun should not have had anything to do with this, but Egyptology is a small world and Oxford even smaller. Alan Gardiner, an Oxford graduate, would move in 1947 – around the time Penelope Fox arrived in Oxford – to a home a mile down the river in the village of Iffley. He maintained his impressive network of connections in the field, as did Percy Newberry, who had retired to Surrey in the 1930s after several years as a professor at the Egyptian University in Cairo. In 1939, after Howard Carter died, Phyllis Walker sought Newberry's advice about what to do with her uncle's records of the Tutankhamun excavation. Carter had left no instructions in his will and had never had an institutional affiliation. Where should this material go? Give it to the new Institute at Oxford, Newberry suggested. Gardiner agreed.

Walker signed a loan agreement with the Ashmolean Museum and the Griffith Institute that same year, and two steel filing cabinets of index cards, plus files of drawings, notes, typescripts, diaries, journals, memoirs, and correspondence, made their way to the offices in Oxford.[52] The intervening years of war meant that only in 1946 were arrangements made to bring the thousand or so glass negatives up to Oxford as well, under the auspices of the director (secretary) of the Griffith Institute and Keeper of Antiquities at the Ashmolean Museum, energetic Roman glass specialist Donald B. Harden. Harden gave special instructions to the moving firm in Oxford's Turl Street that had been tasked with collecting the glass negatives in London's East End and bringing them to the Ashmolean:

> You will, however, I know, take every precaution with these negatives as they are irreplaceable should they get damaged or lost. For your information, they are the original

photographs taken during the excavations in the tomb of Tut-ankh-amen in Egypt, and therefore a priceless record of the original condition of the objects found therein.[53]

Those objects were, for the most part, in Cairo (some things remained crated up in the Valley of the Kings for years to come), and what was left of the king's body was at rest in his tomb, so far as anyone knew. But on glass and paper tucked away in central Oxford was the beating heart of the Tutankhamun discovery, if anyone cared to listen to it.

At first, no one did. Not only had Tutankhamun fallen out of academic fashion, but austerity in post-war Britain meant there were no funds to pay for the kind of large-scale publication that Carter had claimed to have in mind. Alan Gardiner thought it would cost upwards of £30,000, and although he was a wealthy man, he had no intention of paying for it. In the early 1940s, Harden's predecessor at the Griffith Institute, Edward Thurlow Leeds, had worried about making money from the Tutankhamun archive, in particular the Harry Burton photographs. Who owned the copyright? Would the Egyptian authorities be offended if Oxford charged fees for commercial uses of the images? In fact, did the Egyptian authorities even know that the excavation archive was in England? News that the Egyptian Museum in Cairo had reopened, and allowed anyone to take any photographs they liked, soothed these worries. Everyone assumed that one photograph was as good as another, besides which, the photographs Harry Burton had taken in the 1920s, impressive as they were, had started to look a little out of date.

As the daughter and stepdaughter of archaeologists, Penelope Fox was a perfect match for the Griffith Institute under Donald Harden. Not long after she began the job, in March 1948, Harden asked her to deal with some correspondence from New

York, where a research assistant in the Department of Egyptian Art was trying to get to grips with the Tutankhamun archive in the Metropolitan Museum of Art. Scottish-born, North American-raised Nora Scott had studied Egyptology at Oxford in the 1920s before joining the staff of the Egyptian department at the Metropolitan Museum; she went on to become its first female head curator in 1970. To Scott had fallen the job of sorting out the material that had been shipped to New York from Castle Carter and Metropolitan House in 1948 – in particular, the photo albums and negatives from the Tutankhamun excavation.

Few of the Brits and Americans familiar with day-to-day work at the tomb in its heyday were still alive: Lucas had died in 1945, Newberry would pass away in 1949, and Gardiner, who lived until 1963, had only ever been a distant advisor and sometime guest. Penelope Fox and Nora Scott thus faced a transatlantic puzzle: who had which photographs, and why? The problem was compounded by a certain confusion over photographic technology and practices a generation earlier. Fox and Scott's respective bosses – Donald Harden and Ambrose Lansing – thought each institution had an identical set of negatives. They made a gentlemen's agreement to share the copyright and charge only for commercial use of the images. Educational books were fine, and requests did come through now and then, such as a 1943 reprint of Belgian Egyptologist Jean Capart's book on the tomb.[54]

In sorting through the negatives the Metropolitan Museum had received and comparing them to the prints Harry Burton had mounted into albums, Nora Scott noticed some discrepancies. There were prints in the albums that didn't match any of the negatives in New York, and negatives that didn't seem to match any prints. Entire series of negatives seemed to be missing, too. Where, for instance, were the negatives Burton made of the messy Annex, which Carter cleared in 1928? So began a

three-year-long correspondence between Fox and Scott, two women an ocean apart who forged both a working relationship and a friendship as they took care of the Tutankhamun archive that no one else seemed to take much interest in.[55] Their letters wove personal news – Thanksgiving dinners, Penelope's engagement – into the detail-driven task of working out how many negatives there were, how many there had been, and how to come up with a complete set for each institution.

Fox must have taken to the work with gusto, and as she sorted through the Burton negatives in Oxford, she and Donald Harden saw that they would make an attractive – and saleable – 'picture book'. They may well have been familiar with C. W. Ceram's *Gods, Graves and Scholars*, a popular history of archaeology that had been published in 1949 to rave reviews and sales success. Ceram was Berlin-born Kurt Wilhelm Marek, who had been a Nazi propagandist in the Second World War, and then a journalist. His bestselling book devoted two chapters to Carter, Carnarvon, and the tomb of Tutankhamun, with brisk prose and an absorbing narrative – but no pictures, and Carter's own books on the tomb had long been out of print. Perhaps the Griffith Institute could fill the gap.

Penelope Fox published *Tutankhamun's Treasures* in 1951, the first time such a title had been associated with the find. Although Fox, her colleagues, and reviewers downplayed the scholarly credentials of this 'delightful picture book', it was a much more up-to-date and visually rich account of the tomb than any male scholar had yet managed to produce.[56] It could not have been created without Fox's first-hand familiarity with the photographic archive: fewer than half the plates in her book (thirty, out of seventy-two) replicated photographs from Carter's own three books. This was a brand-new look at Tutankhamun.

In writing the book and coordinating the archive with Nora

Scott, Penelope Fox faced a particular challenge, because she had only the negatives or published photographs to hand. Apart from cut-down or folded prints that Carter had filed with the catalogue cards, the Griffith Institute did not have a set of albums like those that Burton had created at Metropolitan House, which were now in New York. Burton had made some albums for Howard Carter, too, but those were still in Phyllis Walker's hands. Walker might have considered them too personal to give away, or else she had not realized their connection to the excavation.

So it was, in 1951, that Nora Scott packed up the Metropolitan Museum's Tutankhamun albums (all twenty-four of them) and sent them back across the Atlantic Ocean on Cunard's S.S. *Queen Elizabeth*, insured for $1,500 – about the price of a new Ford car.[57] In Oxford, Fox spent that autumn and winter working through the New York albums, comparing their prints with the negatives the Griffith Institute had received from Phyllis Walker. It was frustrating to work from the negatives alone, she confessed to Scott, uncertain if minor differences between a negative and one or more prints were significant. The New York prints were Burton's own, and like any photographer printing his own negatives, he will have made darkroom adjustments to the highlights and shadows on each print to get exactly the effect he wanted. Another source of inevitable confusion was the multiplicity of shots he'd made, 'with often so many similar views of the same object', as Fox put it with some slight despair.[58]

She persevered. The loan of the albums from New York allowed Penelope Fox to compile the only more-or-less complete catalogue of the Tutankhamun photographic collection in existence – until I made my own in database form as best I could, given the time constraints of working with glass negatives on two continents. Each has to be slid carefully from a shelf, laid flat like a sleeping baby, and its archival-standard sleeve unfolded with care

before gloved hands can lift it gently towards the light. In the Metropolitan Museum today, Burton's negatives are in cold store under the eaves, just past the work of renowned American photographer Walker Evans. Even in the L. L. Bean down jackets the archivists provide, more than half an hour of research in the storeroom is arctic. My own work on the photographs made me admire even more what Fox had done, along with all the other women (as they have mostly been) who have looked after the Tutankhamun archive and Burton's photos ever since. The Fox catalogue runs to 65 typed and tabulated pages. For many years, staff in the Griffith Institute consulted it on a regular basis to help identify prints for academic researchers or members of the media. It is less used since the Institute put digitized versions of the photographs online, but the catalogue is still preserved in a green vinyl binder, its pages hole-punched, hand-annotated, and softened from use.

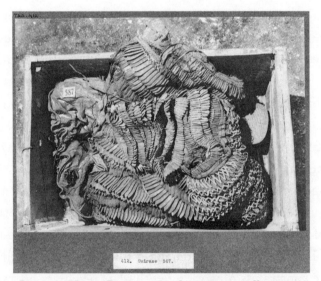

In 1933 Harry Burton sent this print to colleagues in New York, to replace a lost negative; it shows some of Tutankhamun's clothing in Box 587 from the Annex

Fox also came up with a cost-effective scheme to allow both Oxford and New York to have more or less identical sets of photographs. The old glass negatives were fragile and could not themselves be duplicated. But the negatives could be printed again, and where no negative existed, a new one could be made by re-photographing an existing print. Photographing photographs has become obsolete in the age of digital scanners, but for decades, making copies through re-photography was fundamental work in photographic studios. The Ashmolean Museum had its own studio (not all museums did back then), but cost still mattered, as did the sheer quantity of Tutankhamun photographs. Fox and subsequent archivists have estimated that there are between 1,500 and 2,000 Harry Burton photographs from the excavation, surviving either as prints or negatives or both; in reality, there are upwards of 3,400 unique images spread between the two collections. The cost of printing every negative or making a new negative from every orphaned print would have been prohibitive, so Fox worked out which negatives and prints each institution already had, and how to fill their respective gaps. Nora Scott agreed to Fox's plan, gratefully. It only needed to be put to the management committee of the Griffith Institute for a vote – a committee that included Alan Gardiner.

Penelope Fox presented her catalogue of the Tutankhamun photographs to the committee on 24 January 1952. They received it with warm compliments and approved the £75 needed to make new prints and negatives and thus round out the two collections. Two days later, Cairo went up in flames.[59] Protesters poured out their rage on British and other foreign- or Jewish-owned businesses in response to the British army's reprisal attack on an Egyptian police barracks in Ismailia, where there had been several skirmishes in the ever-contentious Canal Zone. It was a foretaste of the revolution that was to come.

In Oxford, Egyptologists sensed that change was on the way, but for Fox, the culmination of her work on the Tutankhamun photographs was a fine ending to her four years of work at the Griffith Institute. She was off to 'marry a doctor', as Nora Scott jokingly put it in one of their exchanges. Not a medical doctor, though. Penelope Fox married J. V. H. Eames, who was a lecturer and later professor in the School of Archaeology at Liverpool University – a specialist in the archaeology of Britain, not unlike her father. The Eameses started a family, including son Florian whom she thanked in the next book she wrote: *Furniture in England, France and the Netherlands from the Twelfth to the Fifteenth Century*, an award-winning 400-page monograph published by the Furniture History Society and still referenced by specialists today for its detailed study and rich illustrations.[60] The book grew out of the doctoral thesis that Fox (Eames, by then) wrote at Liverpool University. Her scholarly capacity had perhaps been underutilized, and had certainly gone unrecognized, in the male-dominated world of mid-twentieth-century academia. Instead, women of Penelope Fox's and Nora Scott's generation carved out their own paths towards professional fulfilment and career advancement with few, if any, female role models to follow. Coming of age in the 1990s, I studied with inspirational women professors at three American universities, but I was still aware of gender inequalities in the field. When I relocated to the UK to pursue a doctoral degree at Oxford University, the difference was stark: women in Egyptology held curatorial posts at university museums rather than more prestigious, and better paid, academic appointments (a situation that has, thankfully, changed since then).

As it happened, moving to Oxford meant that I followed in Penelope Fox's footsteps as far as the door of the old Griffith Institute in Pusey Lane, before that part of the Ashmolean Museum was demolished in 2000. I went most days to use its

library for my research, which dealt with identities and social change when Egypt became part of the Roman Empire. Identity was something I had thought a lot about, even before I moved to another country. Although my topic had nothing to do with Tutankhamun, it brought me closer to him, for across the hall from the library reading room was the office where the work that Fox had started decades earlier was taking its first steps into a digital age. Squirrelled away in cupboards and a storeroom were the excavation records, glass negatives, and a follow-up donation Phyllis Walker made in the late 1950s, consisting of her uncle's photo albums – labelled in Harry Burton's neat script – and a wooden cabinet of magic lantern slides used for public lectures. Walker also donated a full-length oil portrait of Howard Carter painted by his brother William, who had carried on their father's profession as an artist. It hung in the only space large enough to accommodate it – at the bottom of the stairs that gave on to the entrance vestibule. Men like Francis Griffith and Alan Gardiner were born to feel at home in an institution like Oxford University, while Howard Carter had had to die to earn his place upon the wall. That picture was the first thing I saw each time I entered the Griffith Institute as a student, ringing a bell for morning admission from the cobbled alleyway. Looking up at Carter, his face gazing beyond the gilded frame, I imagined each of us was a little surprised to be there. In different ways, we both owed our careers to Tutankhamun – and to Egypt's twentieth-century entanglements with empires old and new.

4

Rescue and Reward

BOATS SLIP ACROSS the Nile between the market town of Aswan, the west bank opposite, and the islands in between. Elephantine is the largest, covered end to end with archaeological ruins. Beyond is Kitchener's Island, awarded to the general in the 1890s for subduing the Sudan; he planted a botanical garden. Further south lies Sehel, with ancient prayers carved into the bluff that overlooks the cataract, where rocky terrain constrains the river. The cataract is 'first' only to people travelling against the current, from the north. Flowing from the south, the Aswan cataract is the last of the rocky barriers the river faces on its long journey to the sea. The ancient Egyptians considered it the source of creation in some myths. The roar of the water as it forced its way through the narrow cliffs and granite boulders was a deafening groan from the birth pains that brought the world into being.

I visited Aswan on my first trip to Egypt in the summer of 1995, staying in a budget hotel chosen from my backpacking guide. I planned which archaeological sites to see each day, counting time as carefully as I counted the scholarship dollars that funded my trip. Public ferries were a bargain and the best way to see the riverscape. Early one morning, I boarded one bound for the west bank, to the tombs at Qubbet el-Hawa, 'the dome of the winds' – where Lady Cecil, with Howard Carter's

help, had found the coffin of Bao-Bao that now lies in a display case in Kalamazoo.

A woman about my age (I was twenty-two) struck up conversation as we waited for the ferry to fill up. 'Which country?' she asked. We carried on from there. She was with two other young women, and she translated back and forth. 'We are Nubians,' she explained. 'Come to our house for tea. It's not far. You are welcome.'

From the landing stage, we followed a sandy path to a cluster of identical domed houses a kilometre or two away. We turned off, passed through an archway, and cut across a courtyard into a cool room with wooden divans around three walls and a television against the fourth, broadcasting a parade or procession. Welcome, said the women arranged around the benches. A little girl in pigtails came to sit beside me. She wore a slender gold bracelet on one wrist, and I wondered what would happen to its seamless circle as she grew. Glasses of mint tea appeared, the fresh leaves pounded with sugar into a hot sweetness as refreshing as the shady room. After half an hour or so in the quiet company, I rose to go. The young woman from the ferry brought out a shallow basket heavy with coins, which she trailed her fingers over, inviting me to look. Some were familiar: flat-sided heptagons with the Queen's head in relief, French *centimes*, a Kennedy half-dollar, and a well-worn 'Indian head' nickel from the 1920s, a miniaturized mythology of the indigenous people America had forced from their ancestral lands. I was meant to add an offering of my own. From the travel wallet tucked into my daypack, I came up with a scatter of coins, said goodbye, and retraced my steps. The tombs were waiting for me.

Had I known more history than hieroglyphs, I would have understood that my Nubian hosts had been forced from their ancestral lands as well. The hospitality I had been offered, in

exchange for a gratuity, has since become an organized form of tourism, supplanting the informal invitations that women once extended to random travellers like me.[1] These families were descendants of Nubians displaced when a British-built dam at Aswan had to be raised in the early 1930s. It presaged the larger-scale depopulation of the early 1960s, when an estimated 50,000 Nubians were forced to resettle in southern Egypt before the Aswan High Dam and its vast reservoir destroyed their homes. All I knew was that the Dam had threatened several ancient temples on my list of sites to visit. An international rescue effort had moved them to higher ground, and I could recite their names, dates, and architectural features by heart. The large and small temples of Abu Simbel, famed for the colossal figures of Ramses II 'the Great' carved into their façades, where the sandstone hillside hugged the Nile banks. Dendur and Kalabsha, from the reign of Roman emperor Augustus. And Philae, home to a temple of Isis, where the Egyptian gods were being worshipped long after Roman emperors had declared them dead. Each of these had been a tourist destination since the nineteenth century, recorded in countless watercolours and photographs that made the most of their riverine settings, impressive scale, and ruined grandeur. As with other sites that drew foreign visitors like me to Egypt, they seemed remote, except to the people who had lived alongside them for centuries.

Before it had generated any hydroelectric power, the High Dam jolted Tutankhamun back awake after his mid-century nap. To raise awareness of its grand project – and the plight of the monuments (but not the people) the Dam would flood – the Egyptian government sent a selection of objects from Tutankhamun's tomb on a three-year tour to the United States, then on to Canada and Japan. Tutankhamun turned out to be an excellent ambassador. Even better, he had the Midas touch. Nubia, the

source of Tutankhamun's gold, was now in need of riches, if the temples threatened by the High Dam were somehow to be saved. The United Nations Educational, Scientific, and Cultural Organization (UNESCO) adopted Abu Simbel as the flagship of an international rescue campaign launched in 1960. The funds would have to come from member states, including Egypt and Sudan, both newly independent nations. With costs rising as quickly as the Nile waters, the world needed wonderful once again.

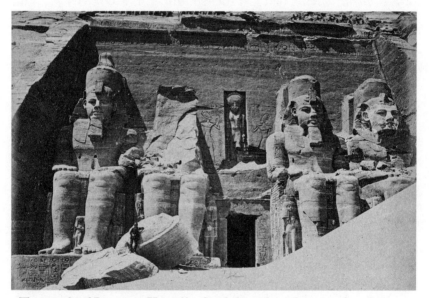

The temple of Ramesses II at Abu Simbel, with its famous colossal statues of the king; photograph by the studio of Pascal Sébah, 1870s

* * *

Formidable, French, and not quite five feet tall, Christiane Desroches Noblecourt was a woman who got things done. When she died in 2011, at the age of ninety-seven, French obituaries struggled for superlatives. President Sarkozy compared her to Jean-François Champollion and an Agatha Christie heroine, both of which had more to do with stereotypes than Noblecourt's

own incredible career. Laden with awards – the *Légion d'honneur* and *Médaille de la Résistance*, to name just two – Desroches Noblecourt herself was perhaps most proud of, and best known for, two professional accomplishments: her role in UNESCO's Campaign to Save the Monuments of Nubia, and her revival of Tutankhamun.

Born into a comfortable and cultivated family in Paris in 1913, Christiane Desroches first met Tutankhamun in the pages of *L'Illustration*. She had just turned nine in November 1922, and the French paper ran photographs by Harry Burton nearly every week as the discovery of the tomb progressed. 'For me, it was a fairy tale,' she told an interviewer in later life.[2] Ancient Egypt felt close to home for the young Parisienne. She often walked with her grandfather to the Place de la Concorde to admire the hieroglyphs on the ancient obelisk erected there. A diplomatic gift from Muhammed Ali to France, the obelisk is one of a pair inscribed for Ramses II which stood outside Luxor Temple; its twin is still there. Re-erected in Paris in 1836, this shaft of divine sunlight in stone form replaced the guillotine that had put an end to divine kingship a few decades before.

Desroches next met Tutankhamun during her course of studies at the École du Louvre, where she had enrolled with encouragement from her father's friend Henri Verne, director of the École and the Musée du Louvre. She took classes with the curator of the Egyptian department, Charles Boreux, and received instruction in ancient Egyptian language at the Institut Catholique, where the priest and scholar Étienne Drioton – *abbé* Drioton, she always called him – took her under his wing.[3] Two years into her studies, Drioton asked Desroches to fill in for him at a public lecture the École had organized. She panicked. She was only twenty years old, had never spoken in public before, and had just three days to prepare. Never mind, came the *abbé*'s

reassuring response: she had recently helped him prepare a talk on Tutankhamun. He would lend her his projection slides, and she could develop her own version for the event. Desroches *père* drilled his daughter in the run-up to the lecture, forcing her to speak from memory rather than rely on notes. She was sick with nerves, she remembered. 'But I did the talk, and I don't thi k I did too badly, thanks to his advice. And that's how Tutankhamun came into my life.'[4]

After graduating from the École, Desroches took a voluntary position at the Louvre, under Boreux, while completing her doctorate at the Sorbonne. In 1938, she was awarded a visiting fellowship at the Institut français d'archéologie orientale (IFAO) in Cairo, the first woman fellow since its founding in 1880. She sailed from Marseilles on the *Champollion*, named for the man whose decipherment of hieroglyphs had helped France imagine that it had mastered Egypt. At her parents' insistence, Desroches travelled first class and packed a *casque colonial*, or pith helmet, against the Egyptian heat. Her fellow first-class guests included Haile Selassie and his family, headed to Jerusalem, and the Aga Khan, whose son Sadruddin played with the Ethiopian princes around the captain's table.[5] Two decades later, Sadruddin and Desroches Noblecourt would meet again through the UNESCO Nubian campaign.

Desroches's old instructor Drioton met her at the railway station in Cairo, the black tassel of his tarboosh 'swaying to the rhythm of his head'.[6] When he became director of the Antiquities Service in 1936, the Church had given him permission to wear the red cap still required for government employees in Egypt, and to don civilian clothes rather than a priest's collar. He shared the director's residence with his mother, who held the Egyptian cooks to Burgundian standards while Drioton held mass each day in the sitting room, sharing it with mummified

bodies from the Egyptian Museum when required.[7] The warm
welcome from the Driotons set the tone for Desroches's stay in
Egypt, a country that she quickly came to love. She contributed
to several French-run excavations in the south, including Karnak
temple at Luxor and the village of Deir el-Medina, where the
artisans responsible for painting tombs like Tutankhamun's had
made their homes.

The end of her fellowship and the outbreak of war took
Desroches back to Paris, where she started work as a curator at
the Louvre. She also joined the French Resistance, with other
Louvre colleagues. The museum had removed some of the Egyp-
tian collection to safe storage in the countryside, which gave
Desroches useful cover for courier trips. She needed it when
the Gestapo removed her from a train en route to Vichy with a
message concealed in her luxurious peccary gloves – a gift from
her best friend in England.[8] Held for three days at Moulins,
Desroches was strip-searched, the heels of her shoes broken,
and her umbrella torn apart, but no one thought to look inside
her gloves. Under interrogation, she feigned ignorance of Ger-
man and stood by her credentials as a Louvre curator. In a room
smoke-thick from lit cigars, she chided her captors: 'Is this how
German officers receive a woman, with their boots propped
on the tables?' Let them take her address book and contact the
Egyptologists it listed in the Reich, who would testify that she
was what she claimed to be. It must have worked. After two more
days of waiting, she was free – 'this time', the warning went.
She continued to Vichy and turned over the message, whose
contents she never knew.[9]

That combination of sangfroid and efficiency served Chris-
tiane Desroches well throughout her life. During the war, she
married André Noblecourt, a schoolmate of her brother whom
she met again by chance while on Resistance business. An

engineer by training, André Noblecourt became a security advisor to the national museums of France, the International Council of Museums (ICOM), and not least UNESCO, for whom he .co-authored a book on the protection of cultural heritage during armed conflict – a subject of grave concern in Europe thanks to wartime destruction wrought by bomb damage and looting.[10] After the war, family life (the Noblecourts had one son), work at the Louvre, and regular research trips to Egypt kept Desroches Noblecourt, as she now styled herself, quite busy – and an accident of communication was about to make her busier still.

In Egypt, prehistorian Mustafa Amer had replaced Drioton as head of the Antiquities Service after the tumultuous events of 1952, when the *abbé* and other foreigners in government posts had to step down. The Cairo Fire that January presaged a revolution that had been years in the making, with roots in earlier anti-imperial movements as well as the 1948 war over the creation of Israel. On the night of 22–23 July 1952, a group of Egyptian military officers known as the Free Officers moved against King Farouk, forcing him first to abdicate in favour of his infant son (Fuad II, who 'ruled' for a few months) and then to seek exile in Italy. A Revolutionary Command Council took over the governance of Egypt for a planned three-year transition period, during which it annulled the country's 1923 constitution and declared Egypt a republic. General Gamal Abdel Nasser manoeuvred himself into lead position on the Council, promulgated a new constitution in January 1956 and became the country's second (and first elected) president that same year.

Against this backdrop of upheaval mixed with optimism, Amer wanted to update the Antiquities Service with the most modern methods of research and recording then available – methods he assumed would need to be brought in from Europe. After all,

European and American institutions had long held themselves up as the authorities where archaeology and ancient Egypt were concerned. Amer drew up plans for an organization known by the acronym CEDAE: *Centre des études et de documentation d'archéol-ogie égyptienne*, a documentation centre dedicated to Egyptian archaeology.[11] The idea of such a centre had been floated by Belgian artist Alexandre Stoppelaere in the post-war years when he worked for the Antiquities Service among the tombs of Luxor. It echoed plans for recording and amassing data that had always pulsed through Egyptology, from the Archaeological Survey that Howard Carter worked on, to the Topographical Bibliography that became (and remains) the focus of the Griffith Institute in Oxford. Now, however, the idea of documenting and archiving ancient sites needed to be adapted to post-revolutionary Egypt, as free as possible from colonial control.[12] That was the idea, at least.

Through Stoppelaere and his contacts in France, the idea of a documentation centre in Egypt came to the attention of a young Paris-based organization. UNESCO had been founded in 1948, in the post-war spirit of international collaboration and cultural preservation. In its early years, archaeology and archaeologists helped shape ideas about what this offshoot of the United Nations could and should be doing.[13] In the wake of the 1952 revolution in Egypt, a centre like the one Stoppelaere had proposed seemed a worthy focus for UNESCO, and the Egyptian Ministry of Education, to which the department of antiquities was then attached, encouraged Mustafa Amer to turn the plan into reality. As Amer conceived it, the aim of the CEDAE would be to develop cutting-edge systems for recording archaeological sites, which would help lift Egyptology out of its post-war lull and make the new Egyptian republic a leader, not a follower, in the field.

In her memoirs, Christiane Desroches Noblecourt wrote that she and Amer had come up with the idea for the CEDAE together. In fact, her involvement with the CEDAE – and hence UNESCO's later Nubian campaign – was something of an accident, if indeed she ever realized how it came about.[14] In 1954, an official from Egypt's Ministry of Education sent a telegram to UNESCO in Paris, with three names that Amer had proposed as foreign consultants for the new centre, each an 'archive specialist': Noblecourt from the Louvre, George Hughes from the University of Chicago's survey base at Luxor, and Rosalind Moss, a former student of Francis Griffith who was a linchpin of the Griffith Institute's recording work. A follow-up, by letter, named Noblecourt, Moss, and Italian Egyptologist Sergio Donadoni, who was then based in Florence. Faced with these two overlapping lists in its Paris offices, UNESCO chose home-grown talent for simplicity.

So it was that Christiane Desroches Noblecourt returned to Cairo in November 1954 as UNESCO's advisor to the CEDAE, which had Egyptian archaeologist Alexander Badawy at the helm. Mustafa Amer later protested that he had never, in fact, recommended her, but the two worked well together, at least as Noblecourt recalled their relationship. She had just turned forty, and most of the Egyptian recruits the centre hired were just out of university. To a greater extent than other European or American Egyptologists might have done, Noblecourt consistently supported the idea that the CEDAE should be run for and by Egyptians – even if the archival principles that she proposed (like Stoppelaere before her) were mired in colonial-era schemes of value, working practices, and patterns of thought. The CEDAE first set out to record some 400 'Tombs of the Nobles' at Luxor, not far from the Valley of the Kings; this yielded a gentle reminder from Rosalind Moss in Oxford that the Griffith

Institute was already undertaking similar work in its own archival way. The overlap was soon beside the point, for in early 1955, Noblecourt reported to UNESCO in Paris that there was a more urgent problem for the CEDAE to tackle – if the international politics surrounding the Aswan High Dam would allow.

<p style="text-align:center">* * *</p>

The Nile was never the same river. Annual floods saw to that. Snowmelt from the Ethiopian mountains filled the Blue Nile each spring as it rushed to join the White Nile at Khartoum. By late summer the brimming river, unified, was coursing north to the Mediterranean Sea. In Egypt, along the Nile valley, farmers dug basins to divert water for irrigation later in the year, and as the river shrank back to size, they grew food and flax in the silt it left behind. The Nile gave Egypt life, as every schoolchild learns. In the 1950s, Gamal Abdel Nasser thought it could go one better and give Egypt electric power.

The British had constructed a barrage dam at Aswan in 1902, just south of Sehel Island. Designed to hold back enough water for year-round irrigation, it had to be raised in 1911–12 and again in 1933–34, trying to outpace the Nile's high floods and meet the demands of intensifying agriculture.[15] What Nasser had in mind was the largest hydroelectric dam yet built, known as the *Sudd el-Ali*: the High Dam. Located four miles south of the earlier Aswan barrage, the High Dam was set to fuel the new Egyptian republic, a modern nation that would stride the international stage in its own right, not in Britain's shadow.

The High Dam won the approval of the Free Officers' Revolutionary Command Council within months of their coup in July 1952. Proposed by an Egyptian engineer already in the 1940s, it promised to expand arable land in Egypt by 20 per cent and increase the output of kilowatt-hours by a factor of ten.[16] That

was just about enough to sustain Egypt's population growth, in optimistic assessments, though by the time the High Dam was finished in 1970, it barely kept pace with demand.

As head of the Antiquities Service, Mustafa Amer was privy to the plans – and concerned about the impact on archaeological sites and ancient monuments in the affected region, a vast swathe of riverscape and land that had been continuously inhabited for thousands of years but only sporadically excavated, studied, or surveyed from an archaeologist's point of view. Amer formed a task force of Egyptologists and engineers to visit Aswan and the proposed High Dam site in December 1954, just after Noblecourt had arrived to work for the CEDAE. They quickly grasped the scale of the problem: more than a dozen famous ancient temples, from the island of Philae to the rock-cut colossi at Abu Simbel, would be submerged beneath the vast reservoir created behind the *Sudd el-Ali*. Also destined to disappear were pharaonic-era cemeteries and military forts, not to mention the ruined medieval town of Faras with its brightly frescoed cathedral.

Known as Nubia, from the ancient Egyptian word *noub*, for 'gold', the region stretched across the national border with Sudan, where modern villages and ancient sites faced flooding, too. The Nubian people comprise different language groups (Kenuzi and Fadija were the two main languages in Egyptian Nubia), but Nubians were not recognized by the Egyptian government as distinct from any other Egyptian people. In their homelands, they made much of their living from dates, grown in date palm groves that were the core of Nubian economic organization, family relationships, and culture.[17] It was – and is – a matriarchal society, and women knew the long, intertwined histories of the palm groves' ownership and management; it was women who kept – and keep – Nubian family archives and community memories alive. Meanwhile, for decades, Nubian men had moved to

Egyptian cities, or south to Khartoum, to find work as cooks, hotel staff, and household servants. The red-sashed waiters who served lunch to Lord Carnarvon and Howard Carter at the tomb of Tutankhamun were Nubian *suffragis*, supplied by the Winter Palace Hotel.

Faced with the endangered sites and temples of Egyptian Nubia, the CEDAE changed tack. Its new project would be to document the two dozen structures that were under threat, which ranged in date from the reign of Tutankhamun's 18th Dynasty ancestor, Thutmose III, to the Roman era. Badawy and the CEDAE team, with Noblecourt, worked steadily through the winter of 1955–56 before plans for the High Dam precipitated a fresh crisis. President Nasser claimed to have no intention of favouring either the USSR or the United States; however, his accepting financial support and engineering advice from the Soviet bloc put paid to promised American funding for the High Dam. On 26 July 1956, four years after the Free Officers' coup, Nasser announced the nationalization of the Suez Canal. Britain had agreed to the phased withdrawal of its troops that summer, but the end of the French and British-controlled ninety-nine-year lease on the Canal was years away – and Egypt needed the Canal income, now.

In late October 1956, Britain, France, and Israel coordinated a retaliatory invasion, with Israeli troops crossing the Sinai Peninsula and the French and British air forces strafing the Canal Zone before invading Port Said in early November. Condemnation by the United States and the United Nations forced the tripartite powers to withdraw. The crisis led Egypt to break off diplomatic relations with France and Britain (it had none with Israel), and it impelled many of Egypt's already diminished Jewish population to flee. Their assets and those of British and French citizens were seized, and the citizenship of Jewish Egyptians revoked.[18]

The Egyptian government wrote to UNESCO to underscore its anti-European and anti-Israel stance: Egypt would no longer welcome academics, advisors, and experts from the complicit countries, 'with the exception of Madame Desroches Noblecourt, if she wished'.[19] She did.

Work on the High Dam pressed forward. The statistics for the new dam were staggering. It would be 3.6 kilometres long, and almost a kilometre wide at its base below the Nile, giving it a volume seventeen times that of Egypt's other great monument – the pyramid of Khufu at Giza. To build it, an estimated 30,000 men toiled for ten years, completing the dam in July 1970. Conditions in the great pit dug for the foundations were 'like an opening to hell'.[20] The reservoir to take the backed-up Nile waters was just as gargantuan in scale, running to 16 kilometres wide and stretching almost 500 kilometres up the Nile to Wadi Halfa in Sudan, 10 kilometres from the Nile's second cataract. It was this lake – now named Lake Nasser in Egypt, Lake Nubia in Sudan – that threatened archaeological sites, including many that had never been explored, as well as the ancient temples. Moreover, it would displace some 50,000 people from Egyptian Nubia and the same again from Sudanese Nubia, uprooting them from their ancestral villages, date palm groves, and entire way of life. The impact of the forced migrations, carried out between 1963 and 1964, reverberates among the relocated communities and their descendants in Egypt, Sudan, and the Nubian diaspora today. In Egypt, Nubians have spent decades seeking financial compensation from the government and a right to return to their lost lands. The erasure of history's layers does not mean that anyone has forgotten them.

But as work on the High Dam got under way, Egyptologists and archaeologists worried about the sites and temples, not the Nubian people. They did not see the human population as their

remit, nor did UNESCO, whose idea of heritage had European experiences of the Second World War at its root. Buildings and monuments mattered more than living cultures, as a glance at the World Heritage list will show. The plight of the Nubian monuments was what captured the attention of UNESCO in the end. Here was a chance to avoid destruction of the scale, if not the kind, seen at the cathedrals of Cologne and Coventry, and in hundreds of towns from Italy to Warsaw. No houses of any god should be in ruins.

The Egyptian government worried about how to pay for it all. Money for the High Dam was the priority. Money to save some temples? Less so. Proposals to slice off part of the famous façade of Abu Simbel and move it to safety, or to create a second dam that would seal off the temple island of Philae, had already been rejected. Too expensive; too much time and effort. At the CEDAE, Badawy and Noblecourt had begun to think that none of the proposals went far enough, but all the centre could do was carry on with its UNESCO remit to document the temples in drawings, measurements, and photographs before the Nile covered them for good.

* * *

Only when you drink from the river of silence shall you indeed sing. Kahlil Gibran's *The Prophet* has sold millions of copies since it was published in 1923, behind only Shakespeare and Lao-Tzu in the otherwise slim stakes of printed poetry.[21] Over the course of his life, Gibran moved between Lebanon and Boston, Paris and New York, an artist first and author later, in both Arabic and English. He fits in everywhere and nowhere, a mystic who drank too much and a Symbolist who arrived too late. English-language critics ignored him. The sixties counterculture adored him. But in the 1920s, Gibran was published in Beirut and Cairo

to some acclaim, earning a reputation in Arabic literature as a rebel and reformer, in keeping with the anti-colonial politics he had embraced in Lebanon before the First World War.

Tharwat Okasha was a man of many and varied talents, who wrote a doctorate on Gibran at the Sorbonne and translated the poet's English-language works *The Prophet* and *Issa* into Arabic in the 1960s and early 1970s.[22] Okasha was also one of Gamal Abdel Nasser's colleagues in the Free Officers movement. Nasser's wife Tahia recalled that it was Okasha who arrived at her door the anxious morning after the July revolution, to let her know that her husband was safe.[23] She and Nasser used to go to the cinema with Okasha and his wife Islah, before evenings out were curtailed by looking after children and planning a coup.

Okasha started life higher up the social ladder than Nasser, but in the face of the British occupation, that didn't matter. Born into a family of *pashas*, Okasha grew up cocooned in privilege and, like other Egyptians of his class, spoke fluent French and English alongside Arabic. Serious, cultured, with a passion for European classical music and ballet, he was the ideal person for the Free Officers to send to Paris in the mid-1950s, as military attaché to the Egyptian embassy. That was when Okasha first met Christiane Desroches Noblecourt.

Okasha went on to serve as Egypt's ambassador to Italy, until in 1958 Nasser called him back to Egypt to head a new ministry of culture and national guidance. The combination matched Okasha's aspirations for his new role and his country, which had adopted the moniker the United Arab Republic to mark its political union with Syria that same year (the union lasted until 1961, the name until 1971). The new ministry would, Okasha hoped, unite Egyptians and raise their cultural ambitions, while at the same time using the best of Egyptian art, literature, music, and dance to represent Egypt to the world.

One of the first problems to cross his ministerial desk was the threat to the Nubian temples. Okasha visited the region with Alexander Badawy to see for himself what was at stake. In his memoir of the subsequent rescue operation, Okasha recalled the impact of his visit. 'I was seized with anguish at the scale of the catastrophe and of my responsibility,' he wrote. 'Created just a few months ago, wasn't the young ministry that I led a symbol of the vitality of the Government and its interest in culture? To allow such a heritage to be destroyed would be a disgrace both to this ministry and to the Revolution. And what then would be the judgment of history and future centuries?'[24]

Christiane Noblecourt urged Okasha to call on UNESCO for advice. Together they approached its Assistant Director-General, René Maheu, during his layover for a few hours in Cairo in January 1959. Maheu promised to make the case to the Director-General of UNESCO, anti-fascist lawyer and Catholic activist Vittorino Veronese. In the meantime, Okasha and Noblecourt got to work on the formal request to UNESCO, so that Okasha could present it to President Nasser and persuade him to sign and submit it.

Okasha's office was in the Abdeen Palace, the former royal residence positioned between Old Cairo and the late nineteenth-century neighbourhoods along the Nile. Keen to keep the matter quiet until he knew Nasser was committed, Okasha asked Noblecourt to help him compose the letter. From her experience at the CEDAE, Noblecourt knew that Egyptian men refused to type, so she agreed to play the part of Okasha's secretary – assuming they could find a typewriter in the elegant salons that were the Ministry headquarters. Okasha had a portable Olivetti, brought back from his ambassadorship to Italy. He retrieved it from a closet, set it up on the grandiose desk once used by King Farouk, and left Noblecourt to polish and type up the letter they had

drafted to UNESCO. It set out Egypt's plea for help and, crucially, pledged that in return Egypt would commit a percentage of the budget, provide boats and labour for archaeological excavations, and permit a 50 per cent share of archaeological finds. It also set out the possibility that smaller temples, dismantled for removal, could be donated to countries that provided substantial financial support.

Okasha retired to the salon next door, and as Noblecourt typed away, she heard *The Four Seasons* by Vivaldi tinkling from a piano. Okasha's fingers had been put to other work, and it was then up to him to secure Nasser's support. The president signed the letter in April 1959, sent it off to Paris, and that July, UNESCO issued an international appeal for help on Egypt's behalf.[25] The twenty-year campaign to save the Nubian temples was under way.

* * *

Tutankhamun re-enters this story by way of bombed-out Berlin and the leafy streets of Philadelphia, America's city of brotherly love. The cities are connected by the German Egyptologist Rudolf Anthes, who had been dismissed as acting director of the Egyptian Museum in Berlin in 1939 for his anti-Nazi sentiments. He did war service as a customs officer and spent several months as a prisoner of war behind Red Army lines, before being restored to the museum directorship in September 1945. After the occupying forces allowed Anthes and other curators back on to the Museumsinsel, he detailed in clinical prose the devastation of the storage areas where those antiquities not sent to bunkers in the city or outside Berlin (such as the bust of Nefertiti, sent with other artworks to the Merkers salt mine 400 kilometres away) had been crated up behind sealed doorways in the basements of the Neues and Pergamon museums. The seals were broken, the

crates open or missing, and any number of objects had disap-
peared or sustained severe damage.[26] It fell to Anthes to repair
the wartime damage to the collection and the building as best he
could – the Neues Museum was a shell propped up by scaffolding
when I first saw it in the 1990s – but he soon found himself on
the wrong side of politics again when the German Democratic
Republic was created in 1949.

An invitation to join the University of Pennsylvania as pro-
fessor of Egyptology offered Anthes a fresh start in his fifties.
His role included being curator of the Egyptian Section in the
University's Museum of Archaeology and Anthropology. The
director of the museum, Montana-raised Froelich Rainey, had
ambitions for his institution and connections in high places,
thanks in part to his service in the US State Department during
the Second World War. When the UNESCO appeal went out,
he saw a chance to get the museum a more promising archaeo-
logical site for Anthes to dig. Their old concession at Memphis,
meant to reveal an ancient palace, had met for the most part
with mud.[27]

The election of John F. Kennedy in November 1960 created a
moment of cultural openness and international warmth in Amer-
ica, even as the Cold War nipped. Less than four months into his
term, Kennedy stated his unwavering support for the UNESCO
campaign, and by association, for Egypt and President Nasser.[28]
The US Congress pledged $12 million towards the relocation of
the Abu Simbel temples, which had been set as the first priority.
In addition, America would offer expertise, such as the archaeo-
logical work that Pennsylvania and other universities were eager
to do.

While on a scouting trip to Nubia for sites, Rainey had the
idea that a loan of Tutankhamun artefacts to the United States
could help foster public interest in the Nubian campaign – and

make its public funding more palatable to Americans. Rainey had some influence as president of the American Association of Museums, and together with the US ambassador to Egypt, John Badeau, he made the case to Tharwat Okasha. The Egyptian government had already sent an exhibition of antiquities to Europe ('5,000 Years of Egyptian Art', which was in London in 1962), and Okasha had encouraged exchanges of singers, dancers, and musicians between Paris and Cairo.[29] Why not bring together a couple of dozen artefacts from the thousands in Tutankhamun's tomb and use them in a similar way?

Like most things involving Tutankhamun, it was easier said than done. America lacked a ministry of culture with which to negotiate, but the Smithsonian Institution came on board as a national-level organization that could receive the loan (as Egyptian law required) and organize a tour to eighteen cities around the United States over three years. Insurance was another sticking point, since the premium was far too high for the Smithsonian or any other museum to afford. The Rockefeller Brothers charitable foundation stepped in to pay, in cash, the insurance costs for the final list of objects: thirty-one small pieces from the tomb of Tutankhamun, plus an additional three from the splendid burial of King Sheshonq, discovered at Tanis on the eve of the Second World War.

So it was that in November 1961, elegant as ever in dark dress, high heels, and pearls, Jacqueline Kennedy arrived alone at the National Gallery of Art in Washington DC to open an unprecedented exhibition.[30] At the gallery, representatives from Egypt – including Tharwat Okasha and his wife Islah, and Professor Ahmed Fakhry from Cairo University – were waiting to show the First Lady the selection of objects from Tutankhamun's tomb, set in simple, standalone vitrines around the museum's rotunda: a pair of linen gloves; an alabaster jewellery box; and

that miniature gold coffin that would later dazzle me, its sur-
face sparkling with sliver-thin inlays of coloured glass and stone.
Mrs Kennedy smiled, chatted, and posed for the ever-present
cameras, which were more interested in her than in the pharaoh
whose tomb goods had travelled so far for the occasion.

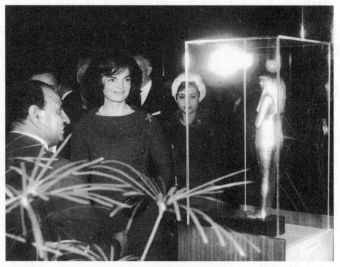

Ahmed Fakhry, Jacqueline Kennedy, and Islah Okasha
admire a gilded statuette from the tomb, at the opening
of 'Tutankhamun Treasures' in Washington, DC,
3 November 1961

Called 'Tutankhamun Treasures', the exhibition was as
restrained as the line of Jacqueline Kennedy's dress. Nonetheless
it was a significant gesture from the Egyptian government. No
artefacts from Tutankhamun's tomb had left the country before
(not legally, at least), but nearly forty years on, here they were
in America, graced by the First Lady. Dr and Mrs Okasha also
presented a gift from Egypt to the Kennedys: a limestone statue
dating to the Old Kingdom. An American television crew filmed

their exchange, and an Arabic-language station spoke to Oka-
sha about the cultural offerings that Egypt was set to share with
the United States. Both Tutankhamun and a troupe of Egyp-
tian dancers were headed for the World's Fair in New York,
in 1964.

First, 'Tutankhamun Treasures' criss-crossed the United States,
and Rainey's initial fears that the public had forgotten about
Tutankhamun proved to be unfounded. At each of the month-
long exhibition runs, people came out in record numbers. Sales of
a simple catalogue, with an introduction by Rudolf Anthes, were
brisk as well.[31] The second stop of the tour, after Washington, was
the University of Pennsylvania Museum, which had decided not
to charge an admission fee. The line for admission ran to 'sev-
eral city blocks', leaving Rainey to admit that he 'had never been
more wrong'.[32] Nor did the tour grace only the east and west
coasts: it took in Omaha, Houston, St Louis, Detroit, and no less
than three cities in Ohio: Cleveland, Dayton, and Toledo (my
mother's home town, though she was too busy with her first baby
to worry about either Tutankhamun or Jacqueline Kennedy).
The final venue was New York, where 'Treasures' was shown at
the Carnegie International Centre, near the United Nations,
before moving to a display in the futuristic United Arab Republic
Pavilion at the 1964 World's Fair.[33] From there, the show went
on to four cities in Canada in 1965 and three in Japan, running
into 1966.

Tutankhamun was winning hearts and minds for the
UNESCO campaign. Press releases and media coverage in each
city stressed the link between the rescue of the Nubian tem-
ples and the unique opportunity to see objects from the tomb
of Tutankhamun outside of Egypt for the first – and possibly
only – time. For part of the run, Ahmed Fakhry took a sabbat-
ical in America and delivered public talks on 'Abu Simbel: The

Pearl of Nile', complemented at several venues by photographic enlargements that showed the great colossi of Ramses II in all their glory, and the Philae temples rising on their island in the Nile. Who could stand by and let these ancient monuments disappear?

No opening could match the glamour that Mrs Kennedy had brought to the National Gallery of Art, but each event did offer an opportunity to grease the wheels of politics and wield some soft power. The treasures spent the summer of 1962 at the Chicago Natural History (now the Field) Museum, where the opening reception guest list included the city's Egyptian (or as it was at the time, United Arab Republic) consul Issa Serag el Din; the Egyptian ambassador to the United Nations, Dr Mahmoud Riad; the governor of Illinois, Otto Kerner; and Chicago mayor Richard Daley, plus a medley of museum patrons, socialites, and academics from the University of Chicago's Oriental Institute.[34] Curators from the Egyptian Museum in Cairo accompanied the objects to every venue as well.

Even after the $4,575 rental fee charged by the Smithsonian Institution's Travelling Exhibition Service, the museums that hosted 'Tutankhamun Treasures' found that it was a nice little earner. The Chicago Natural History Museum hosted 28,000 visitors on peak weekends, including the 4 July holiday, with more than 123,700 people coming just for Tutankhamun over the one-month run. In 1962 the museum had an 11 per cent boost in visitors over the previous year, which it attributed to the publicity 'Treasures' generated: its public relations team had placed stories in city and regional newspapers, advertised on trains and buses, and sent posters and brochures to schools and universities. The opening night featured on Chicago television news, and one lucky 12-year-old, John Witte, received a lifetime membership during his own 'Treasures' trip, thanks to being the museum's

50 millionth visitor. At a 50-cent admission charge (they did not repeat Rainey's mistake), total ticket proceeds were $41,090.75, plus $12,753 for the illustrated catalogue, which sold for a dollar. After expenses (the rental fee, extra security and ticket attendants, a substantial PR budget, transportation for curator Mohammed Hassan Abdul-Rahman, and a speaker's fee for Fakhry, plus the cost of shipping the objects on to their next venue in Seattle), there was still a healthy $11,179.47 left in profit from the show – not bad in a year when income from all paid admissions was just over $54,346. Profit on the catalogue sales stood at $1,867.70, with unsold copies also sent on to the next host.[35] Since the exhibition had been designed to raise awareness of the Nubian campaign, not fund it, this was profit that went straight into each museum's own coffers. Many of the museums – and Tharwat Okasha's Ministry in Egypt – took notice. Tutankhamun was back in business.

* * *

Enterprising British publisher George Rainbird had a good eye for a profit margin. His firm commissioned and designed illustrated books, which it then partnered with other publishers to market. This reduced Rainbird's financial risk and let him indulge his passion for book design. He had been working for some time with Frederick Leslie Kenett, who was making a name for himself in London in the 1950s for his expressive colour images of fine art and sculpture (and who later in life changed from photographing sculpture to making it).[36] Born Manfred Cohn, apparently in Berlin, Kenett came to Britain as a teenager in the late 1930s, perhaps through the charitable efforts known as the Kindertransport, which helped Jewish children flee Nazi Europe. Hard facts about his life are hard to come by, but in 1956, under his new name, Kenett became a naturalized British subject;

Home Office records identified him as a photographer 'of no nationality' living in Onslow Square, South Kensington.[37]

Rainbird and Kenett planned a book on the art of the Amarna period, which brought them to the Musée du Louvre – and to Christiane Desroches Noblecourt, who had become the Egyptian department's chief curator. She and Rainbird discovered a common interest in Tutankhamun.[38] Rainbird had been trying for some time to get permission for Kennet to photograph the tomb objects in the Egyptian Museum in Cairo, but they had not found it an easy process. With the Nubian campaign under way and the tour to the United States taking shape, Noblecourt made a case to Tharwat Okasha on their behalf. She herself thought it right that a British publisher should be able to photograph a British discovery, updating Harry Burton's black-and-white photographs for a Technicolor age. Okasha gave the go-ahead, and the Egyptian Museum curators had to accommodate Kenett's requirements – not always happily, as Noblecourt tells the story. The museum curators were expected to focus on the security of the objects and keeping the exhibitions open to the public, neither of which was helped by the need to open sealed cases and extract objects for time-consuming photography during daylight hours. No electric light was available.

Whatever the frustrations on all sides, Kenett produced the kinds of photographs that Rainbird's readers wanted: saturated reds and blues, gleaming gold and ivory, and a tangible sense of luxurious surface details, thanks to close-ups and angles that were not part of Burton's repertoire forty years earlier. Rainbird rushed to have plates printed in Italy, which had the best colour printing presses then available. All he needed now was an author.

Noblecourt agreed to write a book on Tutankhamun with considerable reluctance, given the heavy demands already placed on her time by her work at the Louvre and for the Nubian

campaign. Tutankhamun and his tomb had been a dormant topic of research for a generation, with the exception of Russian *émigré* scholar Alexandre Piankoff's two-volume study of the burial shrines, published in 1954 – and edited in English by Natacha Rambova (*née* Winifred Shaughnessy), widow of Rudolph Valentino.[39] Impressive as Piankoff's work was, with translations of the complex religious texts on all four shrines, it was too weighty in every sense for the general reader.

Noblecourt set out to write a study that was both more all-encompassing and accessible. Entitled *Tutankhamen: Life and Death of a Pharaoh*, the book was ready for publication in 1963. Alongside Noblecourt's detailed but readable text were thirty-two colour plates by Kennet and more than 130 black-and-white photographs and illustrations.[40] Noblecourt had spent time in Oxford to consult the Howard Carter archives and Harry Burton photographs at the Griffith Institute, which Penelope Fox had done so much to put in order. She had also been able to speak to Alan Gardiner, near the end of his life, and the 6th Earl of Carnarvon, who shared his recollections of his father.

The timing of the book's appearance could not have been better, with the 'Tutankhamun Treasures' tour in the United States still under way. Moreover, Rainbird published the book simultaneously in English, French, Swedish, Norwegian, Danish, Dutch, German, Spanish, and Italian. It sold more than a million copies over the next decade – astonishing numbers for a book on ancient Egypt.

It also received excellent reviews, apart from an anonymous notice in the *Sunday Times* in London, which nit-picked the spelling of ancient names and the then-novel suggestion that Tutankhamun was not a younger brother or half-brother of Akhenaten. Noblecourt suspected that the *Sunday Times'* reviewer was her counterpart at the British Museum, I. E. S. (Eiddon)

Edwards, whom she had known since they were starting out in their careers in the 1930s. He had brought her fresh flowers every day when she was laid up with diphtheria in hospital in Cairo, and he and his wife had hosted her for supper at their home not long before, when she recorded an interview at the BBC about the UNESCO campaign, to which Britain had at that point not contributed very much. Noblecourt wrote to Edwards in feigned innocence. Could he possibly identify the author of the negative review? It obviously was not a gentleman – since a gentleman would have signed it.[41]

In the 1960s, Tutankhamun reclaimed some of the spotlight he had enjoyed four decades earlier. This time, however, he had to share it with a rather different king: Ramses II, the 19th Dynasty pharaoh whose bland countenance had been carved into the rock face at Abu Simbel on a colossal scale. Four seated figures of him stand 21 metres high. Where Tutankhamun had married once, had no living children, and died young, almost forgotten, Ramses lived into his eighties and married as many times as he could; by one estimate he fathered at least a hundred children. The two temples at Abu Simbel – a larger one honouring him, a smaller one for his wife Nefertari – had been known to European travellers since 1813, when the Cambridge-educated Swiss traveller, Jacob Burckhardt, saw the upper part of the larger temple's façade; four years later, the Italian engineer and adventurer Giovanni Belzoni had enough sand cleared away that he could enter its rock-carved sanctuary.[42] Burckhardt reported that the half-buried temples were a place of refuge for local people whenever they and their cattle came under Bedouin attack. The site was always off the beaten track, a few days' journey by boat beyond Aswan. But that only encouraged certain travellers, artists, and photographers to seek it out. Some Egyptologists considered the stocky proportions of the colossi rather coarse, and the battle

scenes inside second-rate. But there was no denying the sublime beauty of its natural setting, facing south to welcome the Nile and ward off would-be invaders.

The proposals UNESCO received for saving Abu Simbel were ambitious, and impossible to execute. One suggested a second dam to protect them; another proposed lifting them intact on hydraulic jacks to higher ground; and a third, from a British consortium, would let the temples be submerged so that tourists could view them from a moving glass bubble underwater.[43] In 1962, Egypt presented an alternative, devised by Swedish engineering firm VBB: cut the temples into blocks, raise them to higher ground, and rebuild them against an artificial reconstructed hill, while maintaining the precise orientation that allowed the sun to reach into the inner sanctuary of the larger temple twice a year, in February and October. It was somewhere between butchery and folly – but it was the only solution that could be achieved in budget and on time. The United States gave its approval to the scheme, converting its promised $12 million contribution from the value of grain shipments it had already sent to Egypt as aid. Egypt promised the same amount again, and Kuwait volunteered enough hard currency to please the bankers.

Abu Simbel was to become a simulacrum of itself, a cyborg of strengthened stone and two concrete domes that served as man-made cliffs. No one spoke of it that way at the time, nor do they now. Abu Simbel is supposed to be as authentic, as real, as ancient, as it ever was.[44] But the processes carried out in cutting, moving, and re-erecting the temples inevitably transformed them – and like the discovery of Tutankhamun's tomb, the process of their transformation became as much a part of their appeal as the monuments and their history. Dramatic films and photographs captured every stage of the Abu Simbel work as the camera

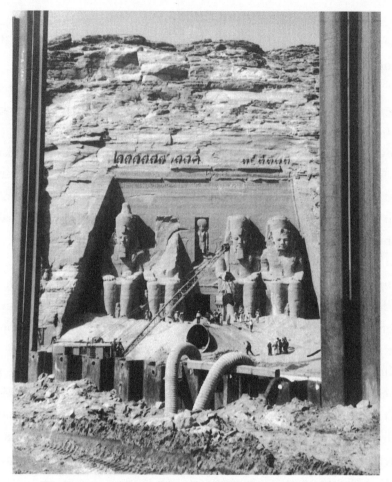

*The Ramesses II temple at Abu Simbel was protected with
heaps of sand to prepare it for the UNESCO-backed
cutting operation, 4 January 1966*

once again interceded to bring ancient Egypt into hearts and
homes abroad.

The coarse, porous, and grainy sandstone of the site had been
easy for the ancient sculptors to carve, compared to other stones,
but it crumbled in the teeth of the modern metal hand saws used
to cut through the sculpted surfaces (chain saws were reserved
for undecorated areas). To solidify the stone, the team of masons

and engineers drilled into it and inserted steel reinforcing bars, which were cemented in place with epoxy resin. More resin impregnated the ancient surfaces to render it waterproof, which darkened the colour of the sandstone. The masons sometimes worked by night so that changes in temperature would not affect the size of the saws' cutting seams, and where even hand saws were too risky, they used wire cutting, line drilling, and wedges to work through the stone surface. Italconsult, an Italian engineering consultancy, was in overall charge of the project, and Italian masons from the marble quarries of Carrera were among the many foreigners who came to work at the site.[45] 'Imagine being asked to dismantle a medieval cathedral,' wrote two German consultants in the UNESCO *Courier*, putting the Abu Simbel relocation into explicitly European terms despite its supposedly universal importance.[46]

Most of the cutting was done by Egyptian and Nubian stone-workers, who were paid Egyptian wages in Egyptian pounds.[47] Each block – more than 8,700 of them – was numbered, inspected, and fitted with lifting bolts, so it could be raised by crane to higher ground, 65 metres above the original site. Cushioned on sand on flat-bed lorries, the blocks were taken to the new site, 208 metres away, and kept in storage until it was time for their resurrection on a newly prepared sandstone foundation.

The work and the living conditions were rough going. To finish in time, the project continued all year round, in summer temperatures of up to 50°C in the shade. Around 3,000 people lived on site at any one time, most in tent cities, some – the foreign engineers and consultants – on houseboats. A temporary town infrastructure grew up, with a mosque, police station, hotel for visitors, shops, a medical centre, swimming pool, and a tennis court. Isolation was a challenge. The nearest town was Aswan, some 300 kilometres north by river. Land transportation was

difficult. Mail and urgent supplies came by four-seater aircraft, everything (and everyone) else by boat. There was nowhere to go but the desert.

For the Nubians forced from their villages, there was nowhere to go but the new villages built to house them between Aswan and Kom Ombo to the north, into domed houses that imitated Nubian domestic architecture – a simulacrum without a soul. The old houses had floors and walls of Nile mud, smoothed by women's hands each time a surface needed refreshing or repair. No new settlement could replicate ties that had grown out of the land and water over long generations, but petitions and protests by the Nubians had no effect. It was a similar story in Sudan: the Nubian population was moved south-east to Khashm el Girba, where another dam project and related developments were under way. The district commissioner responsible for their resettlement, Hassan Dafalla, wrote a detailed account of the heavy responsibility he faced. He and his deputies moved not only the living, but the remains of the blessed dead, such as the *emir* Osman Digna whose forces had resisted invading British and Egyptian troops in the 1880s.[48]

The relocations of Egyptian and Sudanese Nubians took place over the course of 1963 and 1964, with far less media coverage than the relocation of the temples. The efforts of American anthropologist Robert Fernea, then at the American University in Cairo, secured Ford Foundation funding for a three-year ethnological survey in Egyptian Nubia, barely adequate to the complexities of these cultures and the rupture facing them.[49] The Nubians were to all intents and purposes invisible, overshadowed by the monuments that UNESCO had taken as its mission to save. The London *Times* – the paper that had made Tutankhamun famous – was typical in the scant attention that it paid to the mass displacement of the Nubians. Reporting on the new

villages at Kom Ombo, north of Aswan, the paper had to admit that the cement breeze-block structures were no match for the spacious mud-brick homes that would soon be dissolving back into the dammed-up Nile. The villages had modern conveniences like schools, clinics, and electricity, and each family received a field nearby with 'potential' to be fertile.[50] But transplanted date palms withered in the new courtyards, promised improvements to living standards did not materialize, and communities struggled with a sense of loss and isolation. Calls for the right to return to lost homelands have increased in recent years among younger generations of Egyptian Nubians, fuelled by a sense that elsewhere might be better than the somewhere of the present day.[51] Nostalgia has its uses, after all. It is what remains when one accepts that there is no way home.

* * *

UNESCO declared the relocation of the Abu Simbel temples a triumph. In an opening ceremony on 22 September 1968, René Maheu – by then Director-General of the organization – addressed Ramses II as if the ancient pharaoh were alive. 'Your priests, your architects, your masons, your sculptors, scribes and slaves took no greater pains to divinize your glory than we, O King, have done to preserve your presence on earth.' It was a triumph that, according to Maheu, spoke to 'the truth that there is nothing lasting in the works of man except that which has meaning and value for all men'.[52] Tharwat Okasha posed with Maheu next to a commemorative plaque at the site, and in his personal account of the event, he spoke of the 'joyful wind of victory' that blew that day.[53] The Egyptian government had invited the ambassadors of all fifty nations that had contributed to the Abu Simbel project. Christiane Desroches Noblecourt attended, as did the little boy she had once seen playing at the

captain's table of the *Champollion* – Prince Sadruddin Aga Khan, who had been an influential member of UNESCO's International Action Committee for the Nubian campaign, and whose father's mausoleum stands atop a hill at Aswan, overlooking the Nile.

The visual and verbal language of the Abu Simbel relocation today seems overblown, triumphalist, and callow, with its prioritization of monuments over people. The 'common heritage of mankind', as UNESCO began to describe the sites it safeguarded, begs the question of what any of those words mean, apart or strung together. Yet in the Cold War era, with its deep and dangerous rivalries between nation-states, the spirit of cooperation that the Nubian campaign embodied was a welcome respite, an alternative vision of how a world beyond borders might work. Not that national interests ever disappeared during the campaign. UNESCO could only coordinate, not command. It was up to individual countries to organize national committees, approve participants, and raise funds, which UNESCO tallied nation by nation, hard currency by soft.

To the countries that donated the most money and manpower, Egypt promised gifts in the form of small, dismantled temples, their parts stored in crates on the island of Elephantine until such time as transport could be arranged. Sudan relied instead on a division of archaeological finds and moved its small monuments to an open-air museum in Khartoum. For America, the largest donor, Egypt earmarked the Roman-era temple of Dendur; Spain and the Netherlands also each received a Ptolemaic- or Roman-era temple; and Italy, which played a vital role in engineering the Abu Simbel lifting operation, found a home in the Museo Egizio of Turin for the rock-cut temple of Ellesiya, dating to the reign of Thutmose III in the 18th Dynasty. It had crossed the Mediterranean to Genoa, in sixty-six crates weighing 93 tons, then made its

way by freight train to Turin and by lorries into the city's baroque centre, to be built into the Museo Egizio in time for an inauguration in September 1970.[54]

France received a gift of a different kind: Tutankhamun, in the form of a one-off exhibition grander than the North American and Japanese tours. Egypt – and Tharwat Okasha – had not forgotten Christiane Desroches Noblecourt's tireless advocacy for the Nubian temples, nor the support of the French government and Paris-based UNESCO. Okasha had returned as minister of culture in 1966, and he persuaded Nasser to agree the loan. France would also donate proceeds from the exhibition to the Abu Simbel rescue fund.

'Tutankhamun and His Times' opened in February 1967 at the Petit Palais in Paris, to acclaim – but there were several points in the planning stages when it seemed the exhibition might not come off at all.[55] The North American and Japanese tours of Tutankhamun objects had established a set of protocols and expectations at the Egyptian Museum, and Noblecourt prided herself on both her knowledge of the tomb and her working relationships in Egypt. Nonetheless, agreeing on a list of objects that could travel to Paris proved difficult – a sign of the different curatorial cultures in Egypt and Europe, as well as heightened Egyptian sensitivities about how its ancient culture was represented abroad.

On Noblecourt's wish list for the exhibition was one of the many ceremonial walking sticks found in Tutankhamun's tomb, its curved top carved to represent a bound prisoner – a sign of pharaoh's power over Egypt's enemies. Found during the first season of the excavation, in a long wooden chest in the Antechamber, this and several similarly carved sticks, showing symbolic Libyan, Syrian, or African prisoners, had been immortalized in Harry Burton's photographs in the 1920s.[56] One had even

been written up in the *Illustrated London News* to compare the
'Asiatic' prisoner it depicted to screen star Charlie Chaplin.[57]
The stick that Noblecourt requested showed a black African or
Nubian prisoner, his head and arms inlaid in ebony, with a Syrian
prisoner carved on the other side of the crook.[58] To the curators
of the Egyptian Museum, this was no laughing matter when the
forced relocation of Nubians for the High Dam was a live issue.
Egyptian officials did not want to draw attention to the plight
of the Nubians, who were in any case not recognized as a sepa-
rate ethnic group under the pan-Arab unity promoted by Presi-
dent Nasser. By rejecting the loan request as a 'poor ambassador'
for Egypt, the antiquities officials rejected the objectifying images
that European taste found so fascinating.

Part of the loan agreement was that French experts would help
prepare the Egyptian Museum objects for the show, undertaking
any restoration procedures for which Cairo lacked specific skills
or equipment. As a profession, conservation was in its early days
and often couched as restoration or technical research. The Egyp-
tian Museum had a laboratory headed by Dr Zaki Iskander, who
had prepared Tutankhamun objects for the earlier tours and been
present for their installation overseas. Noblecourt had her eye on
larger and more delicate objects than had travelled to the United
States and Japan. Her list included one of the life-size guardian
statues;[59] the gilded funerary bed in the shape of a horned cow;[60]
the small wooden shrine overlaid with gold, showing Tutankha-
mun and Ankhesenamun;[61] and a statuette of the king known
as the harpooner, one of two that were found, wrapped in linen,
inside the small dark shrines stacked together in the Treasury.[62]

To undertake some of the restoration work on these objects,
and stabilize them for travel, two of the most experienced restor-
ers in France spent three months in Cairo in preparation for the
loan: the head of the Louvre's own restoration workshop, and

a specialist from the national *Mobilier*, fresh from restoring a gilded roll-top desk that had belonged to Louis XV.[63] Balancing the tomb treasures would be several impressive stone sculptures and Amarna pieces from the Egyptian Museum, including over-life-size, if fragmented, statues of Akhenaten from Karnak temple and of Tutankhamun from the ruins of his successor Ay's funerary temple at Medinet Habu. The *pièce de résistance* required approval from President Nasser himself, for to France was given the honour of hosting the gold mask of Tutankhamun for the first time anywhere outside of its Egyptian Museum home.

On a visit to Cairo in October 1966, Noblecourt called on Okasha, who had the unenviable task of telling her that something had gone wrong, less than four months from the exhibition opening. The Egyptian authorities had invited British conservator Harold Plenderleith – who had lent a hand to Carter all those years ago with the shrines – to give a final assessment of the objects bound for Paris.[64] The one-time head of the British Museum's research laboratory, Plenderleith had gone on to help formulate and then run UNESCO's International Centre for the Study of the Preservation and Restoration of Cultural Property (ICCROM), established in Rome in 1959. Considered the world's expert on the conservation of antiquities, Plenderleith declared the newly restored objects too fragile to travel. Noblecourt pleaded her case before the relevant committee of the Egyptian Antiquities Organization. She managed to secure approval for the guardian statue and the bed, but the small gilded shrine and the harpooner would not travel. It was a blow she never forgot – nor did Plenderleith, who apologized to her when they met, years later, at a professional conference.

Getting the objects to Paris was the next hurdle. French firm André Chenue made double-skinned custom packing cases for each artefact. The inner case cradled each tissue-paper-wrapped

artefact in layers of cotton wadding, while the outer case was water- and fire-resistant thanks to a lining coated with asbestos fibres.[65] The heavy sculptures were crated up by specialist UK-based art handlers Wingate & Johnston for shipment from Alexandria to Marseilles in January 1967, until a storm forced the ship to divert to Genoa. From there, a lorry accompanied by police motorcycles escorted the sculptures over the Morvan glacier and across France to Paris. The objects from the tomb had an easier journey by military plane, arriving on Christmas Eve, 1966 at Le Bourget Airport, while a second flight brought the mask on its own shortly before the exhibition opening. The plane made a scheduled stop at Rome's Fiumicino Airport, where an Italian military guard surrounded it. At Paris, the Egyptian ambassador and a representative from the French Ministry of Culture met the flight, and heavy security escorted the crated mask to the Petit Palais, where an underground room had been turned into a secure vault to receive it. Cameras were on hand to photograph the opening of the crate, as the famous golden face emerged.[66] Asbestos aside, an actual king could not have had a warmer welcome.

And Noblecourt could not have had a more spectacular success. The opening night crowds were so impatient to enter that they almost damaged the ornamental bronze doors of the Palais. Inside, the Louvre design team had created a series of rooms with wall colours as rich as the jewel-like glass and stone in Tutankhamun's treasures – lapis blue, blood red, blush coral for the dawn. Cabinetmakers had made new wooden vitrines secured by the best locksmith in Paris. For months, Noblecourt had been ordering papyrus plants from all the known producers in France. Gathered in the centre of the exhibition, with a green velour carpet, these created a path for visitors to walk as if they were beside the Nile.

Echoing Howard Carter's phrase, Noblecourt described her own 'day of days' as being the private tour she gave to Charles de Gaulle, one-time leader of the Free French, now president of the Republic. It was meant to be a quick walk-through under the watchful eye of his staff, his wife, and the French minister of culture, André Malraux. They began with the first room, whose walls were covered with photographic enlargements from the time of the discovery – no doubt some of the same images that enthralled the young Christiane in her father's *L'Illustration*. De Gaulle seemed reserved, which did little to calm the grown-up Christiane's nerves. The second room presented the Amarna royal family. De Gaulle stopped in front of an ink sketch on a limestone flake, which showed one of Akhenaten and Nefertiti's young daughters nibbling on a roast duckling. This *canard* broke the ice, and De Gaulle spent an hour and a half touring the show.[67]

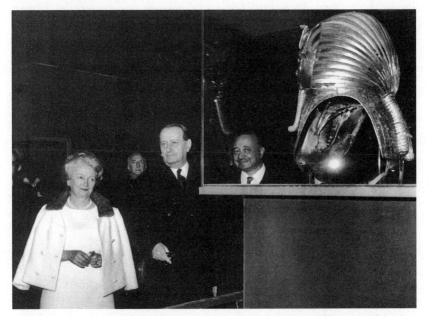

Christiane Desroches Noblecourt, André Malraux, and Tharwat Okasha
with the mask of Tutankhamun on its first trip outside Egypt,
at the Petit Palais, Paris, 16 February 1967

The final room held the mask of Tutankhamun, its gaze higher than Noblecourt's head. The mask had often greeted dignitaries at Cairo, but this was his first ambassadorial appearance overseas – and not his last. The war hero and the wide-eyed pharaoh posed for photographs with Madame de Gaulle, Malraux, and Noblecourt. 'Tutankhamun and His Times' attracted 1.2 million paying visitors and contributed nearly $500,000 in profits to help UNESCO finish the Abu Simbel relocation.[68] The exhibition's run was cut short by the outbreak of the Six-Day War in June 1967. From the French interior ministry came the order to protect two targets in Paris, if need be: the Élysée Palace and Tutankhamun.[69] Still, Tutankhamun had worked his magic, with a satisfying financial outcome (despite high running costs, such as insurance) and a powerful symbolic gesture of French and Egyptian amity. Noblecourt's Tutankhamun was a triumph – and more than reward enough for a girl whose life course had been changed by her early encounters with the golden king.

5

The Dance of Diplomacy

THE NOVELIST PENELOPE Fitzgerald made repeat visits to 'Treasures of Tutankhamun' at the British Museum during its record-breaking nine-month run in 1972, fifty years after Howard Carter's team found the tomb. From the mood of the long queues that backed up into Great Russell Street, to a suspicion that all that gold was too good to be true, Fitzgerald stored the experience up with an author's eye. It inspired her first novel, *The Golden Child*, published in 1977. Beneath the surface of a droll plot involving murder, romance, and Russian spies, the story is a satire in which culture as a public good has been overtaken by greed. The riches buried with the 'Golden Child' are forgeries, a secret the museum director will kill to conceal. Blinded by ticket sales, an institution that should be a moral centre for society instead spins culture into profit and international influence.

Although there was nothing fake about the fifty artefacts which Egypt lent to Britain for the 'Treasures' show, Fitzgerald was nearer the mark when it came to the diplomatic manoeuvres and financial concerns involved. The combined efforts of Christiane Desroches Noblecourt and Paris-based UNESCO in supporting the salvage campaign had helped repair post-Suez relations between France and Egypt in small but significant ways. President Nasser's grand gesture of lending the mask of Tutankhamun

marked the healed rift, a gold-and-glass plaster over a diplomatic wound.

When it came to Egypt's one-time master, however, the wound was deeper after decades of military occupation and imperial rule. The two countries had restored diplomatic relations and, in 1965, signed a reciprocal convention on cultural exchange.[1] But the rapprochement remained uneasy. The British government kept out of the Cold War politics surrounding the High Dam, although it did pledge some funds to the UNESCO campaign to save Abu Simbel (despite concerns over the sequestering of British assets in Egypt since the Suez Crisis). British archaeologists had helped lead archaeological surveys and salvage excavations that took place in Egyptian and Sudanese Nubia, under the remit of individual institutions eager to benefit from the promised division of finds. The Egypt Exploration Society (formerly Fund) was one of them, and one of several examples of how the campaign reconfigured, and perpetuated, colonial spheres of influence in Egypt and Sudan.

Eiddon Edwards – the colleague who had once brought Noblecourt flowers in an Egyptian hospital – watched her Tutankhamun success with a certain envy from across the English Channel. Like other Egyptologists of his generation, Edwards showed no particular interest in Tutankhamun until the rest of the world did. A Cambridge graduate in what the university then called 'oriental' languages, including Arabic, Edwards joined the British Museum at the age of twenty-four, without any training in Egyptology. He picked it up quickly, though, and became well known for his popular Penguin book, *The Pyramids of Egypt*, researched and part-written during a wartime secondment to the British Embassy in Cairo. Although Tutankhamun had not played any part in his academic or museum work, Edwards had one firm conviction about the tomb: it was a British discovery

made by a British archaeologist and funded by a British aristo-
crat. Why should America, Japan, and France be graced with
loans of the tomb's treasures when, had history bent a little fur-
ther in Britain's favour, some of those same objects would have
found their way to Bloomsbury decades earlier, and stayed there?

Tutankhamun's treasures – including the mask that had
graced Paris – did make their way to London, but not in a hurry.
Negotiations between the British and Egyptian governments
occupied top diplomats for several years, and the loan was more
than the British Museum could handle on its own. It contracted
the exhibition's organization and publicity out to Carter and
Carnarvon's old mouthpiece, the London *Times*, but remained
adamant that neither organization would profit from the exhi-
bition. All money earned after expenses would go towards the
second phase of UNESCO's Nubian campaign, which planned
to move the temples of Philae to a different island, downstream
and out of danger.

This was key to securing the loan, but music lover Tharwat
Okasha, still minister of culture when talks began, dropped
one more suggestion into Eiddon Edwards' ear. Could Margot
Fonteyn and the Royal Ballet come to Cairo? The great Brit-
ish ballerina performed at centenary celebrations for the Suez
Canal in 1969 – and the dance paid off.[2] By the time 'Treasures
of Tutankhamun' closed in December 1972, it had surpassed all
expectations. With 1.6 million visitors, it remains to this day the
most popular exhibition ever held at the British Museum. It also
raised more than £600,000 for UNESCO, making up for Britain's
previous lacklustre contribution. In the squares of Bloomsbury,
the old wound began to heal, or at least take different shape, as
British culture staked a claim on Tutankhamun once again.

* * *

These days the queues outside the British Museum are for security screenings, not Tutankhamun. An appointment letter usually allows me to join the priority line as a researcher, when I have visited on the trail of a Tutankhamun who exists not only within living memory but within my own lifetime: I was born the year the London 'Treasures' exhibition took place.

It is history now, and Edwards knew that he was making it. With his secretary Audrey King, he kept assiduous track of all the correspondence, memoranda, and meeting minutes related to the show. King organized the paperwork by theme, indexed it, and had it bound into five fat volumes for the department archives. Those volumes waited for me on a trolley in the high-ceilinged library of the museum's Egyptian department, where researchers sit at a long table, working over artefacts or files, and curators pass through, checking a book or sometimes greeting a colleague. In a different life, I would have been one of those curators, not a visitor. Near the end of my studies at Oxford, the British Museum advertised an assistant keepership in Egyptology. Pushed by well-meaning advisors to apply, I received an offer but declined the job. I was not ready to commit to a museum career, or to England. Spiteful words from one of the curators reached my ears from several sources, as intended, I suppose; Desroches Noblecourt was certainly not the last woman scholar, or Egyptologist, to find herself on the receiving end of a colleague's barbs. Years passed before I set foot in the British Museum again.

Tutankhamun – and Audrey King's careful filing system – called me back. The set of bound archive volumes opens with a first-person recollection by Eiddon Edwards, similar to the account he later set out in his autobiography.[3] Born in London to Welsh parents who were Calvinistic Methodists, Edwards grew up in an abstemious household that observed the Sabbath. The family moved to London when his father, a specialist in Arabic

and Persian, was appointed to an assistant keepership in the British Museum's Department of Oriental Manuscripts and Printed Books (as it was called). Like Desroches Noblecourt, Edwards remembered seeing photographs of Tutankhamun's tomb as a child, in his case in the *Illustrated London News*. The paper impressed other ancient sites on his memory, too. After Carter quit work at Tutankhamun's tomb in 1924, the *News* fed its readers' appetite for archaeological stories with Leonard Woolley's discoveries in the royal cemetery of Ur, birthplace of Abraham in the Bible, and George Reisner's excavations at the pyramids of Giza.

From the Merchant Taylors' School in London, Edwards won a scholarship to Cambridge to study Arabic. When an opening for an Egyptologist came up at the British Museum, Edwards sat the required civil service exam, while his father made enquiries of Sidney Smith, head of the Department of Assyrian and Egyptian Antiquities.[4] In 1934, with no training in Egyptology, Eiddon Edwards joined the institution where he would spend the rest of his career. After a restructuring in 1955, he became head of the first stand-alone department of Egyptian antiquities in the British Museum's history.

Edwards chased Tutankhamun for several years with little luck. The Arts Council, which promotes British arts and culture, had mooted a loan exhibition from Cairo as early as 1961, when some of the tomb objects were touring the United States and a separate show, 'Five Thousand Years of Egyptian Art', was touring Europe. Edwards considered the British Museum's own collection more than enough Egyptian art for London, unless Tutankhamun became available. By the mid-1960s, Edwards had heard about the Paris exhibition that Noblecourt was curating ('Kiki', he called her in letters to male colleagues). Around the same time, he struck up a professional friendship with Tharwat

Okasha, who spent several weeks in London for medical treat-
ment at a point when he had stepped down from his ministerial
role. Hospital visits may have been Edwards' forte, but it was not
enough to convince the Egyptian Ministry of Culture to extend
any of the Paris loan to London. The Antiquities Service in
Egypt had discussed at length requests for Tutankhamun loans
from several countries: Britain, Denmark, Italy, the Netherlands,
Poland, Spain, Sweden, and Yugoslavia. The risks of allowing
the objects to travel was deemed too great, wrote the ministry's
head of cultural exchange, Magdi Wahba, 'and it seemed unfair
to favour one or some countries over others'.[5]

Yet favouring Britain was exactly what Edwards had in mind.
As he wrote to a contact in the British Ministry of Education,
'It is rather absurd that a British discovery should be shown in
America, Japan and France but not in London. Both the Arts
Council and the Trustees of the [British] Museum are anxious
to have it.'[6] Edwards replied to Wahba to express his disappoint-
ment, 'especially as we cannot forget that the discovery of these
antiquities was more closely associated with this country than
with any other country'.[7]

Undeterred, Edwards did not give up on the idea of bring-
ing Tutankhamun to London – nor did the original media outlet
for the excavation news and photographs, the London *Times*,
whose chief executive Denis Hamilton became an unexpected
go-between for Egypt and the British Museum around this
time. A decorated officer in the Second World War, Hamilton
had become chief executive of the Times Newspaper Group in
1967.[8] When Hamilton visited Egypt that year on President
Nasser's invitation, to attend a commemoration of the Battle of
Alamein, he brought up with Nasser the idea of a Tutankhamun
loan to London. Nasser is alleged to have said that he would con-
sider such an agreement, if Lord Snowdon – Princess Margaret's

husband, and a *Times* photographer – would take publicity
shots for him. Edwards had this story from Hamilton over a
gentlemen's club lunch in London, to discuss the renewed pos-
sibility of a Tutankhamun loan. Unfortunately, Edwards recalled,
on the taxi journey back to the British Museum, he saw news
headlines announcing the outbreak of what would become the
Six-Day War.[9]

Suspicions that Britain had lent military support to Israel in
the war ruptured British–Egyptian diplomatic relations, which
had in any case been fragile since the 1956 Suez Crisis. How-
ever, during a British Council visit to London in 1968, Tharwat
Okasha – restored to health and to his post as minister of cul-
ture – was able to give Edwards his personal guarantee of a
Tutankhamun exhibition. Edwards claimed credit for suggesting
to Okasha that the show should be held in 1972, to mark the
fiftieth anniversary of the tomb's discovery.

At the British Museum, Edwards had the support of the
new director, Sir John Wolfenden, who had chaired a series of
government committees focused on education, sport, and the
decriminalization of homosexuality, for which he is remembered
in Britain today. The museum had also appointed Humphrey
Trevelyan as Chair of the Board of Trustees. Lord Trevelyan
had a distinguished diplomatic career behind him, having been
Britain's ambassador to Egypt at the time of the Suez Crisis,
ambassador to Iraq during the 1961 Kuwait crisis, and ambas-
sador to the Soviet Union; he also oversaw Britain's withdrawal
from its Aden protectorate. Trevelyan was a man for sticky sit-
uations. He helped steer the museum through the delicate
negotiation process between Britain and Egypt, where Marrack
Goulding – son of Edwards' close friend from school and uni-
versity, High Court judge Irvine Goulding – now headed up the
British Embassy in Cairo. Every old connection helped.

Denis Hamilton was also made a trustee of the museum, which Edwards considered a little too insular, even by British standards. It was, he reasoned, Wolfenden's attempt to ensure Hamilton had the interests of the museum at heart, not just his newspapers'. This mattered, because *The Times* would once again bring Tutankhamun to the British public. The British Museum was used to holding temporary exhibitions, but nothing on such a pharaonic scale. Hamilton was quick to offer the services of *The Times* in overseeing the organization of the show and, crucially, the marketing and publicity that would ensure its success. It needed to generate enough profit to yield a sizeable donation to UNESCO and convince Egypt of Britain's largesse. The Board of Trustees agreed to Hamilton's offer, on condition that *The Times* did not itself profit from the arrangement or have exclusive rights to press coverage. Quite the contrary, Hamilton assured them: *The Times* would seek maximum media coverage for Tutankhamun.

Hamilton nominated one of his marketing directors, Philip Taverner, to head the office that would be dedicated to organizing 'Treasures of Tutankhamun'. Taverner had joined *The Times'* parent organization, Canadian media conglomerate Thomson International, after a successful stint at the Italian tyre company Pirelli (and an Oxford University stint in student drama that included acting with Maggie Smith). Taverner was the man behind the Pirelli calendar, with its come-hither combination of beautiful women, sleek photography, and sleeker cars.[10] In the penthouse meeting room at Thomson House, he chaired monthly meetings of the main working party responsible for organizing the exhibition, which included Eiddon Edwards and designer Margaret Hall from the British Museum. As plans developed, Taverner also formed a working party for publications and promotion, the latter featuring George Rainbird – publisher of Noblecourt's bestselling *Tutankhamun: Life and Death of a Pharaoh*.

Lord Trevelyan travelled to Cairo in January 1970 to start working out the terms of the treaty that would bind Britain and Egypt together in this joint venture. It took more than a year to get the wording right, as versions passed back and forth between lawyers for both sides. The Egyptian government was anxious that as state property, the Tutankhamun artefacts would not be at risk from impounding while overseas. Egyptian assets in Switzerland had been frozen over a legal dispute there, and Egypt required reassurance that the Tutankhamun objects would have sovereign immunity while in the United Kingdom. The caution was justified, since the Foreign and Commonwealth office received a number of letters from British citizens whose assets had been sequestered in Egypt since the 1950s. When the 'Treasures' exhibition finally opened, one correspondent wrote, 'I am delighted about Tutankhamun, but I feel entitled to my share of the proceeds before they [the 'treasures'] leave this country.'[11]

To make the treaty satisfactory to Egypt, and the exhibition financially feasible, another crucial point involved the British government indemnity that would insure the objects against all loss or damage on British soil. The treaty also enshrined in law the tenet that net proceeds from the exhibition would be paid directly to the UNESCO fund for the temples of Philae. The treaty, in both English and Arabic, was finally ready for representatives of both governments to sign in July 1971 – a deadline set by *The Times* so that planning could get under way in earnest for a 1972 opening. It was 'something of a cliff-hanger', according to British officials present at the signing, which took place at the British Embassy in Cairo. Fortunately, the sound of smashing lemonade glasses in the corridor, dropped by an unfortunate waiter, did not presage disaster.[12]

A separate agreement between the Cairo and London museums set out guiding principles about the packing and transport

of the objects and how they would be monitored in London, where two staff members from the Egyptian Museum would stay throughout the run, changing over every few weeks. Last but by no means least, an appendix to the treaty and the inter-museum agreement listed the objects that would travel – and their all-important insurance values, which totalled £9,060,000. Insurance valuations for works of art always have something of the guesstimate about them, but to give a comparison in terms of market values, the sum insured was more than double what the Metropolitan Museum of Art in New York paid for a renowned Velázquez portrait in 1971, and more than twelve times the jaw-dropping $1 million the same museum paid the same year for the Euphronios krater, an ancient red-painted Greek vase looted from Italy and finally returned there in 2008. Figures like these foretold the surging monetary value ascribed to works of art as they increasingly became investment vehicles for Wall Street wolves and financial institutions.

Since Edwards and Okasha had settled on a 1972 date for the exhibition, to mark the fiftieth anniversary of the tomb's discovery, it followed that the loan would include fifty objects, all from the tomb and more than Egypt had ever before sent abroad. Edwards travelled to Cairo in the autumn of 1969 to make a selection, and his meetings there with Henri Riad, director of the Egyptian Museum, and Zaki Iskander, head of the Museum's Scientific and Technical Service, seemed to go well.[13] Edwards also met with Gamal Mokhtar, head of the Egyptian Antiquities Organization, and gleaned a titbit of inside news, which he reported back to Wolfenden and Trevelyan at the British Museum: the much-vaunted Paris exhibition in 1967 had contributed almost nothing to the UNESCO campaign, he had heard (this was not, in fact, true: it netted $473,623, as Edwards eventually found out). The Paris profits had been eroded by the

high cost of insurance, in the absence of a government indemnity, as well as 'large deductions for entertainment, transport, free tickets and even the purchase of clothes'. In contrast, the Japanese tour of Tutankhamun objects in 1965–66 had raised more than $1.1 million (about £467,000) at venues in Tokyo, Kyoto, and Fukuoka, and this was the sum Edwards thought the British Museum should aim for.[14]

Several of the objects that Riad, Iskander, and Edwards chose for the London loan had gone to Paris as well, notably one of the guardian statues (Carter's number 29, which stood to the left of the sealed opening to the Burial Chamber), the cow-headed funerary bed,[15] and the 'wishing cup',[16] plus a gold canopic coffin and one of the carved alabaster stoppers that had closed its well inside the canopic chest.[17] These last two, or their near-identical mates from the sets of four, had been part of every tour of the Tutankhamun objects. The Egyptian team agreed to include the gold funerary mask,[18] now that the precedent of lending it to Paris had been set, and they held firm in refusing to lend one of the offending walking sticks carved with a subjugated Nubian figure. Like Noblecourt, Edwards had hoped to show the piece on the grounds of its artistic merit, without any apparent concern for the racism of its imagery. On the whole, though, he conceded that its withdrawal was 'no great loss'.[19]

Instead, Edwards had his eye on two pieces that had been withdrawn from the Paris show at the last minute, on the advice of Harold Plenderleith. Edwards wanted the British Museum show to top the Paris version in every possible way. The treasures in question were the small golden shrine, covered with scenes of Tutankhamun and queen Ankhesenamun together,[20] and the gilded wooden statuette known as the harpooner.[21] The shrine required further restoration, for which the British Museum would cover the costs. The harpooner presented, as Edwards

put it, a 'more subtle' objection. First, the fact that it had been refused to Noblecourt was a delicate matter. Second, the object raised particular concerns because of its construction: the figure of Tutankhamun holds a slender harpoon in its outstretched arm, and the king balances on outstretched legs, each foot fixed into the separate skiff. It was one of two nearly identical statuettes, found wrapped in linen as if dressed for the afterlife, and closed together in one of the resin-coated shrines of the Treasury. Long stripped of its linen, and its sacred purpose, the statuette represented a more 'free', naturalistic, and (so the thinking went) 'Western' style of art than other Egyptian sculpture did. Hence its appeal to Noblecourt, Edwards, and their anticipated museum audiences.

The British Museum undertook a two-pronged offensive to secure the harpooner. Even before his trip to Cairo in November 1969, Edwards had written to Plenderleith to sound out his former British Museum colleague about the conservation of the Tutankhamun objects, the harpooner in particular. Meanwhile, Trevelyan was pondering the problem too. He thought they might make use of Denis Hamilton's charm – and flatter Christiane Desroches Noblecourt's professional vanity, since the London exhibition meant that her book on Tutankhamun would be reprinted and reach even higher sales figures. 'I would see what we could do to mollify the lady,' Trevelyan suggested.[22]

Noblecourt gave her own side to this story: George Rainbird phoned her one day, she wrote, to ask if she would speak 'urgently' to Denis Hamilton, who was in Paris. Noblecourt received Hamilton in her office, where he explained that Egypt would not agree to lend the harpooner figure to the British Museum unless she gave her personal consent. Noblecourt had always thought the figure was safe to travel; the work the Louvre's restorers had done, she told Hamilton, would allow it to withstand even the

London fog. She gave her blessing and Hamilton bade farewell with, she thought, tears of gratitude in his eyes.[23]

It was Plenderleith's word that had the most weight, though. He admitted that he had examined the figure only through the glass of the museum case and assumed that the harpoon was fixed in its hands. Once he realized that it was made separately, and therefore could be extracted for transport and reinserted for display, he was happy to backtrack on his earlier opinion and approve the loan.[24] The harpooner would travel to London, with an insurance value of £200,000. The same value was attached to the miniature inlaid coffin, while the funerary bed stood at £500,000 and the small golden shrine at £600,000. Some objects had much lower values; the ivory palette inscribed for Princess Meritaten, who is now a candidate for being Tutankhamun's mother, merited only £15,000. The object with the highest value, at £1 million, was the last on the list and without question the star piece: Tutankhamun's gold funerary mask.[25] 'Priceless' always has a price fixed to it somewhere.

* * *

In the autumn of 1971, the British Museum sent assistant keeper T. G. H. 'Harry' James to Cairo to assist with the packing of the objects, scheduled to travel to London in the new year. James had joined the museum in 1951 right out of Oxford University, where he took two degrees in Classics and Egyptology, interrupted by war service. Like Edwards, whom he succeeded as head of the Egyptian department, James found his career shaped by Tutankhamun in unexpected ways. In retirement, he wrote an authoritative and broadly sympathetic biography of Howard Carter, the man who was in many ways as central to the British Museum exhibition as the pharaoh he had found.

From Cairo, James sent Edwards regular reports on progress at

the Egyptian Museum, alert to any sign that their Egyptian col-
leagues might change their minds about the fifty objects meant
to travel to London. With James was Ian Pearson, director of the
specialist art transport firm Wingate & Johnston, contracted to
oversee every stage of the objects' packing and transportation.
Given the government indemnity at stake, and the extraordi-
nary historical and financial values placed on the Tutankhamun
objects, James, Pearson, and their Egyptian counterparts took
every precaution to inspect each object before packing, noting its
condition, and photographing it where possible. For this, they had
the use of a ground-floor gallery near the museum exit, dedicated
to Byzantine-era finds from Qustul and Ballana in Egyptian
Nubia. The sites had been discovered during British-led survey
excavations ahead of the 1930s raising of the Aswan Dam, when
the gold and silver jewellery in their burials was briefly hailed as
treasure in the media, which at that time was still attuned to any-
thing that hinted at another Tutankhamun.

The director of the Egyptian Museum, Henri Riad, assigned
deputy director Abdel Kader Selim to oversee the packing,
helped by two other Wingate & Johnston employees and, in
James' words, 'two or three girls' from the staff (one of whom
proved to be 'very helpful, holding sticky tape and so on').[26] Selim
had been born in the year they were meant to be celebrating –
1922 – and went on to become director first of the Egyptian
Museum and later of the Nubian Monuments Salvage Fund in
Egypt.[27] Meanwhile, the head of the Egyptian Museum's tech-
nical department, Zaki Iskander, popped in from time to time as
well. Iskander – who had, as a young man, trained with Alfred
Lucas at the museum – was by now an old hand with Tutankha-
mun tours, having accompanied the objects to the United States
on their first foreign journey a decade earlier.

From his room at the Semiramis Hotel, James penned reports

to send via the British Embassy's diplomatic bag, 'so I may speak with some freedom', as he put it to Edwards. In the first two days, they had packed six objects, including the harpooner with its separate harpoon and coil of copper rope, and the figure of Tutankhamun on top of a leopard.[28] James described the process they had adopted. Iskander, Selim, and James examined each object together and agreed on which descriptive points to note. These were then typed up in Arabic – presumably by one of the 'girls' – and signed by all three men as well as Pearson and his assistants. Some of the packing was complicated, especially for figures like the harpooner. Boxes to fit smaller objects into the larger packing crates were being made locally, by a carpenter named George Habib (a Copt, like the carpenters who had made crates for Howard Carter decades earlier). They were 'very elaborate, with fluted decoration,' James wrote, in a tone that suggests at least one eyebrow had been raised. These cases proved to be too heavy and had to be made up again in simpler style.[29]

The next day, four more objects were inspected and packed: the gold dagger and sheath,[30] the alabaster 'wishing cup',[31] a sculpture of the king's wrapped body resting on a bier,[32] and the canopic coffin selected for the tour.[33] One of the gold chevrons on the little coffin was loose but could be 'fixed on the spot', James wrote. It was Ramadan when the work started in November 1971, and after a few more days of packing, there was a pause for the Eid el-Fitr. The rest of the packing came off without a hitch when work resumed, though something must have sparked an acid comment that James made about Zaki Iskander. His job title, James sneered, was 'Director-General of Technical Affairs – you could have fooled me!'[34]

In the new year, James returned to Cairo to accompany one of the three planeloads of crated artefacts to London. Arrangements for transporting Tutankhamun's treasures had gone back

and forth for years between the British Embassy in Cairo, the Ministry of Defence and the Foreign and Commonwealth Office in London, and the two museums. As early as 1969, before any formal agreement for the Tutankhamun exhibition was in place, Edwards had enquired of an acquaintance at the Ministry of Defence as to whether the Royal Air Force would be able to transport the objects on its planes, as the French air force had done for the Paris show. The response to this idea in Britain was lukewarm. 'After all,' an official at the Foreign and Commonwealth Office pointed out, 'the last time the RAF were in Egypt, as far as I can recall, they were dropping bombs.'[35] As negotiations progressed, however, military transport emerged as a key concern of the Egyptian government. It was a point of security as well as pride. Marrack Goulding at the Embassy in Cairo advised Edwards, 'All those concerned at this end remain most unwilling to expose themselves to any charge of putting Egypt's heritage at risk' – no wonder, since it was a charge that Western European powers had been levelling at Egypt for nearly two centuries.[36]

Cost mattered, too. Britannia Airways, a charter company, had underbid the national carrier BOAC (British Airways), until *The Times* convinced BOAC to lower its bid in exchange for free advertising in the paper.[37] In the end, a neat compromise allowed the mask and a selection of other crates to travel by RAF plane to the Brize Norton base in Oxfordshire, while the rest of the crates flew via two BOAC planes to London's Heathrow Airport. One of the BOAC flights had Egyptian Museum curator Saniyya Abd el-Al on board ('a lady assistant keeper', as Edwards described her), the other had Harry James, while the British Museum's head of security R. S. Saunders travelled in the RAF plane with the mask.[38]

RAF *Britannia* landed at Brize Norton at thirty minutes past midnight on a top-secret date during the week commencing

24 January. The Wingate & Johnston handlers loaded the crates on to vans, and a police convoy – along with Ian Pearson in his Jaguar – accompanied the vans as far as the border of the Thames Valley Police force, at which point a fleet from the Metropolitan Police took over. The two BOAC consignments had already arrived, on two consecutive nights, at Heathrow, where they were met by British Museum staff for a similar transfer under heightened security. A hundred police officers surrounded the planes on the runway while the crates were transferred to vans for the journey into central London. It then fell to police from the local station in Bloomsbury to keep watch while the crates were unloaded at the British Museum, behind its cordon of iron gates.[39]

While London slept, Tutankhamun slipped into one of the city's best-known landmarks. Several media outlets had clamoured to cover the transport of the objects from Cairo to England, but the Trustees of the British Museum had rejected such requests.[40] Moving works of art is always a fraught operation, all the more so with objects now indelibly marked out as 'treasures'. Still, the publicity was too good to miss, and Paris had set a precedent by hosting a press call for the unpacking of the funerary mask at the Petit Palais five years before. Philip Taverner's PR specialist, Peter Saabor, invited select journalists, photographers, and a film crew to witness the opening of the packing case at the British Museum in the Egyptian department on 28 January – perhaps on the very tables where I consulted Edwards' bound archives forty-five years later.[41] As a line-up of security officers looked on from one side, and Zaki Iskander and his Egyptian Museum colleagues from the other, Wingate & Johnston handlers in white dust coats unscrewed the top and front of the crate, removed the foam inserts cut to fit around the mask, then lifted away the clear plastic wrapping from the fabled gold face. Harry

James may not have considered Zaki Iskander 'technical' enough, but Iskander had seen this moment before and knew the mask as well as anyone did. With a loupe in hand, he leaned in to inspect Tutankhamun's unblinking eyes beneath their lapis lazuli brows. That was the shot that *Observer* photographer Jane Bown captured: two Egyptians face to face in the heart of the old empire.

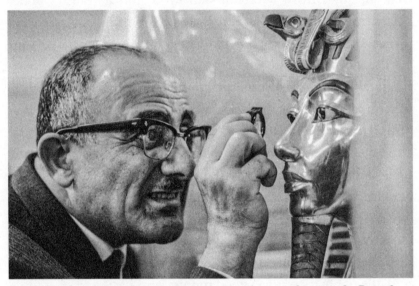

Zaki Iskander inspects the mask during its unpacking at the British Museum; photograph by Jane Bown, 28 January 1972

* * *

Margaret Hall was the woman in charge of putting the mask and forty-nine other priceless objects on display at the British Museum. Hall joined the museum in 1964, the first designer it had ever hired. Trained in interior design at the Royal College of Art, she responded to a job advertisement for an Exhibitions Officer, a 'lightly defined' role aimed at bringing visual coherence to the museum's labelling, which had until then been the responsibility of individual departments.[42] Hall's remit gradually

extended to every aspect of designing temporary exhibitions, and later to more permanent installations, such as the Museum of Mankind in Burlington House. With successes like 'Treasures of Tutankhamun' demonstrating what a benefit good design was to the institution, Hall was able to establish a dedicated – and influential – department that oversaw all aspects of visual display and signage at the British Museum. She authored an authoritative book on the subject (*On Display: A Design Grammar for Museum Exhibitions*) and was Head of Design at the museum until her retirement in 2001.

As planning for the as-yet-untitled Tutankhamun exhibition geared up in 1971, the future trajectory of her career was the last thing on Hall's mind. She was too busy, and Tutankhamun was just another job, Project No. 71 in the filing system she had created when she took up her post. By May 1971, she had drawn up a preliminary budget that covered her entire design remit – not only the build of the exhibition space and vitrines, but additional public toilets, changing rooms for the warders, publicity posters, brochures, invitations to the opening, signage around and within the museum, and a sales area that would be dedicated to the show.[43] Reading through the thick archive volumes of budgets, meeting minutes, and memos in the Egyptian department, I was struck by the fact that, other than the secretaries who took the minutes, Hall was almost always the only woman present when the various planning committees and sub-committees met. Once, over coffee in her calm Cambridge sitting room, I asked whether she had ever felt any bias or disadvantage due to sexism. She seemed a little surprised at the question. No, she replied. If anything, being a woman in this man's world had perhaps come in useful now and then.

The first hurdle Hall faced was where to put the fifty treasures that Edwards and the Egyptian Museum had selected. With

initial estimates projecting around a million visitors, a show
of this size was far too large for the British Museum's existing
temporary exhibition space, while a new, larger exhibition space
would not be ready until at least 1973.[44] Salvation came with the
decision to move the museum's ethnographic collections into a
satellite museum created by renting space in Burlington House,
in London's Piccadilly, which became the Museum of Mankind.

The move meant that an entire suite of rooms on the first floor
of the British Museum, directly above the King's Library, was
put at Hall's disposal, a blank slate on which she could create
a self-contained exhibition worthy of the golden king. External
building contractors created a suite of rooms within rooms using
stud partition walls. Deemed 'very vulnerable' by security con-
sultants, the part-glazed ceiling of the original galleries was fitted
with a metal security frame that the false ceiling of the exhibi-
tion galleries would hide from view.[45] Windows facing into the
courtyard were bricked up as a security precaution as well, and a
turnstile system installed at the entrance and exit of the exhibi-
tion space for crowd control.

Hall's design started, as it always did, from the objects. She
had not seen them in person, either in Cairo or on a previous
tour, but she had Edwards' list and a set of Harry Burton photo-
graphs of the relevant pieces, which Edwards obtained from the
Griffith Institute in Oxford, where Penelope Fox's hard work was
still paying off.[46] Mindful that the show was set to commemorate
the anniversary of the tomb's discovery, Hall wanted to give vis-
itors a sense that they were entering into a tomb-like space. The
dark walls of the final rooms are what impressed visitors at the
time, and what many people still remember. It was the 'first of the
dark exhibitions', Hall recently told an interviewer with an apol-
ogetic chuckle, since dark walls and low lighting would become
de rigueur in later 1970s and 1980s museum design.[47]

In fact, the design of 'Treasures' was more subtle. At the top of a flight of stairs, visitors entered an octagonal space, where they could purchase the catalogue, which Edwards spent much of 1971 writing at a frantic pace. They also passed through a turn-stile system, used to track the flow of visitors, whose number had been determined in part by how much weight the floor could hold. To enter the exhibition itself, visitors walked up a ramp towards a photograph of the mask printed 1.75m tall – a super-sized enticement for what was to come.

From there, they entered a maze-like space where the past loomed large, in the form of sepia-toned enlargements of photo-graphs by Harry Burton and *The Times* journalist who covered the 1920s discovery. The pictures celebrated the find as an achieve-ment of British perseverance (Carter) and aristocratic largesse (Carnarvon). The short texts that accompanied them, written by *The Times*' archaeology correspondent Peter Hopkirk, focused on the first season with no mention at all of the controversies – over press coverage and Egypt's ownership of the find – that had dogged the work. Such silent interludes were crucial to the dance of diplomacy, allowing Egypt and Britain both to save face by avoiding the topic of Britain's one-time colonial rule and Egypt's revolts against it.

Having imbibed this golden-toned history, visitors entered the 'tomb' by descending a ramp into a series of eight galleries dis-playing the fifty treasures. They had already been able to glimpse the guardian statue that greeted them in gallery one, thanks to a cutaway feature in the wall of the photographic display. The first four galleries had walls, ceilings, and carpet-tile floors in shades of yellow, cream, and gold that offset alabaster vases (gal-lery two, with the canopic coffin and alabaster stopper as well), the funerary bed (gallery three), and a selection of chests, stools, and chairs (gallery four). Gallery five displayed a single object:

the small golden shrine, with photographic enlargements around the walls showing Tutankhamun and Ankhesenamun as they appeared on its gilded sides.

In the sixth gallery, dark brown colours enveloped visitors and set off the gilded statuettes displayed there – with the harpooner in pride of place. Hall had designed vitrines that were lit from inside at the top of the case, while the toning of the vitrine structures with each gallery's walls, floor, and ceiling helped create an impression that the objects were almost floating in their own glow. The seventh gallery featured Tutankhamun's jewellery, in black vitrines lined with red silk. Hall had to rearrange these cases a few weeks into the exhibition's run, however, to solve a bottleneck. Visitors were spending much more time than anticipated looking at the breathtaking workmanship of the gold, coloured glass, and semi-precious stones, right when they should have been moving into the final gallery, where object 50 – the million-pound mask – was waiting.

Solitary in the centre of the last room, wrapped in walls of dark grey, the mask of Tutankhamun shimmered. Press photographs show people gathered around the case in rapt attention. Since the vitrine put the face of the mask above adult eye level, visitors either had to stand back or crane their necks to gaze upon the pharaoh, and children asked to be lifted up to take a closer look.

Behind the mask were two exits from the 'tomb' – not into the afterlife, but into the sales area that Hall had also designed. It was the first time the British Museum had attached a gift shop directly to the exhibition space. The novelty worked well from a sales point of view, even if such an explicit association between culture and commerce gave Penelope Fitzgerald an easy target in *The Golden Child*. The museum was sensitive to any suggestion of undue commercialization, or of profiting for its own sake.

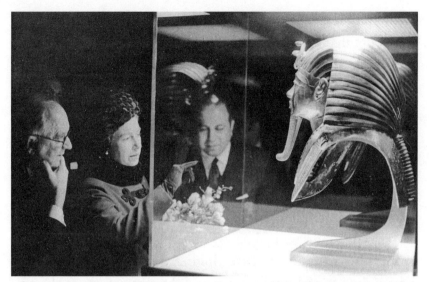

*The Queen with Eiddon Edwards and Gamal Mukhtar at the opening
of the British Museum's exhibition 'Treasures of Tutankhamun',
29 March 1972*

Large lettering on the wall of the sales space reminded visitors
that their purchases supported UNESCO's rescue of the Philae
temples. The selection of items on sale had been selected with
care: a range of jewellery replicas, slide packs and postcards,
posters, printed shopping bags, and a commemorative 3-pence
Tutankhamun stamp the Royal Mail had created for the occa-
sion. The Royal Mail also supplied a 'Treasures of Tutankhamun'
franking machine for anyone who wished to mail a postcard
straight away.

As a member of the publications committee, George Rainbird
had overseen the selection of books on offer in the sales area,
which was kept to a small number to complement the exhibi-
tion catalogue. A reprint of Christiane Desroches Noblecourt's
Tutankhamun: Life and Death of a Pharaoh was a strong seller,
as was a reprint of Howard Carter's three-volume *The Tomb of
Tutankhamun*, condensed into a single volume by leaving out the

photographic plates by Harry Burton. The Edwards catalogue
sold more than 445,000 copies, at 75 pence each, while a check-
list (a folded pamphlet with a small image and description of
each object) was 10 pence. The museum expected large numbers
of children to attend, whether in school groups (early mornings
were reserved for busloads of schoolchildren, at a discounted
entrance rate) or with their patient parents. With them in mind,
Rainbird commissioned a new book by bestselling *Ballet Shoes*
author Noel Streatfeild. Called *The Boy Pharaoh: Tutankhamen*,
it made use of Kennet's splendid colour photographs alongside
Harry Burton images and news photographs from the first exca-
vation season.[48] The text gave children a background to ancient
Egypt, the life of Tutankhamun, and the story of Howard Cart-
er's discovery. Streatfeild glossed over 'troubles and frictions' that
delayed work at the tomb in 1924, instead closing her account on
a triumphant note, with the opening of the coffins. Perhaps she
had read Howard Carter's journals in her research, or perhaps it
was by coincidence that she hit on the same biblical comparison
he noted there, to explain the libations poured generously over
Tutankhamun's wrapped-up body. Whatever her inspiration was,
Streatfeild's book for children ends with a tale from the Gospel
of Mark, in which an unnamed woman pours an entire alabas-
ter box of precious oil over Christ's head – and thus foretells
his death.[49]

* * *

Unlike France, England had a living monarch ready to wel-
come the ancient Egyptian king. Having the Queen open the
exhibition had been on the organizers' wish list from the start.
It matched the solemnity of the occasion without bringing overt
politics into it, as an invitation to the prime minister might have
done. But politics did matter, of course. In September 1971, the

Queen's private secretary, Sir Michael Adeane, wrote to Lord Trevelyan about where things stood – on Balmoral Castle letterhead whose distinctive red crest made me laugh when I came across it in a British Museum file. How absurd that Tutankhamun had now taken me almost to the Queen's own desk. But there had been no laughing matter at the time about political concerns in the Middle East, as Adeane spelled out to Trevelyan:

> We must, as you say, leave the way open for retreat if conditions in the Middle East make it impossible for the Exhibition to take place. I think we ought also to bear in mind that there might be circumstances in which the Exhibition might open in which it would be inappropriate for The Queen to perform the ceremony.[50]

The safe wording decided on for the press release about the exhibition was that 'it was hoped' the Queen would attend the opening reception. She agreed to have it added to her schedule, and she suggested that, if possible, the British Museum invite Lady Evelyn Beauchamp, Lord Carnarvon's daughter, who was the last living English witness to the opening of the tomb – and whose nephew Lord Porchester (the future 7th Earl of Carnarvon) was Her Majesty's racing manager.[51]

The opening of 'Treasures of Tutankhamun' on 29 March 1972 (the Wednesday before Easter) was as flawless as the red carpet laid out for Her Majesty, which British Museum staff had been warned to keep pristine for her arrival.[52] The daughter of an attaché at the Egyptian Embassy in London presented a bouquet of flowers to the Queen, whose speech pointed to Egypt's 'potent and valuable role' in the contemporary world and 'the links between our two countries', which Britain hoped to strengthen 'to our mutual benefit'. The FCO had drafted the

Queen's text, and Edwards edited the details.[53] It was unnecessary, and inappropriate, to specify the nature of the links that had bound Britain and Egypt together.

Six of the key people involved in the exhibition were presented to the Queen: Gamal Mukhtar, Zaki Iskander, and Egyptian Museum director Henri Riad, followed by Eiddon Edwards, Margaret Hall, and Philip Taverner. Time had also been set aside for Her Majesty to speak to Lady Evelyn, away from the cameras. The cameras were back, though, to follow the Queen's progress through the exhibition, guided by Edwards and Mukhtar, until she stood at last in front of the funerary mask – the only British monarch to see it in person since its discovery in the reign of her grandfather, King George V.

Extensive news coverage of the opening was part of the public relations campaign that Saabor and Taverner had devised, complemented by a healthy advertising budget of more than £43,000. Copious advertisements for the show in *The Times* and the *Sunday Times* were a given, and free, but paid advertisements also went into the main national newspapers in England (not Scotland) and several regional newspapers for towns and cities (Birmingham, Luton, Reading) that were within a day's journey by train from London.[54] Listing guides to London carried ads for Tutankhamun, likewise a magazine called *Student* that went out to universities and sixth-form colleges. The organizers sent 2,500 exhibition posters to other museums and placed nearly a thousand metre-high ('quad size') posters on British Rail lines and the London Underground. The sides of London buses were a 'prime medium' and well worth a fee of £5,000 for six months that would see Tutankhamun's mummy mask on a hundred of the city's distinctive red double-decker buses. It was near impossible to be in central London in 1972 and fail to realize that Tutankhamun's treasures were in the city, too.

For those who couldn't travel to London, there were other ways to experience Tutankhamun in Britain that year: every newspaper and television news programme covered the exhibition, and half an episode of the BBC's leading children's programme, *Blue Peter*, was devoted to the boy king just before the show opened. With an audience of 6 million, *Blue Peter* reached four times more people than the number who visited the show – and in the television studio, it featured some of the reproductions used in the 1924 British Empire Exhibition at Wembley, which had incensed Howard Carter into legal action at the time. Crafted in the workshop of London sculptor William Aumonier, the reproductions were part of a visitor attraction at the Empire Exhibition, replicating the Antechamber of the tomb. Carter tried, and failed, to stop it by arguing that the display was based on images whose copyright belonged to *The Times*. After the Wembley exhibition closed, Aumonier sold the reproductions to a businessman named Albert Reckitt in the port city of Hull, in north-east England. Reckitt donated them to Hull in 1936, and they survived the extensive bombing of its port during the Second World War. In 1972, the city's Wilberforce Museum (the abolitionist hailed from Hull) used them to stage its own Tutankhamun exhibition in tandem with the British Museum show and attracted substantial crowds as well.[55] There was a Tutankhamun for everyone – at least, for everyone in Britain.

Taverner had made a back-up plan for extra advertising in case attendance figures were not as high as hoped – always with the need to make a substantial donation to the Philae campaign in mind. He need not have worried. The only problem about getting people through the doors was getting them through fast enough. To that end, the museum set up a van in the forecourt area to sell catalogues ahead of time. Visitors could read while they waited, rather than holding things up on the galleries by checking objects

against their catalogue descriptions. Warders had instructions
about which way to direct traffic around the display cases and
how to regulate the flow from gallery to gallery. Rearranging the
bottleneck around the jewellery cases allowed about 1,500 more
people to pass through per day, Edwards reckoned.[56] Demand
was so high that the British Museum and the Foreign Office
soon asked – and received Cairo's agreement – for a three-month
extension of 'Treasures' until December 1972. Edwards reported
to Gamal Mukhtar in May that 'there has not yet been any time
when the Exhibition has not been full and there has been a queue
waiting outside'.[57]

*Queues for 'Treasures of Tutankhamun' snaked around
the courtyard of the British Museum and out into
the streets of Bloomsbury*

More even than the photographic enlargements, the darkened rooms, and the golden mask, what people who saw the exhibition remember about 'Treasures of Tutankhamun' are those queues. They were so long, and so emblematic of the proud British skill of standing patiently in line, that people who never saw the exhibition remember them as well. The queue and its camaraderie featured in news coverage, with vox pops about what had drawn the expectant visitors to the exhibition and how they had prepared for the wait. The *Times* reporter Peter Hopkirk noted that waits of up to eight hours had not put off visitors, even though a few were often disappointed at the end of the day, when they failed to make the last admission at 8 p.m.[58] A loudhailer gave hourly progress reports, at least, and a refreshment stand offered relief for anyone who had not packed a stalwart British flask of tea and some sandwiches. *Evening Standard* reporter Anne Sharpley described the queue forming at dawn as having 'the air of a cheerful shipwreck', as people arrived with picnic baskets, folding seats, and transistor radios to pass the time.[59] To be able to see the treasures without travelling to Cairo was one common reason people gave for why they had come to see Tutankhamun; others mentioned the pricelessness of the objects, the aura of the discovery, or the powerful association of Tutankhamun, ancient Egypt, and death.

To help accommodate demand, 'Treasures of Tutankhamun' was open Sundays from 12 to 6 p.m. and the rest of the week from 10 a.m. to 9 p.m., apart from Mondays, when the hours of 10 a.m. to 3 p.m. were reserved for school bookings. Schools responded in droves to the dedicated educational visits: there were 50,000 applications within a few days of bookings opening, 'including the whole of Eton College'.[60] Boys who had been through the exhibition told *The Times* that the highlight was the mask – 'the *death* mask', one boy emphasized, while another was

disappointed not to see the mummy. He had seen it in photographs – Noblecourt's and Streatfeild's books had shown the royal head, as photographed by Burton – and had expected it to be there among the treasures, too.[61]

The powerful impression that a visit to the exhibition made on children and adults has been brought home to me time and again. It is a living cultural memory in Britain. Whenever and wherever I have given a talk about Tutankhamun's tomb to a British audience, someone raises a hand or comes up afterwards, with a memory of having been to the British Museum, or of having wanted to go but being thwarted by distance, expense, or uninterested parents. It is the excitement of going, as much as anything they saw, that seems to have stayed with those who did make it to the British Museum. One man I met recalled the thrill of being bussed past the waiting queues of grown-ups when his own school visited – and he still had the *Evening Standard*'s special supplement, bought for 5 pence, its lapis blue cover vivid after 45 years. A businesswoman who had been in beauty school in Bloomsbury at the time heard the queues forming at dawn from her bedsit; another woman remembered queuing, 'very pregnant', to see the exhibition and 'being enthralled by it', in particular the opportunity to see such rare objects up close.[62]

People came to Bloomsbury for what they thought would be a once-in-a-lifetime opportunity – easier, less expensive, and less risky than travelling to Cairo. It was a chance to see a British find on British soil: Edwards' hunch proved right. Some VIP visitors had special access – Prince Charles came early in the morning, via a side entrance – but most of the 1.6 million visitors waited their turn to see the boy king.[63] Penelope Fitzgerald's sharp eyes and pen captured the experience of that waiting better than the glib newspaper journalists: the crowds, she wrote, were 'determined to see and have seen. Like pilgrims of a former day, they

were earning their salvation by reaching the end of a journey.'[64] Up the stairs, through the turnstile, up and down a ramp and through the maze of history. Death was always waiting.

* * *

A reviewer for the British magazine *Country Life* declared. 'If Tutankhamun visited the British Museum this summer he might well think that some new temple had been set up in his honour.'[65] The museum's Robert Smirke façade looked like a Greek temple, not an Egyptian one, of course. Tutankhamun would not have recognized it. But he would have felt on familiar ground at Philae, the island home to a temple of Isis built almost a thousand years after he died. Since temples, like the gods, were eternal, their architectural forms were slow to change. Modest tweaks, not radical reform, were the ancient Egyptian preference. An Egyptian temple represented fertile earth emerging as the Nile flood receded, its columns the marsh plants that flourish on the margins where land and water meet. Cult images of the gods lived locked away in its innermost rooms, tended by priests – and it was there, in the dark, that the hard seed of new life could start to grow.

Like Abu Simbel, Philae had captivated Western tourists for two centuries. 'Philae' was even the name of the *dahabiya* that Amelia Edwards hired for her momentous journey on the Nile in the winter of 1873–74, and she described her approach to its island thus:

> . . . that Temple which has been so often painted, so often photographed, that every stone of it, and the platform on which it stands, and the tufted palms that cluster round about it, have been since childhood as familiar to our mind's eye as the Sphinx or the Pyramids.[66]

Known as the 'pearl of Egypt' already in an Underwood &
Underwood stereograph from 1903, its island setting in the
midst of the river made for the picturesque.[67] The Arabic name
by which local people knew the island evoked a tale from *A
Thousand and One Nights*: it was the Qasr (palace) of Anas al-
Wujud.[68] Instead, the toponym Philae used in European lan-
guages reflects Greek and Roman interest in the island, most of
whose structures date to the Ptolemaic era, when rulers of Mace-
donian descent (like Cleopatra) ruled Egypt. A temple dedicated
to the goddess Isis dominates the island, which also hosts smaller
temples and a charming 'kiosk' associated with emperor Trajan.
Philae was a pilgrimage destination for centuries, and the walls
of the Isis temple include the latest dated inscriptions in both the
hieroglyphic and Demotic Egyptian scripts, from A D 394 and
452 respectively.

*The island temple of Philae, the 'Pearl of Egypt', photographed
when the Nile was not in flood, around 1900; stereograph
by the Underwood company*

When construction of the first Aswan Dam threatened to flood the main temple for most of the year, almost to the top of the tallest columns, French author Pierre Loti (the pen name of naval officer Louis Marie-Julien Viaud) lamented *la mort de Philae* in his dramatic travelogue of the same name.[69] The subsequent raising of the first dam did not alter the situation. The island was submerged for nine months of the year and lost its palm trees to the waters. But to lose the temples altogether was one of the rallying cries of the UNESCO 'Campaign to Save the Nubian Monuments'. Since the mid-1950s, engineers had proposed several potential solutions: a separate series of dams, an artificial lake, raising the temple's foundations, or relocating it to the island of Agilkia downstream, out of harm's way. With Abu Simbel raised to higher ground, UNESCO settled on the last of those options, issuing an appeal to help relocate the temples of Philae, on 6 November 1968.[70] Dutch engineering firm Nedeco was in charge, and the expected cost was $12.3 million.[71]

Just a few weeks after the appeal appeared, Eiddon Edwards wrote to a contact in the British government's Department of Education and Science, glad to hear that Britain had pledged £62,000 to the Philae campaign, paid in instalments over the course of 1971.[72] Philae was 'far more important artistically and historically than Abu Simbel' and would still be in its natural setting, not butted up against concrete domes.[73] The Foreign and Commonwealth Office was keen to support the Philae effort, considering it to be in British interests and to offer some 'insurance against more difficult relations on e.g. the Arab/Israel dispute'.[74] Raising funds for Philae was the key Edwards had needed to open negotiations for a Tutankhamun exhibition – and when 'Treasures of Tutankhamun' ended its record-breaking run on New Year's Eve 1972, Taverner's team began totting up the receipts, costs, and profits as a priority. Had the British delivered

on their promise to raise more than £500,000 – and had they managed to beat the French?

Both France and Cairo had been cagey throughout about the size of the donation raised by Noblecourt's exhibition in Paris five years earlier. Thanks to Swedish Egyptologist Torgny Säve-Söderbergh, who worked closely on the Nubian campaigns, Edwards was able to discover that France had donated $473,623 in proceeds (equivalent to £197,343), while the Japanese exhibitions had yielded $1,122,878 (or £467,860).[75] With all the receipts in – from admission prices, shop and catalogue sales, and the slide show that visitors could pay an extra 10p to see while they waited – it became clear in early 1973 that the British Museum show had exceeded expectations. A donation box added halfway through the exhibition run added a further £3,000, in the form of loose change, dollar bills, and £5 notes.

There was a testy problem to smooth out about the expenses, though, when the exhibition accounts turned up an unexpected fee for management services charged by the Times Newspaper Group. A flurry of phone calls, meetings, letters, and stiff-sounding memoranda failed to dissuade Denis Hamilton that his newspapers had legitimate claim to charge a fee for Philip Taverner's services. Taverner had not been an employee of the Times Newspaper Group during his work on the exhibition but director of an independent company, hence his services had not been for free as the British Museum seem to have assumed.[76] It was a hard blow. But even with the added £22,500 cost of the fee, the 'Treasures of Tutankhamun' yielded £600,000 for UNESCO – which Lord Trevelyan, Chair of the Trustees, presented to Gamal Mukhtar and René Maheu at a luncheon hosted in *The Times* boardroom on 2 May 1973 in London. Denis Hamilton signed the cheque and expressed the hope that the treasures might make their way to Britain again in another half century.[77]

It was left to the Egyptian ambassador, Kamal Rifaat, to empha-
size the non-fiduciary aspect of the Tutankhamun endeavour: it
was, he said, 'a mission of good will from the people of Egypt to
the people of Britain'.

That good will was probably not the message most visitors
to the exhibition took away, although it did spark some inter-
est in contemporary Egypt. The Egyptian Tourism Information
Centre that year noticed a significant increase in enquiries about
travel to Egypt.[78] At Oxford, the Griffith Institute instead felt
somewhat beleaguered by requests from the media concerning
Howard Carter, Tutankhamun, and the history of the excavation.
An 'insatiable desire for prints and information' stretched the
staff 'at times to their limit', according to their annual report.[79]
With all the new public attention paid to ancient Egypt, how-
ever, Egyptology – until that point perhaps a small and rather
stolid academic subject – suddenly took on some of Tutankha-
mun's shine. British Egyptologists and archaeologists gathered to
commemorate the November 1922 discovery with a lavish din-
ner in November 1972, held in the Duveen Gallery of the British
Museum. Tables set with white tablecloths and flowers filled the
floor between the snorting horses of the Parthenon frieze.[80]

A new generation of Egyptologists was no doubt born on the
back of the exhibition and its publicity, but perhaps the most last-
ing, if unintended, impact of the show in Britain was a sense of
pride during what was otherwise a rather bleak period for Brit-
ain's domestic economy and political standing in the world. The
sun may have set on the British Empire, but thanks to Tutankha-
mun and the sepia-toned photographic memories of discovering
the tomb, something of the island nation's old pith-helmeted
pride had blazed back up in a nostalgic glow – and taken its place
in an orderly queue.

The exhibition had kept Edwards working at an astonishing

pace for several years. His efforts were recognized in the New Year's Honours list of 1973, when the Queen appointed Eiddon Edwards as a CMG, that is, a Companion of the Order of St Michael and St George – an honour bestowed on British citizens for extraordinary services in foreign affairs.[81] Tutankhamun continued his own services to foreign affairs on Egypt's behalf, the dance steps of his 'treasures' by now well rehearsed. In November 1973, a similar selection of objects as London had seen headed for a two-year tour taking in Moscow and Leningrad (as St Petersburg then was) in Russia, and Kyiv (then Kiev) in Ukraine. Like Penelope Fitzgerald's fictional state of Garamantia, Egypt had kept its Soviet options open. All costs of the tour were to be borne by the Soviet government, although some sources suggest that the loan helped settle debts Egypt owed to the USSR, presumably for engineering and military expertise.[82]

The director of the Hermitage Museum in Leningrad, Boris Piotrovsky, signed the loan agreement in Cairo in August 1973.[83] Piotrovsky was an eminent archaeologist, best known for his work on the ancient Urartu kingdom that straddles present-day Turkey and Armenia. But his first love was Egyptology, which he discovered as a teenager in the 1920s, when the Tutankhamun discovery was in the news (it may, in fact, have helped inspire Lenin's embalming). Piotrovsky first joined the Hermitage as a volunteer while still in school, copying ancient Egyptian scenes for exhibitions, lectures, and publications by curator Natalia Davidovna Flittner – one of the first women to graduate from a university in Russia, who went on to become an influential museologist and historian of ancient art.

Piotrovsky began to visit Egypt in the late 1950s, when he was director of the Institute of Archaeology in Leningrad, and in 1961 he became the Soviet Union's representative on the International Action Committee for the UNESCO Nubian

monuments campaign. Putting his archaeological experience to work, he led excavations at the sites allocated to Russia as part of the Nubia campaign's archaeological salvage work, uncovering a 2nd millennium BC cemetery associated with a route to the region's ancient gold mines. Bringing a tour of Tutankhamun objects to the Soviet Union – and especially to the Hermitage, where he became director in 1964 – thus had deep personal and professional resonance for Piotrovsky. Moreover, his son Mikhail was an accomplished Arabist who studied in Cairo in the 1960s, married a fellow Arabic scholar specialized in Middle Eastern oil production, and later succeeded his father as director of the Hermitage in 1992, just as the Soviet Union unravelled.

The honour of being the first host of the Soviet 'Treasures' tour fell not to the Hermitage, however, but to the Pushkin Museum of Fine Arts in Moscow, then headed by its long-serving director Irina Antonova – who was born the same year as the Tutankhamun discovery.[84] Antonova dispatched chief curator Evgenia Georgievskaya to Cairo in September 1973 to oversee the packing of the objects at the Cairo Museum. With Georgievskaya were conservator Valentin Petrov and photographer Vasily Robinov from the Grabar State Art Restoration Workshop in Moscow, together with staff from the Vuchetich All-Union Artistic Production Association, which helped coordinate art exhibitions throughout the USSR. Only one object – the guardian statue[85] – remained to be packed when the second Arab–Israeli war broke out on 6 October. To get them safely out of the country, the Soviet curatorial team and staff from the Soviet Embassy were driven in complete darkness to Alexandria to board a merchant ship that took them back to Russia until the situation stabilized. Georgievskaya and the conservator, Petrov, flew back to Cairo on 20 November in an Antonov An-10 military transport plane, with a second plane in tow to accommodate all thirty-four crates

and their armed escort. From the still-warm Egyptian autumn, the crated objects landed at frigid Sheremetyevo Airport in Moscow and were transferred to army trucks for the journey to the Pushkin Museum.

At the museum, director Antonova was on hand to greet the war-delayed arrival of these ancient ambassadors. Soldiers carried the crates up the museum's grand Rose Stairs, named for the colour of their polished stone surrounds. The exhibition occupied the lofty White Hall on the first floor, with fluted classical columns supporting a coffered ceiling high overhead. Installation took place under the watchful eyes of the armed guards who would be a constant presence throughout the Soviet tour. Two Egyptians had accompanied the objects: Dr Ibrahim Nawawy, curator of the Tutankhamun collection, and Saleh Ahmed Saleh from the Cairo Museum's technical department. Alongside their Russian counterparts, they checked the condition of the objects before any were installed in the vitrines. This is standard practice whenever artworks travel, in order to identify changes that may take place in transit or during an exhibition's run. Saleh had concerns about the wintry air in the Pushkin Museum, which was apparently drier than conditions in Cairo and necessitated some protective, but unspecified, intervention. Changes in humidity levels are a danger to organic materials like wood and ivory, which continue to breathe like the living things they once were, taking in moisture or letting it evaporate, expanding and shrinking all the while.

A photographer documented the unpacking of the objects and these consultations, which also involved exhibition curator Raisa Shurinova and the Pushkin's Egyptology curator, Svetlana Hodjash. Women were well represented in cultural professions during the Soviet era, and Hodjash was a formidable figure when I encountered her in Boston in the mid-1990s during a

conference she attended at the museum where I was a student intern. Born into a Karaite Jewish family in the Crimea in 1923, Hodjash lost her mother young and her father in 1941, when he was executed by invading Nazi-led forces.[86] She fled to Moscow and enrolled on an art history course at the university, joining the Pushkin Museum in 1944 and working there until her death in 2008. For some people, the study of ancient Egypt has been life-saving in a literal sense, not just a figural one.

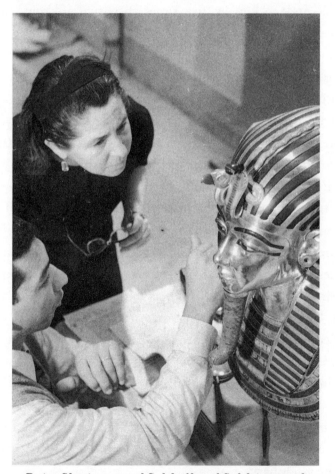

Raisa Shurinova and Saleh Ahmed Saleh inspect the mask of Tutankhamun before its installation in the Pushkin Museum, late November 1973

Opening night of 'Treasures of the Tomb of Tutankhamun'
took place on 7 December 1973, when Antonova and the Min-
ister for Culture, Ekaterina Furtseva, cut a ceremonial ribbon
before crowds gathered in the museum's Italian Hall. During its
six-month Moscow run, until 20 May 1974, 'Treasures' attracted
1.2 million visitors, with late-night openings and timed entrances
at two-hour intervals to accommodate them all. Even so, there
were four-hour waiting times for individual tickets, priced at
1 rouble and 50 kopeks, five times the usual 30-kopek admis-
sion fee. Visitors were admitted in groups of 1,200 for a strictly
observed 90-minute period, giving the security team half an hour
to prepare for the next entrance.

Boris Piotrovsky welcomed 'Treasures' to the Hermitage be-
tween 3 July and 10 October 1974. The Leningrad venue hosted
800,000 visitors, using the same system of timed entrances.
Egyptologist Andrei Bolshakov was already interested in an-
cient Egypt when he visited the exhibition as a teenager, with
the entrance queue stretching down the Winter Canal. The ex-
hibition design echoed Margaret Hall's choices at the British
Museum, with individually lit display cases in otherwise darkened
galleries, so that the artefacts 'seemed to hang in the darkness'.[87]
At a time when foreign travel was unthinkable for most people
in the USSR, the exhibition brought Egypt closer and visitors
travelled long distances to see it. One man, now based in Tatar-
stan, recalls travelling on a bus tour with fellow factory workers
from his home in Pskov, 280 kilometres from Leningrad along
the banks of the Neva.[88] He was struck by the presence of
numerous guards armed with Kalashnikov rifles, including one
who stood on permanent duty next to the armoured case that
held the gold mask.

Visitor comment books – a standard feature of Soviet exhibi-
tions – record visitors from Moldova, Estonia, Latvia, and Siberia,

along with several group visits by school and university students and members of the Komsomol youth organization. There were complaints about the small number of objects, the darkness, the armed guards, and the apparent requirement that women could not bring their handbags into the exhibition space. But most comments expressed amazement and delight for the privilege of seeing the magnificent objects, and gratitude to the people of Egypt for preserving them and allowing them to travel to Russia. Perhaps visiting employees of the Kalinin Atomic Power Station captured the luminous spirit of this Cold War occasion best: *The enormous, impressive force of art provokes thoughts of kindness, of peace, of the desire for riches and power. There's a lot of gold. Man has lived on earth for a short time. People, be more human, be better.* They concluded: *Thank you for a window into world culture.*[89]

The last of the Soviet venues, and least only in size, was the National Art Museum in Kyiv, the historic capital city of Ukraine nestled on the high banks of the Dnieper. There, 'Treasures' had a shorter run, from 6 January to 14 March 1975, but still hosted more than 170,000 visitors – a record that holds today and that exceeded the 120,000 visitors that the Soviet Ministry of Culture had planned. Recent research about the staging of the exhibition in Kyiv, drawing on oral history interviews with visitors, points to the deeper impact the experience had on public opinion towards Egypt.[90] The Marxist–Leninist theory of history had classified ancient Egypt as a slave-owning society, placing it on the second-lowest rung of five developmental stages, with socialism and communism at the top. This understanding of the past, perhaps more influenced by biblical traditions than Lenin would have liked, meant that Soviet education had tended to present the ancient Egyptians as barbarous and oppressive. But the sensitive workmanship of Tutankhamun's treasures, and the dazzling history associated with them, fostered a more positive view of

ancient Egypt – and one that fit more comfortably with Egypt's recent history as a socialist republic under President Nasser, even though he had resisted aligning with either the Soviet or American side in the Cold War.

At the time of the London and Soviet 'Treasures' tours, however, Nasser's successor Anwar Sadat was reconsidering where Egypt's best interests lay. The outcomes of the 1967 and 1973 wars had dented Egyptian confidence and altered balances of power throughout the region, while many reforms that had seemed promising at the start of Nasser's rule had failed to deliver hoped-for prosperity, much less parity. In an era marked by the threat, and lived reality, of Arab–Israeli conflicts, and bolstered by the Non-Aligned Movement in which it had played a key part, Egypt had for many years been disinclined to please America too much. But America was tapping its feet, eager to take Tutankhamun for a spin.

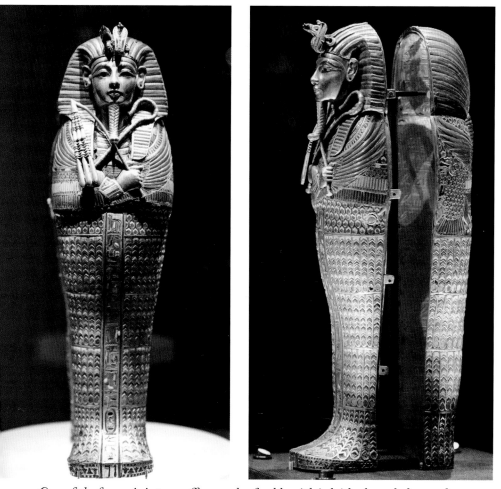

One of the four miniature coffins made of gold, with inlaid coloured glass and semi-precious stone; each contained parts of the wrapped, embalmed organs removed during the embalming of Tutankhamun.

Howard Carter's copy of a scene from Queen Hathshepsut's temple at Deir el-Bahri, showing her grandmother, Queen Seniseneb. Tempera on paper, 35.5 cm high; signed and dated 1899.

Above: *A sheet of linen and a floral wreath, left over from the burial of Tutankhamun and buried nearby in 'tomb' KV54, cleared in 1907.*

Below left: *Painted wooden head of a young royal (possibly Tutankhamun) on a lotus blossom.*

Below right: *Portrait of Howard Carter painted by his brother, William Carter.*

Above left: *One of the guardian statues from the Antechamber, representing the ka-spirit of Tutankhamun.*

Above right: *A vase for perfume oils on a stand, each carved from a single alabaster block.*

Below: *The face of one of the two harpooner statuettes, of gilded wood with eyes and brows inlaid in coloured glass.*

Temple from Dendur in Egyptian Nubia, built around 15 BC, seen above in a late 19th century photograph and below in the Metropolitan Museum of Art, New York, where it was re-erected in 1978.

Above: Evening Standard *newspaper supplement for the 'Treasures of Tutankhamun' exhibition at the British Museum, 1972.*

Below: Facsimile of the burial chamber of Tutankhamun's tomb and sarcophagus, created by Factum Arte.

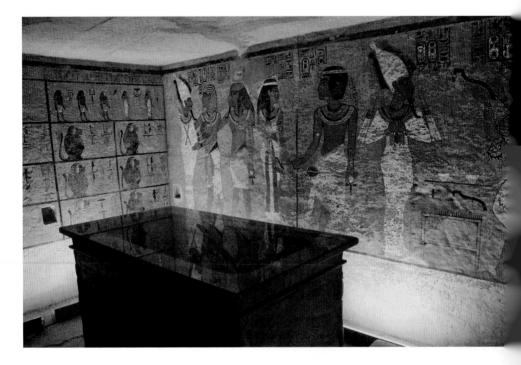

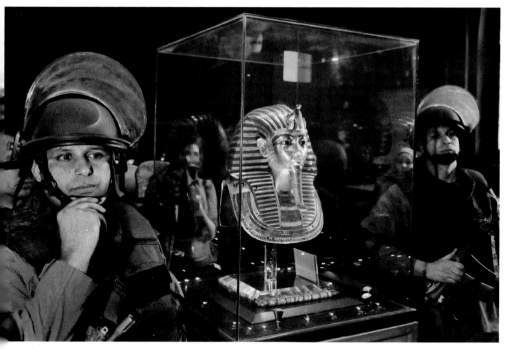

Above: *Egyptian soldiers with the mask of Tutankhamun in the Egyptian Museum, Cairo on 16 February 2011, after protests forced President Hosni Mubarak to resign.*

Below: *Conservator Ahmed Abdel Rabou at work on the largest of Tutankhamun's three coffins at the Grand Egyptian Museum, Giza in early 2020.*

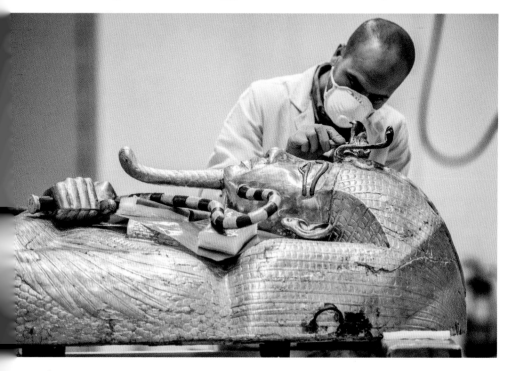

Street art during the 2011 Egyptian Revolution used the mask of Tutankhamun to make political points. Inspired by Leonardo da Vinci's 'Vitruvian Man', this image maps the violence sustained by protesters, including an eye patch from rubber bullets.

6

Land of the Twee

I HAVE MY OWN museum, in a century-old glass-topped box that fits into my hand, saved with permission from the discards of a storage rearrangement in a museum where I once worked. My museum-in-a-box holds jewellery knock-offs in Egyptian style. An *ankh*-ring that I wore in high school, a silver cartouche that spells my name (picked up for me in Cairo by a college boyfriend), scarab bracelets that were chance finds or gifts. The prize items in this tangle are two pendants that are souvenirs of Tutankhamun, or rather of the merchandising melee that his second visit to America inspired in the late seventies, when King Tut became King Tat.

The objects we put into glass boxes defy straightforward explanations. Values may lie not in raw materials but in the memories an object holds. Those pendants to me are souvenirs of one of the last things I did with my father, a month before my sixteenth birthday. We made a day-long drive to the East Coast to visit Brown University for my admissions interview, stopping first in Boston to see an exhibition about Ramses II 'the Great', the pharaoh monumentalized at Abu Simbel. His beak-nosed, desiccated face had been familiar to me since childhood, thanks to a photograph of his unwrapped corpse in *The Last Two Million Years*. I spotted the Boston exhibition in a newspaper and showed it to my father before he creased the pages back to do his evening

crossword. Could we go? Money was tight, and holidays were usually spent on family visits. Somehow, he said yes.

Ramses did not disappoint. I stood, feeling solemn, before the simple wooden coffin that once held his shrouded remains, a legacy of later reburial that may also have stripped the coffin's surface of gold leaf (the body of the king had stayed in Cairo).[1] Outside under a summer sky, Dad and I craned our necks at a colossal statue shipped from Egypt and set up in its own shelter in the Museum of Science grounds. Not the Nile but the Charles River bobbed nearby, heading towards the ocean. I wanted to follow it as far as it would go. Dad wanted to see the USS *Constitution*, moored somewhere on its banks.

The next day we drove an hour south to Providence, Rhode Island, navigating the steep streets and cobbled sidewalks of College Hill. A walking tour took us past the Egyptology department housed in Wilbour Hall. 'That's where I would go, Dad.' He nodded, noncommittal. The August day was overcast and muggy. My stomach butterflied with nerves. My parents looked anxious too, and out of place. They said that I should study something sensible and somewhere close to home.

When we were back on more familiar ground, my father wrote to his mother in Detroit. 'Surprise! A letter from me', it starts; correspondence was my mother's sphere, not his. He wrote about the rebuilt house, his latest job, our trip. 'There's nothing like the Ivy League schools in Ohio nor Michigan. They are definitely better. Brown University would cost $18,500 a year for tuition, books, room and board,' about as much as he was earning. But he went on: 'It does have the best program in Egyptology (which I can't talk her out of).'

Until I read that letter decades later, I was not sure how my father felt about my chosen path. Dead fathers, like dead pharaohs, rarely speak. On that Boston visit, in the inevitable museum

gift shop, I lingered indecisive over two Egyptian pendants, a fly-
ing falcon in red and silver tones and a protective 'Eye of Horus'
enamelled blue and white. Get both, said Dad, in a rare moment
of largesse. They were copies, much diminished, of two jewels
among the dozens in the tomb of Tutankhamun. Base metal can
become a precious thing.

Tutankhamun worked his American alchemy on a seven-city
tour, from 1976 to 1979. There were no Nubian temples left to
save, but the 1973 Arab–Israeli war and ensuing oil crisis made
tighter ties to Egypt a key plank of foreign policy for the United
States. Bigger and bolder than all the other versions held to date,
this 'Treasures of Tutankhamun' was meant to win American
sympathies for ancient and modern Egypt alike, and generate
much-needed income for both the host museums and the boy
king's Cairo home.

The British Museum's Tutankhamun had a stiff upper lip
compared to the 'Treasures' show that took America by storm.
Nor was there any echo of the serious Soviet spectacle that had
seen Tutankhamun disappear behind the Iron Curtain for a spell.
In the United States, cash registers rang to an Egyptian tune, and
King Tut even had a Billboard Number One. The Gatsby glitz
had some serious intentions underneath, however. The American
organizers wanted to expand public access to culture and pro-
mote the idea that all art had aesthetic value. They were in for
a surprise when Tutankhamun went to the nation's head as well
as to its roots, notably the roots of African Americans who had
a long, rich history of identifying ancient Egypt as an ancestral
home. The shine on Tutankhamun's treasures held up a mirror to
a country that had just marked its Bicentennial – but was as blind
to its own history as any nation is.

* * *

Bringing Tutankhamun back to America involved the input of
two museum directors who could trace their families to the coun-
try's founding, and who had been raised amidst the immense ease
and privilege that old names and money buy. Thomas Hoving
became director of the Metropolitan Museum of Art in 1967
and steered it through a decade of expansion, major fundraising,
and headline-grabbing acquisitions and exhibitions, not least
'Treasures of Tutankhamun'. His mother was a descendant of
the Osgoods, who settled in Massachusetts in the seventeenth
century, and his Swedish-born father was a Brown University
graduate who headed up the Bonwit Teller department store and
the jewellers Tiffany & Co.

Hoving grew up in the high life of Manhattan, although
the end of his parents' marriage saw him expelled from several
excellent East Coast boarding schools.[2] Salvation came through
culture, and Hoving earned three degrees in art history at Prince-
ton University. With a connoisseur's eye and a showman's soul,
Hoving shared his father's flair for business. Before becoming
director of the Metropolitan Museum, he spent several years as
a curator at The Cloisters, its medieval outpost in Washington
Heights. He also served as parks commissioner for New York
City in the 1960s, a flirtation with political life that seemed to
suit him – and perhaps made museum directing seem a doddle
in comparison.

John Carter Brown III made his career at one institution:
the National Gallery of Art in Washington DC. He arrived as
assistant director in 1961, just around the time that Jacqueline
Kennedy opened the 'Tutankhamun Treasures' show, and he
led the museum as director from 1969 to 1992.[3] Carter Brown's
ancestors were early settlers of the Rhode Island colony and
leading Baptists. By the eighteenth century, the Brown family
had a thriving mercantile business that included slave shipping

between Africa and the West Indies, a trade in which tiny Rhode Island was dominant. The slave trade split the generation of brothers who founded the college that became Brown University. One brother, John, thrived on it; a second brother, Moses, converted to Quakerism and became an outspoken abolitionist; and a third brother, Nicholas, withdrew the family business from the trade after the unprofitable journey of the *Sally* in 1764, the year the university was founded. More than half of the 196 captive men, women, and children on board died through suicide, starvation, disease, and a failed insurrection on the journey between the Ivory Coast and Antigua.[4] Nicholas Brown found easier ways to make, and keep, a fortune.

Descended from Nicholas's family line, Carter Brown grew up with that fortune between Boston, Providence, and Newport, Rhode Island. As a student at Brown, I often passed the family's elegant eighteenth-century home on Benefit Street on my solitary walks around the city. Tree roots rippled through the cobbled pavements, and windowpanes were slanted by the weight of time. My pinch-me disbelief at where I was had its double in stabbing self-doubt and sadness. I neither belonged nor, I suspected, should have been there. Admissions and financial aid were linked at that time, and my application had included a letter from a hospital neurologist, stating that my father – the family's sole support – was unlikely to recover consciousness. By the start of my second year, depression (though I had no name for it) had me subdued in its grey grip. Dead set on an archaeology degree and graduate school, I poured what energy I had into my studies and part-time jobs. I knew no other students who worked to pay their way, and the ease with which new friends spoke of European travel, internships in Manhattan, and Brie (it was the early 1990s) made me wonder if I would ever belong anywhere again.

Refuge was in 'the Rock', the university library paid for by

the Rockefeller family's oil money, as so many things have been. Long shelves of books, each spine an invitation, and wooden carrels tucked between slim windows: these I understood by instinct and inclination. In retrospect, I think my sense of always looking in from the outside, observing from the edges, made me a better scholar. When you have no preconceptions, it is easier to reason for yourself, and when you see that every institution has its rigging, you can choose which parts to climb and leave the rest. As my degree, and my depression, progressed, my lecture attendance was sporadic, but the time was not entirely wasted. I could read at any hour of the day or night, besides which, my childhood dream of being an Egyptologist was my only fixed reference point. My dwindling visits home were awkward, as my wounded, mourning family faced a stranger in their midst. An older brother turned his back and blamed my 'liberal arts' education for my lack of Christian faith. Numb with grief after the fire and my father's death, my mother claimed Dad had not wanted me to go. She counselled prayer. But studying was the only saving grace that I had known.

Carter Brown had no doubts based on social standing or family approval. Top of his class at the Groton School (he graduated at age sixteen), he spent a year at Stowe School in England, set in an eighteenth-century country house, before enrolling on a history degree at Harvard University, where his chauffeur was a familiar sight. Already set on a management role in the arts, Carter Brown took the unusual step of earning a master's degree at Harvard Business School. To bone up on art history, he went back to England and Europe in 1958, aged twenty-four, including several months spent with Harvard alumnus, art dealer, and influential connoisseur Bernard Berenson at I Tatti, his villa just outside Florence – where Harry and Minnie Burton had been regular visitors, decades earlier, and where photographs Burton

took of Berenson's own art collection were still filed away.[5] Carter Brown went on to Paris, in 1959, to audit classes at the École du Louvre, where Christiane Desroches Noblecourt had studied. A course of lectures in ancient Egyptian art – perhaps by Noblecourt herself, who held a professorship at the École – inspired Brown to travel to Egypt that spring.[6] Even in that, he was following in the footsteps of his father John Nicholas Brown, who had, as a young man, witnessed the excavation of the tomb of Tutankhamun in the 1920s.[7]

Their methods and motivations may have differed – Hoving with his Fifth Avenue flash and Carter Brown a popularizing patrician – but both men wanted to bring the best of the art world to the widest possible audience. Ancient Egyptian art had never sat entirely comfortably in conventional narratives of Western art history, but attitudes and the art market had changed in the generation that came of age post-war. The Egyptian objects that Lord Amherst had crammed higgledy-piggledy into packed cases in his 'Museum', were now sold and displayed as artworks for prices that would have astonished him, and they demanded a setting appropriate for their new status, which was nearer to fine art than ancient curios. The British Museum was not an art museum like the Metropolitan Museum or the National Gallery of Art, but the aesthetic of Margaret Hall's design for 'Treasures of Tutankhamun', with its minimal labelling and vitrines lit from within, made it easier to see Egyptian artefacts as worthy of inclusion in an art-focused exhibition programme. Add to that the sky-high visitor figures and healthy ticket sales, and no wonder Carter Brown and Hoving had each tried to bring Tutankhamun to their respective institutions in the early 1970s, with no success.

Politics was one barrier they faced. Under Kennedy's presidency, the 'Tutankhamun Treasures' tour took place in the calm

between the 1956 Suez Crisis, when America stood up for Egypt against European intervention, and the 1967 Arab–Israeli war, which had humiliated Egypt and reaffirmed allegiances among the NATO powers and between America and Israel. Around the time of the Paris show in 1967 and the London 'Treasures' in 1972, Egyptian authorities refused several Tutankhamun requests from American museums, Hoving's and Carter Brown's among them. Egypt was on America's 'strained relations' list, and cultural organizations felt the strain as well.

In the autumn of 1973, a new Arab–Israeli conflict restored Egyptian military pride – but with wide-reaching consequences for American involvement in and with the Middle East. The surprise opening salvo of the war took place on 6 October, as Egyptian troops crossed the Suez Canal into Israeli-occupied Sinai for the first time since the Six-Day War. The date, which coincided with Yom Kippur observances in Israel and fell in the Muslim holy month of Ramadan, became a public holiday in honour of the armed forces in Egypt, recognizing the initial success of the Egyptian–Syrian coalition. Short but brutal for both sides, the conflict ended later that month in a ceasefire brokered by US Secretary of State Henry Kissinger and the United Nations Security Council.

At the outset of the hostilities, other Arab countries, led by Saudi Arabia, moved to back the coalition by cutting off oil supplies to the West. The ensuing energy crisis highlighted American dependence on oil imports and its high rate of consumption, which amounted to 70 per cent of global oil output at the time. The home-grown 'black gold' that featured in sixties sitcom *The Beverly Hillbillies* (a family favourite) was drying up. Many Americans, my parents included, began to size up their gas-guzzling cars with dismay. Conservative politicians, religious leaders, and media looked for culprits elsewhere, too, hitting on the well-worn

stereotype of greedy and duplicitous Arabs who were keeping all that oil for themselves. With Israel by then a nuclear power, the 6 October war and oil crisis put the Soviet Union and the United States on full-scale nuclear alert. Something had to be done to dampen down tensions in the Middle East.

President Richard Nixon threw money at the problem. In helping broker the terms of a ceasefire between Israel and the Egyptian coalition that autumn, Nixon and his Secretary of State Henry Kissinger offered President Anwar Sadat substantial foreign aid. Sadat's foreign minister, Ismail Fahmy, had a personal meeting with Nixon in Washington, during which Nixon told him that the United States wanted to focus its strategies in the Middle East on Egypt, which it saw as the main Arab power in the region. A visit by Kissinger to Cairo in November 1973 formally re-established relations between the two countries, and Sadat named Ashraf Ghorbal as Egyptian ambassador to America.[8] On the basis of this new relationship, and its financial underpinning, Sadat urged the Saudi-led pact of oil-producing countries to halt the oil embargo.[9] Non-existent in 1973, American aid to Egypt reached \$1 billion by 1976, second only to the aid it gave to Israel.

Nixon became the first American president to visit Egypt in June 1974, two months before the Watergate scandal forced him to resign. He and Sadat proved to have a good rapport, and Nixon had come prepared with a suggestion.[10] Why not seal their deal with a reciprocal gesture from Egypt to the United States – namely Tutankhamun, who had only just got back from his tour of the USSR, where crowds had greeted him in Leningrad, Moscow, and Kiev. Nixon's move was not off the cuff. Since the 1960s, the US State Department had an arts advisor on its books: former *Life* magazine photographer Peter Solmssen. Solmssen knew about the previous attempts both Carter Brown and

Hoving had made to try to bring Tutankhamun back to America, and when the White House asked whether the State Department could come up with some kind of paper for Nixon and Sadat to sign in Cairo, a Tutankhamun loan agreement seemed to fit the bill. Sadat agreed to Nixon's request. In offering Tutankhamun's treasures to America and turning towards that country's diplomacy (and cash), Sadat started down a path that led to the Camp David Accords of 1978, when Egypt became the first nation in the Middle East to recognize Israel.

Tutankhamun once again took on the role of cultural ambassador. The tour was timed to two anniversaries: the 1976 Bicentennial of the American nation, dated by the 1776 Declaration of Independence from British rule, and the fifty-fifth anniversary of the discovery of Tutankhamun's tomb, which would fall in 1977. This 'Treasures of Tutankhamun' was a gift from Egypt to the American people – an ancient state marking the 200th birthday of its younger friend. Behind the birthday greetings, everyone knew that there was more at stake. Thomas Hoving later claimed that Henry Kissinger himself called up Metropolitan Museum trustees to stress that the exhibition was vital to American interests in the Middle East.[11] One of those interests was manifest in the show's corporate sponsor, Exxon, as the Rockefeller family's Standard Oil Company became known in 1972.

The agreement made between Nixon and Sadat kicked off a year of negotiations between the two governments, before a treaty was ready to bring Tutankhamun safely – and spectacularly – to America. Watergate forced Nixon to resign in August 1974, but that did not set back the new US–Egyptian accord. In late October 1975, Kissinger and Fahmy signed the deal agreeing to a six-city tour, twice the number of venues Tutankhamun had visited in the Soviet Union.

As had happened with the Paris and London exhibitions, the cost of insuring Tutankhamun's treasures was a stumbling block, too high even for Hoving's roster of rich donors in New York. The workaround was a new federal law establishing a government indemnity scheme. Tutankhamun's treasures were the first incoming loan covered by the legislation, which Congress passed in December 1975. The federal government also devolved some responsibility for the tour to the National Endowment for the Humanities (NEH), which chose the host cities and made a number of grants to support educational activities at some of the venues.[12] Carter Brown won the inaugural exhibition slot in November 1976 for the National Gallery of Art, much to Hoving's annoyance, but the Metropolitan Museum was set to have the last hurrah with a four-month run from December 1978 to April 1979. From Washington DC, 'Treasures' travelled to the Field Museum of Natural History in Chicago (which had also hosted Tutankhamun in 1962), followed by the New Orleans Museum of Art, the Los Angeles County Museum of Art, and the Seattle Art Museum, which rented the Seattle Center Flag Pavilion, from the 1962 World's Fair, in order to have enough space; funds from the US Department of Commerce helped renovate the Pavilion for the purpose.[13]

The new Tutankhamun tour had no explicit link to UNESCO, whose campaign for the Nubian monuments had already received an American pledge of $4 million (paid in Egyptian pounds) in 1973 towards the re-erection of Philae on Agilkia Island, set for completion in 1980.[14] Nonetheless, there was one sizeable hangover from the High Dam salvage operations: the 682 friable sandstone blocks of the temple of Dendur, which had been sitting under tarpaulins on Elephantine island since 1962. Built shortly after the Roman emperor Augustus conquered Egypt, the temple was America's reward for its role in the Nubian campaign. Apart

from President Kennedy's promised $12 million in aid, private donors like Lila Acheson Wallace – whose family owned *Reader's Digest* – had given generously to UNESCO over the years. A presidential committee set up by Lyndon Johnson had to decide where the temple would go, and the Metropolitan Museum of Art made the most convincing pitch. It was an early victory for Hoving, who had just arrived as director and had plans to shake up the then-struggling museum.[15] A glass-walled extension into Central Park (funded by the pharmaceutical fortune of Arthur Sackler) would protect the reconstructed temple and cap off the simultaneous refurbishment of the Metropolitan Museum's collection of Egyptian art, which had been mothballed for a decade.

The mask at the National Gallery of Art in Washington, DC with Thomas Hoving, Ibrahim Nawawy, John Carter Brown, and museum security guards

Hoving also made the case for the Metropolitan Museum to take the lead in organizing the new 'Treasures of Tutankhamun' tour – what Carter Brown referred to as 'the dirty work' when the

two men smiled through gritted teeth for a joint press conference announcing the tour in September 1976. The funerary mask of Tutankhamun had already arrived. Instead of aeroplanes, the artefacts had travelled with the US Navy, first on the provisioning ship USS *Milwaukee* from Alexandria to Naples, and then on a stores ship, the USS *Sylvania* to Norfolk, Virginia. During the press conference, a museum technician in white gloves un-crated the mask and 'peeled its saran shroud', reported Grace Glueck for the *New York Times* (referring to the American brand of plastic kitchen wrap).[16] Also on hand for the announcement were Mohamed Shaker, chargé d'affaires for the Egyptian Embassy; Ronald Berman, chair of the National Endowment for Humanities; and arts advisor Peter Solmssen from the State Department.

Glueck followed up the announcement of the Tutankhamun tour with a feature asking whether the State Department was 'sweetening its dealings with foreign governments' through museum exhibitions such as Tutankhamun and loans of art from Russia and China.[17] Solmssen firmly and politely denied this, explaining that his office was only helping to facilitate ideas that came from museums themselves. America was not sweetening the deal so much as smoothing the way for goodwill gestures that had no political intent. Whether or not anyone believed that, the way was clear for Tutankhamun to conquer America – again.

* * *

In his colourful memoir, Thomas Hoving took much of the credit for the organization, design, and marketing success of 'Treasures of Tutankhamun'.[18] The Metropolitan Museum's head curator of Egyptian art, Christine Lilyquist, remembers it rather differently. Lilyquist already had her hands full implementing the re-erection of Dendur temple and overseeing the full-scale renovation of the Egyptian galleries.[19] For the design of the new galleries, she

arranged for Hoving and architect Kevin Roche to visit Egypt with her, to better understand the physical context and natural environment in which Egyptian art had been designed. During their visit, they joined Gamal Mukhtar – head of the Egyptian Antiquities Organization – for a lively dinner in Cairo, where drinks and belly dancers were on the menu. (The premier dancer of the day, Nagwa Fouad, was a favourite of Mukhtar's and had performed for Nixon and Kissinger, too.) Over dinner, the topic of the Tutankhamun exhibition came up. It was the first Lilyquist had heard about it, as far as she recalls, but the loan had already been agreed. Hence 'Treasures' landed on her plate as well.

Since fifty tomb objects had travelled to London for the fiftieth anniversary hook of the British Museum show, the United States was to receive fifty-five objects to mark the fifty-fifth anniversary. Hoving claimed that choosing objects for the tour came down to his connoisseurial eye and impeccable taste. Seeing objects from the tomb on display for the first time in Cairo gave him 'aesthetic overload', and he boasted about ignoring the scholarly insights that Lilyquist tried to offer.[20] More drily, Lilyquist recalls that Egyptian officials preferred the American loan to include the same objects that had been on previous tours, since they had already undergone conservation treatment and been approved for travel. The American loan focused on smaller objects, however, leaving out the guardian statue and funerary bed that had been to Paris and London.[21] With several objects to add in order to reach fifty-five, there was some space for the kind of curatorial manoeuvring that Hoving enjoyed. 'I knew what I wanted,' as he put it, and one of the things he wanted for 'his' Tutankhamun show was sex appeal.

The four gilded goddess figures from the canopic shrine in the tomb's Treasury had sex appeal in spades – to 1970s eyes, at least.[22] In the late 1920s, when they made their first debut in the world's

press, the goddesses were likened to the Virgin Mary, arms out-stretched to offer her dead son to a world in need of saving.[23] The statuettes represent Isis, Nephthys, Neith, and Selket, the same goddesses carved on the corners of the sarcophagus box. Each goddess aligns with a cardinal point, protects the mummified organs cached inside the shrine, and welcomes the dead king into the afterlife. Harry Burton's photographs made it clear that the statuettes were carved separately. He posed them on mod-ern bases to hold them upright, turning them this way and that in front of his camera to catch their carved bodies from differ-ent angles. Hoving claimed that the Egyptian Museum curators were unaware of this, instead assuming that the canopic shrine was carved all in one piece. He wagered (so he recounts in his memoir; Solmssen has since told a similar story) that if he could lift one of the figures out of the base of the shrine, it would win their approval to join the tour. Hoving's gloved hands grasped the figure of the scorpion goddess Selket, gave a gentle tug, and victory was his.[24]

It's a typical Hoving anecdote, setting his wit and verve against the plodding Egyptians. He recounts his part in the 'Treasures' negotiations as 'an epic comedy' with himself the straight-faced hero. The Covid pandemic of 2020 cancelled my long-planned trip to consult the exhibition archives at the Metropolitan Museum of Art. Someday, I'll set dry documents against Hov-ing's self-serving prose and see what falls into the gaps. History is always one account weighed up against another, and the stereo-types that Hoving – and his readers – gobbled up are easy enough to spot. Suffice to say the gift that Egypt offered to America was reciprocated with more cash than kindness.

Whoever chose the Selket statuette chose well, from an aes-thetic point of view. With its narrow waist, teardrop breasts, and gently curving hips, to which a silky garment seemed to cling, the

Thomas Hoving at home in New York in 1986 with a replica of the Selket statue, one of the most expensive items sold on the 'Treasures of Tutankhamun' tour he helped organize – and commercialize – in 1970s America

18th-Dynasty goddess conformed to slimmed-down seventies ideals of female beauty. 'A sinuous female with dramatically dark eyes and a side-cast glance', is how one male journalist described the figure, which became the sinecure of visitors' eyes.[25] Apart from the scorpion on her head, Selket would not have looked out of place in the ads for Virginia Slims that were so common at the time; even my mother's *Good Housekeeping* magazines ran them. 'You've come a long way, baby,' went the tagline, using faux feminism to sell cigarettes. Her head turned to one side, the Selket figure might have been playing the flirt, as male viewers had liked to think as far back as Alan Gardiner (who had described them as 'coquettish' in 1923).[26] Or perhaps she was just wondering how much further there was to go.

Opening night at the National Gallery of Art went off without a hitch. In fact, the exhibition space was ready a day

in advance, leaving plenty of time to prepare for the gala dinner hosted by philanthropists and art collectors Paul and Bunny Mellon. 'Little tables blazed with crystal fires from endless candles', with arrangements of irises, calla lilies, and protea blossoms adding to the effect.[27] Carter Brown had convinced Exxon to fly the 6th Earl of Carnarvon over from England to add a touch of aristocratic class and a personal link to the history of the Tutankhamun excavation that the earl's parents had funded. In the toasts, Egyptian ambassador Ashraf Ghorbal praised Henry Kissinger's efforts in bringing Tutankhamun to America through his famed 'shuttle diplomacy'. Kissinger responded with a speech that lauded the ancient Egyptians for leaving behind them 'something more than they found' – perhaps a hint at Kissinger's own ambitions for permanent changes in the Middle East. Whether those changes were for the better was another question, far beyond the grasp of Tutankhamun and his treasures as they paddled through the twentieth century's political wake.

* * *

Grandmother's patchwork quilt, and that old rocking chair from the attic. We think of them as antiques. But what then shall we call the fabled treasures of King Tut? Of... Tutankhamun? The bass voice and bulky frame of Orson Welles – who spoke these words – needed no introduction to American television audiences in 1977. Just in case, though, the star of old Hollywood stepped out of the shadows towards the camera, stopped before a photomural of Howard Carter and Lord Carnarvon, and intoned, 'Good evening. This is Orson Welles.'

So began a fifty-minute tour of the 'Treasures of Tutankhamun' at its opening venue, the National Gallery of Art in Washington DC, for a televised documentary. Aired on 27 July 1977 on NBC, *Tut: The Boy King* was Emmy-nominated and

won a Peabody award for excellence in documentary television. The NBC team filmed the programme with a single video camera over several nights, after the gallery's closing hours. A moody score, heavy on harp strings, accompanied the rather ponderous script by W. W. Lewis ('downright silly', the *New York Times* reviewer called it) and delivered in matching style by Welles.[28] But on the plus side, intense magnification brought viewers up close to selected objects – closer, Welles reminded them, than what museum visitors could see in person.

The patchwork quilts and rocking chairs of Welles' opening monologue were a homespun touch his audience might have recognized in their own living rooms – and a way to gauge the unimaginable antiquity of Tutankhamun's treasures against what Americans considered 'antique'. For families who had just made it to the middle class, like mine, the humblest piece of furniture was a material link to generations past and a valued sign of age in a country anxious about its youth. You could buy the Old World look as well. The Bicentennial set a trend for home decor that reimagined eighteenth-century styles. In 1976, while they were expecting one more baby, my parents redecorated with 'colonial' lamp tables, a patriotic eagle over the front door, and blue Bicentennial wallpaper that peeled for years in the bathroom steam.

Just as the Selket figure owed part of its appeal to the goddess's slender silhouette and placid face (Welles mused that it might be a portrait of queen Ankhesenamun), so the entire Tutankhamun exhibition chimed with another seventies trend: a growing American interest in family history and how it did, or did not, relate to the nation's founding myth. Already in 1972, a great-aunt of mine had gone as far as England to seek out Meads and Morleys in parish registers, avoiding the Tutankhamun crowds in London for rural Lincolnshire. Her postcard from John Wesley's Epworth birthplace arrived around the same time I did.

For Americans who identified their ancestry in Western Europe, 'home' was a concept flexible enough to accommodate imagined ties to European culture, whose whiteness was presumed.

But the Bicentennial celebrations threw into contrast the fact that only some American family histories are histories of migration from Europe. The rights of indigenous peoples and immigrants of Latino and Asian heritage did not figure in laudatory tales of Boston tea parties and rag-tag revolutionaries. Nor did slavery. In the same year Orson Welles presented *Tut: The Boy King*, the ABC network aired award-winning miniseries *Roots*. Based on Alex Haley's novel of the same name, it traced an African-American family's history from West Africa to southern plantation slavery to the Civil War. My parents will have watched both, wobbly antenna (and new baby) permitting.

Tutankhamun thus arrived in a 1970s America where history mattered – and history mattered in the 'Treasures' exhibition, too. Along with the fifty-five objects on loan from Egypt, each museum on the tour received a set of photomurals to incorporate into its staging of the show. According to Christine Lilyquist, it was her idea to make use of the Metropolitan Museum of Art's direct link to the 1920s excavation by incorporating enlargements of Harry Burton photographs throughout the display. Whereas the British Museum had placed its photographic enlargements at the entrance to the exhibition, with only a couple of historic photographs inside Margaret Hall's subdued display space, visitors to the American 'Treasures' followed Carter's own footsteps all the way through the exhibition. The fifty-five objects were displayed more or less in order of discovery, so that the enigmatic wooden sculpture of a head on a lotus blossom was the first object on view, accepting Carter's claim to have found it in the outer corridor of the tomb.[29] There was no photograph of the head *in situ*, but as visitors proceeded through the Antechamber,

Burial Chamber, Treasury, and Annex, enlargements of Burton photographs invited them to time-travel. There was the object as found, and here it now was in spotlit glory.

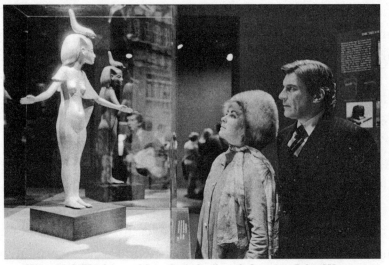

Elizabeth Taylor and her then-husband, Senator John Warner,
admire the Selket statue at the National Gallery of Art

This 'Treasures' told a rugged American tale of the Metropolitan Museum's role in the discovery, a 1920s celebration of close British–American ties. *New York Times* reporter Tom Buckley wrote an introductory essay to the American catalogue that dramatized the 'pitiless sun' beating down on the Valley of the Kings. Buckley's Carter is 'intense, driven, a bachelor', and Metropolitan Museum staff – their nationalities not specified – step in gallantly to share the work.[30] Like the 1972 catalogue by I. E. S. Edwards, the American version made no mention of Carter's self-declared strike, his failed legal action against the Egyptian government, or any of the political fallout from the find. Diplomatic decorum required that this celebration of friendship

between Egypt and America could not hint at past ruptures, any more than the British exhibition years earlier had done.

The Egyptians involved in the Tutankhamun tours knew the history of the excavation perfectly well. They focused instead on the pride and possibilities the vast American operation represented: pride in seeing Egyptian culture acclaimed in the United States, and possibilities for the income the tour was meant to generate for Egypt's cultural heritage. A future director of the Egyptian Museum, who was then a postgraduate student on her way to America for research, Wafaa El Saddik remembered her excitement at joining the Egyptian delegation that attended the opening of the New Orleans show in September 1977. The Egyptian minister of culture (and novelist) Abdel Moneim el Sawy led the delegation, accompanied by his wife, who took Wafaa under her wing throughout the trip. Muhammed Abdul-Qader Muhammed, who had succeeded Gamal Mukhtar as director of the Egyptian Antiquities Organization, was part of the group as well.[31] Each venue opening was a celebration mixing diplomacy, fundraising, and self-congratulations for those involved.

It was also, as El Saddik tells it, good fun. A police escort met the delegation at the airport and accompanied them into New Orleans, which had decked itself out in pharaonic style. Palm trees lined the streets, shop windows were given over to ancient Egyptian themes, and the lobby of their hotel had been turned into an Egyptian temple.[32] The evening gala caught the Egyptians out by requiring evening dress, but this was soon remedied with rental wear. The street between the hotel and the museum had been coloured blue to represent the Nile, and inside, the American women guests were dressed like Elizabeth Taylor in *Cleopatra* – apart from Elizabeth Taylor herself, who complimented El Saddik and chatted with her companion at the dinner table, the actor James Mason. Looking back on the

1970s tours from a vantage point of forty years, El Saddik still considered them the most spectacular and successful loans that Egypt ever organized. They were a national badge of honour and a much-needed source of revenue for improvements to the country's archaeological sites and tourist infrastructure.

If the design of 'Treasures of Tutankhamun' suggested that everyone could take part in the adventure of discovery, there was one caveat hidden in plain sight: this was a discovery made by white men. The Egyptian workforce who had been crucial to the excavation, from the basket boys to chief *Ra'is* Ahmed Gerigar, received no credit in any written essay or image caption. They were visible in many of the 1920s photographs incorporated in the catalogue and displays, but the focus was firmly on Carter and Lord Carnarvon, as it had been at the British Museum. The public image of the archaeologist was a white man who wore a tweed suit as easily as an open-necked shirt – not far off romantic hero Indiana Jones, who made his film debut in 1981.

There was one prominent figure in the 'Treasures' show who wasn't racialized as white, and that was Tutankhamun himself. When European scholars developed the concept of classifying humans by 'race' in the late eighteenth century, they turned to ancient Egyptian art and mummified bodies to try to differentiate so-called 'Ethiopian' or 'Negroid' 'races' from the Caucasian type they assigned to themselves. As a culture that the ancient Greeks had admired for its monuments, writing system, and religious wisdom, Egypt was too old and important for Europeans to ignore. At the same time, colonialism and the slave trade impelled Europeans to see darker-skinned, non-European peoples as lesser forms of humans, or not human at all. Theories about race became ever uglier over the course of the nineteenth and early twentieth centuries, and several Egyptologists contributed to scientific racism, including Howard Carter's early

mentor, Flinders Petrie.[33] In the 1920s, the language with which Carter described images of Tutankhamun, and the facial features of the young king's unwrapped body, relied on stock phrases that his readers would have read as white, or near enough: 'refined and cultured', with the facial features 'well formed'.[34]

African Americans looked at ancient Egyptian art and saw themselves. Nor was that a new phenomenon in the 1970s. African-American emancipation movements recognized Egypt as an ancestor, from the early nineteenth century to the Harlem Renaissance and beyond. A few months after the discovery of Tutankhamun's tomb, a Harlem newspaper interpreted a pause in mainstream press coverage of the find not as a sign of Tut-fatigue (or the end of the first season's work), but as an indication that white journalists had realized the truth. Tutankhamun and his family were as black as 'unbleached coal', and the white media and white archaeologists were covering it up.[35] As an ancient culture with abundant written records, and whose achievements were beyond question, Egypt was the refutation of every white supremacist idea that Africa had no history and that Africans were in any way inferior. As an editorial in the *Negro World* put it in March 1923, 'white Americans [...] call nothing creditable Negroid if they can possibly find another name for it'.[36] In 1926, after photographs of the gold funerary mask and Tutankha-mun's head appeared in the press, the National Association for the Advancement of Coloured People's monthly magazine *Crisis* featured on its cover an Aaron Douglas drawing of the pharaoh – young, proud, black.[37]

In 1970s America, racism had not disappeared with the pas-sage of the Civil Rights Act in 1964, which ended segregation and outlawed discrimination based on race, religion, or national origin. Lives remained split along colour lines, and southern whites, as three of my grandparents were, often brought their

social expectations and prejudices north with them. My parents avowed their own non-racism, and I read and reread a children's biography of Martin Luther King, Jr. But apart from a couple named King who lived across the street for a few years (no relation to the civil rights leader, I was disappointed to learn), we only saw African Americans on TV.

After school, in the Holly Hobbie bedroom I shared with my sister, I liked to copy the elegant outlines of goddesses and queens from paintings in Egyptian tombs. I coloured their skin a nutty tan, the colour of the doctors' daughters in school after they returned from family holidays in Hawaii or the Florida Keys. Everyone I knew wanted to be darker, but no one I knew wanted to be black. As children, we had absorbed a silent hierarchy that had something to do with skin tone but went much deeper. Where that left the ancient Egyptians, or the modern ones (the few times that I thought about them), was a muddle in my childish mind. Sort of brown. At least my colouring pencils could handle that, layering yellows and chestnuts with touches of pink. But nothing I learned at school or in Egyptology classes at university equipped me to recognize and challenge the racist foundations on which the study of ancient Egypt – and in turn, my own fascination for it – had been built. It was the publication of Martin Bernal's *Black Athena* in the late 1980s which first made me aware that disciplines like archaeology had their own history, and that it wasn't a very comfortable one.[38] Bernal visited Brown University while I was studying there, a guest of the African-American Studies programme. We were introduced, and somewhere I have the long letter he wrote to me after I sent him part of my senior thesis, on historiographic bias in the study of Ptolemaic Egypt. Bernal was the grandson of Alan Gardiner; he understood, I think, that personal lives and academic points of view are not so easily unpicked.

Hoving and the curatorial team for 'Treasures of Tutankhamun' seem not to have anticipated the strength of African-American identification with ancient Egypt. But a 1973 exhibition at the Brooklyn Museum (now the Brooklyn Museum of Art) offered a preview of what Tutankhamun might mean beyond the usual patter about English aristocrats, hidden tombs, and priceless treasure. Called 'Akhenaten and Nefertiti: Art from the Age of the Sun King', the Brooklyn exhibition capitalized on the success of the British Museum 'Treasures' a year earlier, which set some visitors up for disappointment when they realized it contained no objects from the tomb of Tutankhamun. On the whole, though, the Brooklyn exhibition received positive feedback, written in comment books at the end. A number of comments from black visitors – many of whom came from neighbourhoods around the museum – drew specific attention to the African-ness of the works on display. *Our culture at its best, the first civilization (African Art)*. Or simply: *Egypt is Africa is Black*.[39] Some expressed anger or surprise at labels that failed to mention black identity or, worse, characterized Akhenaten and his family as 'grotesque', a word that Egyptological literature often applied to Amarna art. *The blackness of Egypt is not enough underscored*, wrote one visitor. Another commented, *Personally I was embarrassed by the curator's attempt to deny the obvious admixture of black ancestry in both the king and queen*. And at least one visitor confronted the museum directly: *Why do you say his [Akhenaten's] features are exaggerated and grotesque. He is obviously a black man. Also, look at Tutankhamun!*

Looking at Tutankhamun is what millions of Americans did during the three-year tour. His enormous popularity tapped into previous black engagements with ancient Egypt as well as a more recent movement loosely characterized as Afrocentrism. Work by Senegalese scholar Cheikh Anta Diop, first translated

into English in 1974, was influential in arguing for the African – and black – character of ancient Egypt, which Diop saw as the antecedent of West African culture.[40] Since West Africa had been the contact point for slave traders, this offered one more tie between Egypt and the descendants of enslaved people in America. When 'Treasures of Tutankhamun' opened at the Los Angeles County Museum of Art in February 1978, it coincided with Black History Month, and the city council linked the two events with a resolution declaring 12 February as 'King Tut Day'. Los Angeles had its first African-American mayor in Tom Bradley, who supported the resolution's call 'to focus on positive black male images'. Tutankhamun and other kings of the 18th Dynasty were 'either black, "negroid", or of black ancestry, and all would be classified as black if they were citizens of the United States today'.[41]

By the time the 'Treasures' exhibition reached New York in late 1978, the African-American head of the Metropolitan Museum of Art's department of community education, Herbert Scott-Gibson, had prepared a pamphlet to address questions of race in ancient Egypt. Scott-Gibson pointed out that black and white were modern constructs, and that categorizing people along such lines does not easily map on to ancient evidence. Scott-Gibson warned that ancient Egyptians 'may very well have cared far less about the answer than we do'.[42] Or at least cared for different reasons. Depictions of physical difference in Egyptian art showed a king's mastery over the known world, but since the early nineteenth century, they had often been used to naturalize Western racist hierarchies. No wonder Tutankhamun's walking stick with a handle in the form of a Nubian prisoner was still excluded from the Egyptian loan to the United States.

In New York, the long-running local television programme *Like It Is*, which focused on issues of interest to African diaspora

communities, dedicated an episode to Tutankhamun ahead of the December 1978 opening of the Metropolitan Museum show. Scripted and produced by host Gil Noble, 'Tutankhamun: A Different Perspective' presented ancient Egypt as a culture rooted in Africa, with input from Hunter College and Cornell University academics.[43] One of the oldest African-American newspapers in the country, the *New York Amsterdam News*, covered these issues as well. An editorial in the paper expressed concerns about a 'conspiracy of silence' surrounding Tutankhamun's blackness.[44] It questioned why exhibition reviews in the mainstream press emphasized the artistic calibre of Tutankhamun's treasures – without drawing attention to their ancient African history.

Neutralizing the African and Egyptian identity of Tutankhamun was the point. In the 1960s and 1970s, public art museums began to embrace art from outside the European canon as having 'universal' appeal. What that meant was that the material culture of ancient Mexico, Egypt, or Peru; the Pacific archipelagos or the south-western United States; the Fang people of Gabon or the Yolngu of Australia, could be extricated from the social or historical contexts that archaeology and anthropology museums emphasized and instead put on display in art museums for visual appreciation alone.[45] Analysing objects by the aesthetic categories of Western European art, such as form, patina, or pattern, did 'primitive' art a favour, so the thinking went, by making it worthy of the label 'art'. Scratch its own patinated surface and universal taste was Western taste by another name. At the same time the Metropolitan Museum was preparing to host Tutankhamun in the renovated Egyptian galleries, it was also building a wing to house Norman Rockefeller's collection of 'primitive' art, a gift Hoving had secured for the museum in 1969. Under the Metropolitan Museum's massive roof, the visual arts were meant to co-exist, their histories and contexts levelled out to testify to

human inventiveness across the globe – even if European paint-
ing stayed on the top floor.

Using Harry Burton's photographs in the American 'Treas-
ures of Tutankhamun' tour did provide an archaeological context
for the artefacts and put to good use the glass negatives Nora
Scott had sorted years before (today, they live in cold storage
under the roof). But as much as anything, the photos were a
badge of authenticity and a mark of the excavation's own his-
tory. Indeed, the tour helped turn Burton's photographs into
works of art themselves, which was the last thing he had in mind
when taking them. The *Washington Post*'s review of the opening
venue, at the National Gallery of Art, described it as two shows
in one: the treasures ('there is no better word') and the 'portrait
of a modern excavation' seen in the enlarged photographs. Cases
were spaced several feet apart and labelled on each side, so that
multiple visitors could gather and view the objects in the round.
Wall colours shifted between dark greens, greys, and blues. The
reviewer singled out for praise the National Gallery's exhibition
team, headed by Gaillard Ravenel, and lighting designer George
Sexton, who mixed direct and ambient lighting so that the arte-
facts 'in their simple lucite cases look as if they have been bottled
in a cube of light'. [46]

When the exhibition finally reached New York in December
1978, it occupied part of the new Sackler wing, along with the
permanent Egyptian galleries and the temple of Dendur. The
challenge for chief designer Stuart Silver was to start viewers
off in darkness ('a nod of acknowledgement to the tomb') and
then embrace the natural daylight that flooded in. Silver said he
considered the exhibition in 'cinematic terms' of close-ups and
establishing shots, but what greeted visitors first was the same
object that Orson Welles had encountered at the National Gal-
lery – the wooden head on a lotus blossom, against a wall painted

'Tut red' to match the burnished brick colour of its painted face. [47]
No question of racial identity entered the exhibition space, how-
ever, and the next room gave visitors the glittering objects they
had queued up to see – and, importantly, to buy.

* * *

Tutankhamun's golden treasures were a golden opportunity to
do what America did best: sell stuff. Whereas previous loans
of the Tutankhamun objects had explicit fundraising links to
UNESCO's Nubian monuments campaign, the 'Treasures of
Tutankhamun' tour that reached America in 1976 had neither
salvage nor salvation as its goal. Instead, the deal that Hoving
struck with Gamal Mukhtar was about profit generation, pure
and simple. Once the host museums had covered their costs,
Hoving promised that the tour would feed much-needed hard
currency into the Egyptian Antiquities Organization – a pro-
jected $1.6 million share of the profits, which wound up being
closer to $7 million by the end of the original six-museum tour.[48]
'Treasures' proved so successful that Egypt agreed to further
venues, independent of the original treaty and National Endow-
ment of Humanities support. The De Young Museum in San
Francisco brought Tutankhamun back to the west coast after
his triumphant New York run, and from there the show made a
two-month stop in Toronto, Canada.

To cover costs and generate the promised profits, Christine
Roussel, the head of the Metropolitan Museum's reproduction
studio, had taken moulds and measurements of several Tut-
ankhamun artefacts at the Egyptian Museum in Cairo. These
became the basis for reproductions in a range of materials and
price points, together with other design tie-ins. Egypt received
all profits from the sale of the reproductions, for which the Met-
ropolitan Museum retained the rights in perpetuity: hence the

cheaper pendants my father bought for me in 1988, scaled down in every sense from the 1970s offer.

With money in mind, Hoving also brought photographer Lee Boltin to Cairo to take dramatic new photographs of the objects that would join the loan. The Boltin photographs would feature in the exhibition catalogue, as well as feeding into publicity materials, news features (like *National Geographic* magazine), and product sales. Boltin posed the treasures against jewel-toned backgrounds and blasted such bright lights on to them that Hoving had to find an electrician to splice into the city's electrical supply. This had the happy side effect, for Boltin, of allowing his cassette player and speakers to blare Beethoven while he worked.[49]

The Metropolitan Museum of Art took the lead on merchandise and commercial partnerships, with a line of around 450 products that were available for sale across the consortium of host museums.[50] At the Seattle Museum of Art, which had rented the Flag Pavilion to maximize space, the gift shop was as large as the exhibition galleries. A full-colour catalogue and related publications, including a new book by Eiddon Edwards, were just the start, likewise the posters, postcards, calendars, and 35mm slide sets that reproduced both Boltin and Burton photographs.[51] There were T-shirts, ties, and tote bags featuring the mummy mask, but also less predictable items of wearable Tut gear, such as gold-buckled leather belts and a white canvas handbag patterned with wings.[52] Gold, sterling silver, and enamelled jewellery items sold well, including pins, cufflinks, bracelets, earrings, and necklaces that were copied from items and motifs in the tomb. Each came in a pale blue box reminiscent of Tiffany's packaging, with 'The Treasures of Tutankhamun' branded on the lid and a leaflet inside about the piece and its link to the exhibition. Children had not been forgotten, with a 'Build your own pyramid' game and Tutankhamun jigsaw puzzles selling briskly at the

dedicated shop the Los Angeles County Museum of Art set up in its piazza.[53]

At the top end of the product line, the Boehm porcelain factory produced pricey gilded replicas of the Selket statuette, the funerary mask, and the head on a lotus blossom, as well as plaques representing Tutankhamun and Ankhesenamun at their most resplendent, taken from objects in the tomb. Hermes offered one of its luxurious silk scarves in Tutankhamun's honour, designed by Vladimir Rybaltchenko and resplendent with objects that did not travel to the United States (the guardian statue and the jackal shrine), but that were by then so famous from Harry Burton photographs, it scarcely mattered.

Sales of official merchandise were crucial to the tour's financial success, since some of the host institutions – in particular the National Gallery of Art – could not charge admission to recoup their own expenses. Those that did, like the Los Angeles County Museum of Art, turned the profit over to Egypt. Museums did generate income in other ways; they had to, since what limited government funding existed for the arts in America had started to dry up. Private views and corporate visits sold briskly (the Metropolitan Museum earned $2.4 million this way), as did membership schemes that offered Tutankhamun tickets as an incentive for joining. The Field Museum added 40,000 new members, yielding a total of $600,000 in subscriptions, and the Seattle Museum of Art quadrupled its membership from 6,000 to 24,000 over the four-month run. More money flowed in through museum restaurants and non-Tutankhamun shop sales, as institutions realized how crucial these could be at generating needed income. In New Orleans, the museum gift shop took in $1 million over its run of the exhibition, compared to $75,000 in the entire preceding year. So successful were some of the venues at raking in the cash that the National Endowment of the

Humanities had to deny rumours that it was considering asking them to repay their NEH grants.[54]

The financial impact of 'Treasures' rippled far beyond museum walls and into the host cities, who relished the arrival of Tut-mania. Billboards, window displays, and restaurant menus embraced ancient Egyptian themes however they could. Department stores sold props from Hollywood epics and genuine antiquities sourced through local auction houses. Before the show had even opened in Los Angeles, the *LA Times* reported on the 'Tutillating' merchandise that filled the city. A 23-inch paint-it-yourself plaster version of the funerary mask was selling well, as were pyramid-shaped meditation huts (it was California, after all).[55] Throw pillows, sleeping bags, bed linen, Hallowe'en costumes, toaster covers, Frisbees, colouring books, jigsaw puzzles, coffee mugs: anything that could be given a Tut twist was up for sale. If that wasn't enough to open your wallet, The Tut Shoppe in Los Angeles gave every purchaser a peacock feather, too.

Serious, and not so serious, culture benefited from the Tut-ankhamun effect as well. Each venue hosted lectures, often by early career Egyptologists (including some of my future professors), while community colleges put on ancient Egyptian-themed evening courses that had an excellent uptake. More than forty publishers brought out Tutankhamun- and Egypt-related books to tie in with the show, in a 'Tut glut', and in addition to the Exxon-sponsored *Tut: The Boy King* documentary, other television programmes picked up on the theme. An episode of Leonard Nimoy's *In Search Of...* series looked at 'The Mummy's Curse' (air date 14 May 1977), and popular detective dramas *Hawaii Five-o* and *The Rockford Files* both featured plots that riffed on Tutankhamun. The title of *The Rockford Files*' double episode, which aired in 1979, gives a sense of the level of Tut-saturation America had reached: 'Never send a boy king to do a man's job'.

Whether from light entertainment, private enterprise, or the official museum merchandise, the commercialization of Tutankhamun did not pass by without critique – even if it fell to a stand-up comic to offer it. The seventies were golden years for the American skit programme *Saturday Night Live*, which blew its production budget for a novelty song by Steve Martin, complete with black back-up dancers and a gilded black saxophonist who emerged from a coffin at the end. I was sent to bed long before *Saturday Night Live* aired, but my older brothers were fans. They played Martin's records, and Richard Pryor's, in the bedroom next to mine, as our mother clucked disapproval at both men's profanities. I only wanted to hear Martin's catchy chorus over and over again: *Born in Arizona, had a condo made of stone-a, King Tut* . . . It topped the Billboard music chart in 1978, but none of us realized that this pharaonic spoof was aimed at the hype that had become intrinsic to the show – nor that the 'gold-face' of the black musicians hinted at racial ambiguities. The televised version opened with Martin admonishing the audience, 'It's a national disgrace the way we've commercialized him with trinkets and toys, T-shirts and posters' – but ended with Martin offering a blender to the reawakened sax soloist. If you can't beat capitalism, you might as well join in.

All the money earned by 'Treasures of Tutankhamun' was meant to be for a good cause, but without the UNESCO project as a badge of honour, the host museums had to work a little harder to convey the benefits of the show for both home audiences and for Egypt. In New Orleans, the museum commissioned an economic impact study from the University of New Orleans' tourism school. Just short of $70 million had been spent in local restaurants, accommodation, and entertainment venues as a result of 'Treasures of Tutankhamun', at its only stop in the southern United States. The report estimated that $4 million in

sales taxes had gone into state and city coffers, too. The Seat-
tle Museum of Art was able to give $1 million of its estimated
$7 million in ticket revenue towards the renovation of the Seattle
Centre, the pavilion the museum had rented to host the exhibi-
tion; it had generated another $2 million gross in shop sales, part
of which would go to Egypt.[56] All told, the Seattle Art Museum
expected to clear a profit for itself of $800,000. As for the two
institutions whose directors had been the driving force for bring-
ing Tutankhamun back to America, the Metropolitan Museum
estimated that it had just about broken even, while the National
Gallery of Art rose above the fray by emphasizing the small scale
of its temporary exhibition space, its free admission policy, and its
public educational remit.

A sign in the Metropolitan Museum of Art gift shop had
encouraged visitors to open their wallets for a good cause: 'The
profits from the sale of publications and reproductions in this
shop will be donated to the Egyptian Organization of Antiq-
uities for use in the renovation of the Cairo Museum and for a
new installation of Tutankhamun treasures – a cultural project of
international importance'. When New York Times reporter Grace
Glueck sought out more detail about the prospective renovation,
the situation proved to be less clear-cut. Egypt would use the
funds for cultural projects but could not promise any direct link to
the Egyptian Museum in Cairo. The Egyptian ambassador to the
United States, Ashraf Ghorbal, underscored the Tutankhamun
loan as a cultural gift. 'We didn't do it to make money,' he said.
'The show's tour was conceived as a Bicentennial gesture of good
will to the American people. What has resulted is a beautiful cul-
tural bridge between our two countries. Nothing has attracted
the attention of Americans to Egypt like King Tut.'[57] Pressed
again a few months later, a spokesman at the Egyptian Embassy
stressed that the estimated $7 million generated by the show was

a drop in the ocean compared to the tens of millions of dollars needed to maintain, restore, and conserve Egypt's museums and built heritage. Had Egypt wanted to make serious money from the tour, embassy spokesman Ahmed Abushadi told Glueck, it would have cut a more favourable deal.[58] In the future, it would.

Beyond the financial transactions that mapped Tutankhamun's second tour of America, the value of the 'Treasures' exhibition lay in its promotion of Egyptian and American relationships. The universal artistic values the objects were meant to embody – Tom Hoving's 'aesthetic overload' writ large – echoed other 'universals' that Western powers embraced as their empires splintered overseas and their hierarchies of race and gender began to crack at home. Cultural heritage was one such universal, piloted by the UNESCO Nubian campaign to mark out remote temples as a common good worth saving at all costs. But goods did come at a cost, and it was the cost of oil that had pushed America to seek an Arab ally in Egypt, with Tutankhamun helping seal the deal. Oil should benefit all mankind as well, the logic went; it was too vital a resource to confine it by national territory. The Middle East had raw materials to die for, from ancient art to oil reserves, but the West was convinced that it knew best how to appreciate, care for, and consume them.

The geopolitics of post-colonial capitalism were not at the forefront of people's minds as they waited in line for hours to see 'Treasures of the Tutankhamun' at the National Gallery of Art (which had tried and failed to organize a ticketing system, as several later venues did). Waiting was by now a ritual in itself, all part of paying homage to the boy king. Some visitors told reporters it was the queue that convinced them to come and see what all the fuss was about. A few older people recalled news reports of the discovery from their childhoods, more than fifty years before. Commentators hoped that interest in the exhibition

was evidence of increased American interest in the arts and an appreciation for cultures much older than its own.[59] Exxon subsidized guides for teachers, which included a poster of the funerary mask, a hieroglyphic alphabet, a page copied from the 1923 *News of the World* announcing Carnarvon's death, plus a detailed plan of the tomb, guides to the wall paintings and information on selected objects.[60] It was a slick educational offer, at a time when American museums were increasing their school programmes; at each venue, groups of school pupils attended in their hundreds of thousands. The final visitor tally, across the seven American hosts, stood at nearly 8 million people. What did they see, or want to see, in Tutankhamun?

'It's so beautiful,' was Jimmy Carter's verdict after an early morning visit to the National Gallery of Art with his wife Rosalynn, accompanied by John Carter Brown, the ambassador Ghorbal, and Tutankhamun's curator from Cairo, Ibrahim Nawawy. The down-to-earth new president detoured his Secret Service detail to the end of the line outside, to assure people that it would be worth the wait.[61] A group of local schoolchildren was less convinced on their way out. It was 'gyppy', one said, because it didn't have 'all the good things in it' that they had already studied in school.[62] A certain Mark Rostline from Bethesda, Maryland, was disappointed, too. 'I wanted to see the mummy,' he told waiting reporters. 'I thought they had the mummy.'[63] All that art and splendour was no substitute for death. Tutankhamun might well have agreed.

7

Restless Dead

Most ten-year-olds can tell you what the ancient Egyptians did to the bodies of their dead. 'How to make a mummy' is by now a fixture of primary school curricula and museum visits, never mind pop culture. What few children, or grown-ups, can tell you is what archaeologists, anatomists, and curators have done to the bodies of the Egyptian dead over the years. Forget the gory details of embalmers eviscerating bellies and liquefying brains. Consider instead how all those well-wrapped, desiccated bodies, once sealed away in tombs and coffins, wound up stripped bare and parcelled up into the pages of books; the galleries of museums; a million boxes, drawers, and plastic bags in storage; or simply disappeared, like the body of Bao-Bao.

Mummification was never on the syllabus when I studied Egyptology, apart from occasional mentions when we translated prayers and incantations about the sanctification of the body and the reanimation of the *ba*, or soul. Professors must have assumed we knew the gruesome bits, or perhaps they felt themselves above a subject that had acquired such popular appeal, along the lines of Tutankhamun. Much of what you learn of a profession takes place outside the classroom anyway, by watching, listening, doing. Thus my first up-close encounter with a wrapped and embalmed body was as a student volunteer in the Ashmolean Museum at Oxford

University. One morning, before opening hours, I helped remove a mummified toddler from display. It was time for a changeover, besides which, confessed the curator – a softly spoken, scholarly woman whom I admired – it no longer felt right to have this helpless body on public view in its swaddling bands of tightly wound linen. Hands gloved in purple nitrile, it was a moment's work to lift it from the vitrine and set it on a trolley, holding it for a brief moment like the baby it had been.

Its stiff stillness struck me, for it echoed the last encounter I'd had with a dead body: my father's. Unlike most American funerals, the casket was closed to spare mourners the sight of his atrophied corpse. For nine months – the whole of my final year in high school – he had been comatose after his car was hit by a drunk driver in the dead of night, on his way home from a work shift. The coffin was opened just for family, the evening before the burial. I looked at the incurved hands folded on his chest, the fingers thin and twisted. I let my own fingers rest there, lightly. Hollow, unmoving. That was what I felt in the child's mummified body that morning, and in all the other bodies in my charge when I became a curator myself. I could not understand their ghoulish appeal, never mind to museum visitors but among students and researchers, too. Had these people never lost someone? Had we become so distant from the dead?

The treatment of Tutankhamun's body over the past century has not been any more dignified or scientifically sound than the various procedures enacted upon other ancient Egyptian bod-ies over the past 200 years. The difference is that Tutankhamun was a king and the world's press were often watching. From the moment they realized the burial was intact, Howard Carter and Lord Carnarvon emphasized the reverence with which they would approach the royal 'mummy', as these embalmed bodies are invariably known. Carnarvon was himself a corpse long before the

autopsy of Tutankhamun's body took place in autumn 1925, after
which Carter delivered the respectful reburial they had promised.

Yet in the decades since, what remains of Tutankhamun has
been broken further into pieces, X-rayed, sampled, CT-scanned,
and photographed in the highest resolution technology allows.
The entire rationale for Tutankhamun's tomb – his premature
death and his dead body – rarely featured in the presentation or
reviews of the 'Treasures' tours in the 1970s, as if thoughts of loss
and mourning might somehow tarnish the gold. In sharp con-
trast to the objects buried with him, which have been put back
together, cleaned up, and conserved with such care, the body
of Tutankhamun gained in value through its disassembly and
destruction. It is a paradox he shares with so many of the ancient
Egyptian dead. If there is a mummy's curse, it has been placed
on them, not us.

* * *

Howard Carter was in a biblical frame of mind as the date fixed
for opening the wrapped body of Tutankhamun approached:
11 November 1925. Armistice Day in Britain, commemorating
the end of the First World War, but Tutankhamun would know
no peace. One week was set aside for the unwrapping and autopsy
of the king. Scheduling even that was difficult, but it was all the
time the two anatomists and in particular the hard-pressed head
of the Antiquities Service, Pierre Lacau, could spare.

As soon as Carter arrived on site that October, he set to work
with chemist Alfred Lucas and the Egyptian *ru'asa*. The problem
they faced was getting to the body at all, through the three nested
coffins that held it tight inside the immovable stone sarcophagus.[1]
Stuck fast together, the two innermost coffins had to be lifted
clear of the largest, outer coffin – not easy in the confined space
of the burial chamber. Only then could Carter and his colleagues

raise first one lid, then the next, rolling back the shrouds that covered them and lifting off the fragile floral wreaths. The hardened residue of a dark liquid covered the whole of the innermost coffin lid, as well as the wrapped body inside. Poured liberally over both, the resin-rich substance had slid down into the snug crevices between the two inner coffins and around the wrapped body, adhering it to its golden carapace. At least Carter could see the face of Tutankhamun's funerary mask for the first time, peering up with stony eyes. The king was there. But how to get to him?

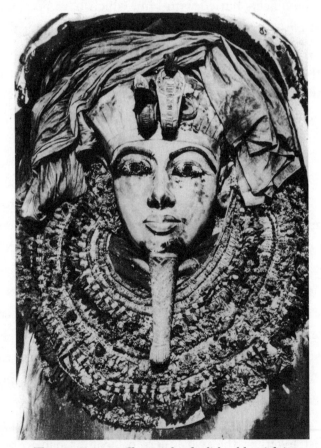

The innermost coffin, made of solid gold, with its shrouds pushed back and floral wreaths still in place; photograph by Harry Burton, 24 October 1925

On 1 November, All Saints' Day, it took ten men to lift the body in its stuck-together coffins out of the tomb and up the road to the workshop in KV15. By then, they had realized that the inner coffin was made of solid gold, adding to the weight of the gilded wooden second coffin, the mask, and all those resin residues. The men left the coffins to sit outside for several hours, hoping that the heat of the sun would help budge the stubborn gunk. The only thing that softened was its perfume, 'penetrating, somewhat fragrant, not unpleasant, and suggestive of wood-pitch,' as Carter described it.[2]

He turned to the Bible to comprehend the stubborn substances that weighed down the royal body – and weighed on his mind. In his excavation journal, Carter gathered verses on the pouring of oil libations. One, from the Gospel of Mark 14:8, foretells the crucifixion of Jesus, who is in the house of the leper Simon when a woman pours the valuable contents of an alabaster jar of spikenard oil over his head. Those present are aghast at the waste of such an expensive commodity, but Jesus speaks in the woman's defence and tries to warn his followers of his impending death: 'She hath done what she could. She is come aforehand to anoint my body for the burying.'[3]

Like Howard Carter, I knew something of the Bible from my upbringing. The Gospels tell us that a body can be both human and divine at once. That was how Christ, the son of God, could live a mortal life and die for our sins. 'Human remains' is the blanket term museums use for the dead bodies and body parts left in their care today. But in ancient Egypt, a body like Tutankhamun's was much more than human, by virtue of his birth and status – and his wrapped-up, embalmed corpse was outright divine. When priests rewrapped and reburied the robbed body of Ramses II, in the simple wooden coffin I had admired as a teenager in Boston, they knew exactly how to label it for future reference: *The god*.[4]

European surgeons and natural historians began to unwrap mummified bodies in earnest in the late eighteenth century, when anatomical studies of the ancient Egyptian dead became central to the invention of race. Previously, the few such bodies known in private collections – like that of the painter Peter Paul Rubens – were exotic curiosities imported from a distant land. Inspired by the ideas of Persian physician Ibn Sina in the early eleventh century (Avicenna, in Latin sources), some bodies, and parts of bodies, had been ground into a powder used medicinally, especially as a cure for stomach ailments. The word 'mummy' derives from the Persian and Arabic word *mumia*, which refers to bitumen – one component of the resinous black substance that impregnated their linen wrappings and coated their skin. That taking *mumia* meant consuming human flesh was not lost on some observers in the seventeenth century, for whom it echoed the troubling commodification of bodies in the slave trade that was making Western Europe rich.

In Norfolk, the antiquary and physician Sir Thomas Browne lamented, '*Mumia* is become merchandise, and Pharaoh is sold for balsam.'[5] Browne's musing on the fate of human bones foretold the troubled history of his own skull, removed from his grave in St Peter Mancroft Church in Norwich in the 1840s and reburied only in 1922 – the year of the Tutankhamun discovery.[6] It first went to University College London to have its measurements made by Karl Pearson, a protégé and promoter of eugenicist Francis Galton and, like Galton, a friend and colleague of Flinders Petrie, Howard Carter's one-time mentor. Dead bodies have a way of becoming quite detached from death. Or as W. G. Sebald observed: *We study the order of things, says Browne, but we cannot grasp their innermost essence.*[7]

Browne lived at a time when colonial expansion, which went hand in hand with the enslavement of Africans, brought

Europeans into contact with the diversity of human life around the globe. To understand this diversity – and justify European domination – scholars began to describe, depict, and classify the physical features and cultural traits of the people they encountered in the Americas, Africa, and across Asia and the Pacific. Closer to home, the lands bordering the Mediterranean offered material for study, too. The Ottoman Empire had been Europe's neighbour, and sometime enemy, for centuries, and Arabs had once controlled the Iberian Peninsula and Sicily. In the friction of this physical proximity, how to classify the people of North Africa, West Asia, and the Middle East presented a certain quandary: they weren't 'Ethiopian', but they weren't 'Caucasian' either, to use two of the terms developed by German scientist Johann Blumenbach in the late eighteenth century. Blumenbach unwrapped Egyptian bodies to see how modern populations compared to ancient ones. Ethiopian, he thought – more black than white. But debate raged on. In the 1820s, French scientist Georges Cuvier declared that ancient Egyptians were Caucasian types instead. As the century developed, and imperial ambitions with it, the science of race found new means to formulate its theories, and archaeology in Egypt yielded plenty of new corpses to unwrap.

By the late nineteenth century, when Howard Carter went to Egypt, any qualms about disturbing the dead had long been overtaken by the interests of science. It was taken for granted that almost any dead body an archaeologist found would undergo some kind of investigation. Anthropometry kits, made up of calipers, rulers, and charts, allowed archaeologists to measure skulls and long bones to standardized norms. Bodies that had been embalmed in some way (actual practices and states of preservation varied enormously) were usually unwrapped in the field, described, and similar measurements taken. Almost all of these

remains were then discarded. Interesting examples were boxed up to ship home or sent to the School of Medicine that had been based at Kasr el-Aini, Cairo, since the 1830s. Only the most attractively wrapped and decorated bodies were spared an anatomist's knife.

There were a few lingering doubts about the desecration and display of the dead, chiefly where the bodies of royalty were at stake. In 1890, the painter and patron of Egyptology, Sir Edward Poynter, used a letter to the London *Times* to express a 'feeling of regret' that the royal bodies found at Deir el-Bahri a few years earlier (including Ramses II) lay exposed under glass; archaeologist Édouard Naville suggested reburying them in the pyramids.[8] After the discovery of Tutankhamun's tomb in 1922, novelist H. Rider Haggard wrote to the same paper in outrage at the thought that Tutankhamun would be stripped bare like the other royal bodies. 'Is this decent? Is it doing as we would be done by?' he asked. He argued that the so-called 'mummy room' in the Egyptian Museum in Cairo should be closed and all the bodies of Egyptian pharaohs reburied with state honours, perhaps in a chamber of the Great Pyramid.[9]

Carter and Carnarvon were quick to lay out their plans for Tutankhamun's body, which were being questioned in the press and even the House of Commons.[10] They offered a compromise solution: when the time came, the young pharaoh's body would be unwrapped and studied for science's sake, of course. But if the Egyptian government approved, it would then be 'reverently rewrapped', as Howard Carter put it, and returned to the tomb to continue its eternal rest without further interruptions.[11]

The reality was less than reverent, in the end, though it got off to a smiling start with photographs of the committee who assembled on the appointed day. Harry Burton posed the men around the coffins in the entrance of KV15 early in the morning, before

the work commenced: Howard Carter and Pierre Lacau stood side by side, Alfred Lucas kept to the back, and several Egyptian colleagues from the Egyptian Museum, the Antiquities Service, and the Ministry of Public Works arranged themselves around the space. Two esteemed anatomists would oversee the work, one Egyptian and one British in the more collaborative spirit meant to prevail after the rift caused by Carter's strike. Dr Saleh *bey* Hamdi was a former head of the Cairo medical school, working at the time as director of sanitation in Alexandria. The other medical expert was Dr Douglas Derry, professor of anatomy at the School of Medicine and the go-to consultant for British archaeologists in Egypt whenever they found human remains. Derry wrote up his findings for Carter to include in the latter's second book on the tomb.[12]

To Derry went the honour of making the first incision into Tutankhamun's wrappings 'as soon as the wax had cooled', since a modern libation of liquid paraffin had been poured over the body to help consolidate the friable textiles and whatever lay beneath them.[13] The poor condition of the textile wrappings frustrated everyone involved. They crumbled to soot on contact, affected by extreme heat and damp. It was just possible to distinguish some of the criss-cross bandages and folded pads that were typical of embalmers' wrapping techniques. Although archaeologists like Carter downplayed the significance of textiles, rites involving linen cloth and wrapping were fundamental to Egyptian religious practices, including mummification. Woven in temple workshops from the fibres of the flax plant, high-quality linen was a gift of the earth and therefore of the gods. The finer the fabric, the greater its cultural and financial value; the best was known as 'royal' linen. Wrapping a body required hundreds of square metres of cloth, supplied from meaningful sources: the deceased's own wardrobe, family heirlooms, gifts from colleagues, and

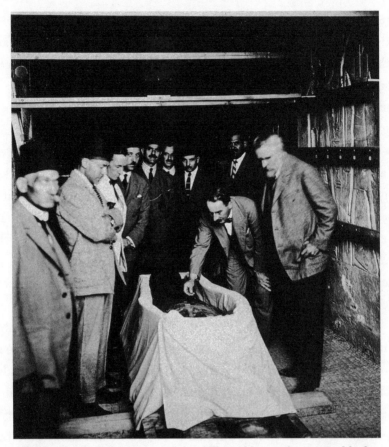

*Gathering to begin the opening of Tutankhamun's wrapped body,
with Douglas Derry (in white jacket), Saleh Hamdi (behind him,
white pocket square), Howard Carter (reaching down), and Pierre
Lacau (at right); photograph by Harry Burton, 11 November 1925*

temple textiles that had been wrapped around statues of the gods
to dress them – much like the gilded pairs of statues found in the
resin-coated shrines in the Treasury of Tutankhamun's tomb.

Its linen wrappings may have been unimpressive, but the
amulets and objects that formed part of Tutankhamun's embalm-
ing proved to be beyond compare. By Carter's count, 143 items
had been placed on the body, within the wrappings, or on the
outer layer, forming an ensemble with the mask.[14] He catalogued

them in 101 groups, running through the English alphabet four times to create enough subsets of the mummy's own number, 256 (down to 256vvvv, the 5-cm-long headrest of meteoric iron found at the back of the mask, under the king's wrapped head). The gold mask with its striking blue glass strips was 256a, as were its separate beard and three-strand necklace of yellow and red-tinged gold beads separated by blue faience discs. The mask was only one part of the stunning goldwork on the surface of the wrappings. A flexible gold strap hung from the neck with a scarab carved from solid resin in a gold mount. It rested on the chest between two gold hands, sewn on to the top layer of the linen, which held the shepherd's crook and winnowing flail that symbolized Egyptian kingship. Further inlays of minuscule cut stone (feldspar, lapis, carnelian) and coloured glass hieroglyphs were set in gold bands across the mummy's legs, spelling out the speech with which the sky goddess Nut welcomed Tutankhamun to the afterlife.

Since Harry Burton needed daylight for photography, work on the body could only take place between 8 a.m. and 3 p.m. each day. The anatomists and Carter did not unwrap the body of Tutankhamun so much as excavate it, as they dug the linen wrappings, jewelled adornments, and fragile limbs layer by layer out of the solid gold coffin.[15] Burton set up a tripod at the foot end, from which he could shoot downwards to let as much of the coffin and body fill the plate as possible. He also made close-ups as different groups of objects appeared within the strata, once the printed number and letter cards had been inserted into the scene. Work began with the body's lower half. Over the legs and between the thighs were seven gold circlets (an eighth lay on the abdomen above) and eight gold collars, each representing a divine falcon, cobra, or vulture with its wings spread out like a shield. By 14 November the long bones of the legs – and a loose kneecap

that revealed a femur end – enabled Derry and Hamdi to determine that the king had died aged around eighteen years old.[16] Destruction was inherent to the process of unwrapping any mummified remains, and all the more so with Tutankhamun's body already in a fragile state. Derry kept neatly pencilled notes on the autopsy's progress, which indicate just how delicate the tissues of the body were. Any tendons, muscle, or tissue between the skin and bone had shrunk to cardboard thickness in some places, he observed, and was liable to shatter.

The pelvic region was covered to the knees by an apron-like garment of gold inlaid with multi-coloured glass, and to the right side of the hip was one of the most remarkable objects from the entire burial: a dagger with an inlaid and granulated gold haft topped by a rock-crystal knob, and a blade of meteoric iron, steel-bright when Carter first laid eyes on it.[17] A second dagger, with a gold blade, a granulated gold hilt inlaid with glass and stone, and a gold sheath chased with wild animals on one side, was found tucked under the apron's waistband; it was later included in the 1960s and 1970s loans.[18]

Moving up the body towards the mask, the king's chest and abdomen were dense with objects placed over his thorax, ribs, and bracelet-laden arms, which lay folded, one above the other, on his belly. Carter counted thirteen distinct layers of wrapping in this area and thirty-five objects, including layers of gold collars and a second scarab carved in solid resin, near the king's navel. At the deepest layers, closest to the body, were several breast ornaments ('pectorals') of incredible workmanship, suspended on flexible gold chains and straps and separated from each other by linen that was 'gossamer' thin, as Carter described it.[19] Each breast piece was a miniature work of art, inlaid with glass and stone to create scenes that represented the rising sun, the healing Eye of Horus, and a retinue of gods and goddesses.

The passive voice served Carter well when he wrote the results up for his second book on the discovery: 'Even after the greater part of the bandages had been carefully removed, the consolidated material had to be chiselled away from beneath the limbs and trunk before it was possible to raise the king's remains.'[20] What Carter did not mention was that the royal remains were in pieces after the anatomists had done their work. Once Derry had coated the revealed arms, torso, and legs with hot paraffin wax to stabilize the surface as much as possible, and let Burton get a photograph, he and Hamdi dismembered the body to remove it from the coffin. They extracted the bracelets from Tutankhamun's slender arms, the gold finger sheaths and heavy rings from his hands, and the toe sheaths and sheet gold sandals from his feet.[21]

Of necessity, the men saved the head end of the king's body for last. The funerary mask adhered to the bottom of the coffin, and the wrapped head and neck were wedged fast inside it. Decapitating the dead king was the only solution. With the rest of the coffin empty, apart from textiles and resin where the body had been stuck to the bottom, they could insert hot knives between the mask and the residue-soaked wrappings, until it was possible to pull the head out of the mask. For the moment, they left behind the padding over the crown of the head and some of the outer bandages, where a tiny amulet in the form of an iron headrest had been placed to protect the pharaoh in his sleep.

With the head resting on striped ticking pillows on one of the workshop tables, Hamdi and Derry could finish the unwrapping. Under the first few layers of linen, they found an inlaid gold diadem (the cobra and vulture for its forehead had been found over the legs), and inlaid gold 'ribbons' that extended down the back of the neck. A tight gold circlet fit over the head a few further layers down, and the shaved head itself was covered in a delicate linen skullcap, with four rearing cobras worked in tiny gold and

faience beads. With a few more webs of fabric brushed from the
royal face, they could gaze on Tutankhamun at last. The skin had
shrunk taught over the cheekbones and pulled the lips back over
prominent teeth; the nose was squashed from the tightness of
the wrappings; the eyes, coated with resin, still had long lashes.
Carter saw a 'serene and placid countenance', a 'refined and cul-
tured' type – more or less Caucasian, is what he had in mind.[22]
It was 18 November, the end of a long week's work. Lacau set off
for Cairo. Derry and Hamdi left the following day.

Harry Burton photographed the head on two separate
occasions, probably several months apart. On the day of its un-
wrapping, he took several photos of the work in progress, with
flakes of fabric and skin and the steely tools – scalpels, tweezers,
scissors – lying all around. A length of white muslin let him cover
the ticking pillows and swathe the head below the neck, conceal-
ing its decapitation, to take two shots for the press. Showing the
head from the front and in profile, they appeared in the *Illustrated
London News* two months later, revealing Tutankhamun to the
world.[23] Carter and Lucas carried out further cleaning and treat-
ment of the head the next autumn, in preparation for the reburial
of the remains. It was probably at that point that Burton returned
to take a more thorough set of photographs. They mounted the
head on a well-used sawhorse. A paintbrush handle served to
prop the skull up at the back, while a thin nail kept the neck in
place at the front. Burton took views of the rear, front, and top
of the skull, both profiles, and a three-quarters pose, as if Tut-
ankhamun were sitting for a Da Vinci or Van Dyck portrait.

Those photographs were not published until the 1960s, when
Christiane Desroches Noblecourt included one of the profile
views in her book for George Rainbird. A piece of masking
tape erased the paintbrush handle.[24] In 1972, Noel Streatfeild's
book for children printed the same image at much larger scale

and without the discreet masking of the prop.[25] Young readers could take in the king's cracked skin, taut lips, buck teeth, pierced ear, and sightless eyes, preserved in front of Burton's camera in 1925 or 1926. That was as good as things would ever get for the remains of Tutankhamun.

* * *

After the autopsy was finished, Howard Carter, Alfred Lucas, and the *ru'asa* faced the challenge of separating the mask and the two coffins. They lined the solid gold inner coffin with zinc plates and suspended the whole stuck-together mass on trestles placed over paraffin lamps running at full power. Wet towels over the top and around the mask offered some protection during the hours it took for the hardened ancient libations to turn into viscous goo. Only at that point could the men slide the two coffins apart and pull the mask free. Its inlays had come loose in the heat, and Carter and Lucas spent the next month cleaning it of the resinous residues and inside and out, using a blast lamp and solvents, and replacing the inlays one by precious one. The solid gold coffin needed serious attention to clear it of the hard, dark coating, too. They worked to a tight deadline, since an Egyptian army detail would arrive to escort the treasures by train to Cairo on 31 December 1925, accompanied by an exhausted Carter and Lucas.

The body of Tutankhamun stayed in KV15 until the following October, when Carter put 'the final touches' to it before the reburial.[26] Unable to remove the delicate skullcap or a beaded, bib-like garment on the chest, he coated them with the ubiquitous paraffin wax and laid the body out on sand in a shallow tray. Burton photographed it one last time from above, with no trace of its fragmentation visible, and years later, in an interview for the BBC, Alfred Lucas recalled that they had swathed the body in

linen before returning it to the tomb.[27] In the Burial Chamber, the men lowered the tray with ropes into the gilded outer coffin, whose lid was put back in place to keep the body out of sight.[28] A sheet of glass over the box of the sarcophagus allowed tourists to see the coffin but no more. Reburial was meant to be the end of the disruption to the king's eternal rest.

It was not the end of the human remains found in his tomb, however. Clearing the Treasury over the next two years yielded his embalmed internal organs, sealed inside in the four gold coffins at the heart of the canopic canopy and alabaster chest.[29] Less expected was a plain wooden box perched nearby, its lid cast aside.[30] In the box lay two similar coffins, head to toe, decorated in black resin banded with gold and secured by strips of linen that had been sealed by the priests of the royal necropolis. Snug inside each coffin was a second wooden coffin, entirely gilded and lightly incised with fine details and a funeral prayer. Each of these inner coffins held a stillborn foetus, neatly wrapped (one had a gilded mask fitted over it as well) and embalmed as far as the birdlike bodies could sustain the invasive process.

When Derry had a chance to examine the stillborn bodies years later, in 1932, the larger was still wrapped.[31] He unwrapped it and compared the two. Someone photographed them in that state as well, laying a 12-inch ruler alongside the pitiful remains; it dwarfs them. The embalming priests had placed linen packing in the tiny skulls, and the older foetus had a small abdominal incision from the mummification rite; both still had an end of the umbilical cord, sliced through to separate them from their grieving mother. Derry estimated their sex as female and their age at about five and seven months' gestation. The best explanation is that they were the daughters of Tutankhamun and Ankhesenamun, buried with their father as royal children sometimes were. There was no talk of replacing them in the tomb

with their father. There was no mention of what happened to them at all.

The outbreak of the Second World War put Egypt on the front line once again. Egyptian men were called up for service under the British flag, and food shortages were rife in the countryside. Between 1942 and 1945, a devastating outbreak of malaria hit the Luxor region; more than a third of the population of Gurna, the village nearest to Tutankhamun's tomb, died from the disease.[32] It was the deadliest known form of malaria, caused by the *gambiae* mosquito – which had been brought north by troop movements from the Sudan and found ideal conditions in the sugar-cane plantations around Luxor, with their perennial irrigation canals. The only tourism to speak of was from soldiers on leave; some British soldiers reported visiting the tomb of Tutankhamun, which like many sites remained accessible.[33] Too accessible, perhaps, since not all visitors came in holiday spirit. Vandalism scarred several monuments, including the theft of tomb walls at Luxor and Amarna and of artefacts from storage magazines. It was almost certainly around this time that further acts of violence were also wreaked on Tutankhamun's body, by unknown actors.

The disturbance to his body came to light in 1968, when BBC television filmed a documentary called *Tutankhamun Post-Mortem*, in full colour, for its 'Chronicle' series of archaeology-themed programmes.[34] The cameras were running as Zaki Iskander – from the Egyptian Museum in Cairo – supervised the team of Egyptian workmen who lifted the outer coffin lid up and away from the sarcophagus and hauled up, with ropes, the tray containing the remains of Tutankhamun. There was no trace of any linen that had covered up the corpse. The body parts of the boy king lay scattered about, looking nothing like the Burton photograph from 1926, but no one made a public comment

about the shocking condition at the time. Only many years after-
wards did Iskander's colleague Mohamed Saleh – who went on
to be director of the Egyptian Museum – reveal that they spent
hours retrieving pieces that had fallen to the bottom of the cof-
fin (including the penis and scrotum) or been moved aside in
the tray, where the right thumb, left hand, a clavicle, and a femur
were all out of place.[35] The arms – separated by the 1925 autopsy
– had been shifted down the sides of the body to give access to
the chest, where only a few scattered beads of the bib remained.
The head was where a head should be. But it was tilted at an
angle, absent its ears, eyelids, and lashes, and stripped of the intri-
cate skullcap. In the film several men, including Iskander, pass it
around with a certain nonchalance between their ungloved hands.

 Tutankhamun Post-Mortem was the work of producer Paul
Johnstone, head of the Archaeological and Historical Unit at
the BBC, where he championed the use of colour film for docu-
mentaries. Johnstone had been approached by Ronald Harrison,
professor of anatomy at Liverpool University. Harrison had
visited Egypt in 1963 at the request of a Liverpool colleague,
Egyptologist H. W. Fairman, who wanted him to examine the
fragmented remains of another royal body – the remains found
in KV55, the tomb that had served as Harry Burton's dark-
room during the Tutankhamun excavation and, before that, had
held an unidentified member of Tutankhamun's family, perhaps
Smenkhare. Harrison caught the mummy studies bug. He took
a toe from the KV55 body back to Liverpool for further tests
(apparently this was not questioned at the time), and as interest
in Tutankhamun geared up throughout the 1960s, he began to
contemplate a fresh examination of the most famous royal body
of them all.

 Through connections in Cairo, including his former student
Dr Ali Abdalla, Harrison managed to win the support of Zaki

Iskander, who could make the case to antiquities officials. Funding from the BBC clinched the deal. The Egyptian authorities agreed that Harrison could undertake a new examination of Tutankhamun's body on site at the tomb, in December 1968. The chief aim was to X-ray the remains, which Derry and Hamdi had not done because of the difficulty of getting a machine to the Valley of the Kings.

From Derry's former department at the Cairo medical school, Harrison secured the loan of an old but serviceable X-ray machine, small enough to bring to Luxor and into the tomb. It was a Siemens-Reiniger-Veifa model produced between the mid-1920s and early 1930s in Germany – in fact probably acquired by Derry not long after his work on Tutankhamun.[36] Harrison brought his Liverpool colleague Lyn Reeve to serve as radiographer. To the accompaniment of German military marches, which he liked to listen to as he worked, Reeve turned his bathroom at the Winter Palace Hotel into a makeshift darkroom and ran a test run of the Ilford X-ray film the team had brought from England.[37] The Siemens was not ideal, but it worked. To be on the safe side, though, Reeve took the rest of the exposed films back to Liverpool for development under more controlled conditions.

The sweet-smelling resins in Tutankhamun's broken body perfumed the tomb under the heat of the television lights and the X-ray machine.[38] Each body part took its turn in the apparatus, with special attention given to the head. Another member of the British team was Frank Filce Leek, a dentist who had retired early to take a degree in Egyptology at University College London. Leek brought Tutankhamun into the atomic age, in hopes of obtaining X-rays of the teeth.[39] Normal dental X-rays require the film to go inside the mouth, which was impossible to do through Tutankhamun's closed jaws. The Atomic Energy Authority in

the UK had offered a solution using radioactive iodine. The idea was to insert the isotope into the mouth with a hypodermic needle. X-ray film could then be placed outside the jaws and left to expose for several hours. It was the kind of technological innovation that appealed to scientists, archaeologists, and funders, though in the end Leek found it did not work.

The *Post-Mortem* programme aired more than a year after filming, in February 1971, giving the researchers time to analyse their results. It had an audience of about 1.5 million viewers, and at least the same again when the BBC repeated it a year later on the eve of the British Museum's Tutankhamun exhibition.[40] There wasn't all that much to add to Derry and Hamdi's original conclusion that Tutankhamun was about five foot six inches tall and had died around age eighteen, of unknown causes. Harrison thought there was a shadow, perhaps an aneurysm, on the back of the skull, and it was possible to make out two layers of resin poured into the cavity of the skull, from different angles. Apart from the X-rays, Harrison had hoped to analyse Tutankhamun's blood type, to which end he'd brought a royal toe back to Liverpool to join the toe he already had from the KV55 body. Decades later, Harrison's colleague Robert Connolly still kept what was left of the Tutankhamun toe tucked away in a vial, looking 'like toast crumbs' as science journalist Jo Marchant described it. Connolly had sent the KV55 toe back to Egypt.[41]

Harrison had also hoped to X-ray the two mummified foetuses from Tutankhamun's tomb. He had seen one of them on his first trip to Egypt in 1963, when Douglas Derry's former assistant and successor in the chair of anatomy, Dr Ahmed el-Batrawi, located the fragile body in a plain wooden box in a storeroom at the Kasr el-Aini medical school. But el-Batrawi died suddenly before the BBC programme went ahead, and no one could locate the box again until 1975, when an anatomy

teacher named Soheir Ahmed found it.[42] She twice provided
Harrison with X-rays and fragments of the foetus's skull, so that
Connolly could run his blood-group tests. Other mummified
bodies and mummy research projects were garnering more atten-
tion by then, however. The Tutankhamun impetus had passed.
An American project to X-ray all the royal bodies in the Egyp-
tian Museum was under way, and in 1976 the body of Ramses
II flew to Paris for analysis and treatment organized by Christi-
ane Desroches Noblecourt, complete with a full military fanfare
and the secretary of state for universities, who were waiting to
greet the pharaoh at Le Bourget Airport, Paris.[43] The presumed
daughters of Tutankhamun, one lost, one found, faded into the
background for two more decades, until science came calling for
them again.

* * *

My father and I were front-page news on the same day:
16 September 1988. The phone rang in the early hours that
Friday, echoing in the rebuilt house, still sparsely furnished and
not yet wearing the accumulated signs of time. By evening, the
local newspaper could report beneath its masthead that John
M. Riggs, 51, was in critical condition following an automobile
collision on state route 37. Two columns to the right his name
appeared again, because Christina Riggs, daughter of, had won
a prestigious scholarship for college. She was, it said, planning
to attend Brown University to study Egyptian archaeology. As
I thought of it, my life was finally about to start. My father's life
had started towards its end.

The paper – which my brother and I had delivered by bicycle
for years, from ink-stained canvas sacks – must have been wait-
ing in the mailbox when we arrived back late that night from
the university hospital in the nearest city. My mother set it aside,

unread. We knew then what the headlines hadn't. An injury at the back of the head made it unlikely that John M. Riggs, a 51-year-old father of five, would ever regain consciousness.

I found the copy, soft with age, at the bottom of an antique chest of drawers in the bedroom my parents had shared for just six months. The house had sold as the Covid-19 pandemic gripped in the spring of 2020, and we were clearing the accumulation of three decades in preparation for my mother's move. I knelt on the floor and lifted out the artefacts of her life one by one, each a story that needed to be packed away: her own mother's high school diploma from the 1920s, Grandma's hair cut into the bob she kept throughout her life; the scorch-marked christening dress my mother and her brother wore, saved from the ashes of the house fire; and envelopes of family photographs sent by relatives to make up for those we'd lost. The stratigraphy was all disturbed, the oldest material on top and most recent at the bottom, where the yellowed newsprint lay folded over to the crossword puzzle no one had ever done.

'I never liked that dresser,' my mother announced as I slid the emptied drawer back into place. 'We bought it because we needed furniture after the fire.' Everything was before the fire or after the fire, a timeline to which we now added an even more painful notch. Before the accident, after the accident, or as I came to think of it, before Dad died, after Dad died. It was easier to pretend he was already gone than to explain what a persistent vegetative state (as the neurologists call it) does to a human body and to those who watch it waste away.

After two months in intensive care, Dad was transferred to a nursing home thirty miles down country roads. My mother drove it almost every day to sit with him, check with the nurses, talk, read, pray. A respirator kept him breathing, and one set of tubes took food into his body, while another siphoned away the waste.

Sometimes his eyelids fluttered open and the pupils cast blind looks around the room, before they shuttered down again. Keep him stimulated, was the advice. I went one time only, a grey New Year's Day, and found I could not make it through the doorway where that silent cyborg slept. The hospital gown seemed obscene on a man who was most comfortable in suits. His head rolled sideways, hair cropped close in a way he would have hated, with stubble shadowing his chin. My acceptance to Brown University had arrived at Christmas. I was counting down the months to my escape.

Another phone call in the pre-dawn hours brought the news that Dad had died. Family came from neighbouring states for the funeral in our white clapboard church, packed with mourners. The sexton – Mr Miller, a tall farmer who tapped his maple sugar trees in winter – pealed the bell long and slow over the valley where I'd grown up, and when the time came, we followed the undertakers down the familiar aisle and out into the cemetery to the waiting grave. In the church basement, the Sunday school classroom dividers had been rolled aside. The sexton's wife, a bright, efficient woman, tended an urn of percolated coffee and piled bowls full of potato chips few people touched. There were sandwiches and paper napkins, both dry and thin. At some point, we could leave. I headed up the basement stairs into the June sunlight, turning once to look back towards the grave. Mr Miller was toiling there, alone, shovelling the soil back in. Dealing with the dead is heavy work.

I graduated from high school two days later, and at the end of summer, like a swallow, I was gone. *If thou wilt, remember*, wrote my father's favourite poet, Christina Rossetti. He'd named me after her, he told me once. *And if thou wilt, forget*. In my new environment at university, I found I could do neither. Nor could the subject I'd chosen to study, as it turned out. Archaeology

dug through the remnants of the dead, the throwaways and left-behinds of long-gone people. That was part of its appeal: the immediacy of contact with a past almost too distant to conceive, and the puzzling together of material remains to work out what had happened when and how and why.

Accidents of survival drove the solutions offered up in archaeological reports and textbooks, but oversights, erasures, and intentional destruction should have featured, too. More has been forgotten of the ancient past than can ever be remembered, even if we take into account all that has been lost (a beaded skullcap), or overlooked (acres of hand-spun and -woven textiles), or momentarily misplaced (a foetus that would fit into a hand). I knew that not everything, or everyone, could be saved. But I wondered if we were right to place so much faith in the tangible things that did remain, and in the headlines whose dark ink lingered long after the real story had moved on.

*　　*　　*

Tutankhamun and his tattered body are now a stalwart of sensational news stories. Was he club-footed? A transvestite? Killed in a chariot race? Murdered by a blow to the back of the head? In the past fifteen or twenty years, investigators have tried to determine the king's age, cause of death, family relationships, and physical appearance, the last of these casting the long shadow of scientific racism over ancient Egypt once again. For the most part evading peer review in academic journals, theories about the boy king and his broken body are spun out instead via press conferences and television shows.

After the filming of the BBC *Post-Mortem* documentary, an air of semi-sanctity returned to the tomb, with the fragmented body out of sight within its coffin and sarcophagus again. The Pilkington Glass company replaced the old sheet glass that Carter had

used to cover the sarcophagus, though his number card (240) is still there. A railing keeps tourists out of the Burial Chamber, but from the vantage point of the Antechamber they can look down on the placid gilded face of the third coffin, knowing or at least believing that his remains were safe inside.

Other ancient dead were not so lucky. The royal bodies in Cairo, which had been on and off display over the years, had a respite from the public gaze when President Sadat ordered Room 52 – the 'mummy room' – closed after he visited in October 1980. He declared it a violation of the dead. The poor condition of the bodies in their decades-old vitrines had made a strong impression on him, and a government commission was set up to review the situation.[44] After Sadat's own death, by assassination, and with the help of the Getty Conservation Institute, the Egyptian Museum carried out an extensive conservation project and developed oxygen-free display cases to display the bodies.[45] Sheets of pristine cloth covered all but the heads and sometimes feet of the bodies, and gallery lighting was kept low both for preservation and to encourage some sense of propriety. In March 1994, after seven years of work, the world's press could announce that the royal mummies (as they are known) were once more on the tourist trail.[46]

From the 1960s onwards, museums in Europe and North America had been turning to their own displays and storerooms for bodies to analyse with medical techniques developed for living humans. The BBC 'Chronicle' series that had featured the 1968 Tutankhamun 'post-mortem' filmed the unwrapping of a mummified girl, barely pubescent, at Manchester University in 1976. The bone, tissue, and textile fragments that this process yielded were in dozens of cardboard boxes and ziplock bags in a storeroom of the university museum, where I accepted a job as curator after finishing my PhD and a research fellowship at Oxford. 'The

mummy store', the space was called. One of the boxes from an unwrapping was labelled 'dust and sweepings', which struck me as a more accurate designation.

Two months into that job, I had to wheel a mummified adult out of the corner where it usually lay on a metal trolley, under a sheet of opaque plastic. A headless, handless, footless body crystalline with resin, its scent – think frankincense and myrrh – suffused the storeroom's chilly air. The museum had purchased the body years earlier from the owners of a health-food store in Glasgow, to support the previous curator's work. That day, the former curator had returned to visit with a group of postgraduate students and a retired endoscope salesman, who would demonstrate this medical imaging technique.

I welcomed the group, discussed the sensitive nature of curating human remains, and set out a box of purple nitrile gloves for the endoscopist, who ignored them. He slid the tool's thin, rigid probe into the narrow opening of an exposed neck vertebra, poked it back and forth a few times, withdrew it, then pulled on the layers of ancient linen that cradled one hip, looking for some other hole his wand could enter. I froze, too anxious to speak out; the visit had been negotiated far above the level of my post. The sweet perfume grew sickly as our living bodies warmed the dead. The endoscopist stepped aside to let the students view the corpse themselves ('Look at its fingernails!' gushed one). He expressed his disappointment at the poor results. The body was packed so full of resin that the tool could only show the darkness deep inside.

Archaeology had always been an early adopter of new technologies in fieldwork, and museums have welcomed the chance to apply advances in medical imaging to ancient Egyptian remains. X-rays became old hat once computed tomography (CT scanning) became more widely available after its British inventor

first announced it to the public in 1972. By the end of the 1970s, a handful of museums had ventured CT scans of Egyptian bodies in their collections, and the pace picked up in the 1980s and 1990s. Each refinement of the technology – thinner 'slices', sharper resolution, three-dimensional imaging – trickled down to Egyptology.[47] By now, some bodies have been X-rayed and CT-scanned multiple times. Scientists and archaeologists characterize these techniques as 'non-destructive' or 'non-invasive' because they do not open or physically penetrate the surface of the remains, in whatever state they may be. For bodies that still have most or all of their original textile wrappings, it is the only way to peer inside not only the corpse but the layers of linen and any objects wrapped up with them. Yet the body must be handled and transported for such investigations to take place, which carries an inevitable element of risk. More difficult to square is the intractability of cultural perspectives. If we took seriously the strong cultural value ancient Egyptian religion placed on secrecy and concealment, such imaging seems just as invasive as an unwrapping and autopsy would be.[48]

Tutankhamun's body was late to the CT-scanning party. In 2004, the National Geographic media behemoth and the German engineering firm Siemens donated a CT scanner to Egypt's Supreme Council of Antiquities (as it then was). Worth an estimated $1 million, the scanner was installed on a truck so that it could be driven to sites, minimizing the travel distance for ancient bodies.[49] Head of the Supreme Council since 2002, and a regular consultant for National Geographic (he was rumoured to be on an annual retainer of £200,000), Zahi Hawass announced that the scanner would be the linchpin of a large-scale, long-term project to study mummified remains throughout Egypt. Technicians first tried it out on some bodies and body parts in the Egyptian Museum, expecting to start the scanning project

among its sizeable collection. Hawass – and National Geographic – had a better idea. The remains of Tutankhamun would be the first case study, and the American television channel would be there to film it, as the BBC had done almost four decades before.

Controversy dogged the project from the start, which was not surprising with two big names – Hawass and Tutankhamun – involved. At least one Egyptian scientist left the longer-term project, fearing that its academic aims had been hijacked by publicity, and other Egyptian observers raised red flags over the question of who would own and have access to the complex data that CT scans produce. How would other scientists evaluate the Hawass team's conclusions or put forth interpretations of their own? In an ironic echo of Carter and Carnarvon's long-ago contract with the London *Times*, Hawass excluded Egyptian media from the scanning itself, although they could join reporters from Japan, America, and elsewhere, who waited at a distance from the tomb on an overcast January day in 2005.

The scanning took place in the evening, after tourists had vacated the Valley of the Kings. On film the Burial Chamber is packed with the National Geographic crew, Hawass in his customary Indiana Jones fedora, and the *gallabiyah*-clad Egyptian handlers who lift the coffin lid with ease. Hawass, in Arabic, calls out 'slowly, slowly' as the men pull the wooden tray upwards on the ropes left beneath it in the coffin for this purpose. It sways at an angle, and the camera zooms in on the face, left bare above the sheet that covers the rest of the body. Someone, Hawass perhaps, thanks Allah, the all-merciful, before the body is swept out to the waiting truck for scanning. When the film cameras weren't rolling, there was time to take publicity stills of Hawass nearly head to head with Tutankhamun at the entrance of the scanner, or back inside the tomb, lifting and replacing the cloth covering over the body in the shallow tray.

The results of the CT scan were considered of such national (or rather, international) importance that they were announced by the Minister of Culture, Farouk Hosni, on 8 March 2005, after two intensive months of study by the Egyptian-led team and some European experts who were brought in to consult. The team members could agree on some points: Tutankhamun had been well nourished, with no childhood malnutrition, and had very good teeth. But other observations split opinions on the team, in particular a fracture on the left thigh that some considered a possible cause of death from infection but that the more cautious Swiss specialist, Frank Rühli, considered post-mortem damage from an unknown point in the mummy chequered modern history. As Rühli and Egyptologist Salima Ikram have since pointed out, 'post-mortem alterations [to Tutankhamun's and other ancient bodies] are often so severe, that an ultimate diagnosis is difficult to achieve'.[50]

Nonetheless, taken together with other signs of harm done to the body – in particular the lower ribs, likely damaged either in 1925 or the 1940s – speculative theories about Tutankhamun's death made for good television. A chariot accident was a favourite theory, reimagining Tutankhamun as a boy racer or warrior king who met a tragic end in a road accident. Producers took the opportunity to commission computer reconstructions of how a horse-drawn chariot moved at high speed. Other pundits used the supposed leg injury, a hint of cleft palate, and an alleged club foot to propose that Tutankhamun was disabled and therefore feeble. According to this interpretation, the large number of walking sticks in the tomb were movement aids rather than status symbols. Media outlets took the bait without blinking, apparently happy to link acquired or congenital disabilities with weakness in a way (one hopes) they would be embarrassed to do for any living person.

In May 2005, an even bigger splash hit the press in the form of three facial reconstructions based on the new CT data.[51] Three different teams of reconstruction experts, based in France, America, and Egypt, had been given enough data about the head to create a model of what Tutankhamun might have looked like. Only the American team knew his identity before they started the work, however, and once the identity was revealed, the French team went to the extra effort of creating a mannequin head with tinted silicon 'skin', glass eyes, hair, and make-up, using details based in part on their reconstruction, but in part on representations of the king found on objects from the tomb.

This doe-eyed, shaven-headed, and lightly tanned Tutankhamun made the cover of *National Geographic* magazine, stirring up ever-simmering debates about the 'race' of the ancient Egyptians. The American and French reconstruction teams identified what they termed Caucasian and North African characteristics in the skull. Both Afrocentric and white supremacist websites lashed out at the results: how dare science deny Tutankhamun's Black African or White European identity? Facial reconstructions have been popular in archaeology and museum displays since the 1970s, following on from the use of the technique in criminological research and courtroom trials.[52] In 1983, American forensic sculptor Betty Gatliff created the first reconstruction of Tutankhamun's face either using X-rays or a plaster cast (accounts vary), a photo opportunity for which she became as well remembered as her legal work helping to identify murder victims.[53] But like any visualization drawn from the remains of the ancient dead, or from works of art, the 'accuracy' of these reconstructions is often overplayed. Stark differences between the three Tutankhamun reconstructions highlight the element of interpretation that goes into making them, and the influence of data about tissue depth, nose shape, or skin colour, which will

have biases built into it. The American and Egyptian Tutankha-muns resemble each other most closely, with strong, squared-off jaws and foreheads that read like a stereotypical male face. With its adept use of eyeliner, the French Tutankhamun seemed more boyish or even androgynous, in echoes of the gender ambiguity that Egyptologists had sometimes read into Amarna art.

A few years later, it was the Discovery Channel's turn to have the film rights for Hawass's next announcement, which com-bined the CT scan with the results of DNA analysis undertaken on Tutankhamun, the two foetuses from the tomb (both of which had finally been located), and several other royal bodies. In addi-tion to a four-hour documentary miniseries called *King Tut Unwrapped*, the results of this study on Tutankhamun's health and family relationships appeared in the prestigious *Journal of the American Medical Association* in February 2010, listing Hawass as first author and German geneticist Carsten Pusch as corre-sponding author, with a long list of participants in between.[54] The article's confident conclusions about Tutankhamun and his family relationships splashed across the news again, but a series of expert responses in the journal, and elsewhere, questioned every single one of the conclusions.[55] The alleged club foot was a side effect of tight wrapping during mummification; suggested bone necrosis was more likely the result of the embalming process and the poor condition of the remains; a missing toe was not an injury but the work of Ronald Harrison; and the proposed identification of malaria as a cause of death is debatable and does not seem to fit epidemiological patterns. Ancient DNA studies are a minefield in themselves, with deep divisions over the accuracy of amplifi-cation tests that claim to identify ancient DNA with ease. It is not at all clear that adequate chains of DNA survive in ancient tissue, especially those transformed by an embalming process. There is also the caveat that researchers may be amplifying DNA

that has contaminated the mummy of Tutankhamun over the decades since its unwrapping. His remains have by now passed through many hands.

The DNA study also concluded with more than 99 per cent certainty that the two foetuses from box 317 were indeed the daughters of Tutankhamun. In a paper co-authored with Hawass, Sahar Saleem, professor of radiology at the Kasr el-Aini medical school, used the results of CT scans of the remains to adjust their gestational ages to 30 and 38 weeks.[56] She suggested that this made it unlikely that the infants were twins at unequal stages of development, as a 2001 paper had proposed.[57] However, in a response to the Hawass and Saleem study, three French radiographers countered that a twin theory was still viable.[58] Like Saleem, the French scientists draw attention to the parlous condition of the two bodies, which made physical examination impossible. 'Multiple postmortem comminuted fractures', is how Saleem described the larger foetus, because most of it has been reduced to minute fragments since both tiny bodies were photographed in the late 1920s and early 1930s.

'But Science is implacable,' wrote British journalist Leonard Cottrell in the 1950s, in a book on the 'romance' of Egyptian archaeology which included Sir Alan Gardiner's reminiscence of first entering the Burial Chamber and Treasury of Tutankhamun's tomb.[59] Implacable and, as Cottrell's upper case spelling of the word suggests, too grandiose to question. Good scientists, and perceptive Egyptologists, do ask hard questions of research methods and results, and weigh up the ethics of turning ancient human remains into a media circus. Few people notice the rebuttals, however, and television documentaries play on almost permanent repeat.

Whether the time, money, and effort expended on such studies is repaid by useful knowledge, is not the only question we

should ask in any case. When government officials hold press conferences, academic knowledge is unlikely to be the under-lying concern, whether the year is 1924 or 2010. The corpse of Tutankhamun, and the two tiny bodies that may have been his daughters, were long ago reduced to fragments of a disintegrated whole. Try to bring them back to life in our time and we sap what little humanity might still pulse in them from theirs. The 'rever-ent rewrapping' that Carter promised, and delivered as best he could, has long since been undone. On 4 November 2007 – a date chosen because it marked eighty-five years after the finding of the first step to the tomb – what is left of the human (and divine) remains of Tutankhamun were removed from the coffin and sarcophagus in the Burial Chamber and placed in a climate-controlled display case in the Antechamber. Tourists can now take in his crackled face and look into his sunken eyes for what-ever it is they hope to see.

8

Tourists, Tombs, Tahrir

WITH A FAÇADE the coral pink of a Nile sunset, the Egyptian Museum is by far the brightest spot in Cairo's Tahrir Square. It opened its doors in 1902, providing the first purpose-built home for the national collection of pharaonic antiquities, which had previously been located in a damp merchant's house near the Bulaq docks and a disused royal palace at Giza. An international competition to design the new museum yielded an all-French shortlist, won by architect Marcel-Lazare Dourgnon.[1] The Italian engineering firm of Garozzo and Zaffarani oversaw the construction of Dourgnon's Beaux Arts-inspired design. Around a central court, open to roof level, high-ceilinged galleries form a square with staircases at each corner. A dome pierced by windows covers the entrance, which is flanked by Ionic columns and two plaques carved with curvaceous Egyptian goddesses in filmy gowns.

The museum would not look out of place in any European capital, and that was the idea. It was meant to fit the Parisian-style neighbourhood of Ismailia, named after *khedive* Ismail and constructed during the 1860s boom. When the museum opened, it looked across Ismailia Square to the British army barracks and parade grounds at Kasr el-Nil. After the 1952 revolution, however, Midan Ismailia became Midan Tahrir – Liberation Square – and the Free Officers had the British barracks razed to the ground.

In 1995, on my first visit, the museum's view had changed. It faced a busy bus station and the Nile Hilton, where I sat in the air-conditioned lobby for an hour or so each sticky summer day, to read a book or watch the weddings. I visited the Egyptian Museum over several days on that trip, showing my student card for discounted entrance and a photography pass. Straight ahead, in the central court, stood a colossal statue of Tutankhamun's grandparents, or perhaps great-grandparents, Amenhotep III and Queen Tiye. I turned left, to start the chronological circuit around the building, which began more than 2,000 years before Tutankhamun had been born.

When the Egyptian Museum was built, no one could have predicted that it would need to accommodate thousands of objects from an entire royal burial. Each year, as Howard Carter sent more crates of objects north from Luxor, the curators found a little more space and built a few more cases, to house as many highlight objects as they could. The last objects to arrive were the four great shrines and the framework for the linen pall. With curator Rex Engelbach and archaeologist Laurence Kirwan (who later worked for Sudan during the UNESCO Nubian rescue campaign), Carter helped re-erect them in vast, glass-walled cases, filling what had been a wide corridor. A side room that could be closed off – Room 3 – held the most valuable objects from the find: the two inner coffins; the jewellery, amulets, and other adornments from the body; and the splendid mask, placed dead centre in its own case.

It must have been midday by the time I traipsed upstairs, my energy sapped by the close air and dogged concentration. I joined dozens of other tourists milling around the Tutankhamun galleries that fill two sides of the upper floor. I'd long since abandoned any interest in Tutankhamun or the 18th Dynasty. All gold, no grit, I would have sniffed. But viewing the treasures was a must,

a diversionary break between other galleries I wanted to see in more detail. I trudged past the shrines (big), filed past the coffins and the mask (also big), and wandered around rows of *shabti* figures and gilded statuettes. The child-sized chair, the toy-like crook and flail, the chests that had held his clothes and jewellery, like a royal dressing-up box: those were smaller than you'd think. It was the stuff of childhood – mine and his.

Many of the objects were familiar to me from photographs, postcards made flesh before my eyes: the mask, of course, but also the golden throne, the miniature coffins, the harpooner, the alabaster vases. All present and correct. But that same familiarity added to my bafflement. How could I know so little about the tomb of Tutankhamun, after six years at two prestigious universities? My first few days in Egypt already had me feeling an uncomfortable disconnection between the ancient culture I had studied and the modern culture that I faced. I snapped a few photographs of Tutankhamun's glassed-in treasures, determined to seem a scholar, not a tourist. But a tourist I was, and not the first foreigner to come here looking for an Egypt that existed only in my mind. Nowhere had I belonged less than in the place that, in the casual arrogance of my imagination, I thought would feel like home.

* * *

The tomb of Tutankhamun became a tourist attraction almost as soon as Howard Carter and his team began to work on it. Once news of the discovery hit the European and American press that winter of 1922–23, the hotels of Luxor, still sleepy since the war and revolution, began to fill with clients seeking winter sun and pharaonic splendour. Anyone who had already booked an Egyptian holiday was in luck, but with more company than might have been expected. The Winter Palace pitched tents in its garden to

accommodate the overflow and offered themed evenings where patrons could dance to 'the Tutankhamun rag'.[2]

The tomb was open to the public on Tuesdays, the local market day, when the Egyptian workforce did its shopping. Tourists could apply to the local office of antiquities inspectors for admission, with sixty-five people a day allowed into the cramped space, still full of objects. Those who couldn't get a ticket gathered along the road in the Valley of the Kings, where the Antiquities Service erected a low stone wall to help define a viewing space and protect visitors from the drop into the area around the tomb entrance below. Still, the crush of people at peak times, and persistent requests for access, added to the strain on Carter. He pointed out to the Antiquities Service that the team lost half a day's work making the tomb safe for visitors, then setting up for work again the next day.[3] But demand was too great, besides which the visits generated income and interest that could prove influential.

By the time the tomb had more or less been cleared in the late 1920s, apart from the dismantled burial shrines and the sarcophagus box and lid, it was a firm fixture on tourist itineraries to the Valley of the Kings. Throughout the 1920s, Egyptian politicians, celebrities of the day, and royalty had continued to make high-profile stops as well, from King Fuad, in the wake of Carter's self-described strike, to Umberto, the crown prince of Italy, in 1927.[4] Howard Carter hosted several past, present, and future prime ministers of Egypt in the late 1920s, and Prince (soon King) Farouk in 1936.[5] A 1942 guidebook written 'by an English resident of Luxor' recommended six days to explore the area in comfort, with two days a bare minimum.[6] Visitors organized a guide and a packed lunch from their hotel the night before, and the guide made travel arrangements for a 7 a.m. start. After crossing the river by boat, tourists visited the sites by donkey ('or carriages,

where desired'). The Valley of the Kings was the farthest site to
visit, more than five miles from the river, and the anonymous
author of the 1942 guidebook described the journey thus:

> The sensation while traversing this road, the deathly silence,
> the absolute desolation, and the feeling of the World left
> far behind, is certainly somewhat eerie, and unconsciously
> provides the right atmosphere of awe and respect with
> which the tombs of the Pharaohs should be regarded.[7]

During his time as Chief Inspector for the region, Howard
Carter was responsible for erecting a shelter for the donkeys at
the entrance to the Valley and installing security gates and elec-
tricity in the royal tombs, although for many years afterwards
only a handful were illuminated, and then only for a few hours
a day.[8]

Around the time Gaddis Photo Stores, at the Winter Palace
Hotel, published the 1942 edition of the Luxor guidebook, tour-
ism in the area had dwindled on account of war and the malaria
epidemic. Post-war, it returned slowly, hampered by a cholera
outbreak in northern Egypt in 1947 and by anxieties ahead of,
during, and after the 1952 revolution. Nonetheless, by 1953,
foreign consultants were already considering how to encourage
foreign tourism to the country. The UNESCO campaign for the
Nubian monuments drew attention to the natural beauty and
archaeological monuments that Egypt offered and coincided
with the upswing in tourism that air travel made possible. The
1960s Tutankhamun tours to America and Japan may have been
designed to raise awareness and funds for the Aswan High Dam
and the rescue of Abu Simbel, but Egypt's willingness to lend
objects from the tomb of Tutankhamun also had the happy side
effect of bringing hundreds of thousands, and then millions, of

tourists to Cairo and the Nile valley. Why not meet Tutankha-
mun, and his fellow pharaohs, on their home ground?

President Nasser established a separate ministry of tourism
in 1966, the same year that he appointed Tharwat Okasha to
head the first ministry of culture. Between the 1960s and 1990s,
Egypt developed an extensive tourist infrastructure, catering to
both independent visitors and package holidays. An international
stream of young Europeans, North Americans, and Australians
added Egypt to the backpacker trails that sprang up in the 1970s,
but the package holiday market, especially at the higher end,
was more appealing in financial terms. Egypt borrowed from
the World Bank to build more and better hotels and encourage
river cruises, which had a boost from the film version of Agatha
Christie's *Death on the Nile* in 1978 (another win for Tutankha-
mun's marketing). At Luxor, tourist numbers doubled between
the 1980s and 1990s, although lengths of stay shortened to just
one night, if that.[9]

Egyptians whose work relied on tourism came to know, too
well, their place in the bigger economic picture. Most tourism
money went to foreign companies, though the steady influx of
travellers created both direct and indirect employment, from
hotel and restaurant staff, to travel agencies and transportation,
to souvenir sellers, licensed guides (who are university-qualified
in their field), and the guards at archaeological sites, who rely
on tips (*baksheesh*) to supplement below-subsistence salaries. By
1990, tourism was worth $2 billion a year to Egypt and by 2010,
six times that. In 2000, the tourist industry accounted for 11.6
per cent of the country's GDP, rising closer to 20 per cent in
peak years.[10] Those figures include tourism from the Gulf States,
drawn by the hotels, shopping, and nightlife of Cairo, as well as
tourists visiting the sun, sand, and scuba attractions of the Red
Sea Coast.[11] Not everyone goes to Egypt for the antiquities.

But many people do. When Tutankhamun-inspired travel took off in the 1970s, Luxor once again became a tourism hub, this time with all the conveniences that modern life could offer. Taxis, minivans, and tour coaches zipped visitors around in air-conditioned comfort, and rest houses with simple refreshments and public toilets made it easier to spend a few hours visiting the sites in one or two days, taking in a temple or two, some of the painted Tombs of the Nobles, and the highlights of the Valley of the Kings. Just as older visitors to the Tutankhamun exhibitions were within living memory of the discovery of Tutankhamun's tomb, so too were many residents of Gurna able to remember the famous find. Some men of the right age, who came into contact with foreign tourists between the 1970s and early 1990s, recounted that they had worked as boys either for Howard Carter or, more rarely, Harry Burton. One man – *Sheikh* Hassan, from a branch of the large Abd el-Rassul family – identified himself as the unknown, unnamed boy in a Burton photograph, posed in one of the heavy gold and carved stone collars from an ebony- and ivory-veneered chest in the Treasury which was labelled as containing jewels from the king's funeral procession.[12]

The Abd el-Rassuls are one of several large, interconnected Gurnawi families, enshrined in Egyptological memory for their involvement in the 1881 discovery of a cache of royal reburials at Deir el-Bahri – including the body of Ramses II, buried in the reused coffin I had admired that day in Boston with my father. *Sheikh* Hassan's branch of the family still run the rest house near Ramses II's funerary temple, the Ramesseum, and photos of Hassan with the Burton photograph adorn the walls. A Swiss journalist who was married for a time to one of Hassan's grandsons embroidered the story in a memoir whose title (*At the Tomb Robbers*) speaks to the persistent and pejorative identification of Gurnawis as thieves.[13] More recently, and in conjunction with

new tours of Tutankhamun objects that Zahi Hawass has facil-
itated, *Sheikh* Hassan's story of being photographed by Burton
has been conflated with a separate story told by Thomas Hoving
in his bestselling 1978 account of the Tutankhamun discovery.[14]
Hoving dug out a second-hand account in the Metropolitan
Museum of Art archives, whose author claimed Howard Carter
had told him that the actual discovery of the tomb's first step was
made by an Egyptian boy who carried water to the workmen.

Another version of the 'real discoverer' tale appeared in the *Bos-
ton Globe* already in April 1924, picked up by their reporter Karl
Kitchen, who arrived to write his trademark tongue-in-cheek –
and disparagingly racist – dispatches from Cairo and Luxor just
as Carter's conflict with the Egyptian government hit the head-
lines. According to Kitchen, thirteen-year-old Mohamed Gorgar
(another spelling of Gerigar, the family name of *Ra'is* Ahmed)
found the tomb's first step while digging in an area Carter had
told the workmen to ignore. Kitchen claimed to have heard
the story from a local guide and had it confirmed by Mohamed
bey Fahmy, head of the Luxor police, who added that the boy
had been paid off by Howard Carter. When Kitchen tracked
down Mohamed Gorgar – by then fifteen, and still in Carter's
employ – at the home of his blind father in Gurna, questioning
him via a translator, the reporter was met with shy laughter and
silence. All Mohamed would say, as Kitchen tells it, was that he
was glad work on the tomb had stopped so he could take a rest.
An illustration by well-known caricaturist Herb Roth, showing
the Egyptian workmen as tarboosh-wearing blackface figures,
accompanied all of Kitchen's *Globe* reports that spring.[15]

Neither Mohamed Gorgar nor the mysterious water boy
of Hoving's version featured in any of Howard Carter's many
accounts of the find, though Carter certainly didn't mind em-
broidering stories himself. In the hands of Zahi Hawass (or his

ghostwriters), the water boy and the boy wearing Tutankha-
mun's gold jewels in Burton's photograph have both become
Hassan Abd el-Rassul – and this uncorroborated story has
been presented as firm fact in exhibitions, catalogues, and tele-
vision documentaries.[16] Some version of the story, or the earlier
tale of Mohamed Gorgar, may be true. It is hard to say, after a
century, and whatever the truth may be, the water boy is now
a firm favourite with Luxor tour guides. It's worth pointing
out that the Burton photograph dates no earlier than late 1926
or early 1927 – not to 1922, as often assumed. Hawass, who
worked at Luxor in the early 1970s, claims to have had the water
boy and necklace-wearing story from *Sheikh* Hassan in person.
According to Hawass, the *Sheikh* was also eyewitness to a secret
romance between Howard Carter and Lady Evelyn, who took
long moonlit walks together among the ruins. Make of that what
you will.

Encounters between tourists and the residents of Luxor and
its environs had been shaping foreigners' perceptions of both
modern and ancient Egypt long before the discovery of Tut-
ankhamun's tomb, and they have continued to do so, in a circle
of repeated tropes and tales that tend to confirm what foreigners
already imagined. It is difficult to break the circle, when Euro-
American Egyptology itself seems more ready to embrace the
identification of a token child in a Tutankhamun photograph,
than to do the much harder work of critiquing its complicity in
colonialism and empire. There are plenty of known and named
Egyptians in Egyptology's own history whose contributions
are past due for recognition. What matters is less the question
of who is, or is not, represented in Burton's images, but the fact
that other accounts and memories of Tutankhamun do exist,
from Egyptians who were never meant to be part of the official
archive of the excavation. But since the archive is what has made

the tomb's discovery famous, other narratives feel obliged to peg themselves to it where they can.

Ironically, then, while tourism brought some Egyptian accounts of Tutankhamun's tomb to Western ears, the reference point remained Howard Carter, Lord Carnarvon, or Harry Burton. Tourism needed Tutankhamun, and as tourism increased from the 1970s into the 1980s, the Valley of the Kings required physical changes to make it more accessible – and more profitable. In the 1980s, the Egyptian authorities built a tourist rest house and installed fluorescent lights in several tombs, including Tutankhamun's. They improved walkways and signposting, installed handrails and protective glass over the paintings and reliefs, and mounted information boards. Visitor numbers rose – but so did the heat and humidity they generated in the tombs, as did the lights that had to be kept running up to twelve hours a day in high season. The much-needed toilets in the rest house pumped sewage into some of the tombs for a few years, while rising groundwater levels from the High Dam led to damp and salination in the bedrock of those cut more deeply than the tomb of Tutankhamun.[17] As the most famous of them all, his tomb is in the heaviest demand. To control the number of visitors, entrance requires a separate ticket (costing about £12 at the time of writing); even so, up to 1,000 people a day pass through at peak times.

On that first trip to Egypt, after I had been to Cairo and Aswan, I met up in Luxor with a fellow student and the professor we had been studying with in America. It was late July, and we rose by 5 a.m., to see as many sites as possible before the heat cranked up. Each day, at the ferry landing, we were met by Ahmed, a taxi driver the professor had known since her own research visits to the Valley twenty-five years before. They must have been contemporaries, or nearly so. She had made a career out of her work in Egypt, and he had made a living at the wheel

of his spotless car. A beaded wooden cover on the driver's seat rustled gently, like hollow river reeds, each time he eased himself in or out. Ahmed went about his own business while we trekked up and down the massive tombs whose once-secret entrances gape open in the rock face. Inside, we studied painted reliefs of gods, dead kings, and an underworld menagerie of crocodiles, beetles, and birds. We followed winding passages underground to vaulted burial chambers, where golden constellations lit the sun's rebirth across a sky of midnight blue. It was always a long way back up to daylight.

At the mouth of the valley, Ahmed waited for us at the agreed time, his blue car a beacon among the usual white taxis and tour agency minivans. The Valley had nearly emptied. Few people stayed as long as we had, under the midday sun. But there was the sign for Tutankhamun's tomb, which I had not visited; a tour group had been queuing up when we arrived, and the entrance fee was not included on my student antiquities pass. Should I see it, quickly, for the sake of it? 'Go ahead,' urged the professor, so down the famous steps I went. The guard was an older man, as the *ghaffirs* at Tutankhamun's tomb tend to be, and he waved me in for a few soft notes of Egyptian pounds instead of the right pass. I walked along the corridor and into the plain white Antechamber, with its viewing platform into the Burial Chamber, the only room with paintings on the walls. Electric light reflected off the sheet of glass laid over the sarcophagus, where the largest coffin gazed up through its gilding at the bare ceiling overhead. I turned, deflated and a bit confused. Was that it?

The guard encouraged me to retrace my steps and look through the low opening into the tiny Annex, the space Carter saved for clearing last, daunted by its jumble of upended furniture and boxes. I was hot, hungry, and aware that people were waiting for me up above. How much had gone on in those rooms, and how

empty, how anticlimactic, they now seemed. *Shukran, shukran*, I told the guard in thanks, the only Arabic that crossed my lips with ease. 'Seen it?' the professor asked, when I emerged. Yes, I thought I had.

* * *

I might have been more naïve than other tourists or students of Egyptology. You can take the girl out of Ohio, as the saying goes (but not Ohio out of the girl), and most of us look back on our younger selves and marvel at how much passed us by. Still, how much I did not know, or had blithely assumed, about the relationship between ancient Egypt and modern history was not an individual failing but a product of that relationship, with its complex colonial and imperial roots. Ignorance enables the nostalgic air that suffuses Egyptology and the tourist experience alike. It is a nostalgia that the Tutankhamun industry has done as much as anything or anyone to fuel. If only antiquity were waiting, passive and pristine, for its discovery and the Nile were the same river as all its flooded pasts.

At the end of our last day, Ahmed, the driver, invited us for tea in the extension to his house, so new its concrete walls were bare. The tea was hot and sweet, and the family's youngest son, a spirited five-year-old, was charmingly naughty while the grown-ups chatted, our spoons a rhythmic clatter now and then against the glass teacups. Ahmed drove us back to the ferry landing, his son in tow this time. I have a photograph somewhere in a scrapbook of the little boy with one of our wide sunhats on his head, the trail of its floral-patterned trim dangling over one wide eye. I made a copy when I got back to America and posted it to Ahmed at the address he gave me. New Gurna, West Bank, Luxor. I hope it found him.

Gurna is the collective, colloquial name for several settlements

that clustered among the tombs and temples of Luxor's west bank, derived from the Arabic name of the Theban mountain, al-Gurn (or al-Qurn). Small communities had lived among these ancient sites for centuries. The hillsides into which the ancient nobles' tombs were cut, and the ruins of the massive temples packed high with debris, offered useful shelter, far from the flood-plain but close enough to give agricultural workers access to the fields. When European travellers, treasure hunters, and archae-ologists put Luxor and its west bank on the tourist trail, the Gurnawis began to service Western needs. They shared their first-hand knowledge of the sites and supplied the workforce for the heavy physical labour that archaeology required. They also sup-plied antiquities, genuine or copied, to tourists eager to take home a souvenir and to the dealers who set up shop in Luxor town. Gurna had a symbiotic relationship with archaeology, though one side always benefited more: Egyptian homes in Old Gurna had no running water, long after it was piped into the dig houses of foreign excavation teams.

'Tutankhamun's modern neighbours', the anthropologist Kees van der Spek has called the people of Gurna and its constituent settlements.[18] In the twentieth century their fate, like the phar-aoh's, grew ever more dependent on that uneven relationship with the West – and on the building of the Aswan High Dam. The malaria epidemic that struck the Luxor area in the 1940s took a deadly toll on Gurna and drew the attention of authorities in Cairo, who determined to improve living conditions by build-ing a new settlement to rehouse the families of Old Gurna. After the damage to tombs and thefts of antiquities during the war years, authorities were also anxious to remove settlements adja-cent to archaeological sites. Europeans had been characterizing Gurnawis as tomb robbers for a century or more. The label could serve the Egyptian government's purposes, too.

Architect Hassan Fathy drew up plans for a settlement he called New Gurna, which would be closer to the Nile and built in Fathy's modernist 'vernacular' style of mud brick. Fathy took inspiration from visits he made to Nubian villages in the Aswan region, where families displaced by the earlier dams had made their homes. With their distinctive domes and date palm courtyards, Nubian houses bore no relation to Gurnawi homes, but the urban architect's vision prevailed over local construction methods. Traditional Gurna houses used the trunks of male date palms for flat timber roofing; domes, like those on Castle Carter and the Metropolitan Museum dig house, were more labour- and material-intensive and less commonly used. In any case, the Aswan High Dam would put an end to the floods that produced the mud required for bricks, which fewer people had time to make once perennial irrigation kept families busy all year round in the sugar-cane plantations.

Nonetheless, Fathy's designs for New Gurna called for mud-brick structures with domed roofs, laid out in careful rows with plans for new schools, a marketplace, a mosque, a police station, a women's clinic, public baths, a sporting club, and a theatre. Hassan Fathy came from Egypt's upper class and wrote about his work in English and French. He described the Egyptian countryside as a 'paradise lost' both to the urban dweller and to the downtrodden rural poor, who had become detached (he assumed) from the skills that mud-brick building methods required and, just as importantly, from a feeling and appreciation for it.[19] Cosmopolitan observers in Egypt and Europe admired Fathy's architecture for its attempt to preserve an imagined 'tradition' linking peasants and the land. That was how I first heard about him: after Ahmed dropped us at the ferry landing, my professor gave a rundown of the New Gurna development, echoing the usual praise of Fathy's mud-brick buildings, and pointing

out that concrete has environmental costs, including air conditioning to keep it cool in summer. The government hailed the benefits of the new housing (running water, sewage, electricity) and offered incentives for those who moved. Many families did, but for some, modern conveniences could not replace generations of ties to their homes and the landscape, nor the source of revenue from passing tourist trade.

Tensions simmered around the two Gurnas, Old and New. A few international activists joined the residents of Old Gurna to campaign against the wholesale demolition of the village.[20] Efforts to have it included in the UNESCO World Heritage listing for the west bank's archaeological heritage came to nothing, and by the 1990s, local government authorities and the Supreme Council of Antiquities ramped up threats to expel the last few families by force if necessary. A new development plan for Luxor tourism sealed the fate of the last few settlements on the hillside, which were bulldozed between 2006 and 2009 – to the sound of silence from the international archaeological community that is always active in the area.[21] With USAID funding, the American Research Center in Egypt returned to the demolished villages between 2011 and 2014, turning the recent ruination of people's homes into another archaeological site.[22]

Drawn up with input from foreign consultants, the Luxor plan was pushed through by mayor General Samir Farag, who was close to President Hosni Mubarak; Mubarak appointed Farag to the role in 2004, and in 2009 made Luxor its own governate, separate from Qena.[23] In Luxor itself, the development plan called for the demolition of houses in the city centre to make way for a reconstructed sphinx-lined street between the temples of Karnak and Luxor. The demolitions displaced thousands of residents, often at short notice and with little compensation, and destroyed the old marketplace. The same development plan called

for the creation of vast car parks for tourist coaches on both banks of the Nile and a $3 billion marina for cruise ships, as well as golf courses, luxury hotels, an IMAX theatre, new roads, and street lighting.[24] Enclave tourism was the goal, whereby big hotels and cruise ship companies try to capture as much of the tourist spend as possible by creating a bubble to take visitors from hotel to ship to sightseeing without encountering contemporary Egyptian life or interacting with independent guides and vendors.[25]

If, that is, the tourists kept coming. In the early 1990s, Islamist groups began to stage attacks on tourist targets, such as a bomb detonated near the Egyptian Museum in March 1993 and another, that June, near a tourist bus on the Pyramids Road, which killed an Egyptian and wounded several tourists.[26] Lost revenue mattered as much as damage to Egypt's reputation. The deadliest attack to date occurred in November 1997 at the temple of Deir el-Bahri, set into the cliffs that back on to the Valley of the Kings. Assailants with guns and knives mounted a morning-long slaughter in which more than sixty people, including five Egyptians, died before police could overpower the perpetrators. It was a traumatic event for the Gurna communities, stunned by the violence against local men who worked there.[27] Among the victims was a site guard named Shahat, who left behind a wife and seven children. Egyptian Egyptologist Wafaa El Saddik had come to know him while excavating nearby. In her memoir, she described his dedication to the temple. Never having been to school, he learned about its history from the foreign specialists who worked there – and from his own experiences of the sacred place. On night duty, he had seen priests moving through its porticoes and heard the voice of the ancient goddess of the holy mountain above, Meretseger, 'She who loves silence'. Shahat's family received no compensation for his death, according to El Saddik, nor any visit from government authorities. President

Mubarak flew to Luxor to greet foreign survivors instead, in front of the news cameras.[28]

Funding for the attack on Deir el-Bahri was later traced to Osama bin Laden. Tourism had recovered when bin Laden struck again, this time the 11 September 2001 attacks on the United States; the pilot who flew American Airlines Flight 11 into the north tower of the World Trade Center was Egyptian. Since that date, the fortunes of tourism in Egypt have been up and down, and with them the fortunes of Tutankhamun's tomb and his treasures. Plans already in the works for streamlining – and securing – package tourism to Cairo and the Nile valley pressed ahead with greater urgency. But another possibility emerged as well: if the people would not come to Tutankhamun, Tutankhamun could go to them. Again.

* * *

After their North American wanderings, the touring Tutankhamun artefacts returned to Cairo in January 1980, but only briefly, because Egypt had negotiated further tour venues in West Germany, including Cologne, Munich, Hanover, Hamburg, and Berlin.[29] In a mark of warming relationships between Egypt and West Germany (the Federal Democratic Republic, or FDR), Anwar Sadat had acceded to a direct request from President Walter Scheel for a Tutankhamun exhibition. Egypt deemed the FDR a neutral country in the 1973 Arab–Israeli war, and a diplomatic push won German firm Deminex oil exploration rights in the Red Sea. West Germany would have its 'Tutanchamun', too, before almost twenty years of touring came to an abrupt end in 1981. The statue of Selket sustained a knock during its installation in Berlin, dislodging the scorpion figure atop the goddess's head.[30] The damage was repaired by German experts at German expense, but the incident let Egypt, perhaps with some relief, halt

the circus of the Tutankhamun tours. Apart from concerns about wear and tear on the well-travelled artefacts, Egypt had seen too little of the profits, and the money it did receive never reached the promised projects. Funds meant to refurbish the Egyptian Museum in Cairo went into a general budget for the ministry of culture instead. Tutankhamun had become big business, but for whose benefit was difficult to say.

Enter the well-connected Zahi Hawass, who became head of the Supreme Council of Antiquities in January 2002. From humble origins in a Delta village, Hawass had studied archaeology at the universities of Alexandria and Cairo and received his PhD from the University of Pennsylvania, on a Fulbright Fellowship. His passion for archaeology was inseparable from his fondness for publicity.[31] With an extrovert's instinct for performance and a narcissist's temper, he had parlayed his years of work at the Giza pyramids into lucrative television appearances and speaking engagements; he was a close associate of Egypt's first lady Suzanne Mubarak, too. A savvy navigator of the media, Hawass could see that a revived travelling exhibition of Tutankhamun objects, on better financial terms, made business sense.

The result was 'Tutankhamun: The Golden Hereafter', hosted in 2004 and 2005 at museums in Basel and Bonn. Sponsored in Switzerland by UBS bank and Germany by Deutsche Telekom, the exhibition combined fifty tomb objects from Cairo with seventy finds from other royal burials. Around forty of the Tutankhamun objects were new to touring, although they fit familiar models. It takes an expert to distinguish one of the inlaid canopic coffins from its three siblings. Also part of the display was a full-colour reproduction of the painted burial chamber. Some 620,000 visitors saw the show at Basel's Museum of Antiquities, and more than 700,000 at the Kunsthalle in Bonn.[32] The director of the museum in Basel was tight-lipped about the exhibition

financing, noting only that negotiations had been lengthy and emphasizing the money the show generated for tourism in the Swiss city. A win for all, including tens of thousands of Swiss and German schoolchildren who retraced the pharaoh's footsteps through the afterlife. The *Wall Street Journal* heralded the 'return of the king', giving voice to hopes that Tutankhamun would resume his tours once more.[33]

With only a brief pause, he did. At the end of the Bonn tour in 2005, the US-based National Geographic Society, together with a firm called Arts and Exhibitions International (AEI), contracted with the Supreme Council of Antiquities to continue the tour using more or less the same roster of artefacts. Rebranded as 'Tutankhamun and the Golden Age of the Pharaohs', it crisscrossed the United States for two years, made a much-trumpeted return to London, then went back to America before finishing up in Melbourne, Australia, in 2011.[34] Most of the venues on the tour were museums, including the Field Museum that had hosted Tutankhamun in Chicago twice before. In a break from previous practice, however, AEI also made use of two commercial exhibition venues: the Discovery Times Square Exposition space in New York City and the O2 Arena in London. Such spaces have advantages of scale over many museums, in terms of crowd capacity, and they may attract visitors who are not traditional museum goers, by cutting out any perception of the exhibition as elite. Their ticket prices are just as high or higher than museums would charge, however, and rather than a public or civic institution sharing the proceeds, private enterprise companies benefit – not least AEI and its director, American businessman John Norman. 'Golden Age' was so successful that Norman organized a parallel tour between 2008 and 2013, again mixing Tutankhamun objects and other royal material from Cairo. 'Tutankhamun: The Golden King and the Great Pharaohs' opened in Vienna

before heading to another seven American museums and exhibition centres.

Norman and his company re-emerged as the organizers of a new Tutankhamun tour in 2018, this time under the larger umbrella of IMG Exhibitions. Now called 'Treasures of the Golden Pharaoh' (the formula clearly works), this tour assembled more than 160 objects and bragged that most of them were travelling outside of Egypt for the first time. Rather than guardian statue 29, which had travelled to Paris in 1967 and London in 1972, viewers who paid up to £38 for a ticket to the show's third venue, at London's Saatchi Gallery, could see guardian statue 22 instead. The IMG exhibition was a multimedia experience with an introductory film, music, an audio guide, and, for an extra charge, a virtual reality visit to the tomb. The curator was Tarek El Awady, a protégé of Zahi Hawass and director of the Egyptian Museum during the Tahrir Square protests that rocked Egypt in January 2011. Hawass loomed large in the gift shop of the Saatchi Gallery venue, with photomurals on every wall, a rack of his leather fedoras for sale, and his name on the cover of every book.

For both the AEI and IMG tours, press releases emphasized that Egypt would reap significant financial benefits; the previous AEI tour, according to Hawass, had netted $120 million for Egypt. Each venue hosting 'Treasures of the Golden Pharaoh' paid a $5 million fee to Egypt's Ministry of Antiquities, followed by a portion of the proceeds; attendance numbers broke records during a six-month stop in Paris, at the Grande Halle de la Villette. But moving art around the world is never without risk, which must be offset against other benefits. The funds raised were meant to go towards spiralling cost at the Grand Egyptian Museum (GEM) on the edge of Cairo, but the financing and authorization of the tours was less than clear. In Egypt, lending objects to a private company, rather than a specific cultural

institution or governmental body, contravened Antiquities Law
117 – until the wording of the relevant articles was hastily
changed after the fact. A BBC Arabic documentary, aired in
July 2020, drew attention to the legal questions, the involvement
of Hawass, and the fact that if the tour travelled to all ten host
cities, its Tutankhamun objects would not return to Egypt until
2024 – long after the 2022 centennial and the planned opening
of lavish new Tutankhamun displays at the GEM.[35] When the
Covid-19 crisis closed the Saatchi Gallery and made the next
venues nervous to commit, the tour was cancelled and the objects
quietly returned to Cairo. A selection of twenty statues, jewellery
items, and *shabti* figures took an excursion to the Red Sea, for
any tourists who took a break from diving to visit the museums
of Hurghada and Sharm el-Sheikh.[36] Even Tutankhamun needs
a holiday now and then.

<p style="text-align:center">*　　*　　*</p>

For those unable to see the tomb of Tutankhamun and its treas-
ures in person, seeing replicas has been an option almost from the
start. Like other colonial and imperial expos of the nineteenth
and early twentieth centuries, the British Empire Exhibition of
1924 and 1925 offered education and entertainment all in one.
Visitors (including Harry and Minnie Burton) came in their
millions to see displays about the cultures and commercial prod-
ucts of Britain's imperial possessions and stroll the grounds and
gardens, purpose built at Wembley in west London. But there
was a funfair atmosphere as well. Roller coaster rides, refresh-
ment stands, and live performances livened up the doughtier
displays – and a furnished replica of the tomb of Tutankhamun
stood right near the amusement park, with sand, a camel, and
a tarboosh-wearing guide to add to the supposed authenticity
of the experience.

*Sculptor William Aumonier in his London studio with
some of the tomb replicas his workshop created for the
British Empire Exhibition in 1924*

The tomb was the brainchild of London sculptor Wil-
liam Aumonier, who worked with Egyptologist-turned-author
Arthur Weigall to design a full-scale replica of the Antechamber
and some of its star objects.[37] Weigall had already earned How-
ard Carter's ire while covering the discovery for the *Daily Mail*.
Rival papers to *The Times* were an annoyance, as was Weigall's
well-meant advice that Carter should be more mindful of Egyp-
tian sensitivities. The Aumonier exhibition infuriated Carter so
much that he filed a lawsuit to stop it, arguing that the repli-
cas were based on photographs and information exclusive to *The*

Times. Weigall submitted to the court his own photographs and notes to demonstrate that the Aumoniers and their craftsmen had been able to recreate the artefacts without recourse to copyrighted material. Carter's lawsuit was dismissed.

After the exhibition, the replicas wound up in Hull thanks to local businessman Albert Reckitt, who knew Aumonier's work (the sculptor was responsible for the city's First World War memorial). Perhaps it was seeing the Aumonier replicas on the BBC's *Blue Peter* programme in 1972, in conjunction with the British Museum 'Treasures' show, that helped give Dr Michael Ridley the idea to create a replica of the tomb in Dorchester, England – otherwise more famous for Thomas Hardy than for Tutankhamun. Opened in 1986, 'The Tutankhamun Exhibition' attracts curious tourists on their way to the coast and moors of south-west England, but there is local business, too. Thanks to the inclusion of ancient Egypt on the National Curriculum in England and Wales, groups of Dorset schoolchildren 'do the Egyptians' via the attraction's straw-strewn recreation of the Antechamber and a Burial Chamber that turns Harry Burton's photographs into 3D, with awkward-looking mannequins of Carter and his Egyptian colleagues at work.[38] The exhibition is located in a deconsecrated Catholic church, built in 1889 for the monastery of a Passionist order at the Dorset village of Wareham. When the brothers' devotion to Christ's passion and death proved greater than their devotion to Wareham, the Catholic church in Dorchester arranged for the structure to be dismantled and re-erected in the city in 1907, until larger premises became available in the 1970s. The church of Our Lady, Queen of Martyrs and St Michael is as fitting a building as any for attempting to recreate the sacred space of Tutankhamun's tomb.

Tutankhamun seems ready-made for hyperreality – the condition of experiencing reconstructed objects and environments

as more intense, authentic, and 'real' than anything daily life can offer. In the 1960s and 1970s, philosophers of semiotics (the study of signs and their meanings) argued that in industrialized countries with capitalist systems, hyperrealism is an offshoot of consumer society, yielding copies of places and things that had never existed. Why should a copy be faithful to an original if it can conjure up a more convincing simulation – the more so if the copy, or the experience of it, can be bought and sold? The immersive and emotional effect on visitors of the simulacrum is the same or, in fact, more intense, because hyperreality makes possible what otherwise wouldn't be, such as a stroll through Tutankhamun's tomb with all the artefacts still in place.

In 1975, just before Tutankhamun took America by storm, the author and semiotician Umberto Eco wrote a long essay called 'Travels in hyperreality', based on visits he had made across the United States in search of what he called 'authentic fakes'. His Italian eyes were well attuned to reproductions of Da Vinci's *Last Supper* (my grandmother had one on the wall of her little-used front room), various Venetian-inspired palaces, and J. Paul Getty's Villa of the Papyri in Los Angeles, based on the ancient villa at Herculaneum. Eco acknowledged the European temptation to sneer at these American copies. Crass or cultivated, they all attempt to recreate the old world in the new. But which approach to making a reproduction is correct, he wondered: 'How do you regain contact with the past? Archaeological respect is only one of the possible solutions.'[39]

Knowledge only goes so far in the quest for an authentic fake. The most exacting copy of an ancient structure or work of art involves inevitable choices: should the copy show the effects of time on ancient surfaces, recreate lost colour, or replace missing parts? In the case of Tutankhamun's tomb, should the copyists restore the linen wrappings, the closed doors, and the intact seals

that were integral to its original state? There is a paradox at work
here, like the warning my professors drummed into us in archae-
ology classes. To excavate is to destroy. Try to reconstruct a site or
tomb as it existed in the past – whether 1323 BC or 1922 – and
time itself stands, always, in the way.

But try we do. The Supreme Council (since 2011, the Min-
istry) of Antiquities has its own reproduction workshop in the
Citadel of Cairo, where skilled sculptors and metalworkers
specialize in high-quality versions of Tutankhamun artefacts,
including the funerary mask, pieces of furniture, and chariots.[40]
At the Egyptian Institute in Rome, inside the country's embassy,
a mini-museum of these Tutankhamun replicas fills a set of base-
ment rooms used by Italian schoolchildren and any visitors who
have exhausted the Eternal City's more familiar sites. Enlarged
photographs provide backdrops to the displays, from 1920s
images by Harry Burton to press photos from the 1970s tours
in the United States. The final wall is plastered with newspaper
front pages in a dozen languages, from 1922 to 2012. Tutankha-
mun has become his own palimpsest, with new layers now added
before the previous strata have had time to fade.

Replicas from other sources, as well as the antiquities minis-
try (in December 2019 changed to the Ministry of Antiquities
and Tourism), have toured exhibition venues around the globe
for several years, bringing Tutankhamun to cities that did not
host any of the earlier tours and are unlikely to do so now. Some
displays have tried to position the replica artefacts to suggest the
'look' of Harry Burton's photographs, forgetting (if the creators
ever knew) that a camera lens is not a human eye. Besides, the
sets of replicas are only a selection, and a small fraction, of the
finds. No one recreates decrepitude and collapse, nor are the dis-
plays as jumbled as the sight that greeted Carter on that first,
unphotographed foray into the tomb. Reconstructions of the

Antechamber invent placements for two now-iconic objects – the lotus head and alabaster 'wishing cup' – whose precise find spots Carter did not record,[41] while they leave out the textiles and sealed doors that concealed so many artefacts from human view. Burton's images always hid the little lie that claims photography can catch time standing still, not for the split second or two it takes for the shutter to blink, but for the three millennia that have gone by and done their work.

The hyperreal is designed to improve on history, which is not the same as understanding it. Harry Burton's photographs drove the Tutankhamun story in the 1920s, and they have continued to do so since the 1960s and especially 1970s loan exhibitions. A German firm behind one of the replica exhibitions, SC Exhibitions (for Semmel Concerts or Showbiz Culture, depending on their mood), in 2015 partnered with the Griffith Institute at Oxford University to add digital colourization to some of Burton's best-known images, via high-resolution scans of the glass negatives that Penelope Fox had cared for in the 1950s. Digital colour turns Burton's careful shades of grey into buttery gold and vintage pastels, flattening the extremes of light and shadow that the electric lamps created – and heightening the contrast between creamy tan and rosy pink on Howard Carter's skin and the sludgy brown used for the sole, unnamed *ra'is* in one of the colourized images.

The colourization craze makes the past feel so immediate, so much more real, its fans and practitioners claim.[42] On the contrary, it makes it hyperreal, by ignoring the historical past of the photographs themselves in favour of a form that feels comfortable and familiar to viewers today. A photograph is not a direct representation of 'reality' or 'what really happened', just as a camera lens is not a human eye. Colourization projects start from that false premise and embrace others along the way. The archival

Tutankhamun images that have been colourized rely on digit-
ized glass negatives, for a start; these do not reflect how Harry
Burton printed his photographs, whose look depends on a range
of choices made in his darkroom. In any case, no monochrome
photographs contain colour information. The negative emul-
sions widely available in the 1920s – known as panchromatic or
orthochromatic – registered only part of the colour spectrum, and
different parts at that. Burton chose panchromatic plates for max-
imum tonal contrast when shooting the black-coated and shining
gold surfaces in his dramatic first shots of the Antechamber.

Another common misapprehension is that old photographs
are black and white because colour photography was not available.
It was, and Burton made several colour transparencies showing
objects from the tomb, using a product called Autochrome that
suspended microscopic grains of red-, green-, and blue-dyed
potato starch on a glass plate coated with light-sensitive emul-
sion. Few of Burton's Autochromes survive, however: I have
seen just one, kept in a separate storeroom in the photographic
department of the Metropolitan Museum of Art, where it lay
safely swaddled in acid-free tissue on a bed of foam inside its
own specially constructed box. For Burton, Autochromes were
an extra dimension to his work, not the mainstay. An excavation
needed record photographs, in the shades of grey that had long
been associated with scientific objectivity and image clarity. The
human-interest or publicity photographs preferred by news-
papers were monochrome as well, because they were much easier
to reproduce for publication.

Tutankhamun may have travelled far in hyperreality, but the
hyperreal has also helped keep him close to home. In 2009,
the Supreme Council of Antiquities commissioned a full-scale
facsimile of the tomb of Tutankhamun from Madrid-based
digital art fabricators Factum Arte and its affiliated foundation.[43]

The founder of Factum Arte, Adam Lowe, refers to the three-dimensional digital replicas they produce as 're-materializations' of the original. The idea is to combine traditional methods of artistic dexterity with the highest standards of scanning and printing technology. Do either of these badly (as rival outfits have) and Disneyland awaits.

Trained as a painter at the Ruskin School of Art in Oxford, Lowe moved into digital printing when it was a novel technique.[44] With Factum Arte, he became the go-to fabricator for artists like Anish Kapoor, and the income from that work has allowed the Factum Foundation for Digital Technology in Conservation to undertake its heritage-related work on charitable terms. The Tutankhamun facsimile cost about £500,000 to create, but it is a gift from the Factum Foundation to Egypt. Lowe emphasizes that the data belongs to the Egyptian government, and the high-resolution images are free to access online.

Factum technicians spent seven weeks inside the tomb of Tutankhamun, using its millimetre-sensitive scanners to record the painted walls of the Burial Chamber, as well as the sarcophagus box. Rather than treating the paintings as two-dimensional images, the Factum Arte scanners capture their three-dimensionality in hundreds of dots per inch, including the most minute variations in the hand-chiselled surface of the rock face and the brushstrokes of ancient pigments applied on layers of thin plaster. From this complex body of computer data, the firm recreated the walls of the Burial Chamber in panels of high-density polyurethane. With an outsized inkjet printer brought to Luxor for the purpose, and thousands of hand-mixed paint samples tested for accuracy, they printed the scenes in fine layers on a flexible skin that was then wrapped over the polyurethane panels. These have been erected in a brick-built structure that also replicates the layout and dimensions of the

other chambers and entrance corridor. It stands next to the domed mud-brick house where Carter lived, above the modern road connecting Deir el-Bahri to the Valley of the Kings.

The Factum facsimile tomb of Tutankhamun opened to the public in April 2014, in a ceremony attended by the Egyptian ministers of tourism and antiquities and twenty-six ambassadors. The hope is that in the long run, tourists will accept the simulacrum and spare the real thing. A video and several information panels, including actual-size prints of Burton photographs, give visitors much more information than a hurried on-site talk can offer, and although the space is just as small, it is more comfortable than the original, where temperatures can reach into the 40s. Factum also used a Harry Burton photograph to recreate the painted portion of the Burial Chamber's south wall that Carter and his team destroyed in autumn 1923 for access to the burial shrines. Carter judged the painting on that part of the wall 'rough, conventional, and severely simple', as if to help justify its demolition.[45] Now lost, the painting represented the goddess Isis greeting Tutankhamun with her hands down and open towards him in a gesture of welcome, as ripples of life-giving water – in hieroglyphic form – trickle down her palms.

While the creation of the facsimile tomb was under way, the Getty Conservation Institute was at work on a long-planned, long-term project to analyse, clean, and conserve the Burial Chamber paintings. The work began in earnest in 2009 and finished in time for a press release and symposium in late January 2019.[46] (Keen-eyed observers may have noticed that since the 25 January uprisings that forced Hosni Mubarak from office in 2011, high-profile stories about Egyptian antiquities are especially popular in January's final week.) Getty conservators have decades of experience working on tomb paintings in Egypt. In the 1980s and '90s, they conserved the painted tomb of

Ramses II's wife Nefertari in the Valley of the Queens; like Factum, the Getty funds its projects from its own resources and works in partnership with Egyptian specialists and trainees. The fragile surfaces of the paintings had undergone previous treatments and restorations, including repainting an area of the north wall, behind the sarcophagus, in the late 1920s or early 1930s.[47] Carter's own work in the Burial Chamber may have caused inadvertent damage, and since the 1960s, the space has been in heavy demand not only from tourists but also from film crews and their cumbersome equipment.

The Getty team carried out extensive analysis of the pigments and plaster substrates on the walls, cleaned decades of accumulated dust, and stabilized small flaking areas of paint. They were also able to conclude – as Alfred Lucas had – that the brown spots flecking the surfaces are microbiological (some kind of mould or fungus) but no longer active; they are old enough to have bonded with the ancient pigments, so they have not been removed. The Getty conservators point to the tomb's 'inherent fragility'; people, not time, are the risk it faces. A new air supply and filtration system at the tomb promise to reduce dust accumulation and improve air quality, which tighter restrictions on visitor numbers would further help.[48]

Castle Carter has had a makeover as well. After decades of use as office, storage, and living space for Egyptian antiquities officials, in 2009 the house was refurbished as a museum, furnished and fitted out as it might have been when Howard Carter lived there. A holographic projection of him welcomes visitors. Furnishings have been bought or borrowed to create a period feel, including a bulky wooden studio camera that has no association with the excavation. Newspaper clippings and photographs of his most famous discovery enliven the walls, even if their anachronistic presence pierces any illusion that we have time-travelled to

the 1920s. Like the king he found, Carter has become an attraction too, a historical person taken out of the stream of time in the very building that he once called home. The gardens, where he hosted guests for lunch, are a green refuge on the edge of the escarpment, a compromise between desert and water, past and present, the living and the dead. It is a place where a caged canary might consent to sing.

* * *

In 2009, President Mubarak declared 25 January a national holiday in Egypt to honour the police. It commemorates the British military attack on an Egyptian auxiliary police barracks in Ismailia in the Suez Canal Zone, which took place on that date in 1952 and precipitated the Cairo fire the following day. On 25 January 2011, crowds filled Cairo's public spaces not to celebrate the police but to protest their brutality. Activists had been gathering momentum since the brutal murder of Khaled Said by police six months earlier, in broad daylight in an Alexandria street; photographs of the young man's disfigured corpse circulated on social media. After thirty years in power – since the assassination of President Sadat during a military parade celebrating the 6 October holiday in 1981 – Hosni Mubarak and his family headed a state in which the police, military, and intelligence services acted with impunity, too important (and too expensive an investment) for foreign powers to contravene where domestic matters were concerned.

The Egyptian Museum became the backdrop for the largest protest gathering, in Tahrir Square. Its coral-coloured façade was on nightly news broadcasts around the world as reporters tried to account for the unprecedented turnout and determination of the crowd. For three days, men and women of all ages and every background packed the square, peaceful, hopeful, united. But

thirty years, and billions of dollars in American military aid, is a rather long time in regime-making. On the first Friday – the weekend, and Muslim holy day – of the protests, 28 January, police counteractions in Tahrir intensified, killing dozens of protesters and inciting widespread looting of surrounding buildings. Mubarak's National Democratic Party headquarters next to the Egyptian Museum caught fire that evening, spewing smoke as black as fear into the sky.

The protesters formed a human chain around the Egyptian Museum to ward off any threat of looting. No one knew what was happening inside, and the government had turned off internet cables and some phone towers, blocking communication within and outside Egypt. But screen grabs and confused reports were soon circulating on the internet and social media. At the back of the museum, away from the square, vandals had smashed glass in the Tutankhamun displays and hurled statuettes and walking sticks to the ground, causing wanton damage. The Qatari channel Al Jazeera showed one of the gilded statuettes found in shrines in the Treasury splintered on the floor, with Tutankhamun's gilded feet still striding on a resin-darkened leopard while his slender body lay on its side, a metre away. In another part of the museum, two embalmed heads appeared to have been detached from their bodies and dumped on the floor (they were, it turned out, long detached and had been used to test the CT scanner donated by National Geographic).

Watching the news about the Egyptian Museum in horror, on one of the TV channels that had not been blacked out, was Dr Wafaa El Saddik, who had retired as its director only a few weeks before. She had just heard from former colleagues seeking her advice at Luxor Airport, where that evening one of Tutankhamun's chariots had arrived back from a loan to New York; it had been 'a late, crowd-luring addition' to the AEI 'Tutankhamun

and the Golden Age of the Pharaohs' exhibition at the Discovery Times Square Exposition space.[49] After three months overseas, the chariot was meant to be returned to its usual space in the Luxor Museum, where it had been on display since 2004. After years under the thumb of local governor Samir Farag, the Mubarak associate who oversaw the bulldozing of Old Gurna, the whole of Luxor had erupted in protests, too. El Saddik advised her Luxor colleagues, and the German firm of art handlers agreed, that the chariot should stay under police guard at the airport until daybreak.[50]

Now it seemed that Tutankhamun was under worse threat in Cairo. News of damage to the Egyptian Museum flooded Western media outlets immediately, with reporters, commentators, and Egyptologists quick to compare the breach to the notorious looting of the National Museum in Baghdad during the US-led invasion of Iraq in 2003. There were all too predictable outcries about Egypt not looking after the 'universal' heritage of its antiquities, and opinion column inches of thanksgiving that the bust of Nefertiti was tucked up safely in Berlin and the Rosetta Stone secure in London.[51] Egyptian antiquities took precedence over the lives, voices, and stymied hopes of Egyptian people.

The appearance of order inside the Egyptian Museum was quickly restored. In his role as minister of antiquities, Zahi Hawass gave reassurances that no antiquities had been stolen and the minor damage would be repaired in a mere five days. He posed for photographs next to the bulletproof display case that holds the mask of Tutankhamun as soldiers in riot gear clustered around, machine guns in hand. Thieves, Hawass explained to the world's reporters, had accessed the museum from the fire escape and vandalized thirteen cases on the way to their real target, the recently refurbished gift shop; all had been apprehended and turned over to the army. El Saddik wondered why

Hawass made no reference to footage (if any existed) from the surveillance cameras installed all over the museum during her tenure as director, and how thieves managed to reach the fire escape unnoticed when she had had its lower part removed for security reasons.

Quick repairs to Tutankhamun and his leopard offered another public relations opportunity, with an Egyptian conservator in a white lab coat photographed reconnecting the dowelled joints. After Mubarak resigned on 12 February, Zahi Hawass backtracked on his earlier statement to confirm that eighteen objects had been stolen, including a bronze trumpet;[52] another gilded statue from the tomb, showing the king carried by the goddess Menkaret;[53] and the upper part of the harpooner statue (or its twin), which had entranced Christiane Noblecourt and Eiddon Edwards a generation earlier.[54] These, and other missing artefacts, were found in the Egyptian Museum grounds and other places that suggested the 'looters' had had second thoughts, cold feet, or some other purpose. For instance, a public relations employee of the antiquities ministry spotted a black bin bag at Shubra Metro station during his daily commute. He opened it (convinced that it was not a bomb, for whatever reason) and saw Tutankhamun staring up at him in the form of a figurine that had gone missing.[55]

The curators of the Egyptian Museum were less lucky. They had not had access to the museum for weeks, and the lists of missing objects, public announcements, and treatment decisions were made without them. The curator of the Tutankhamun collection, Hala Hassan, ruminated that Tutankhamun's trumpet – returned unharmed – had foretold the turn of events, since an employee had blown through it the week before the protests began. It had been played on the eve of the Second World War, and, she said, before the 1967 Arab–Israeli war and the 1991 Gulf War as

well. If ancient curses were to blame for Egypt's contemporary problems, they might be easier to solve.

What happened in the museum on the night of 28 January, and the days and weeks that followed, remains obscure. As the strange story unfolded, my first thought was that some branch of the security forces had decided that moderate vandalism to renowned antiquities would outrage Western powers enough that they would back the Mubarak regime and help restore order – with America's belated guarding of the Iraq National Museum in 2003 in mind. But America let events in Cairo unfold.[56] Planned vandalism may have inspired rogue actions, and stealing small to mid-sized artefacts requires only large pockets or a sturdy bag. Egyptian police or military units were certainly inside the Egyptian Museum as the Tahrir protests rumbled on. At some point they used the basement storerooms as holding cells and an interrogation centre, where women protesters reported being subjected to 'virginity tests'. To the Tahrir activists the Egyptian Museum – home of Tutankhamun's treasures – became known as the *salakhana*, 'torture chamber'.[57] Artefacts from the tomb of Tutankhamun will have paid mute witness from the basement shelves where some of them still lay in wooden crates the Coptic carpenters of Luxor had made for them almost ninety years before.

In the streets east of Tahrir Square, clashes between protesters and security forces continued during the months of transition that followed Mubarak's resignation, under the caretaker regime of the Supreme Council of Armed Forces. A lengthy stand-off took place in November 2011 on Muhammad Mahmoud Street. Along the street and around the city, graffiti artists turned two iconic ancient objects – the bust of Nefertiti and the mask of Tutankhamun – into protest symbols. Ganzeer gave Tutankhamun the face of a 'V for Vendetta' mask with a bandage over one eye, a reference to police aiming rubber bullets in order to blind

protesters. El Zeft gave Nefertiti a gas mask, and Ahmed Abdal-lah did the same with the Tutankhamun mask, in a stencil dubbed 'the military pharaoh'.[58] Young male protesters saw themselves as fighters, and Tutankhamun – a young man when he died – made an effective rallying point for Egyptian strength and pride.

But in the galleries upstairs at the Egyptian Museum in a pac-ified Tahrir Square, Tutankhamun, who had been the Egyptian government's most successful ambassador since 1961, became its greatest magician. That gold mask, with its steady gaze and splen-did bright-blue glass, is a master of misdirection, and the cameras of the world's media appear to be entirely in his command. That Arab Spring, it was Mubarak's turn to fall; two years later, a military coup would see an elected president, Mohamed Morsi, forced from power, too. Under General Abdel Fattah el-Sisi, who became president in 2014 with the backing of the armed forces, civil rights have further eroded. Illegal imprisonments, docu-mented torture, and repeated infringements of press freedom are on the rise.[59] Yet not even the 2016 murder of a foreign researcher, Italian doctoral student Giulio Regeni (in which one of el-Sisi's sons may have been implicated), has shifted Egypt's standing as a valued ally of America and Western Europe.[60] Nothing to see here. Look over there instead, at the golden pharaoh boy king of eternal priceless treasures. Abracadabra, another twirl, and Tutankhamun is always ready for another big reveal.

The Museum of Dreams

TUTANKHAMUN IS IN Storeroom 93, behind a bland door that opens off the wide service corridors inside the Grand Egyptian Museum. He shares it with a queen named Hetepheres, whose son Khufu built the Great Pyramid that looms nearby at Giza. Rolling storage units along the back wall contain some of the thousands of stone and pottery vessels found in her burial cache in March 1925, by *Ra'is* Ahmed Said and photographer Mohammedani Ibrahim, who worked for American archaeologist George Reisner. Meticulous in his recording methods, Reisner had considered Howard Carter an inadequate excavator, tainted by his ties to the antiquities trade and his fondness for the press. 'The recent great publicity campaign concerning the tomb of Tutankhamun was based largely on [an] appeal to the imagination of the layman,' Reisner wrote in 1925, preferring to appeal to history instead.[1]

History has consigned the two rivals' archaeological finds to the same storeroom, a legacy of the fact that Tutankhamun and Hetepheres both fall under the curatorship of Section 1 at the old Egyptian Museum in Tahrir Square. In the new museum, which has been taking slow shape for more than a decade, Storeroom 93 is a utilitarian space of steel shelves and concrete walls, as grey as the duct tape that frames the electrical outlets. Like other spaces I glimpsed in the vast building, the room felt not so

much unfinished as in between. Suspended in a state of coming into being.

I visited Storeroom 93 at the invitation of Hassan Mohamed, the collections manager responsible for Tutankhamun objects at the Grand Egyptian Museum, or as it's often known, the GEM – a jewel, if still unpolished. While Mohamed spoke to one of his colleagues, I wandered back towards the rolling racks, drawn by the prints of Harry Burton photographs stuck on to the ends: his photographs of the Antechamber, where it all began in November 1922. The 'prop department of an opera house', as Carter first described it to himself, and some of those props were now stored here for whatever act comes next.

The rolling racks bore numbers from 1 to 13, right to left in the direction of Arabic script but using Western ('Arabic') numbers. A young woman came over to introduce herself as a doctoral student working at the GEM. I explained my interest in the history of the Tutankhamun excavation, and she rolled open the Tutankhamun units one by one. We walked up and down, inches from some of the stools and boxes from the tomb, their woods, veneers, and inlays vivid against the pale steel and thin white foam lining the shelves. Her dissertation focused on the predynastic period, she explained, far removed in time from these 18th Dynasty riches. I sympathized. I wrote mine on Roman Egypt, at the other extreme of Egyptology's timeline. Tutankhamun brings us all into his ambit in the end.

On open racks, and resting on the floor, were larger objects from the tomb, including several of the 'sinister' shrines (as Carter called them) from the Treasury, their layer of black coating flaked away to bare wood in places. Seven wine jars, some with their thick mud sealings still in place, stood upright in modern wooden tripods,[2] and I could just glimpse large alabaster vases on the shelves behind. Two whitewashed beds were pushed

against one wall[3] and in between them, on an upturned crate covered with acid-free tissue paper, was the gilded head of a cow that had been placed between the jackal shrine and the canopic chest, laid out in their ritual row before the pharaoh's burial shrines. Mehet-Weret ('the great flood'), the cow goddess who gave birth to the sun at dawn, now guarded a bright red fire extinguisher mounted on the wall.[4]

Mohamed granted me permission to photograph one thing that caught my eye: a shallow, wooden crate, one of the items he and his team have brought over from the Egyptian Museum in Tahrir Square. It is one of the crates made for Carter in the 1920s by the team of local carpenters. Painted on to it in black are Carter catalogue numbers from the Antechamber (50YY, 46A123, 48Y, 65A, 100E, 147C), which designate several dozen reed arrows and a few arrowheads, and number 148, three fly-whisks made of horsehair. On top of the crate is the distinctive cross-shaped arrangement used for temporary inventory numbering at the Egyptian Museum, until such time as objects could be registered in the *journal d'entrée*. The crated objects at some point became 27-3-34-37, written top to bottom, left to right, in the quadrants of a plus-sign, indicating that this was the thirty-seventh item registered on 27 March 1934. At the Grand Egyptian Museum, whatever is inside the crate will have GEM catalogue numbers added to it as well, welcoming the artefacts to their new home and slotting them into its database. Like tattoos on skin, these inked numerical layers tell the story of a moment or event, making visible a transition that might otherwise only be felt, not seen, as objects make their way through time.

In Storeroom 93 that day, I watched the inking in process at a table where a collections assistant sat in concentration, a thin-nibbed pen between her fingers to write a GEM number on to the edge of an object from the Annex of Tutankhamun's

tomb. Illustrated in Penelope Fox's book for the first time, it is a lid long separated from its jar, in the form of an alabaster dish with four separate alabaster eggs resting inside.[5] Between them sits a painted wooden figure of a just-hatched gosling, beak squawked open to a pink-stained ivory tongue and useless wings flapped upright in alarm. The assistant finished her last pen stroke, exhaled, and smiled in relief. She picked the piece up in her hands and carried it to a nearby trolley where other objects from the tomb were ready for their turn at renumbering – their next transition through a century they never thought to see. The eggs trembled in their shallow nest, stone solid and still waiting to be born.

*　　*　　*

When the Grand Egyptian Museum opens to the public, it will be the new home for all 5,640 or so objects from Tutankhamun's tomb. At the time of my visit to Storeroom 93 in December 2019, minister of antiquities and tourism Khaled el-Anany had just announced a Phase 1 opening for October 2020, meaning that the galleries devoted to Tutankhamun would be ready for public view by then. That date put the museum five years behind schedule, but it too had to be postponed in the wake of the Covid-19 crisis.[6] As I write this in mid-2021, the Grand Egyptian Museum hopes to reveal the completed Tutankhamun galleries by the year's end and certainly in time for the centenary of the discovery in 2022.

The idea of a new museum of antiquities at Giza, removed from the traffic of central Cairo, emerged in the 1990s, in tandem with plans to streamline tourism and concentrate it in dedicated enclaves. Many saw it as a vanity project for President Mubarak, a monument of Ozymandian ambitions. With the equivalent of four football fields of exhibition space, the GEM will rival the

size of the British Museum and aims to attract as many visitors per year, some 6 million people, mainly foreign tourists. One rationale for building a museum outside of crowded downtown Cairo was to draw tourists away from the centre, especially in the wake of 1990s terrorist attacks. Tour-bus tourism is both more lucrative and considered easier to guard, although there are plans to connect the Cairo metro system to the GEM via an extension currently being tunnelled west from the city centre. Still, opening Sphinx International Airport at Giza to commercial flights will allow tour groups to fly in for day trips from the Red Sea resorts, taking in the GEM and the pyramids without ever setting foot in Cairo.

Dublin-based architects Heneghan Peng won an international design competition for the new museum in 2003.[7] They have designed a vast and sleekly modern edifice that bridges the gradient of the desert escarpment between the urban edges of the Giza suburb and the plateau from which the pyramids rise, some 50 metres above. The plan is that the entire museum, covering some 100,000 square metres, will anchor an even larger complex of parks and landscaped gardens, shops and restaurants, a 3D cinema, a hotel, and a congress centre. Inside, the GEM will include a children's museum for local schools and an arts and crafts centre, creating hand-made products in so-called 'traditional' materials and methods. A full-size cedar boat discovered near the Great Pyramid is in the process of being conserved for reconstruction at the GEM as well, where it will be joined by a boat that has been displayed in a purpose-built museum near Khufu's pyramid since the 1980s.[8] The GEM has ample space to house them both. When the Grand Egyptian Museum is complete, its galleries will display more than 50,000 objects, some in spaces whose ceilings are up to 33 metres high. This is museum-making on a pharaonic scale.

It comes at a cost, however, and every dollar counts. At the outset of the project, its budget was about $500 million, funded by Japanese loan guarantees coordinated by JICA, the Japan International Cooperation Agency. The budget is estimated to reach $1.5 billion, in a country where a third of the 100 million-strong population lives below the poverty line (and 40 per cent are between the ages of ten and twenty-nine).[9] Running costs will be sky-high as well, since the displays have been designed to state-of-the-art conservation standards for climate control, light levels, and the minimization of dust and vibration, as well as incorporating digital technologies for interpretation and security monitoring. Generating revenue through admission and retail sales will be essential, likewise having measures in place to maintain and inevitably repair the technological wizardry. Everything depends on tourism returning to pre-pandemic levels and one day exceeding them.

No one could fault the architects on the dramatic design of the GEM, which incorporates triangular shapes and pyramidal volumes in conversation with its setting near the most recognizable human-built structures in the world. Corners have had to be cut as time and budget limits ran on, however: the 800-metre-long façade was meant to incorporate a separate metal wall set with triangular panels of alabaster sliced thin enough to let light through, but the design has been simplified, using stone quarried in Sinai and polished by Egyptian stonemasons on site. As the GEM's social media account explained, 'we are following in the steps of our ancestors in this great engineering and construction project', and saving a purported $230 million in the process.[10] Major General Atef Moftah, an army engineer and the man charged by President al-Sisi with seeing the GEM through to completion, took credit in some news coverage for coming up with this cost-saving solution.

Visitors will pass through the façade into a 35-metre-high atrium that holds a colossal 14-metre-high statue of Ramses II, which was moved into place in 2018 with a military guard, marching band, and line-up of Egyptian and foreign dignitaries on hand. Until 2006, it had stood in front of Cairo's main train station, having been reassembled there on President Nasser's orders in 1955.[11] In Nasser's Egypt, Ramses 'the Great' became a symbol of the revolutionary nation's ancient roots and timeless glory, further bolstered by the UNESCO campaign's re-erection of the pharaoh's famous temples at Abu Simbel.[12] The 2018 transfer of the Ramses II statue from Ramses Square to the GEM took place on 25 January, the seventh anniversary of the Tahrir Square protests – not to mark the date but to draw attention away from it. Better a soon-to-be-realized museum for Ramses, Tutankhamun, and the rest, than the unrealized dreams of democratic reform.

From the atrium of the GEM, a monumental staircase rises up to the main exhibition hall, with a planned eighty-seven stone statues punctuating its landings – although many visitors will presumably take the travelator. Like all the other objects that will be part of the GEM's collection, the statues have been brought from the old museum in Tahrir Square, from smaller museums around the country, and from archaeological sites. The staircase culminates in a view of the Giza pyramids, framed through a 28-metre-high wall of triangular glass panes that echo their famous forms.

The top level of the museum gives access to the main exhibition halls, where GEM visitors will be able to choose from two itineraries. To the left will be a route ordered by both chronology and themes (kingship, society, beliefs) through four millennia of Egyptian art. But to the right will be the biggest draw: a 7,000-square-metre suite of rooms dedicated to Tutankhamun.

Apart from the sarcophagus left in the tomb, and the king's battered physical remains, the plan is that every single object from the tomb will luxuriate here in climate-controlled, carefully lit galleries, including a space dedicated to the fabled discovery in November 1922. Visitors will see the four shrines, three coffins, half a dozen chariots, every last *shabti* figure and statue, the famous funerary mask, plus all the jewellery, clothing, potted meat, vintage wine, perfume jars, and furniture that accompanied the young pharaoh to his grave. Both foreign and Egyptian museologists have developed the displays, which will include a full-scale replica of the tomb, a new reconstruction of Tutankhamun's face, and a gallery on the discovery, with Harry Burton photographs supplied by the Griffith Institute in Oxford.

I sipped thick cardamom-infused coffee while the director of exhibitions, Mona Nouman, explained the narrative behind the display. We were in her team's temporary open-plan, windowless office space, around the corner from the tall-windowed room where the foreign consultants, employed by project management company Hill International, have their desks. I was curious as to whether the story of the tomb's discovery would include the context of British colonialism and Egyptian independence in the 1920s, but I could sense a reluctance to cause offence to foreign visitors (Egyptians could teach the British a thing or two about politeness). Nouman emphasized, though, that the display will address Egyptian involvement in the excavation, including the *ru'asa* and Prime Minister Sa'd Zaghloul. Foreign tourists are more lucrative, but local visitors and schoolchildren are just as important to Nouman's team.

Construction work on the GEM began in 2008, and its high-spec conservation centre was the first part of the structure completed, in 2010. The centre comprises seventeen laboratories dedicated to artefact research and treatment, in tandem with

Japanese-led training programmes that have built impressive capacity in a new generation of Egyptian conservators.[13] With the rest of the museum a construction site requiring hard hats and high-vis (even with 95 per cent of it said to be complete in spring 2020), the conservation labs have been vital not only for the study and treatment of objects being prepared for display, but also for photo opportunities, public relations, and diplomatic visits. The news cycle has been the GEM's lifeblood from the start – perhaps inevitable for a museum designed to house the entire collection of objects from the tomb of Tutankhamun. Before his ousting, a long-running Egyptian joke had it that President Mubarak broke ground for the GEM on a regular basis, to ensure that state-run media had a fresh news story to cover.[14]

A similar public relations strategy has continued in the years since Mubarak's fall, with press releases linked to the transfer of antiquities to the GEM or updates on the conservation of objects from the tomb – a twenty-first-century version of the 'openings' that Howard Carter coordinated years ago. The eye-catching removal of well-known Tutankhamun artefacts from the Egyptian Museum in Tahrir Square to the GEM's conservation studios has involved custom packing crates and air-cushioned lorries, their sides emblazoned with a photograph of the object inside. Given that works of art are normally moved in strict secrecy, this unusual step indicates how important it is for the GEM to succeed in the eyes of Egyptians as well as the tourists who need to visit in unprecedented numbers to make it a success. Press releases and social media have also regularly reported the remarkable transformations that Egyptian conservators are effecting on the tomb objects, many of which have been untouched since the 1920s. It is a targeted message to the world at large, delivered in full awareness that the flip side of Egypt having called on foreign expertise for so long, from the UNESCO campaign in

1960s Nubia to Japanese cooperation today, is a lingering perception that the country is incapable of caring for its archaeological heritage on its own.

The Grand Egyptian Museum represents an extraordinary ambition, by any measure. But a museum on such a scale would be difficult to build at the best of times, and Egypt has not been having the best of times for quite a while now. There are overlapping museum developments in Cairo, hit with similar delays. The National Museum of Egyptian Civilization (NMEC) has been under construction at the same time, in the Fustat area of Old Cairo. Together with the Nubia Museum at Aswan (opened in 1997), the NMEC is a UNESCO-coordinated project that follows on from the 1960–80 campaign to save Abu Simbel, Philae and other Nubian monuments.[15] It differs from the GEM in that it will cover the entire timespan of human culture in Egypt, from prehistory to the present day. But the pharaonic era will be a major draw. The NMEC houses many of the unwrapped royal bodies that had been on display in the Egyptian Museum in Tahrir Square, including famous names like Thutmose III, Amenhotep III, and Ramses II 'the Great' himself. A planned parade of their transfer through the streets of Cairo, timed for national holidays in July 2020, was another cancellation in the Covid-19 crisis. It finally took place on 3 April 2021, in a lavish production that mixed live coverage and pre-recorded segments for broadcast around the world. Featuring performances by top Egyptian talents in the performing arts, the parade saw Egyptians cheering their ancient kings from vantage points along the route, as a cortège of adapted military vehicles carried the bodies in concealed crates, draped in the national flag, to their new museum home. The streets along the advertisement-lined route were heavily policed, and the scripted narration emphasized Egypt's enduring quality as a country that invented and

embodies *tamaddun* – civilization. Under President al-Sisi, Egypt is stable, secular, and decidedly spectacular: a similar parade may accompany the transfer of Tutankhamun's gold burial mask to the GEM when the time comes.

A number of museum professionals and Egyptologists, both within Egypt and abroad, have kept a sceptical eye on the Grand Egyptian Museum, whose grandness may get in the way of smooth coordination. The initial UK-based designers, Metaphor, left the project in the wake of the 2011 uprisings; various directors and hired consultants on the GEM have come and gone; and there are rumours of poor communication among the museum collections that have been put in unwelcome competition with each other. Some would argue that the money and effort spent on the GEM could have gone on much-needed maintenance and improvement of existing museums, in particular the Egyptian Museum in Tahrir Square, which has been starved of investment for decades. Thomas Hoving's account of the museum's limited electricity supply, back in the 1970s, has its equivalent today in the absence of Wi-Fi, making it difficult for staff to do the work that most museums take for granted.

The director of the Egyptian Museum, Sabah Abdel Razek Saddik, is an unflappable woman who grew up in a Nubian family in Giza and worked closely with a previous director, Wafaa El Saddik (no relation). Sabah Saddik has been steering the institution through a series of updates to the displays, which would have been desirable in any case but are now essential as the galleries are denuded of statuary, the Tutankhamun collection, and other objects destined for the NMEC or the GEM. There are always foreign institutions hovering, eager – just as Hoving was – to offer well-meaning advice. Most recently, the European Union has proffered €3 million of funding, for three years, to 'transform' the Egyptian Museum in partnership with some of the oldest

collections of Egyptian art in Europe (at London, Paris, Turin, Leiden, and Berlin).[16] Each of these European museums is a living legacy of Egypt's colonial exploitation by foreign powers for their own gain; most have done little to address the colonial history of their own collections, and the EU collaboration makes no mention of it. Where antiquities once flowed freely down the Nile into the British Museum or the Louvre, what counts as expertise now flows the other way. Egypt remains caught midstream, trying to shape a future from an ancient and idealized past, while more recent histories cast shadows from behind.

* * *

I was grateful that a last-minute ministerial visit delayed my own trip to the Grand Egyptian Museum. It was the week before Christmas 2019, and I had arrived in Cairo battered by a weird winter flu. The delay gave me two more days to recuperate in an old friend's old flat in Zamalek, a genteel neighbourhood that shelters on an island in the Nile, between the east bank where Cairo proper lies, and the west, where the city sprawls towards Giza and the Sixth of October suburb beyond. Amidst furnishings that Howard Carter would have recognized – the 1930s apartment had its original heavy sets of carved wooden beds, wardrobes, and dressing tables – I curled beneath a quilt, with Tutankhamun's treasures either side. For Zamalek is also in between the objects' historic home and the new one being built for them at such effort and expense.

The GEM is a riposte to every tourist who has ever muttered that the museum in Tahrir Square is dirty, poorly labelled, badly lit, and overcrowded. Stinging criticism has made Egyptians understandably sensitive to any suggestion that the country's antiquities would be better cared for elsewhere in the world. A case in point is the press furore that arose in January 2015, when

a tourist's photograph revealed a clumsy, unofficial repair job to the beard on Tutankhamun's funerary mask – a 2.5kg chunk of gold and glass that had only been reattached in the 1940s. I was working in the Tutankhamun archive at Oxford University when the story broke. The staff patiently fielded phone enquiries and emails, since Harry Burton's photographs show the condition of the mask first as Carter found it, in early 1924, then after its removal and restoration in December 1925. I wasn't the only Egyptologist not to have studied Tutankhamun very closely on my degrees, it seemed, as experts made confident claims that the beard was an integral, integrated part of the mask. A retired scholar in Europe had examined news photographs and wondered if holes in the mask's neck might be damage from gunshots dating to the Tahrir Square protests of 2011. They are, in fact, the attachment points for a bead necklace that once covered the gold throat – and in the Egyptian Museum, the mask sat in a bullet-proof display case.

The display case may inadvertently have caused the damage to the beard. When a light inside it needed changing in August 2014, staff had to remove the mask to do the work, their movements perhaps hampered by the glass 'hood' of the case, which slides up and down on rigid poles. Opening and closing any case in the Egyptian Museum requires at least six people to be present, a deputation called a *lagnah*. It is a security feature built into public roles in Egypt and to daily work in the museum, where much older cases are still closed with wire and official seals reminiscent of the shrines in Tutankhamun's tomb. In the context of Egypt's state museums, should anything go wrong, as it did that August day, lives and livelihoods are at stake. Hence when an accidental knock loosened or detached the beard, the staff involved panicked (understandable in such a distressing situation). Overnight, hasty and misguided attempts to repair the beard were

made with an inappropriate adhesive. The staff involved have faced criminal charges for damaging cultural heritage, even though the mask has since been repaired.[17]

'Shit happens,' as a German newspaper quoted conservator Christian Eckmann, the man responsible for removing the botched glue and reattaching the beard.[18] Eckmann helped restore Egypt's national pride in the process. Having worked in museums for a decade myself, I can only agree with his assessment. A moment's slip, or the slightest pressure on a weak joint, is all it takes to break an ancient artefact. I have done it and witnessed it, and the conservators I worked with were always the least concerned about the damage. They know that objects and materials are in constant flux. Besides which, we are human, and the antiquities we place in our museums have endured millennia without quite meaning to.

I met Eckmann during my Cairo visit, at a low-key Thursday evening get-together hosted by a mutual friend. He and his wife Katja Broschat are conservators at the Römisch-Germanisches Zentralmuseum in Mainz, specialized in ancient metal and glass. They have worked on material in the Egyptian Museum for many years, most recently focused on gold, iron, and glass objects from Tutankhamun's tomb. Egyptian conservators have worked alongside them, like metal specialist Eid Mertah who showed me some of the work in progress on gold collars found among the wrappings of the king's body. An earlier project restored horse trappings and hunt-related equipment from the Antechamber, still in the crate where Carter, Arthur Mace, and Alfred Lucas had placed them after treatment in 1923.[19] In the intervening decades, the gilded and embossed leather, backed by a layer of textile and thin plaster, had flaked apart, but Eckmann's team was able to reassemble the pieces and render them more stable, revealing the hunting scenes that had enlivened every surface.

The team's research also confirmed the meteoric origin of the iron dagger blade buried on the pharaoh's body[20] and analysed two stunning headrests made of turquoise-blue and lapis-blue glass, one catalogued by Carter, the other received from the Carter estate via King Farouk's collection.[21] Blown, translucent glass was unknown before Roman times. Instead, ancient glass was made by heating crushed quartz, plant ash, and a colourant derived from copper, cobalt, or manganese. Pressed into moulds, the molten product cooled to a hard sheen shot through with solid colour – qualities that made it seem even more miraculous than it was. When glass technology emerged in Egypt in the 18th Dynasty, around 1500 BC, both the products and the knowledge to make them were kept under tight control. By the time Tutankhamun reigned two centuries later, Egypt had some of the best glassmakers in the world, and this luxury material was valued alongside the finest metalwork and semi-precious stones.

Like other objects from his tomb, the mask of Tutankhamun brings the techniques of glassmaking and metalworking together in a single, superb object. Howard Carter and Alfred Lucas had little time to study it, given the time pressure they faced to repair it and see it safely to Cairo at the end of 1925. When the mask toured the United States in the 1970s, Egyptologist Emily Teeter, then at the Seattle Art Museum, observed the presence of rivets around the edges of its face, which Nicholas Reeves confirmed more recently.[22] The mask comprises perhaps seven separate pieces of worked gold that were soldered and pressed in place. Since the face is one of those separate pieces, Reeves has proposed that the rest of the mask was intended for a woman who ruled as king before Tutankhamun, and the original face replaced; however, it is difficult to see how this could have been done with the mask in a finished state. Like Tutankhamun's four canopic coffins, its pierced ears may be in keeping with the

representation of women, not men, in that era, but the evidence is scanty and can be used to argue either way.

The mask is otherwise consistent with the appearance of an Egyptian king in all his glory. A cobra and vulture, representing the sister goddesses Isis and Nephthys, guard his forehead. The long eyebrows and lined eyes, inlaid in lapis lazuli, marked his transfigured, divine state, and the striped headscarf (or *nemes*) conveyed the radiant, refracted sunlight that enveloped him. Its deep blue bands have often been identified as the stone lapis lazuli, but they are glass as well. I had assumed they were mould-made and the gold shaped to fit around them, but Eckmann and Broschat believe that glass strips were made to size and heated until soft, then pressed into place. The craftsmen needed astonishing control to reach the correct temperature without softening the 22-carat gold. The braided beard, of gold with more glass inlays, was then set with a natural adhesive, such as beeswax, into the raised rim prepared for it on the mask's chin. Egyptologists call these 'false beards', assuming they were part of a costume, but facial hair might have been shaved and groomed this way sometimes; in any case, long beards were divine symbols, and only a king or god was ever shown with one.

The mask of Tutankhamun went back on display in December 2015, after Eckmann and his colleagues spent three months removing every trace of the insoluble epoxy glue by hand with wooden sticks, one millimetre at a time. With the beard now secured by an inert and reversible adhesive, the mask weighs almost 12kg, the same as a small dog or two-year-old toddler. It has never been an easy object to move, mount, pack, and unpack, making it all the more remarkable in retrospect to think of its travels between Egypt, Europe, and North America half a century ago. That the beard came loose in 2014 is no surprise, but it was bad luck and terrible timing for Egypt's beleaguered museums.

Apart from its jaunts around the world, the mask has occupied a central vitrine in Room 3 since it arrived in time for new year 1926 – and will be there until its transfer to the GEM. Elsewhere in the Tutankhamun galleries of the Tahrir Square museum, some of the early twentieth-century display cases stood empty during my visit at the end of 2019, huddled in corners as if trying to disappear. The most challenging objects earmarked for removal to the new museum are the four burial shrines and pall framework that Howard Carter and his team spent years repairing and then reassembling on the spot, with the glass walls of the vitrines installed when they were done. The largest shrine measures 3 metres wide, 5 metres long, and weighs an estimated 2 tons, thanks in part to the blue faience inlays set into layers of gypsum plaster that lie up to a centimetre thick over the wooden structure.[23] The wood had already shrunk over long centuries in the tomb and now shifts, imperceptibly, with fluctuations in humidity, temperature, and vibration; there is no climate control in the Egyptian Museum galleries or cases. Each time the wooden substrate moves, the plaster lifts away, taking the gilded surface and inlays with it.

In autumn 2016, conservators sponsored by the Egyptology committee of the International Council of Museums (ICOM-CIPEG, of which I am a member), visited at the invitation of antiquities minister Khaled el-Anany and the then director of the GEM, Dr Tarek Tawfik.[24] Over the course of a week, they studied the outer shrine and the pall framework, which sits inside it. Their report emphasized that these, and the other shrines, would require extensive consolidation before being taken apart, transported to the GEM and erected in new cases there. Moreover, since the 1920s–30s intervention is by now so old, and has been patched up at various points, a lengthy period of investigative research should first take place, in order to devise the best method

of consolidation and repair. The team advised against a GEM suggestion that the shrines could be lifted out whole through the roof of the Egyptian Museum by a crane or helicopter – with the film rights sold to pay for it. The German and British consultants sent by ICOM offered to undertake their proposed research project at no cost to Egypt, but they heard no more from the Ministry of Antiquities, the GEM, or Zahi Hawass, who also entered into the discussions.

Sunlight streamed through the museum skylights as I walked around the shrines on a December afternoon. Like most of Tutankhamun's treasures, I know them better through the silver gelatin tones of Harry Burton's photographs than for the dazzling Oz-like colours in which they revel in real life. I remember what he wrote about the shrines to Herbert Winlock, after photographing them here in November 1932: 'They make a fine show, but I think it's rather a pity to display them all in a row in the upper gallery, as it is rather a squeeze + when they get the glass cases over them, it will be even more so'.[25] It is a squeeze, but there was nowhere else to put them. Up close, with the sun slanted across the surfaces, details pop out, each loop and line worked in by patient goldsmiths' hands. I spot the hieroglyphic signs painted in black on each side, advising which part of the gilded puzzle went where ('south rear' on the back end). But the cracks are showing, too: missing flakes of gold and myriad dents and surface fissures reveal the bones of white plaster and bare wood beneath. The shrines wear the 3,200 years of age they had in 1922, plus the long century that has passed since then, with all its losses.

Curling prints of 1920s photographs lay on a thin-legged table next to the second shrine, inside its vitrine – as a reference point for tour guides, a makeshift mini-exhibition, or an offering laid out for Tutankhamun's wandering soul. In a newspaper

snapshot, Howard Carter stood with Lord Carnarvon, Alfred
Lucas (in pith helmet), and Harry Burton (in his favourite plus
fours). Other prints were Burton photographs made famous
and familiar from repeated use, set out in an order that denied
time any straight line. Carter and Mace dismantling the blocked
doorway to the Burial Chamber in February 1923. Carter and
one of the *ru'asa* – *Ra'is* Hussein, perhaps – removing resin from
the inner coffin in autumn 1925. Carter kneeling in front of the
open shrine doors in January 1924, a lamp angled over his shoul-
der towards the king within. The second coffin still wrapped in its
red shroud. The funerary mask looking right past us through the
floral wreaths that withered all around it long ago. A seal of Nile
mud on its looped string, the moment before the cord was cut
and a statue's sacred shrine cracked open. What can you see? We
know too well, by now, what Howard Carter must reply.

* * *

The little lie that Burton's photographs reveal some truth about
Tutankhamun is difficult to shift. We are in the realm of the
before and many afters, except we have forgotten how to tell
them all apart. Unable to go back in time to 1323 BC, we satisfy
ourselves that 1923 is more or less the same. Photographs of the
find invite us to believe that we can reach an untouched ancient
past, where the tomb, its objects, even Tutankhamun himself
exist in some primordial, pristine state. They place a halo on the
excavation and its history, cleansed both of empire's bitter taint
and several revolutions that had higher hopes.

My own hope is that the halo can be set aside at some point
amidst the centennial commemorations of 2022. Endless cele-
brations, on every scale, will mark the centenary of the discovery
of Tutankhamun's tomb, and the Grand Egyptian Museum
plans an inauguration fit for presidents and princes to attend.

Painstakingly cleaned and conserved, all the wonderful things from the young pharaoh's burial will have pride of place there, in the finest display cases and gallery spaces that money can buy. The GEM will give the world a Tutankhamun for generations yet to come, but he will bring his past with him, as we all do. Perhaps it is too much to think that among the golden platitudes and self-congratulations, it will be possible to speak of loss, acknowledge painful histories, and reckon with the dead.

A century on from that November day in 1922 when Tutankhamun made his debut in the modern world, our fascination with the golden king shows no sign of waning, despite his wide-eyed silence – or perhaps because of it. His mythology by now is ready-made, the headlines written, the photographs reprinted, the television programmes on repeat. Yet Tutankhamun will shape new generations, and be shaped by them in turn. This book has argued that his treasures, his tomb, and his fractured body have often drawn attention for the wrong reasons, whether propping up imperial privilege, arguing for racial hierarchies, priming the pumps of fossil fuels, or deflecting attention from despotism. At a time of climate crisis, rising inequalities, and growing awareness of the influence colonialism and empire still exert, it is worth asking what today's Tutankhamun can offer to the future. Museums, archaeology, and heritage sites will continue to play a role in global political, economic, and social developments. For whose good, is the question. Decolonization is a long-term project, not a quick fix or a buzzword. It requires those countries, groups, institutions, and individuals who have benefited from historical acts of exploitation to accept our implication in that history and cede our impulse to control what happens next. Close looking and careful listening are always the best tools, but often the least used. The time for change has come.

Tutankhamun has been many things to many people in the

past century. A triumph for Howard Carter and Lord Car-
narvon, in the waning years of colonial archaeology's so-called
'golden age'. A sign of rebirth to Egypt's founding fathers in
the 1920s, and a source of cultural capital and diplomatic cur-
rency to its leaders during the Cold War. A money-spinner
for museums, tourism, media outlets, and all the makers of
Tutankhamun-themed knick-knacks, reproductions, and other
merchandise. A saving grace for Egyptology, which might oth-
erwise have stayed tucked away in the dustier corners of elite
universities. An ambassador and public relations frontman who
put in a million miles for UNESCO's Nubian campaign – and
more recently for Egypt's Ministry of Antiquities and IMG,
which revived his touring schedule on a commercial scale, trying
to milk the golden cash cow for all its worth.

Not everyone sees Tutankhamun with a price tag or public-
ity in mind. He has been a powerful symbol to African diaspora
communities for whom ancient Egypt is too important to white-
wash. Even more so, he remains a source of pride to millions of
Egyptians for whom the pharaohs are not only the national foot-
ball team but a daily reminder of their country's renowned past.
In Egypt, pride can veer towards nationalism – which has always
been the flip side of colonialism and its neo-colonial counter-
parts today. The unbalanced relationship that still exists between
foreign and Egyptian Egyptology can make it difficult even for
those Egyptians in positions of authority to speak as freely as
they might wish about biases in both historic and contemporary
practices. Nor is a decolonizing agenda necessarily desirable or
comfortable for some Egyptians involved in the country's vast
antiquities infrastructure. The colonial mimicry of Zahi Hawass,
with his Indiana Jones-style fedora and teary-eyed visit to
Howard Carter's grave, has made him popular (and well paid),
but it has also been an effective weapon in its own way against

the privileges of foreign Egyptology.[26] It was under Hawass's directorship of the then Supreme Council of Antiquities that foreign archaeologists had to submit their excavation reports in Arabic for the first time.

For all the cultural complications and hackneyed stories attached to the history of Tutankhamun and his tomb, and all the inaccuracies, oversights, and bland superlatives that every iteration of that tale repeats, nearly everyone can agree on this: there is genuine wonder in the burial of this young man and the wealth of objects that were found with him. That wealth is not in the obvious places people look for it, like the solid gold coffin, the inlaid throne, or the sheer bewildering bounty of material goods and works of art that filled the tomb. In archaeological terms, the value of the find was its uniqueness and the glimpse it has offered into how a royal burial, even a rushed or minor one, was carried out. It was a time capsule of sorts, as it first seemed to me in Mrs Williams' social studies class – a series of human actions and traces of human lives, suspended in what almost passed for eternity.

Once discovered, eternity could not last. The undoing of Tutankhamun's burial and the desecration of the body at its centre are acts whose ethics few have questioned. As a field of study, Egyptology is still unversed in reparative histories or self-critique, and the Egyptian government has arguably been more concerned with the tourist dollars and bragging rights that Tutankhamun brings. If we are left with no concept more profound than 'treasure' to describe the tomb, then at least its wealth, like the devil, can be located in its details. Colour-drenched glass, mottled feldspar, translucent chalcedony, veined alabaster. The pink-dyed ivory tongues of birds and beasts. The seals, knots, and all the linen wrappings that defied air and time for as long as they could. Survivals that we still cannot explain

without recourse to words like ritual or protection, which make our human barterings with the divine seem as dry as a footnote and as vague as wishful thinking ever is.

When I emerged from the air-conditioned conservation centre of the GEM into the welcome mid-day warmth, my driver for the day, Nasir, was waiting for me with a smile. How was it, he wanted to know; it was his first visit, too, even if he only saw the car park. Big, I said, and so much gold, I explained, for my last stop had been a studio where all six chariots, the three funerary couches, and the outer coffin, recently brought up from the Luxor tomb, gleamed within the clinical white space. Starting up the car, Nasir asked if I wanted to visit the pyramids next, which is what most tourists to Giza do. I shook my head, happy to enjoy the view as we wove our way back around their pointed hulks to head towards Cairo.

I have a perfect, sealed-off memory of the day I spent at Giza as a student, doggedly visiting each pyramid and several tombs. A lean Australian, who had been backpacking for months, invited me to share a camel ride and helped me scoop sand into two ziplock bags I'd carried all the way from California for the purpose. My brother had asked me to bring some sand from the pyramids back to Ohio, a little bit of Egypt to plant in foreign soil. When I went home for Christmas, we each filled a glass jar with it and took the rest to our father's grave. On a wintry afternoon, in the weak solstice sun, we poured grains of the Egyptian desert into a shallow hole as if it might warm Dad up.

As Nasir navigated the thrum of traffic, I gazed out of the window at roadside stalls heaped with fat citrus fruits, purple turnips, and piled-up carrots. Laundry lines and palm trees waved in quiet alleyways, where signs pointed to the riding stables for which Giza is well known. The reinforced concrete walls of unfinished buildings spewed rusty skeletons into the clear blue

sky. Suddenly the car swerved, and Nasir slowed to a dead crawl. A small girl had almost fallen out of a minivan in the lane next to us as its driver sped on, unaware. The sliding side door had come unlatched or been left open. Nasir and other drivers honked and gestured furiously to get the van's attention. The girl's thin legs dangled in mid-air as other passengers grabbed her back to safety just in time and her mother clutched her tight. Not for the first time, useless guilt washed through me, heavier than sand in a suitcase and more difficult to disperse. My childhood encounter with Tutankhamun – the product of chance and American oil politics in the Middle East – shaped what became a privileged career. Whether the glass walls and grand ambitions of the Grand Egyptian Museum can offer half as much to children in Egypt, may need another half a century to see.

In the hundred years since he was brought back to life, Tutankhamun has been an inspiration to hundreds of children who, like me, needed something outside the everyday to raise their eyes just high enough to see over the limitations that life sets. Not every child has the opportunity to surpass those limitations, however, or to see a dream fulfilled. Too often, studying ancient history amounts to ignoring more recent, uncomfortable pasts, but until those are confronted, and their wounds where possible assuaged, tales of gold and glory, lost tombs and treasures, are more grist to the same mill. What's needed is a wider range of views and voices, for a start. I think of photographs Howard Carter took of basket boys and girls at work for Lord Carnarvon, clearing rubble in the Valley of the Kings. Their dusty faces look towards the camera, straight at Carter, and I wonder what they saw from that side of the lens.

The other side of winter found me back where I began, in a home erected as a palimpsest on the ashes of the past. We rebuild, move on, and rewrite our stories, if we can. Lived time moves

in only one direction, however much it seemed to slow in that pandemic spring. One soft evening, with the trees easing into bud, I walked up through the valley to the simple white church where my father is buried, closed off by a wrought-iron gate on which I used to swing. Five white obelisks greet me in a neat row, inscribed for Hockmans who died before the current church was built, mid-Civil War; Hockmans were still in the congregation when I went there as a girl. My father's simple headstone lies further on, where the hill begins to bend. The Giza sand we buried years ago must now be mixed with dust and bone and roots beneath the soil. On the granite ledge before Dad's name, I leave a single rose. There is little we can offer to the dead, and a history of absence is the hardest one to write.

The shadows of the obelisks stretch across the fresh-mown grass, another piece of Egypt in Ohio. My phone pings with a message from half a world away. With Cairo set to close for a coronavirus shutdown, a friend has been to visit the Egyptian Museum in Tahrir Square. He snapped a photo through the doorway of Room 3. Not a soul stands in the lofty room, where an open window lets a Nile breeze flow through onto a pharaoh's face. In its lone case set off by golden ropes, the mask of Tutankhamun is wide-eyed and waiting. Emptied, mounted, repeatedly repaired, it is not what it was at the moment of its creation. Time, and human frailties, have seen to that. But perhaps by sheer survival it signals us to trust that something better, even wonderful, may yet be on the way.

Acknowledgements

E VERY BOOK IS an author's leap of faith. This one is not only mine but that of many other people who believed in it and me. For that, I am indebted to my agent Patrick Walsh and to John Ash and Margaret Halton at PEW Literary. At Atlantic Books, Karen Duffy could not have offered a more welcoming home, and I could not have asked for a more sensitive reader and supportive editor than James Pulford.

Years of research in archives, libraries, and museums are at the heart of my encounters with Tutankhamun. At Oxford University, as always, I extend my sincerest thanks to the Griffith Institute and its staff, Francisco Bosch-Puche, Elizabeth Fleming, and the much-missed Cat Warsi. At the British Museum, I thank Patricia Usick and Francesca Hillier, and at the Metropolitan Museum of Art, Marsha Hill and Catharine Roehrig (now retired) in the Department of Egyptian Art, Teri Aderman and Nancy Rutledge in the photographic studio and storage facility, and Melissa Bowling in the central archives. Sincere thanks also to Jocelyn Anderson-Wood, formerly of Hull Museums; Foy Scalf, at the Oriental Institute, University of Chicago; and Franklin Burton at the National Gallery of Art in Washington DC, who did so much to make material accessible that I could not see in person once the pandemic hit.

At the Grand Egyptian Museum, I offer warm thanks to Dr

Eltayeb Abbas for hosting my visit and taking time for Tutankhamun chat, and to Susanna Thomas for making it possible. I am also deeply grateful to staff of the GEM who shared their work and workspaces with me, including Hassan Mohamed, Mona Nahmoun, conservators Ahmed Abdel Rabou and Mohamed Ayab, and other colleagues in the storerooms and studios. At the Egyptian Museum in Cairo, it was a privilege to be invited by Sabah Saddik to share my Tutankhamun research with her colleagues, including Hala Hassan, long-time curator of Section I – including the Tutankhamun collection – until her retirement in early 2020.

Colleagues and correspondents far and wide have pointed me to sources, information, and ideas that I would otherwise have missed. William Carruthers unstintingly shared his own archival research and work in progress, as did Vivian Ibrahim and Mario Schulze, who have done stellar work on the Tutankhamun exhibitions. For insights into Tutankhamun's glass, metalwork, and funerary mask, I owe sincere thanks to Katja Broschat, Christian Eckmann, and Eid Mertah. Ruth Addison and Ilya Zabolotnyi gave me a wealth of information about the Soviet tours, including Ruth's translations, without which I could not have written the last part of Chapter 5: спасибо большое! John Wyver introduced me to the wonders of 1970s British television, and Claire Wintle gave me advance access to her oral history interviews with Margaret Hall. I have had the great pleasure of meeting Margaret herself, and I appreciate the interest she has taken in my research on the Tutankhamun exhibitions. William Joy and Angela Reid have been generous with Carter- and Amherst-related resources; my friend and former neighbour Mary Wilkinson accompanied me to Swaffham on the Carter family trail; the owners of the AnewAgain shop on Etsy shared information on 1970s Tutankhamun merchandise; and Mark Hazelgrove remembered

visiting the 1972 exhibition in London with his school, while we struggled to install an exhibition of my own. A research grant from my department at Durham University supported image costs, and in Cairo, Francis Amin was a great help with photographs: *grazie mille*. For the past and present of Gurna, I thank Caroline Simpson and Mahmoud Hassaan Al Hashash, whose great-grandfather was a *ra'is* working with Carnarvon and Carter before the First World War. Closer to home, and after I had finished the book, I made the serendipitous re-acquaintance of Barbie Jo Williams (courtesy of my childhood friend Dawn Hosmer): thank you, Mrs Williams, for sharing your memories of working for my father at West School and teaching ancient Egypt at Sanderson.

Writing this book at a time of global, and personal, upheaval was not part of the plan, but I am blessed with friends and family who helped me see it through. I am grateful to my mother, Shirley Riggs, for letting me type away during our unexpected (and treasured) time together in the strange spring of 2020, and to my brother Neil for his half-century of support. Heartfelt thanks to Mirjam Brusius, Sabine Laemmel, and Margherita Lo Bue, at whose home, with cats for company, I finished the second draft in record time. Most of all, my friend Tom Hardwick exceeded himself in his close read-through of the text, saving me from errors and giving me exactly the encouragement I needed for this leap. Tom's own research and observations inform many of my own, and my 2019 visit to Cairo would have been impossible without him. We will always disagree about the spelling of carnelian.

Timeline

Howard Carter and *Ra'is* Ahmed Gerigar locate the tomb of Tutankhamun, November.

1924 Mid-February, Carter refuses to continue work on the tomb.

1924–25 A replica of the tomb features at the British Empire Exhibition, Wembley, London – infuriating Howard Carter.

1925 Carter returns to work; opening and autopsy of royal body.

1932 Work on the tomb draws to an end when the burial shrines are installed in the Egyptian Museum, Cairo.

1952 In July the Free Officers stage a successful coup against Britain; King Farouk abdicates in favour of his infant son Fuad.

1953 Egypt declared a republic, deposing King Fuad II.

1954 Egypt decides to build the Aswan High Dam.

1956 British troops withdraw from Suez Canal Zone. President Nasser nationalizes the Suez Canal, provoking the Suez Crisis. Sudan wins independence from Britain.

1960 After requests from Egypt and Sudan, UNESCO launches the International Campaign to Save the Monuments of Nubia.

1961–64 *Tutankhamun Treasures* tours seventeen cities in the United States and Canada, including the New York World's Fair in 1964.[1]

1965–66 Another, enlarged, version of *Tutankhamun Treasures* tours Japan, stopping in Tokyo, Kyoto, and Fukuoka.

1967 *Tutankhamon et sons temps* runs from February to September at the Petit Palais, Paris – including the gold funerary mask.

1968 September inauguration of the relocated Abu Simbel temples.

1972 *Treasures of Tutankhamun* runs from 29 March to 31 December at the British Museum in London.

1973–75 *Treasures of the Tomb of Tutankhamun* visits museums in Moscow, Leningrad (St Petersburg), and Kiev (Kyiv) in the USSR.

1976–79 *Treasures of Tutankhamun* opens at the National

Gallery of Art in Washington DC and travels to seven cities across America, including the Metropolitan Museum of Art in New York; it makes a final stop in Toronto, Canada.[2]

1980 March inauguration of the relocated Philae temples; conclusion of the UNESCO Campaign for the Monuments of Nubia.

1980–81 *Tutanchamun* tours five cities in West Germany: Berlin, Cologne, Munich, Hanover, and Hamburg.

1986 *The Tutankhamun Exhibition* opens in Dorchester, England.

2004–05 *Tutankhamun: The Golden Hereafter*, combining tomb objects and other royal artefacts from Cairo, runs in Basel and Bonn.

2005–11 *Tutankhamun and the Golden Age of the Pharaohs* (similar to the above) visits seven US cities, London, and – after the January 2011 Egyptian revolution – Melbourne, Australia. It is organized by American entertainment company AEI.[3]

2008–13 *Tutankhamun: The Golden King and the Great Pharaohs*, using other tomb objects and royal artefacts from Cairo, starts in Vienna and stops in seven North American cities; it is also organized by AEI.[4]

2009 Howard Carter's house at Luxor opens as a visitor attraction.

2011 Egyptian revolution; resignation of President Hosni Mubarak.

2013 President Mohamed Morsi removed from power in Egypt.

2014 Factum Arte's digitally produced facsimile of the tomb opens for visitors, next to the Howard Carter house at Luxor.

2018–20 *Treasures of the Golden Pharaoh* visits Los Angeles, Paris, and London, where the Covid-19 pandemic forces its closure and the cancellation of the rest of the planned tour. It is organized by entertainment conglomerate IMG, who acquired AEI.

2021 Planned opening of the Grand Egyptian Museum near Cairo.

2022 Centenary of the discovery of KV62, the tomb of Tutankhamun.

Bibliography

All online sources cited here and in the notes were live as of 1 July 2021.

PRIMARY SOURCES

Annual reports: Ashmolean Museum, 1945–74; Chicago Natural History Museum, 1962.

British Museum, Department of Ancient Egypt and Sudan (Edwards, Tutankhamun volumes); Central Archives (Tutankhamun files and box of photographs).

Cambridge University Library: Papers of E. J. Dent (for correspondence to Dent from Harry Burton and R. H. H. Cust); Newspaper clippings file, transferred from the Faculty of Asian and Middle Eastern Studies (including *Illustrated London News*, *The Sphere*, *The Egyptian Gazette*, and others).

Griffith Institute, Oxford University: Harry and Minnie Burton correspondence; Minnie Burton diary (online); Howard Carter Archive (including Burton negatives); Carter Deposit files; Carter diaries and journals (online); Green and Black Binders (for Tutankhamun photographs); Alfred Mace diaries (online); NYMMA (New York Metropolitan Museum of Art) Photos files.

Metropolitan Museum of Art, New York, Department of Egyptian Art: albums of Tutankhamun photographs, unbound; Harry Burton correspondence files. Photographic studio and storage: Harry Burton TAA negatives.

Oriental Institute, University of Chicago: Tutankhamun Treasures Exhibit file.

DIGITIZED NEWSPAPERS AND PERIODICALS, INCLUDING:

Gallica (Bibliothèque nationale de France; *Le Monde, Le Petit Parisien, Le Petit Journal Illustrée*)

Illustrated London News Digital Archive

The Listener Historical Archive

The London Gazette

Newspapers.com (*Los Angeles Times, San Francisco Chronicle, Washington Post*)

ProQuest News (*Chicago Tribune, Manchester Guardian, New York Times, The Sphere*)

The Radio Times Historical Archive

The Times Digital Archive

UKPressOnline (*Daily Express, Daily Mail, Daily Mirror*)

WORKS CITED

___. *5,000 Years of Egyptian Art*. London: Royal Academy of Arts, 1962.

___. *The Egyptian Museum, Cairo: A Brief Description of the Principal Monuments*. Cairo: Imprimerie de l'Institut Français d'Archéologie Orientale, 1938.

___. *The Last Two Million Years*. New York: Reader's Digest Association, 1973.

___. *Nubiana: The Great Undertaking that Saved the Temples of Abu Simbel*. Milan: Mondadori, 2019.

___. *Treasures of Tutankhamun*. London: Thames & Hudson, 1972, for the British Museum.

___. *Tutankhamun Treasures* [in Japanese]. Tokyo: Asahi Shimbun, 1965.

Acocella, Joan. 'Prophet motive: The Kahlil Gibran phenomenon', *The New Yorker*, 7 January 2008 (https://www.newyorker.com/magazine/2008/01/07/prophet-motive).

Adams, John M. *The Millionaire and the Mummies: Theodore Davis's Gilded Age in the Valley of the Kings*. New York: St Martin's Press, 2013.

Agha, Menna. 'Nubia still exists: On the utility of the nostalgic space', *Humanities* 8.24 (2019), doi:10.3390/h8010024.

Aldred, Cyril. 'The Temple of Dendur', *Metropolitan Museum of Art Bulletin* 36.1 (1978).

Alexander, Michael and Sushila Anand. *Queen Victoria's Maharajah: Duleep Singh, 1838–93*. London: Weidenfeld & Nicolson, 1980.

Allais, Lucia. *Designs of Destruction: The Making of Monuments in the Twentieth Century*. Chicago: University of Chicago Press, 2018.

___. 'Integrities: The salvage of Abu Simbel', *Grey Room* 50 (2013), pp. 6–45.

Andreu-Lanoë, Guillemette. 'Christiane Desroches Noblecourt (1913–2011)', *Bulletin de l'Institut Français d'Archéologie Orientale* 111 (2011), pp. 1–12.

Anthes, Rudolf. *Tutankhamun Treasures: A Loan Exhibition from the Department of Antiquities of the United Arab Republic*. Washington DC: American Association of Museums and Smithsonian Institution, 1961.

___. 'Über das Ägyptisches Museum zu Berlin während der Jahre 1939/1950', *Zeitschrift der Deutschen Morgenländischen Gesellschaft* 102 (1952), pp. 1–7.

Austin, Algernon. *Achieving Blackness: Race, Black Nationalism, and Afrocentrism in the Twentieth Century*. New York: New York University Press, 2006.

Avraham, Eli. 'Destination marketing and image repair during tourism crises: The case of Egypt', *Journal of Hospitality and Tourism Management* 28 (2016), pp. 41–8.

Balout, Lionel, Colette Roubet, and Christiane Desroches Noblecourt. *La Momie de Ramsès II: Contribution scientifique à l'égyptologie*. Paris: Éditions Recherche sur les civilisations, 1985.

Beavan, John. 'Hamilton, Sir (Charles) Denis (1918–1988), newspaper editor.' *Oxford Dictionary of National Biography*, 2004 (https://doi.org/10.1093/ref:odnb/40157).

Beckett, Matthew. *Lost Heritage: England's Lost Country Houses* website, 2020 (http://www.lostheritage.org.uk/houses/lh_norfolk_didlingtonhall.html).

Bell, Alan. 'Amherst, William Amhurst Tyssen-, First Baron Amherst of Hackney (1835–1909)'. *Dictionary of National Biography*. Oxford: Oxford University Press, 2004 (https://doi.org/10.1093/ref:odnb/30402).

Benedick, Richard Elliot. 'The High Dam and the Transformation of the Nile', *Middle East Journal* 33.2 (1979), pp. 119–44.

Bernal, Martin. *Black Athena: The Afroasiatic Roots of Classical*

Civilization. Rutgers: Rutgers University Press, 1987 (vol. 1), 1991 (vol. 2), 2006 (vol. 3).

Bertsch, Julia, Katja Broschat, Christian Eckmann, et al. *Tutankhamun's Unseen Treasures: The Golden Appliqués*. Cairo: DAI/RGZM, 2017.

Betts, Paul. 'The warden of world heritage: UNESCO and the rescue of the Nubian monuments', *Past & Present* 226, Suppl.10 (2015), pp. 100–25.

Bhabha, Homi. *The Location of Culture*. London: Routledge, 1994.

___. 'Of mimicry and man: The ambivalence of colonial discourse', *October* 28 (1984), pp. 125–33.

Bierbrier, M. L. (ed.) *Who was Who in Egyptology*, 4th ed. London: Egypt Exploration Society, 2012.

Boba, Eleanor. 'Treasures of Tutankhamun exhibit opens at Seattle Center on July 15, 1978', *History Link*, 21 May 2018 (https://www.historylink.org/File/20564).

Bolshakov, Andrey O. 'Tutankhamun at the Hermitage' [in Russian], in *250 Stories About the Hermitage: 'Collection of Motley Chapters . . .', Book Three*. St Petersburg: The State Hermitage Publishers, 2014, pp. 135–40.

Bonomi Joseph and John Lee. *Catalogue of the Egyptian Antiquities in the Museum of Hartwell House*. London: W.M. Watts, 1858.

Broschat, Katja, Thilo Rehren, Christian Eckmann, 'Makelloses Flickwerk: Die gläsernen Kopfstützen des Tutanchamun und anderes', *Restaurierung und Archäologie* 9 (2016), 1–24.

Burckhardt, John Lewis. *Travels in Nubia*. London: John Murray, 1819.

Carnarvon, Countess of. *Lady Almina and the Real Downton Abbey: The Lost Legacy of Highclere Castle*. London: Hodder & Stoughton, 2011.

Carnarvon, Earl of and Howard Carter. *Five Years' Explorations at Thebes*. London: Constable, 1912.

Carruthers, William. *Flooded Pasts: UNESCO, Nubia, and the Recolonization of Archaeology*. Ithaca, NY: Cornell University Press, forthcoming.

___. 'Records of dispossession: Archival thinking and UNESCO's Nubian campaign in Egypt and Sudan', *International Journal of Islamic Architecture* 9.2 (2020), pp. 287–314.

___. 'Visualizing a monumental past: Archaeology, Nasser's Egypt, and the early Cold War', *History of Science* 55.3 (2017), pp. 273–301.

Carter, Howard. 'Report on general work done in the Southern Inspectorate', *Annales du Service des Antiquités de l'Égypte* 4 (1903), pp. 43–50.

___. 'Report on the tomb of Mentuhotep I at Deir El-Bahari, known as Bab El-Hoçan', *Annales du Service des Antiquités de l'Égypte* 2 (1901), pp. 201–5.

___. *The Tomb of Tut.Ankh.Amen*, vol. II (The Burial Chamber). London: Cassell, 1927.

___. *The Tomb of Tut.Ankh.Amen*, vol. III (The Annexe and Treasury). London: Cassell, 1933.

___ and A. C. Mace. *The Tomb of Tut.Ankh.Amen*, vol. I. London: Cassell, 1923.

Cecil, Lady William (Mary). 'Report on the work done at Aswan', *Annales du Service des Antiquités de l'Égypte* 4 (1903), pp. 51–73.

Challis, Debbie. *The Archaeology of Race: The Eugenic Ideas of Francis Galton and Flinders Petrie*. London: Bloomsbury, 2013.

Chamberlain, Geoffrey. 'Two babies that could have changed world history', *Historian* 72 (2001), pp. 6–10.

Charlier, Philippe, Suonavy Khung-Savatovsky, and Isabelle Huynh-Charlier. 'Forensic and pathology remarks concerning the mummified fetuses of King Tutankhamun', *American Journal of Roentgenology* 198 (2011), p. W629 (web only).

Colla, Elliott. *Conflicted Antiquities: Egyptology, Egyptomania, Egyptian Modernity*. Durham, NC and London: Duke University Press, 2007.

Collins, Paul and Liam McNamara. *Discovering Tutankhamun*. Oxford: Ashmolean Museum, 2014.

Collins, Robert O. 'In search of the Nile waters, 1900–2000', in Haggai Erlich and Israel Gershoni (eds), *The Nile: Histories, Cultures, Myths*. Boulder: Lynne Rienner, 2000, pp. 245–68.

Cone, Polly (ed.) *Wonderful Things: The Discovery of Tutankhamun's Tomb*. New York: Metropolitan Museum of Art, 1978.

Connor, Simon and Eid Mertah, 'Des répliques dans une exposition', in Simon Connor and Dimitri Laboury (eds), *Toutankhamon: À la recherche du pharaon oublié*. Lièges: Presses Universitaires, 2019, pp. 24–9.

Corbould, Clare. *Becoming African Americans: Black Public Life in Harlem, 1919–1939*. Cambridge, Mass.: Harvard University Press, 2009.

Cottrell, Leonard. *The Lost Pharaohs: The Romance of Egyptian Archaeology*. London: Pan Books, 1956 [1950].

Cox, Samantha L. 'A critical look at mummy CT scanning', *The Anatomical Record* 298 (2015), pp. 1099–1110.

Dafalla, Hassan. *The Nubian Exodus*. London: C. Hurst, 1975.

Darwin, J. G. 'Baring, Evelyn, first earl of Cromer (1841–1917)', *Dictionary of National Biography*. Oxford: Oxford University Press, 2004, 2008 (https://doi.org/10.1093/ref:odnb/30583).

David, Francine Marie. *Bei den Grabräubern: Meine Zeit im Tal der Könige*. Zürich: Unionsverlag, 2011.

Delvaux, Luc. 'Toutankhamon et Akhénaten au Musée du Cinquantenaire', in Simon Connor and Dimitri Laboury (eds), *Toutankhamon: À la recherche du pharaon oublié*. Lièges: Presses Universitaires, 2019, pp. 322–25.

Derr, Jennifer L. 'Drafting a map of colonial Egypt: The 1902 Aswan Dam, historical imagination, and the production of agricultural geography,' in Diana K. Davis and Edmund Burke III (eds), *Environmental Imaginaries of the Middle East and North Africa*. Athens, Ohio: Ohio University Press, 2011, pp. 136–57.

Desplat, Juliette. 'Antiquity versus modernity? Philae and the Aswan Dam', The National Archives blog, 8 February 2017 (https://blog.nationalarchives.gov.uk/antiquity-versus-modernity-philae-aswan-dam/).

____. 'A trickle of pharaonic valuables', The National Archives blog, 5 February 2016 (https://blog.nationalarchives.gov.uk/trickle-pharaonic-valuables/).

Donzé, Pierre-Yves. *Making Medicine a Business: X-ray Technology, Global Competition, and the Transformation of the Japanese Medical System, 1895–1945*. London: Palgrave Macmillan, 2018.

Drower, Margaret S. 'Petrie, Sir (William Matthew) Flinders (1853–1942)', *Dictionary of National Biography*. Oxford: Oxford University Press, 2004, 2012 (https://doi.org/10.1093/ref:odnb/35496).

Eames, Penelope. *Furniture in England, France and the Netherlands from the Twelfth to the Fifteenth Century*. Furniture History: The Journal of the Furniture History Society. Leeds: W. S. Maney, 1977.

Eaton-Krauss, Marianne. *The Unknown Tutankhamun*. London: Bloomsbury, 2016.

Eco, Umberto. *Travels in Hyperreality: Essays*. London: Pan Books, 1987.

Edwards, Amelia. *A Thousand Miles up the Nile*. London: Longmans, 1877.

Edwards, Elizabeth. Review of Dan Jones and Marina Amaral, *The Colour of Time* (London: Head of Zeus, 2018), in *History of Photography* 43.3 (2019), pp. 331–2.

Edwards, I. E. S. *From the Pyramids to Tutankhamun: Memoirs of an Egyptologist*. Oxford: Oxbow Books, 2000.

___. *Tutankhamun: His Tomb and Its Treasures*. London: Knopf, 1976.

El Daly, Okasha. *Egyptology: The Missing Millennium: Ancient Egypt in Medieval Arabic Writings*. London: UCL Press, 2005.

El Mallakh, Ragaei. 'Some economic aspects of the Aswan High Dam project in Egypt', *Land Economics* 35.1 (1959), pp. 15–23.

El Saddik, Wafaa. *Protecting Pharaoh's Treasures: My Life in Egyptology*, transl. Russell Stockman. Cairo and New York: American University in Cairo Press, 2017.

Elias, Jonathan. 'Regional Indicia on a Saite Coffin from Qubbet El-Hawa', *Journal of the American Research Center in Egypt* 33 (1996), pp. 105–22.

Elcheikh, Zeina. 'Tales from two villages: Nubian women and cultural tourism in Gharb Soheil and Ballana', *Dotawo* 5 (2018), pp. 241–60.

Elsheshtawy, Yasser. 'Urban transformations: The Great Cairo Fire and the founding of a modern capital, 1952–1970', *Built Environment* 40.3 (2014), pp. 408–25.

Fagan, Brian. 'Herbert, George Edward Stanhope Molyneux, fifth earl of Carnarvon (1866–1923)', *Dictionary of National Biography*. Oxford: Oxford University Press, 2004, 2011 (https://doi.org/10.1093/ref:odnb/33830).

Fahim, Hussein M. 'Egyptian Nubia after resettlement', *Current Anthropology* 14.4 (1973), pp. 483–5.

___. *Egyptian Nubians: Resettlement and Years of Coping*. Salt Lake City: University of Utah Press, 1983.

Fahmy, Ismail. *Negotiating for Peace in the Middle East*. London: Croom Helm, 1983.

Fahmy, Khaled. *All the Pasha's Men: Mehmed Ali, His Army and the Making of Modern Egypt*. Cambridge and New York: Cambridge University Press, 1997.

Fathy, Hassan. *Architecture for the Poor: An Experiment in Rural Egypt*. Chicago: University of Chicago Press, 1973.

___. *Gourna: A Tale of Two Villages*. Cairo: Ministry of Culture, 1969.

Fernea, Robert. 'The ethnological survey of Egyptian Nubia', *Current Anthropology* 4.1 (1963), pp. 122–3.

Fielding, David and Anja Shortland. 'How do tourists react to political violence? An empirical analysis of tourism in Egypt', *Defence and Peace Economics* 22.2 (2011), pp. 217–43.

Fitzgerald, Penelope. *The Golden Child*. London: Fourth Estate, 2014 [1977].

Fletcher-Jones, Nigel. *Abu Simbel and the Nubian Temples*. Cairo: American University in Cairo Press, 2019.

Fox, Aileen. *Aileen, A Pioneering Archaeologist: The Autobiography of Aileen Fox*. Leominster: Gracewing, 2000.

Fox, Penelope. *Tutankhamun's Treasure*. Oxford: Oxford University Press, 1951.

Frayling, Christopher. *The Face of Tutankhamun*. London: Faber and Faber, 1992.

Fryxell, Allegra. 'Tutankhamen, Egyptomania, and temporal enchantment in interwar Britain', *Twentieth-Century British History* 28.4 (2017), pp. 516–42.

Gabolde, Marc. 'An Egyptian gold necklace for sale: Comparisons with Tutankhamun's jewellery', *HAL Archives Ouvertes* 2019 (pre-print) (https://halshs.archives-ouvertes.fr/halshs-02117225).

___. *D'Akhenaton à Toutânkhamon*. Lyon: Boccard, 1998.

Gabolde, Marc. *Toutankhamon: Akhenaton, La Vallée des Rois, Howard Carter*. Paris: Pygmalion, 2015.

Gamal Abdel, Tahia. *Nasser: My Husband*, transl. Shereen Mosaad. Cairo and New York: American University in Cairo Press, 2013.

Gange, David. 'The Ruins of Preservation: Conserving Ancient Egypt 1880–1914', *Past & Present* 226, Suppl. 10 (2015), pp. 78–99.

___. 'Unholy water: Archaeology, the Bible, and the First Aswan Dam', in Astrid Swenson and Peter Mandler (eds), *From Plunder to Preservation: Britain and the Heritage of Empire, 1800–1950*. Oxford: Oxford University Press for the British Academy, 2013, pp. 96–114.

Gilbert, Katharine Stoddert (ed.) *Treasures of Tutankhamun*. New York: Metropolitan Museum of Art, 1976.

Grillot, Marie. 'Exposition "Toutankhamon et son temps"', *Egyptophile* blogspot, 15 February 2016 (https://egyptophile.blogspot.com/2016/02/exposition-toutankhamon-et-son-temps.html).

Guitart, Miguel. 'The failed utopia of a modern African vernacular: Hassan Fathy in New Gourna', *Journal of Architectural Education* 68.2 (2014), pp. 166–77.

Hammer, Joshua. 'The rise and fall of Zahi Hawass', *Smithsonian Magazine*, June 2013 (https://www.smithsonianmag.com/history/the-rise-and-fall-and-rise-of-zahi-hawass-72874123/).

Handy, Basma and Don Karl (eds). *Walls of Freedom: Street Art of the Egyptian Revolution*. Berlin: From Here to Fame, 2012.

Harris, Neil. *Capital Culture: J. Carter Brown, The National Gallery of Art, and the Reinvention of the Museum Experience*. Chicago: University of Chicago Press, 2013.

Harrison, R. G. 'The Tutankhamun post-mortem', in Ray Sutcliffe (ed.), *Chronicle: Essays from Ten Years of Television Archaeology*. London: BBC, 1978, pp. 41–52.

___ and A. Abdalla. 'The remains of Tutankhamun', *Antiquity* 46.1 (1972), pp. 8–14.

Hassan, Fekri. 'The Aswan High Dam and the International Rescue Nubia Campaign', *African Archaeological Review* 24 (2007), pp. 73–94.

Hawass, Zahi. *Tutankhamun: Treasures of the Golden Pharaoh, The Centennial Celebration*. New York: Melcher Media, 2018.

___ and Sahar N. Saleem, 'Mummified daughters of King Tutankhamun: Archeologic and CT studies', *American Journal of Roentgenology* 197 (2011), pp. W829–36 (web only).

___ et al. 'Ancestry and pathology in King Tutankhamun's family', *Journal of the American Medical Association* 303.7 (February 2010), pp. 638–47.

Heffernan, Gabrielle. '"Wonderful things" in Kingston upon Hull', in Eleanor Dobson and Nichola Tonks (eds), *Ancient Egypt in the Modern Imagination: Art, Literature, and Culture*. London: Bloomsbury, 2020, pp. 13–28.

Hellier C. A. and R. C. Connolly, 'A re-assessment of the larger fetus found in Tutankhamen's tomb', *Antiquity* 83 (2009), pp. 165–73.

Hindley, Meredith. 'When the boy-king was the hottest ticket in town', *Humanities* 36.5 (2015) (https://www.neh.gov/humanities/2015/septemberoctober/feature/king-tut-classic-blockbuster-museum-exhibition-began-diplom).

Hopkins, Nicholas S. and Sohair R. Mehanna (eds), *Nubian*

Encounters: The Story of the Nubian Ethnological Survey 1961–1964.
Cairo and New York: American University in Cairo Press, 2011.

Hoving, Thomas. *Making the Mummies Dance: Inside the Metropolitan Museum of Art*. New York: Simon & Schuster, 1993.

___. *Tutankhamun: The Untold Story*. London: Simon & Schuster, 1978.

Howe, Stephen. *Afrocentrism: Mythical Pasts and Imagined Homes*. London: Verso, 1998.

Hunter, F. Robert. 'Tourism and empire: The Thomas Cook & Son enterprise on the Nile, 1868–1914', *Middle Eastern Studies* 40.5 (2004), pp. 28–54.

James, T. G. H. *Howard Carter: The Path to Tutankhamun*. London and New York: I.B. Tauris, 2001 [1992].

Janmyr, Maja. 'Nubians in contemporary Egypt: Mobilizing return to ancestral lands', *Middle East Critique* 25.2 (2016), pp. 127–45.

Keith, Arthur and Karl Pearson, 'The skull of Sir Thomas Browne', *Nature* 110.149 (1922) (https://doi.org/10.1038/110149c0).

Kemp, Barry. *The City of Akhenaten and Nefertiti: Amarna and its People*. London: Thames and Hudson, 2012.

Kingsley, Nicholas. *Landed families of Britain and Ireland* website, Entry 122 'Tyssen-Amherst', 11 May 2014 (https://landedfamilies. blogspot.com/2014/05/122-tyssen-amherst-later-cecil-of.html).

Kirkpatrick, David D. *Into the Hands of the Soldiers: Freedom and Chaos in Egypt and the Middle East*. London: Bloomsbury, 2018.

Kulik, Karol. 'A short history of archaeological communication', in Timothy Clack and Marcus Brittain (eds), *Archaeology and the Media*. Walnut Creek: Left Coast Press, 2007, pp. 111–24.

Landau, Jacob M. *Jews in Nineteenth Century Egypt*. London and New York: Routledge, 2016 [1969].

Laskier, Michael M. 'Egyptian Jewry under the Nasser regime, 1956–70', *Middle Eastern Studies* 31.3 (1994), pp. 573–619.

Lavachery, Henri and André Noblecourt, *Les techniques de protection des biens culturels en cas de conflit armé*. Paris: UNESCO, 1954.

Lee, Christopher C. *The Grand Piano Came by Camel: Arthur C. Mace, the Neglected Egyptologist*. Edinburgh: Mainstream Publishing, 1992.

Leek, F. Filce. *The Human Remains from the Tomb of Tutankhamun*. Oxford: Griffith Institute, 1972.

Lively, Penelope. *Oleander, Jacaranda: A Childhood Perceived*. London: Harper, 1995.

Loti, Pierre. *La mort de Philae*. Paris: Calmann-Lévy, 1908.

McAlister, Melani. *Epic Encounters: Culture, Media, and US Interests in the Middle East, 1945–2000*. Berkeley: University of California Press, 2001.

___. '"The common heritage of mankind": Race, nation, and masculinity in the King Tut exhibit', *Representations* 54 (1996), pp. 80–103.

MacDonald, Sally. 'Lost in time and space: Ancient Egypt in museums', in Sally MacDonald and Michael Rice (eds), *Consuming Ancient Egypt*. London: University of London Press, Institute of Archaeology, 2003, pp. 87–99.

Maekawa, Shin (ed.) *Oxygen-Free Museum Cases*. Los Angeles: Getty Conservation Institute, 1998.

Mak, Lanver. *The British in Egypt: Community, Crime, and Crisis, 1822–1922*. New York: I.B. Tauris, 2012.

Mansfield-Meade, N. F. *The Latest Pocket Guidebook to Luxor & Environments, including also Tut-Ankh-Amen*. Luxor: Gaddis Photo Stores, 1942 [4th ed.].

Marchant, Jo. *The Shadow King: The Bizarre Afterlife of King Tut's Mummy*. Boston: Da Capo, 2013.

Meskell, Lynn. *A Future in Ruins: UNESCO, World Heritage, and the Dream of Peace*. Oxford: Oxford University Press, 2018.

Mitchell, Timothy. *Rule of Experts: Egypt, Techno-Politics, Modernity*. Berkeley: University of California Press, 2002.

Montagu, Jeremy. 'One of Tutankhamun's trumpets', *Journal of Egyptian Archaeology* 64 (1978), pp. 133–4.

Montet, Pierre. *La Nécropole royale de Tanis*, 3 vols. Paris, 1947–51.

Montserrat, Dominic. *Akhenaten: History, Fantasy, and Ancient Egypt*. Abingdon and New York: Routledge, 2000.

Morlier, Hélène (ed.) *L'architecte Marcel Dourgnon et l'Égypte*. Paris: Publications de l'Institut national d'histoire de l'art, 2010.

Naunton, Christopher. 'The Archaeological Survey', in Patricia Spencer (ed.), *The Egypt Exploration Society: The Early Years*. London: EES, 2007, pp. 67–93.

Noble, Louise. *Medicinal Cannibalism in Modern English Literature and Culture*. New York: Palgrave Macmillan, 2011.

Noblecourt, Christiane Desroches; *La grande Nubiade: Le parcours d'une égyptologue*. Paris: Stock/Pernoud, 1992.

___. *Sous le regard des dieux*. Paris: Albin Michel, 2016 [2003].

___. *Tutankhamen: Life and Death of a Pharaoh*. London: Rainbird, 1963.

Noblecourt, Christiane Desroches (ed.) *Toutankhamon et son temps*. Paris: Petit Palais, 1967.

Norman, Geraldine. *Dynastic Rule: Mikhail Piotrovsky and the Hermitage*. London: Unicorn Publishing, 2016.

O'Connor, David. 'In memoria' [Rudolf Anthes], *Expedition Magazine* 27.1 (1985), pp. 34–6.

O'Connor, Kevin. 'Photographer & Sculptor Frederick Leslie Kenett 1924–2012', *London Photographic Association* blogpost, 14 October 2012 (http://londonphotographicassociation.blogspot.com/2012/10/photographer-sculptor-frederick-leslie.html).

Oddy, Andrew. 'Harold Plenderleith and *The Conservation of Antiquities and Works of Art*', *Intervención* 2.4 (2011), pp. 56–62.

Okacha, Saroite [Tharwat Okasha]. *Ramsès Re-couronné: Hommage vivant au Pharaon mort*. Cairo: Daar al-Maaref, 1974.

Orsenigo, Christian. 'Una guida d'eccezione per illustri viaggiatori: Pierre Lacau e i Savoia in Egitto', in Christian Orsenigo (ed.), *Da Brera alle Piramidi*. Milan: Scalpendi Editore, 2015, pp. 113–17.

Owen, Roger. *Lord Cromer: Victorian Imperialist, Edwardian Proconsul*. Oxford: Oxford University Press, 2004.

Pagliarulo, Giovanni. 'Passions intertwined: Art and photography at I Tatti', in Carl Brandon Strehlke and Machtelt Israëls (eds), *The Bernard and Mary Berenson Collection of European Paintings at I Tatti*. Florence: Villa I Tatti and Officina Libraria, 2015, pp. 71–85.

Parker, Ian. 'The pharaoh: Is Zahi Hawass bad for Egyptology?', *The New Yorker* 16 November 2009 (https://www.newyorker.com/magazine/2009/11/16/the-pharaoh).

Peate, Iorwerth Cyfeiliog. 'Sir Cyril Fred Fox (1882–1967), Director of the National Museum of Wales, 1936–48', *Dictionary of Welsh Biography*, 2001 (https://biography.wales/article/s2-FOX0-FRE-1882).

Pezzati, Alessandro. 'Tutankhamun Treasures: The first Tut show came to the Museum', *Expedition Magazine* 48.3 (2006), pp. 6–7.

Piankoff, Alexandre. *Les chapelles de Tout-Ankh-Amon*. Cairo: Imprimerie de l'Institut Français d'Archéologie Orientale, 1951–2.

___. *The Shrines of Tut-Ankh-Amun*, 2 vols. New York, 1954

Prag, A. J. N. W. and Richard Neave. *Making Faces: Using Forensic and Archaeological Evidence*. London: British Museum Press, 1997.

Price, Sally. *Primitive Art in Civilized Places*. Chicago: Chicago University Press, 1989 [2nd ed., 2000].

Rainey, Froelich. *Reflections of a Digger: Fifty Years of World Archaeology*. Philadelphia: University of Pennsylvania Museum of Archaeology and Anthropology, 1992.

Reeves, Nicholas. 'The burial of Nefertiti?', *Amarna Royal Tombs Project*, Occasional Paper No. 1 (2015) (web publication only).

___. 'The coffin of Ramesses II', in Alessia Amenta and Hélene Guichard (eds), *Proceedings of the First Vatican Coffin Conference, 19–22 June 2013*, vol. 2. Rome: Edizioni Musei Vaticani, 2017, pp. 425–38.

___. *The Complete Tutankhamun*. London: Thames and Hudson, 1990 [and later editions].

___. 'The decorated north wall in the tomb of Tutankhamun (KV62)', Amarna Royal Tombs Project, Occasional Paper no. 3 (2019) (web publication only).

___. 'Tutankhamun's mask reconsidered', *Bulletin of the Egyptological Seminar* 19 (2015), pp. 511–26.

Reeves C. N. [Nicholas] and John H. Taylor, *Howard Carter before Tutankhamun*. London: British Museum Press, 1992.

Reid, Angela. *The Amhersts of Didlington Hall* website, 2008 (http://www.amhersts-of-didlington.com/index.html).

Reid, Donald Malcolm. *Contesting Antiquity in Egypt: Archaeologists, Museums, and the Struggle for Identities from World War I to Nasser*. Cairo: American University in Cairo Press, 2015.

___. *Whose Pharaohs? Archaeology, Museums, and Egyptian National Identity from Napoleon to World War I*. Berkeley and Los Angeles: University of California Press, 2002.

Reisner, George A. 'The dead hand in Egypt', *The Independent* 114, no. 3903 (21 March 1925), p. 318.

Reynolds, Nancy Y. *A City Consumed: Urban Commerce, the Cairo Fire, and the Politics of Decolonization in Egypt*. Stanford: Stanford University Press, 2012.

Riggs, Christina. *Egypt: Lost Civilizations*. London: Reaktion, 2017.

___. *Photographing Tutankhamun: Archaeology, Ancient Egypt, and the Archive*. London: Bloomsbury, 2019.

___. *Unwrapping Ancient Egypt*. London: Bloomsbury, 2014.

___. 'Visitor views', *Photographing Tutankhamun* blog, 18 June 2018 (https://photographing-tutankhamun.com/2018/06/).

___. 'Water boys and wishful thinking', *Photographing Tutankhamun* blog, 20 June 2020 (https://photographing-tutankhamun.com/blog/).

Romanova, Olena. 'Kyiv receives Tutankhamun: The exhibition "Treasures of Tutankhamun's Tomb" in Kyiv 6 January–14 March 1975', in V. M. Danylenko (ed.), *Ukraine in the Twentieth Century: Culture, Ideology, Politics*. Kyiv: Institute of History of Ukraine, National Academy of Science, 2018, pp. 298–318 [in Ukrainian].

Romer, John and Elizabeth Romer, *The Rape of Tutankhamun*. London: Michael O'Mara Books, 1993.

Rühli, Frank J. and Salima Ikram, 'Purported medical diagnoses of Pharaoh Tutankhamun, c. 1325 BC–', *HOMO: Journal of Comparative Human Biology* 65.1 (2013), pp. 51–63.

Ryzova, Lucie. *The Age of the Effendiya: Passages to Modernity in National-Colonial Egypt*. Oxford: Oxford University Press, 2014.

___. 'The battle of Muhammad Mahmoud Street in Cairo: Politics and poetics of urban violence in revolutionary time', *Past & Present* 247.1 (2020), pp. 273–317.

Sabit, Adel. *A King Betrayed: The Ill-Fated Reign of Farouk of Egypt*. London and NY: Quartet Books, 1989.

Säve-Söderbergh, Torgny. *Temples and Tombs of Ancient Nubia: The International Rescue Campaign at Abu Simbel, Philae and Other Sites*. London: Thames and Hudson, 1987.

Savoy, Bénédicte (ed.) *Nofretete: Eine deutsch-französische Affäre 1912–1931*. Cologne: Böhlau, 2011.

Schmid, Karl Anthony. 'Doing ethnography of tourist enclaves: Boundaries, ironies, and insights', *Tourist Studies* 8.1 (2008), pp. 105–21.

Schultz, Bernd. *James Simon: Philanthrop und Kunstmäzen*. Munich: Prestel, 2007.

Schulze, Mario. 'Tutankhamun in West Germany, 1980–81', *Representations* 141 (2018), pp. 39–58.

Schwyzer, Philip. *Archaeologies of English Renaissance Literature*. Oxford: Oxford University Press, 2007.

Sebald, W. G. *The Rings of Saturn*, transl. Michael Hulse. London: Vintage, 2002 [1998].

Seggerman, Alexandra Dika. 'Mahmoud Mukhtar: "The first sculptor from the land of sculpture"', *World Art* 4.1 (2014), pp. 27–46.

___. *Modernism on the Nile: Art in Egypt between the Islamic and the Modern*. Chapel Hill: University of North Carolina Press, 2019.

Seyfried, Friederike. 'Die Büste der Nofretete: Dokumentation des Fundes und der Fundteilung 1912/1913, *Jahrbuch Preussischer Kulturbesitz* 46 (2010), pp. 133–202.

___ (ed.) *In the Light of Amarna: 100 Years of the Nefertiti Discovery*. Petersberg: Michael Imhof Verlag, 2012.

Shokr, Ahmad. 'Hydropolitics, economy, and the Aswan High Dam in mid-century Egypt', *The Arab Studies Journal* 17.1 (2009), pp. 9–31.

Simpson, R. S. 'Griffith, Francis Llewellyn (1862–1934)', *Dictionary of National Biography*. Oxford: Oxford University Press, 2008 [2004] (https://doi.org/10.1093/ref:odnb/33579).

Smith, H. S. 'Edwards, (Iorwerth) Eiddon Stephen (1909–1996)', *Oxford Dictionary of National Biography*, 2004 (https://doi.org/10.1093/ref:odnb/70768).

Stevenson, Alice. *Scattered Finds: Archaeology, Egyptology, and Museums*. London: UCL Press, 2019.

Stock, Hans and Karl Georg Siegler, 'Moving a temple as big as a cathedral', *The UNESCO Courier* (1964), pp. 38–9.

Streatfeild, Noel. *The Boy Pharaoh: Tutankhamen*. London: Michael Joseph, 1972.

Sugg, Richard. *Mummies, Cannibals, and Vampires: The History of Corpse Medicine from the Renaissance to the Victorians*. Abingdon and New York: Routledge, 2011.

Tanré-Szewczyk, Juliette. 'The fate of seven "lion headed sphinxes" and the sale of the Egyptian collection of John Barker in London, 1833', *Journal of the History of Collections* 30.2 (2018), pp. 235–9.

Tawfik, Tarek S., Susanna Thomas, and Ina Hegenbarth-Reichardt. 'New evidence for Tutankhamun's parents: Revelations from the Grand Egyptian Museum', *Mitteilungen des Deutschen Archäologischen Instituts, Abteilung Kairo* 74 (2018), pp. 177–92.

Taylor, John H. 'Intrusive burials and caches', in Richard H. Wilkinson and Kent R. Weeks (eds), *The Oxford Handbook of the Valley of the Kings*. Oxford: Oxford University Press, 2016, pp. 361–71.

Tvedt, Terje. *The River Nile in the Age of the British: Political Ecology and the Quest for Economic Power*. London and New York: I.B. Tauris, 2004.

Tyldesley, Joyce. *Nefertiti's Face: The Creation of an Icon*, Cambridge, Mass.: Harvard University Press, 2018.

University of Michigan Audio-Visual Education Center. *Educational Media Resources on Egypt.* Washington DC: Department of Health, Education, and Welfare, Office of Education, 1977.

Van der Spek, Kees. *The Modern Neighbors of Tutankhamun: History, Life, and Work in the Villages of the Theban West Bank.* Cairo: American University in Cairo Press, 2011.

Walker, Clarence E. *We Can't Go Home Again: An Argument about Afrocentrism.* Oxford: Oxford University Press, 1989.

Wedge, Eleanor F. (ed.) *Nefertiti Graffiti: Comments on an Exhibition.* Brooklyn: The Brooklyn Museum, 1976.

Weeks, Kent. 'Tourism in the Valley of the Kings', in Richard H. Wilkinson and Kent R. Weeks (eds), *The Oxford Handbook of the Valley of the Kings.* Oxford: Oxford University Press, 2016, pp. 559–66.

Wheeler, Sir Mortimer. 'Homage to Sir Cyril Fox', in I.Ll. Foster and Leslie Alcock (eds), *Culture and Environment: Essays in Honour of Sir Cyril Fox.* London: Routledge and Kegan Paul, 1963, pp. 1–6.

Wilkinson, Caroline. *Forensic Facial Reconstruction.* New York and Cambridge: Cambridge University Press, 2009.

Wong, Lori et al. 'Examination of the wall paintings in Tutankhamen's tomb: Inconsistencies in original technology', *Studies in Conservation* 57 Suppl. 1, pp. S322–30.

Wynn, L. L. *Pyramids and Nightclubs: A Travel Ethnography of Arab and Western Imaginations of Egypt.* Austin: University of Texas Press, 2007.

Zalewski, Daniel. 'The Factory of fakes', *The New Yorker,* 21 November 2016 (https://www.newyorker.com/magazine/2016/11/28/the-factory-of-fakes).

Zavorotnaya, L. A. 'The exhibition "Treasures of Tutankhamun's Tomb" at the State Museum of Fine Arts A. S. Pushkin, 1973–1974' [in Russian] (https://pushkinmuseum.art/data/epublication/chronic/8690_file_pdf.pdf).

Zivie, Alain-Pierre. 'La nourrice royale Maïa et ses voisins: Cinq tombeaux du Nouvel Empire récemment découverts à Saqqara', *Comptes rendus des séances de l'Académie des Inscriptions et Belles-Lettres Année* 142.1 (1998), pp. 33–54.

___. *La tombe de Maïa, mère nourricière du roi Toutânkhamon et grande du harem.* Toulouse: Cara Cara, 2009.

Notes

INTRODUCTION *Discoveries*

1 University of Michigan Audio-Visual Education Center,
 Educational Media Resources on Egypt. Washington DC:
 Department of Health, Education, and Welfare, Office of
 Education, 1977.

2 *The Last Two Million Years.* New York: Reader's Digest
 Association, 1973.

3 For an important and engaging account of how late nineteenth
 and early twentieth-century observers interpreted Akhenaten and
 the Amarna era, see Dominic Montserrat, *Akhenaten: History,
 Fantasy, and Ancient Egypt.* Abingdon and New York: Routledge,
 2000.

4 Joyce Tyldesley, *Nefertiti's Face: The Creation of an Icon*, Cambridge,
 Mass.: Harvard University Press, 2018, pp. 137–55, gives an
 overview of the controversy surrounding the discovery of the bust
 and how it reached Berlin. See also Montserrat, *Akhenaten*, p. 72;
 Friederike Seyfried, 'Die Büste der Nofretete: Dokumentation
 des Fundes und der Fundteilung 1912/1913, *Jahrbuch Preussischer
 Kulturbesitz* 46 (2010), pp. 133–202; Bénédicte Savoy (ed.),
 Nofretete: Eine deutsch-französische Affäre 1912–1931. Cologne:
 Böhlau, 2011; Friederike Seyfried (ed.), *In the Light of Amarna:
 100 Years of the Nefertiti Discovery.* Petersberg: Michael Imhof
 Verlag, 2012.

5 Bernd Schultz, *James Simon: Philanthrop und Kunstmäzen.*
 Munich: Prestel, 2007.

6 I have drawn here on Marianne Eaton-Krauss, *The Unknown
 Tutankhamun* (London: Bloomsbury, 2016), which sums up the
 dense undergrowth of evidence and competing interpretations on
 Tutankhamun's family relationships. See also Nicholas Reeves,

The Complete Tutankhamun. London: Thames and Hudson, 1990 (and later editions); Marc Gabolde, *D'Akhenaton à Toutânkhamon*. Lyon: Boccard, 1998; and Barry Kemp, *The City of Akhenaten and Nefertiti: Amarna and its People*. London: Thames and Hudson, 2012.

7 Tarek S. Tawfik, Susanna Thomas, and Ina Hegenbarth-Reichardt, 'New evidence for Tutankhamun's parents: Revelations from the Grand Egyptian Museum', *Mitteilungen des Deutschen Archäologischen Instituts, Abteilung Kairo* 74 (2018), pp. 177–92.

8 Catalogue number 91. Catalogue numbers throughout the notes refer to those assigned by Howard Carter, which remain the most convenient way to locate objects from the tomb online; see http://www.griffith.ox.ac.uk/gri/carter/. Many objects have additional numbers based on their exhibition position in the Egyptian Museum, Cairo; their entry log or temporary inventory numbers in the same museum; and new numbers assigned after their transfer to the Grand Egyptian Museum.

9 Catalogue number 108.

10 Eaton-Krauss, *Unknown Tutankhamun*, pp. 1–3.

11 Alain-Pierre Zivie, *La tombe de Maïa, mère nourricière du roi Toutânkhamon et grande du harem*. Toulouse: Cara Cara, 2009; Alain-Pierre Zivie, 'La nourrice royale Maïa et ses voisins: Cinq tombeaux du Nouvel Empire récemment découverts à Saqqara', *Comptes rendus des séances de l'Académie des Inscriptions et Belles-Lettres Année* 142.1 (1998), pp. 33–54.

12 Catalogue number 21z.

13 Catalogue numbers 39, 35.

14 Catalogue numbers 261, 261a.

15 Catalogue number 262.

16 Catalogue number 266g.

17 Carter's journal entry for 26 November 1922: transcription and scan of handwritten pages at http://www.griffith.ox.ac.uk/discoveringTut/journals-and-diaries/season-1/journal.html.

18 For this interpretation, see Eaton-Krauss, *Unknown Tutankhamun*, pp. 92–3. In contrast, Nicholas Reeves has suggested, with copious media coverage, that Tutankhamun's burial (KV62) is part of a larger tomb with further corridors and rooms concealed behind the walls of his Burial Chamber: Reeves, 'The burial of Nefertiti?', *Amarna Royal Tombs Project*, Occasional Paper No. 1 (2015). I thank Dr Francesco Porcelli, of the Politecnico di Torino, for

discussing with me his ground-penetrating radar study of KV62 and the Valley of the Kings.

19 Catalogue numbers 257–260.
20 Catalogue number 14.
21 Catalogue number 266b.
22 Catalogue numbers 266c–f.
23 See chemist Alfred Lucas's research notes for canopic coffin 266G NE (Northeast): http://www.griffith.ox.ac.uk/discoveringTut/ conservation/4lucasn5.html.

1 *Creation Myths*

1 Carter MSS vi.2.1–14, Griffith Institute, Oxford University: full list available at http://www.griffith.ox.ac.uk/gri/4cartervi+vii.pdf. At the time of writing, the best available biography of Howard Carter is T. G. H. James, *Howard Carter: The Path to Tutankhamun*. London and New York: I.B. Tauris, 2001 (first published 1992), complemented by C. N. Reeves and John H. Taylor, *Howard Carter before Tutankhamun*. London: British Museum Press, 1992. I have drawn on both of these for my discussion in this chapter, as well as material about the Carter family presented in the Swaffham Museum, Swaffham, Norfolk.

2 The family name and its spelling changed from Tyssen-Amhurst to Tyssen-Amherst, with Amherst becoming the most familiar version after their ennoblement. See Alan Bell, 'Amherst, William Amhurst Tyssen-, First Baron Amherst of Hackney (1835–1909)'. *Dictionary of National Biography*. Oxford: Oxford University Press, 2004 (https://doi.org/10.1093/ref:odnb/30402); M. L. Bierbrier (ed.), *Who was Who in Egyptology*, 4th ed. London: Egypt Exploration Society, 2012, p. 18; Nicholas Kingsley, *Landed families of Britain and Ireland* website, Entry 122 'Tyssen-Amherst', 11 May 2014 (https://landedfamilies.blogspot.com/ 2014/05/122-tyssen-amherst-later-cecil-of.html); correspondence of Lady Margaret Susan Amherst in the Newberry Collection, Griffith Institute, Oxford University (NEWB2/014); papers of William Amhurst Tyssen-Amherst, 1st Baron Amherst of Hackney in the Bodleian Library, Oxford University (MSS. Eng. misc. c. 740–2). For Didlington Hall, see Angela Reid, *The Amhersts of Didlington Hall* website, 2008 (http://www. amhersts-of-didlington.com/index.html); Matthew Beckett, *Lost Heritage: England's Lost Country Houses* website, 2020 (http://

www.lostheritage.org.uk/houses/lh_norfolk_didlingtonhall.html).

3 Joseph Bonomi and John Lee, *Catalogue of the Egyptian Antiquities in the Museum of Hartwell House*. London: W. M. Watts, 1858. On the early collection history of the Sekhmet statues, see Juliette Tanré-Szewczyk, 'The fate of seven "lion headed sphinxes" and the sale of the Egyptian collection of John Barker in London, 1833', *Journal of the History of Collections* 30.2 (2018), pp. 235–9. To see two of the Sekhmet statues in their current museum homes, see https://sanantonio.emuseum.com/objects/5355/sekhmet and https://www.metmuseum.org/art/collection/search/544484.

4 Letter from Mrs (Margaret, later Lady) Amherst to Percy Newberry, 29 May 1891, quoted in James, *Howard Carter*, p. 17. NEWB2/014, letter 9, Percy Edward Newberry Collection, Griffith Institute, Oxford University.

5 See Christopher Naunton, 'The Archaeological Survey', in Patricia Spencer (ed.), *The Egypt Exploration Society: The Early Years*. London: EES, 2007, pp. 67–93; James, *Howard Carter*, pp. 22–34; Reeves and Taylor, *Howard Carter*, pp. 20–33.

6 Khaled Fahmy, *All the Pasha's Men: Mehmed Ali, His Army and the Making of Modern Egypt*. Cambridge and New York: Cambridge University Press, 1997.

7 Okasha El Daly, *Egyptology: The Missing Millennium: Ancient Egypt in Medieval Arabic Writings*. London: UCL Press, 2005.

8 Donald Malcolm Reid, *Whose Pharaohs? Archaeology, Museums, and Egyptian National Identity from Napoleon to World War I*. Berkeley and Los Angeles: University of California Press, 2002, pp. 54–8.

9 J. G. Darwin, 'Baring, Evelyn, first earl of Cromer (1841–1917)', *Dictionary of National Biography*. Oxford: Oxford University Press, 2004, 2008 (https://doi.org/10.1093/ref:odnb/30583); Roger Owen, *Lord Cromer: Victorian Imperialist, Edwardian Proconsul*. Oxford: Oxford University Press, 2004.

10 Debbie Challis, *The Archaeology of Race: The Eugenic Ideas of Francis Galton and Flinders Petrie*. London: Bloomsbury, 2013; for an overview of Petrie's life, see Margaret S. Drower, 'Petrie, Sir (William Matthew) Flinders (1853–1942), *Dictionary of National Biography*. Oxford: Oxford University Press, 2004, 2012 (https://doi.org/10.1093/ref:odnb/35496).

11 Petrie's epistolary journal for the 1891–92 season offers insights into camp life and visitors, including Aquila Dodgson and Oxford professor of Assyriology Archibald Sayce: Petrie's MSS 1.11,

Griffith Institute, Oxford University, digitized in three parts at
http://archive.griffith.ox.ac.uk/index.php/petrie-1-11.

12 Petrie MSS 1.11.51-100, p. 75, 3–9 January 1892 (see n. 11).

13 Petrie MSS 1.11.101-138, pp. 137–8, 17–23 April 1892 (see n. 11).

14 Petrie MSS 1.11.51-100, p. 80, 24 January 1892 (see n. 11).

15 James, *Howard Carter*, p. 43; Reeves and Taylor, *Howard Carter*,
pp. 42–3.

16 Petrie MSS 1.11.101-138, p. 138, 24 April to 1 October 1892
(see n. 11).

17 For a sense of ex-patriate life in Egypt, see Lanver Mak,
The British in Egypt: Community, Crime, and Crisis, 1822–1922.
New York: I.B. Tauris, 2012.

18 For a history of the Egyptian antiquities service at this time, and
of the Egypt Exploration Fund's interactions with it, see Reid,
Whose Pharaohs?; Alice Stevenson, *Scattered Finds: Archaeology,
Egyptology, and Museums.* London: UCL Press, 2019; David
Gange, 'The ruins of preservation: Conserving ancient Egypt
1880–1914', *Past & Present* 226, Suppl. 10 (2015), pp. 78–99;
Spencer (ed.), *Egypt Exploration Society.*

19 See for instance Édouard Naville, *The Temple of Deir el Bahari*,
vol. 3. London: Egypt Exploration fund, 1898, at https://digi.
ub.uni-heidelberg.de/diglit/naville1898bd3/0046.

20 Lucie Ryzova, *The Age of the Effendiya: Passages to Modernity in
National-Colonial Egypt.* Oxford: Oxford University Press, 2014.

21 F. Robert Hunter, 'Tourism and empire: The Thomas Cook & Son
enterprise on the Nile, 1868–1914', *Middle Eastern Studies* 40.5
(2004), pp. 28–54.

22 Howard Carter, 'Report on the tomb of Mentuhotep Ist at Deir
El-Bahari, known as Bab El-Hoçan', *Annales du Service des
Antiquités de l'Égypte* 2 (1901), pp. 201–5, and see Christina Riggs,
Unwrapping Ancient Egypt. London: Bloomsbury, 2014, pp. 37–9.

23 John M. Adams, *The Millionaire and the Mummies: Theodore Davis's
Gilded Age in the Valley of the Kings.* New York: St Martin's Press,
2013, and for Andrews see also http://www.emmabandrews.org/
project/emma-b-andrews.

24 For Carnarvon's life, see Brian Fagan, 'Herbert, George Edward
Stanhope Molyneux, fifth earl of Carnarvon (1866–1923),
Dictionary of National Biography. Oxford: Oxford University Press,
2004, 2011 (https://doi.org/10.1093/ref:odnb/33830); Almina *née*
Wombwell is the subject of Fiona, Countess of Carnarvon, *Lady*

Almina and the Real Downton Abbey: The Lost Legacy of Highclere Castle. London: Hodder & Stoughton, 2011.

25 Michael Alexander and Sushila Anand, *Queen Victoria's Maharajah: Duleep Singh, 1838–93*. London: Weidenfeld & Nicolson, 1980, is one of many accounts of Duleep Singh's extraordinary life; for the family, see also resources at www.duleepsingh.com.

26 Carnarvon, Earl of and Howard Carter, *Five Years' Explorations at Thebes*. London: Constable, 1912, p. v.

27 Carnarvon and Carter, *Five Years' Explorations*, p. 1.

28 Reeves and Taylor, *Howard Carter*, p. 104.

29 See Kyle J. Anderson, 'The Egyptian Labor Corps: Workers, peasants, and the state in World War I', *International Journal of Middle Eastern Studies* 49.1 (2017), pp. 5–24.

30 Theodore M. Davis, *The Tombs of Harmhabi and Touatânkhamanou*. London: Constable, 1912 [reprinted 2001]; Dorothea Arnold and H. E. Winlock, *Tutankhamun's Funeral*. New York: Metropolitan Museum of Art, 2010 [reprinting Winlock's 1941 account].

31 Lady William (Mary) Cecil, 'Report on the work done at Aswan', *Annales du Service des Antiquités de l'Égypte* 4 (1903), pp. 51–73.

32 'Notes and news', *Journal of Egyptian Archaeology* 7.3–4 (1921), p. 218: 'It is understood that a number of the best objects have gone to the United States'.

33 https://kalamazoomuseum.org/localhistory/thecollection/amtodd/ and Jonathan Elias, 'Regional indicia on a Saite coffin from Qubbet El-Hawa', *Journal of the American Research Center in Egypt* 33 (1996), pp. 105–22 (esp. p. 105 n. 2).

34 Cecil, 'Report', p. 71. The tomb and its burials dated to Dynasty 26, around 600 BC.

2 *The Reawakening*

1 Images and transcriptions of Carter's diaries (agendas) and more discursive journals are available to browse online: http://www. griffith.ox.ac.uk/discoveringTut/journals-and-diaries/.

2 Reeves, *Complete Tutankhamun*, pp. 53, 92–4.

3 Journal entry for 5 November 1922: http://www.griffith.ox.ac.uk/ discoveringTut/journals-and-diaries/season-1/journal.html.

4 As above. I have drawn here mainly on Carter's diaries and journals, but his published accounts of the discovery are crucial sources, too: Howard Carter and A. C. Mace, *The Tomb of Tut*.

Ankh.Amen, vol. I. London: Cassell, 1923; Howard Carter, *The Tomb of Tut.Ankh.Amen*, vol. II (The Burial Chamber). London: Cassell, 1927; Howard Carter, *The Tomb of Tut.Ankh.Amen*, vol. III (The Annexe and Treasury). London: Cassell, 1933.

5 Journal entry for 25 November 1922 (see n. 3).

6 For transcriptions of Mace's diaries, see http://www.griffith.ox.ac.uk/discoveringTut/journals-and-diaries/season-1/mace.html and http://www.griffith.ox.ac.uk/discoveringTut/journals-and-diaries/season-2/mace.html. Family papers contribute to the biography by Christopher C. Lee, *The Grand Piano Came by Camel: Arthur C. Mace, the Neglected Egyptologist*. Edinburgh: Mainstream Publishing, 1992.

7 Journal entry for 26 November 1922 (see n. 3).

8 Undated manuscript in the archives of the Metropolitan Museum of Art, Department of Egyptian Art, quoted in full in James, *Howard Carter*, pp. 478–9 (Appendix III).

9 For these photographs, see Christina Riggs, *Photographing Tutankhamun: Archaeology, Ancient Egypt, and the Archive*. London: Bloomsbury, 2019, pp. 73–80.

10 Catalogue number 14. Quoted passage is from journal entry for 26 November 1922 (see n. 3). In the diary of Minnie Burton, wife of photographer Harry Burton, the entry for Sunday, 17 December 1922, notes that they went to Carter's house and saw the 'King's Cup': http://www.griffith.ox.ac.uk/minnieburton-project/1922.html.

11 Journal entry for 27 November 1922 (see n. 3).

12 Catalogue numbers 22, 29.

13 Catalogue number 207.

14 Catalogue numbers 261, 261a.

15 Catalogue numbers 266a–g.

16 Catalogue numbers 182–192.

17 Known as caches, these multiple re-burials were found in Deir el-Bahri tomb 320 (cleared in 1881) and the tomb of Amenhotep II, KV35 in the Valley of the Kings (cleared in 1898). See John H. Taylor, 'Intrusive burials and caches', in Richard H. Wilkinson and Kent R. Weeks (eds), *The Oxford Handbook of the Valley of the Kings*. Oxford: Oxford University Press, 2016, pp. 361–71.

18 Journal entry for 29 November 1922 (see n. 3).

19 Journal entry for 30 November 1922 (see n. 3).

20 Journal entries for 8 and 11 December 1922 (see n. 10); she and

Harry had already talked about the tomb with Lord Carnarvon on 5 December.

21 For Burton's early life and work, see Riggs, *Photographing Tutankhamun*, pp. 77–9.

22 Riggs, *Photographing Tutankhamun*, pp. 19–20, 178–82; James, *Howard Carter*, pp. 277–80, 480–5.

23 'Interior of Tutankhamun's tomb: First photographs', *The Times*, 30 January 1923, p. 14.

24 Undated memorandum, catalogued as 'notes on the robberies', by Carter, Lucas, and Lord Carnarvon, transcription at http://www.griffith.ox.ac.uk/gri/4robbery.html.

25 Catalogue number 44b.

26 Catalogue number 435.

27 See Kees van der Spek, *The Modern Neighbors of Tutankhamun: History, Life, and Work in the Villages of the Theban West Bank*. Cairo: American University in Cairo Press, 2011, p. 222 (with n. 6).

28 Riggs, *Photographing Tutankhamun*, pp. 141–71.

29 Riggs, *Photographing Tutankhamun*, pp. 118–25.

30 Front page of its Saturday edition on 10 February 1923.

31 See Elliott Colla, *Conflicted Antiquities: Egyptology, Egyptomania, Egyptian Modernity*. Durham, NC and London: Duke University Press, 2007, p. 192 (with n. 32).

32 Manuscript dated 3 March 1923, parts of which were incorporated into Carter and Mace, *Tut.Ankh.Amen*: http://www.griffith.ox.ac.uk/discoveringTut/alt-accounts/4maceope.html.

33 Letter from Alan Gardiner to his mother, 17 February 1923, partial transcription at http://www.griffith.ox.ac.uk/discoveringTut/alt-accounts/4garope.html.

34 Leonard Cottrell, *The Lost Pharaohs: The Romance of Egyptian Archaeology*. London: Pan Books 1956 [1950], p. 162.

35 Allegra Fryxell, '*Tutankhamen*, Egyptomania, and temporal enchantment in interwar Britain', *Twentieth-Century British History* 28.4 (2017), pp. 516–42; Christopher Frayling, *The Face of Tutankhamun*. London: Faber and Faber, 1992.

36 For instance, 'Borne like a war casualty from the tomb', was the subtitle of an article in the *Manchester Guardian*, 30 November 1923, p. 9; see Riggs, *Photographing Tutankhamun*, p. 183 (with n. 18).

37 'The suggested pharaoh of the Exodus causes an influx into Egypt: Tutankhamen attracts tourists', *Illustrated London News*, 10 February 1923, pp. 196–7.

38 Colla, *Conflicted Antiquities*, pp. 216–22 for Shawqi (quoted passage at p. 216), and pp. 241–60 for Mahfouz.

39 Alexandra Dika Seggerman, 'Mahmoud Mukhtar: "The first sculptor from the land of sculpture"', *World Art* 4.1 (2014), pp. 27–46; Alex Dika Seggerman, *Modernism on the Nile: Art in Egypt between the Islamic and the Modern*. Chapel Hill: University of North Carolina Press, 2019, esp. pp. 68–100.

40 Riggs, *Photographing Tutankhamun*, pp. 187–8.

41 Journal entry for 5 April 1923 (see n. 3).

42 Diary entry for 31 March 1923 (see n. 3).

43 See Riggs, *Photographing Tutankhamun*, pp. 161–3 for photographic and written accounts of the transport.

44 '"Spellbound": The third great thrill at Tutankhamen's tomb', *Illustrated London News*, 26 January 1924, p. 144.

45 Riggs, *Photographing Tutankhamun*, pp. 26–32; Donald Malcolm Reid, *Contesting Antiquity in Egypt: Archaeologists, Museums, and the Struggle for Identities from World War I to Nasser*. Cairo: American University in Cairo Press, 2015, pp. 51–79; Colla, *Conflicted Antiquities*, pp. 172–226.

46 Anon. ['Our special correspondent'], 'At the tomb of Tut: The government's hospitality', *The Egyptian Gazette*, Saturday, 8 March 1924, p. 3.

47 Howard Carter and Nicholas Reeves, *Tut.Ankh.Amen: The Politics of Discovery*, London: Libri, 1998, pp. 122–3.

48 Carter and Reeves, *Politics of Discovery*, pp. 145–9.

49 Colla, *Conflicted Antiquities*, p. 206.

50 Published as Carter and Reeves, *The Politics of Discovery*.

51 James, *Howard Carter*, p. 390, although the men may have patched things up: Minnie Burton mentions Arthur Callender spending two nights at Metropolitan House, 15–17 April 1926. See entries at http://www.griffith.ox.ac.uk/minnieburton-project/1926.html.

52 Journal entries for 28 and 29 October 1925: http://www.griffith.ox. ac.uk/discoveringTut/journals-and-diaries/season-4/journal.html.

53 Catalogue numbers 276, 277.

54 Catalogue number 261.

55 Catalogue number 264.

56 Catalogue number 265.

57 Catalogue number 266.

58 Catalogue number 267.

59 James, *Howard Carter*, pp. 403–4.

60 Letter from Burton to Winlock, 20 January 1933 (Metropolitan
 Museum of Art, Department of Egyptian Art archives, Harry
 Burton file 1930–35).

3 *Caring for the King*

1 Letter from Minnie Burton to Ambrose Lansing, 16 January 1941
 (Metropolitan Museum of Art, Department of Egyptian Art
 archives, Harry Burton file 1936–42).
2 *Illustrated London News*, 17 April 1935, colour supplement, p. xiii.
3 For their American trip, see the entries between 6 June and
 13 August 1924, in Minnie Burton's diary, now in the Griffith
 Institute, Oxford University: http://www.griffith.ox.ac.uk/
 minnieburton-project/1924.html.
4 Letter from Burton to Winlock, 12 August 1937 (Metropolitan
 Museum of Art, Department of Egyptian Art archives, Harry
 Burton file 1936–42).
5 Letter from Burton to Winlock, 15 April 1935 (Metropolitan
 Museum of Art, Department of Egyptian Art archives, Harry
 Burton file 1930–35).
6 Letter from Burton to Winlock, 18 September 1934
 (Metropolitan Museum of Art, Department of Egyptian Art
 archives, Harry Burton file 1930–35).
7 Carter, *Tomb of Tut.Ankh.Amen*, vol. II (1927) and vol. III (1933).
8 Letter from Burton to Winlock, 27 March 1934 (Metropolitan
 Museum of Art, Department of Egyptian Art archives, Harry
 Burton file 1930–35).
9 Adel Sabit, *A King Betrayed: The Ill-Fated Reign of Farouk of Egypt*.
 London and NY: Quartet Books, 1989, p. 99; recounted in Reeves
 and Taylor, *Howard Carter*, pp. 180–1.
10 Letter from Burton to Winlock, 17 November 1936
 (Metropolitan Museum of Art, Department of Egyptian Art
 archives, Harry Burton file 1936–42); see also James, *Howard
 Carter*, pp. 444–5.
11 In November 2017, the flat (enlarged to create a duplex) was listed
 for sale at nearly £10 million: https://www.mansionglobal.com/
 articles/10-million-duplex-with-ties-to-famed-archaeologist-
 lists-in-london-81906. See also https://www.countrylife.co.uk/
 property/albert-court-an-immaculate-apartment-in-one-of-
 londons-first-purpose-built-block-of-mansion-flats-172541.
12 James, *Howard Carter*, p. 457.

13 'Mr. Howard Carter', *The Times*, 3 March 1939, p. 16.

14 Catalogue numbers 50gg, 175. 'Tutankhamun's trumpets', *Radio Times* 63, no. 811 (14 April 1939), p. 21 (regional London listing for 16 April). For Rex Keating's involvement, and a copy of the recording, see http://rex.keating.pagesperso-orange.fr/. On the copper alloy trumpet, which was displayed at the British Museum in 1972, see Jeremy Montagu, 'One of Tutankhamun's trumpets', *Journal of Egyptian Archaeology* 64 (1978), pp. 133–4.

15 Letter from Abd-El-Aal Ahmed Said and Hossein Ibrahim Said to Phyllis Walker, 19 March 1939; quoted in James, *Howard Carter*, p. 469 and Reeves and Taylor, *Howard Carter*, p. 181.

16 James, *Howard Carter*, p. 470.

17 See Marc Gabolde, *Toutankhamon: Akhenaton, La Vallée des Rois, Howard Carter*. Paris: Pygmalion, 2015, pp. 530–1 and James, *Howard Carter*, pp. 469–71, the latter drawing on Percy Newberry's correspondence in the Griffith Institute, Oxford University. The objects in question were registered in the Egyptian Museum's *Journal d'Entrée* with numbers 87848 to 87857 (87850 comprises 9 pieces, a to i). They include faience *shabti* figures, a miniature faience vase with the cartouche of Tutankhamun, and a bronze nail from the second coffin.

18 Gabolde, *Toutankhamon*, pp. 495–531 (Annexe II, objects not in Egypt that perhaps come from the tomb of Tutankhamun). In his biography of Carter (pp. 447–8), T. G. H. James suggests that some of the objects in Carter's possession may have been things he had withdrawn from Lord Carnarvon's collection, to save the family from embarrassment when the aristocrat's Egyptian antiquities were sold.

19 Luc Delvaux, 'Toutankhamon et Akhénaten au Musée du Cinquantenaire', in Simon Connor and Dimitri Laboury (eds), *Toutankhamon: À la recherche du pharaon oublié*. Lièges: Presses Universitaires, 2019, pp. 322–25.

20 See Gabolde, *Toutankhamon*, pp. 511–20.

21 Further details in Marc Gabolde, 'An Egyptian gold necklace for sale: Comparisons with Tutankhamun's jewellery', *HAL Archives Ouvertes* 2019 (pre-print) (https://halshs.archives-ouvertes.fr/halshs-02117225).

22 James, *Howard Carter*, p. 470.

23 Wilkinson and colleague Walter Hauser sold some of the Metropolitan House contents as well. I. E. S. Edwards recounts

acquiring from them a set of the Egyptian Museum in Cairo's *Catalogue Général* for his department at the British Museum, in I. E. S. Edwards, *From the Pyramids to Tutankhamun: Memoirs of an Egyptologist*. Oxford: Oxbow Books, 2000, p. 176.

24 Letter from Minnie Burton to Lansing, 16 January 1941 (Metropolitan Museum of Art, Department of Egyptian Art archives, Harry Burton file 1936–42): '[Phyllis] says that all his furniture, rugs, pictures which she had stored in London, had been destroyed in two fires. She was thankful that the best Egyptian pieces had been sold in America. The other things are at Spinks and were all right when she wrote'.

25 Letters from both Burton and R. H. H. Cust, sent in 1914 to their mutual friend E. J. Dent (then a Fellow of King's College, later Professor of Music, Cambridge University) give an outline of their falling out and the agreed outcome: E. J. Dent Correspondence, Cambridge University Libraries, B/163, B/164, C/75, C/76.

26 'Mr. R. H. H. Cust', *The Times*, 26 July 1940, p. 7, quoted verbatim in a letter from Minnie Burton to Caroline (Mrs Ambrose) Lansing, 9 September 1940 (Metropolitan Museum of Art, Department of Egyptian Art archives, Harry Burton file 1936–42).

27 'Egypt hides treasures of King Tut-ankh-Amen', *New York Times*, 1 September 1939, p. 2.

28 *The Egyptian Museum, Cairo: A Brief Description of the Principal Monuments*. Cairo: Imprimerie de l'Institut Français d'Archéologie Orientale, 1938, p. 145. This text does not appear in the next *Brief Description* the museum produced, published in 1946.

29 Catalogue number 91.

30 Catalogue numbers 255, 256a.

31 Catalogue number 620.112.

32 Catalogue number 8.

33 Probably parts of catalogue numbers 120, 122.

34 Catalogue number 209.

35 Catalogue number 263, perhaps.

36 Reid, *Contesting Antiquity*, pp. 29–33; Reid, *Whose Pharaohs?*, pp. 186–90, 201–4.

37 Reid, *Contesting Antiquity*, pp. 110–14.

38 I am grateful to Fatma Keshk for making me aware of Selim Hassan's visit and newspaper article (in Arabic).

39 Reid, *Contesting Antiquity*, pp. 266–7, 278–91.

40 Pierre Montet, *La Nécropole royale de Tanis*, 3 vols. Paris, 1947–51.

41 Penelope Lively, *Oleander, Jacaranda: A Childhood Perceived*.
 London: Harper, 1995, pp. 67–9.

42 Reid, *Contesting Antiquity*, p. 334; Bierbrier (ed.), *Who was Who*,
 p. 321.

43 I thank Katja Broschat for this information (personal
 communication via email), 11 July 2020.

44 Leibovitch was secretary of the Bar-Kochba Zionist Society,
 established in Egypt in 1897: Jacob M. Landau, *Jews in Nineteenth
 Century Egypt*. London and New York: Routledge, 2016 [1969],
 pp. 116–17.

45 Diary entries for 24 January (taking snapshots) and 30 January
 (filing prints), 1923: http://www.griffith.ox.ac.uk/minnieburton-
 project/1923.html.

46 Iorwerth Cyfeiliog Peate, 'Sir Cyril Fred Fox (1882–1967),
 Director of the National Museum of Wales, 1936–48', *Dictionary
 of Welsh Biography*, 2001 (https://biography.wales/article/s2-
 FOX0-FRE-1882); Sir Mortimer Wheeler, 'Homage to Sir
 Cyril Fox', in I. Ll. Foster and Leslie Alcock (eds), *Culture and
 Environment: Essays in Honour of Sir Cyril Fox*. London: Routledge
 and Kegan Paul, 1963, pp. 1–6.

47 'Holiday drowning accidents. Several lives lost', *The Times*,
 20 August 1932, p. 12; death notice in *The Times*, 23 August 1932,
 p. 1 (with *in memoriam* notices for Rudolph Valentino alongside).

48 Aileen Fox, *Aileen, A Pioneering Archaeologist: The Autobiography of
 Aileen Fox*. Leominster: Gracewing, 2000, pp. 69–74.

49 Fox, *Aileen*, pp. 94, 103.

50 Ashmolean Museum, *Report of the Visitors, 1948*. Oxford: Oxford
 University Press by Charles Batey, p. 58.

51 R. S. Simpson, 'Griffith, Francis Llewellyn (1862–1934)',
 Dictionary of National Biography. Oxford: Oxford University Press,
 2008 [2004] (https://doi.org/10.1093/ref:odnb/33579).

52 See Riggs, *Photographing Tutankhamun*, pp. 50–4 for the history of
 Phyllis Walker's loan and the physical transfer of the material.

53 Harden to Charles Scott's Road Service, 25 April 1946 (Griffith
 Institute, Oxford University, file Carter Deposit 1945–6).

54 Jean Capart (with Marcelle Werbrouck), *Tout-ankh-Amon*.
 Brussels: Vromant, 1943 [1st ed. 1923].

55 For the Scott and Fox exchanges, see Riggs, *Photographing
 Tutankhamun*, pp. 62–9.

56 Penelope Fox, *Tutankhamun's Treasure*. Oxford: Oxford University

Press, 1951; quoted phrases are from a review by Winifred Needler, *The Phoenix* 7.2 (1953), pp. 80–2: 'Penelope Fox was in an excellent position to show that the world could still be dazzled by the discovery.'

57 Riggs, *Photographing Tutankhamun*, p. 40 (relevant documents: Griffith Institute Archives, file NYMMA Acquisitions MMA photogr. Tut Corres. 1952–).

58 Fox to Scott, 15 March 1952 (Griffith Institute Archives, file NYMMA Acquisitions MMA photogr. Tut Corres. 1952–).

59 For the fire, its context, and its impact, see Nancy Y. Reynolds, *A City Consumed: Urban Commerce, the Cairo Fire, and the Politics of Decolonization in Egypt*. Stanford: Stanford University Press, 2012; Yasser Elsheshtawy, 'Urban transformations: The Great Cairo Fire and the founding of a modern capital, 1952–1970', *Built Environment* 40.3 (2014), pp. 408–25.

60 Penelope Eames, *Furniture in England, France and the Netherlands from the Twelfth to the Fifteenth Century*. Furniture History: The Journal of the Furniture History Society. Leeds: W. S. Maney, 1977. Florian Congreve Eames became an architect of some renown.

4 Rescue and Reward

1 Zeina Elsheikh, 'Tales from two villages: Nubian women and cultural tourism in Gharb Soheil and Ballana', *Dotawo* 5 (2018), pp. 241–60.

2 Christiane Desroches Noblecourt, *Sous le regard des dieux*. Paris: Albin Michel, 2016 [2003], p. 24

3 Christiane Desroches Noblecourt, *La grande Nubiade: Le parcours d'une égyptologue*. Paris: Stock/Pernoud, 1992, p. 12. For accounts of her life, see also Bierbrier, *Who was Who*, pp. 151–2; Guillemette Andreu-Lanoë, 'Christiane Desroches Noblecourt (1913–2011)', *Bulletin de l'Institut Français d'Archéologie Orientale* 111 (2011), pp. 1–12, and obituaries in *Le Figaro* and *Le Monde*, dated 24 June 2011.

4 Noblecourt, *Sous le regard*, p. 29.

5 Noblecourt, *La grande Nubiade*, p. 40, and *Sous le regard*, pp. 56–60.

6 Noblecourt, *Sous le regard*, p. 62.

7 Noblecourt, *La grande Nubiade*, p. 97.

8 Noblecourt, *Sous le regard*, p. 152: 'They were very nice gloves indeed, and they probably saved my life.'

9 Noblecourt, *Sous le regard*, pp. 152–5, gives a much fuller account
 of this event than the brief mention in her autobiography,
 La grande Nubiade, p. 90.

10 Henri Lavachery and André Noblecourt, *Les techniques de
 protection des biens culturels en cas de conflit armé*. Paris: UNESCO,
 1954. I thank William Carruthers for bringing André
 Noblecourt's work to my attention.

11 For the history of the CEDAE, see William Carruthers, *Flooded
 Pasts: UNESCO, Nubia, and the Recolonization of Archaeology*.
 Ithaca, NY: Cornell University Press, forthcoming, esp. Chapter 2
 ('Archiving the past, archiving the future'). I am indebted to Will
 for sharing his work in progress with me.

12 The colonial slant of the CEDAE and its 'archival impulse' are
 discussed in William Carruthers, 'Records of dispossession:
 Archival thinking and UNESCO's Nubian campaign in Egypt
 and Sudan', *International Journal of Islamic Architecture* 9.2 (2020),
 pp. 287–314.

13 Lynn Meskell, *A Future in Ruins: UNESCO, World Heritage,
 and the Dream of Peace*. Oxford: Oxford University Press, 2018,
 pp. 1–27. For the CEDAE's involvement, see Torgny Säve-
 Söderbergh, *Temples and Tombs of Ancient Nubia: The International
 Rescue Campaign at Abu Simbel, Philae and Other Sites*. London:
 Thames and Hudson, 1987, pp. 65–7.

14 Noblecourt, *La grande Nubiade*, p. 125, and see discussion in
 Carruthers, 'Records of dispossession'.

15 David Gange, 'Unholy water: Archaeology, the Bible, and the
 First Aswan Dam', in Astrid Swenson and Peter Mandler (eds),
 *From Plunder to Preservation: Britain and the Heritage of Empire,
 1800–1950*. Oxford: Oxford University Press for the British
 Academy, 2013, pp. 96–114; Jennifer L. Derr, 'Drafting a map of
 colonial Egypt: The 1902 Aswan Dam, historical imagination, and
 the production of agricultural geography,' in Diana K. Davis and
 Edmund Burke III (eds), *Environmental Imaginaries of the Middle
 East and North Africa*. Athens, Ohio: Ohio University Press, 2011,
 136–57; Terje Tvedt, *The River Nile in the Age of the British: Political
 Ecology and the Quest for Economic Power*. London and New York:
 I.B. Tauris, 2004; Robert O. Collins, 'In search of the Nile waters,
 1900–2000', in Haggai Erlich and Israel Gershoni (eds), *The Nile:
 Histories, Cultures, Myths*. Boulder: Lynne Rienner, 2000,
 pp. 245–68.

16 Ragaei El Mallakh, 'Some economic aspects of the Aswan High
 Dam project in Egypt', *Land Economics* 35.1 (1959), pp. 15–23;
 Richard Elliot Benedick, 'The High Dam and the transformation
 of the Nile', *Middle East Journal* 33.2 (1979), pp. 119–44;
 Collins, 'In search of the Nile waters', pp. 255–6; Ahmad Shokr,
 'Hydropolitics, economy, and the Aswan High Dam in mid-
 century Egypt', *The Arab Studies Journal* 17.1 (2009), pp. 9–31.

17 See papers included in Nicholas S. Hopkins and Sohair R.
 Mehanna (eds), *Nubian Encounters: The Story of the Nubian
 Ethnological Survey 1961–1964*. Cairo and New York: American
 University in Cairo Press, 2011.

18 Michael M. Laskier, 'Egyptian Jewry under the Nasser regime,
 1956–70', *Middle Eastern Studies* 31.3 (1994), 573–619.

19 Noblecourt, *La grande Nubiade*, p. 164.

20 Säve-Söderbergh, *Temples and Tombs of Ancient Nubia*, p. 53.

21 Joan Acocella, 'Prophet motive: The Kahlil Gibran phenomenon',
 The New Yorker, 7 January 2008 (https://www.newyorker.com/
 magazine/2008/01/07/prophet-motive).

22 Kahlil Gibran, *Al-nabī*, transl. Tharwat Okasha. Cairo: Dār
 al-Maʿārif, 197[2]; Kahlil Gibran, *ʿĪsá*, transl. Tharwat Okasha.
 Cairo: Dār al-Maʿārif, 1962.

23 Tahia Gamal Abdel, *Nasser: My Husband*, transl. Shereen Mosaad.
 Cairo and New York: American University in Cairo Press, 2013,
 p. 53 (and for their earlier acquaintance with the Okashas, see
 pp. 15, 33–4).

24 Saroite Okacha [Tharwat Okasha], *Ramsès Re-couronné: Hommage
 vivant au Pharaon mort*. Cairo: Daar al-Maaref, 1974, p. 3. Okasha
 donated proceeds from his book to the UNESCO campaign for
 safeguarding Venice.

25 Noblecourt, *La grande Nubiade*, pp. 182–4.

26 Rudolf Anthes, 'Über das Ägyptisches Museum zu Berlin
 während der Jahre 1939/1950', *Zeitschrift der Deutschen
 Morgenländischen Gesellschaft* 102 (1952), pp. 1–7. For Anthes'
 life, see Bierbrier, *Who was Who*, pp. 22–3; David O'Connor, 'In
 memoria', *Expedition Magazine* 27.1 (1985), pp. 34–6.

27 Froelich Rainey, *Reflections of a Digger: Fifty Years of World
 Archaeology*. Philadelphia: University of Pennsylvania Museum
 of Archaeology and Anthropology, 1992, pp. 159–65; Alessandro
 Pezzati, 'Tutankhamun Treasures: The first Tut show came to the
 Museum', *Expedition Magazine* 48.3 (2006), pp. 6–7; and on the

University of Pennsylvania's excavations in Egypt, see William Carruthers, 'Visualizing a monumental past: Archaeology, Nasser's Egypt, and the early Cold War', *History of Science* 55.3 (2017), pp. 273–301.

28 Paul Betts, 'The warden of world heritage: UNESCO and the rescue of the Nubian monuments', *Past & Present* 226, Suppl.10 (2015), pp. 100–25; Lucia Allais, 'Integrities: The salvage of Abu Simbel', *Grey Room*, vol. 50, 2013, pp. 6–45, at p. 22.

29 *5,000 Years of Egyptian Art*. London: Royal Academy of Arts, 1962.

30 News coverage explicitly linked the exhibition to the Abu Simbel rescue, e.g. Marjorie Hunter, 'Tut-ankh-Amen treasure shown', *New York Times*, 4 November 1961, p. 21. For news photos and film reel coverage of the opening, see the holdings of the John F. Kennedy Library, https://www.jfklibrary.org/asset-viewer/ archives/JFKWHP/1961/Month%2011/Day%2003/JFKWHP-1961-11-03-C and https://www.jfklibrary.org/asset-viewer/ archives/USG/USG-01-11/USG-01-11.

31 Rudolf Anthes, *Tutankhamun Treasures: A Loan Exhibition from the Department of Antiquities of the United Arab Republic*. Washington DC: American Association of Museums and Smithsonian Institution, 1961.

32 Rainey, *Reflections*, pp. 164–5.

33 'Art from Tutankhamen's tomb displayed in benefit on 46th St.', *New York Times*, 19 December 1963, p. 49. For Egypt's pavilion at the World's Fair, see Julie Nicoletta, 'Art out of place: International art exhibits at the New York World's Fair of 1964–1965', *Journal of Social History* 44.2 (2010), pp. 499–519 (esp. at pp. 504–6, 513).

34 'Tutankhamun Treasures Exhibit' file, Oriental Institute archives, University of Chicago.

35 The Oriental Institute Museum – not the host, but a partner with the Chicago Natural History Museum – received $6,117.19 as its share, a 50:50 split. Oriental Institute archives, University of Chicago, 'Tutankhamun Treasures Exhibit' file; Chicago Natural History Museum, *Annual Report*, 1962.

36 Kevin O'Connor, 'Photographer & sculptor Frederick Leslie Kenett 1924–2012', *London Photographic Association* blogpost, 14 October 2012 (http://londonphotographicassociation.blogspot. com/2012/10/photographer-sculptor-frederick-leslie.html).

37 *The London Gazette* no. 40832, 17 July 1956, p. 4146.

38 Noblecourt, *La grande Nubiade*, pp. 17–22.

39 Alexandre Piankoff, *The Shrines of Tut-Ankh-Amun*, 2 vols. New York, 1954; Bollingen Series no. 40. French edition: *Les chapelles de Tout-Ankh-Amon*. Cairo: Imprimerie de l'Institut Français d'Archéologie Orientale, 1951–2.

40 Christiane Desroches Noblecourt, *Tutankhamen: Life and Death of a Pharaoh*. London: Rainbird, 1963 and several subsequent editions.

41 Noblecourt, *La grande Nubiade*, pp. 19–20

42 John Lewis Burckhardt, *Travels in Nubia*. London: John Murray, 1819, pp. 88–93 ('Ebsambal').

43 On the Abu Simbel rescue, see Säve-Söderbergh, *Temples and Tombs of Ancient Nubia*, pp. 98–126. *The UNESCO Courier* devoted an issue to the project, entitled 'Victory in Nubia', in December 1964 (https://unesdoc.unesco.org/ark:/48223/pf0000062384). More recent accounts include Fekri Hassan, 'The Aswan High Dam and the International Rescue Nubia Campaign', *African Archaeological Review* 24 (2007), pp. 73–94; Meskell, *Future in Ruins*, pp. 28–58; Nigel Fletcher-Jones, *Abu Simbel and the Nubian Temples*. Cairo: American University in Cairo Press, 2019; and a 'coffee table' book, *Nubiana: The Great Undertaking that Saved the Temples of Abu Simbel*. Milan: Mondadori, 2019, drawing on the archives of engineering firm Salini Impregilo.

44 Allais, 'Integrities'; see also Lucia Allais, *Designs of Destruction: The Making of Monuments in the Twentieth Century*. Chicago: University of Chicago Press, 2018, pp. 219–54.

45 *Nubiana*, pp. 242–55 ('Marble heroes' and 'My days at Abu Simbel', by Luciano Paoli).

46 Hans Stock and Karl Georg Siegler, 'Moving a temple as big as a cathedral', *The UNESCO Courier* (1964), pp. 38–9.

47 Allais, 'Integrities', which I have drawn on for other details of the work here, too.

48 Hassan Dafalla, *The Nubian Exodus*. London: C. Hurst, 1975, pp. 262–7.

49 Robert Fernea, 'The ethnological survey of Egyptian Nubia', *Current Anthropology* 4.1 (1963), pp. 122–3; Hussein M. Fahim, 'Egyptian Nubia after resettlement', *Current Anthropology* 14.4 (1973), pp. 483–5; Hussein M. Fahim, *Egyptian Nubians: Resettlement and Years of Coping*. Salt Lake City: University of Utah Press, 1983; Hopkins and Mehanna (eds), *Nubian Encounters*. A rich new seam of scholarship on the impact of

the Nubian displacements has opened in recent years, including among descendants of the displaced, e.g. Menna Agha, 'Nubia still exists: On the utility of the nostalgic space', *Humanities* 8.24 (2019), doi:10.3390/h8010024.

50 'Nubia heritage saved from the waters', *The Times*, 15 February 1967, p. 5.

51 Maja Janmyr, 'Nubians in contemporary Egypt: Mobilizing return to ancestral lands', *Middle East Critique* 25.2 (2016), pp. 127–45.

52 Maheu speech quoted in *Nubiana*, pp. 236, 206.

53 Okacha, *Ramsès Re-couronné*, p. 130, photograph opposite p. 152; see also Säve-Söderbergh, *Temples and Tombs of Ancient Nubia*, pp. 122–3.

54 Säve-Söderbergh, *Temples and Tombs of Ancient Nubia*, pp. 142–4.

55 Christiane Desroches Noblecourt (ed.), *Toutankhamon et son temps*. Paris, 1967.

56 Catalogue numbers 48a–d, 50uu, 100a.

57 Catalogue number 48d. 'A Charlie Chaplin of Tutankhamen's day: Sticks and a standard', *Illustrated London News*, 29 September 1923, p. 561 (illustrating Carter no. 48d, Griffith Institute Burton negative P0337).

58 Catalogue numbers 48d or 50uu.

59 Catalogue number 29.

60 Catalogue number 73.

61 Catalogue number 108.

62 Catalogue number 275c.

63 Noblecourt, *La grande Nubiade*, pp. 21–25 recounts the exhibition planning and object restoration.

64 On Plenderleith, see Andrew Oddy, 'Harold Plenderleith and *The Conservation of Antiquities and Works of Art*', *Intervención* 2.4 (2011), pp. 56–62.

65 Noblecourt, *La grande Nubiade*, pp. 25–27.

66 For images and links, see Marie Grillot, 'Exposition "Toutankhamon et son temps"', *Egyptophile* blog, 15 February 2016 (https://egyptophile.blogspot.com/2016/02/exposition-toutankhamon-et-son-temps.html).

67 Noblecourt, *La grande Nubiade*, pp. 28–31.

68 British Museum, AES Ar. 797, vol. 2, 448: Letter from Säve-Söderbergh to Edwards, 7 November 1972.

69 Noblecourt, *La grande Nubiade*, p. 32.

5 *The Dance of Diplomacy*

1 Mentioned in the agreement the two countries eventually signed
 for a Tutankhamun exhibition: The National Archives (UK), FCO
 39/997 (Tutankhamun Exhibition London, 1972).

2 British Museum, AES Ar.797, vol. 2, 593; the Ministry of Defence
 transported the lighting equipment.

3 British Museum, AES Ar.797, vol. 1, 1–15 ('Preface', by I. E. S.
 Edwards); I. E. S. Edwards, *From the Pyramids to Tutankhamun:
 Memoirs of an Egyptologist.* Oxford: Oxbow, 2000, esp. pp. 247–62.

4 Edwards, *From the Pyramids to Tutankhamun*, pp. 8–12 (early life,
 education), 29–32 (hired at the British Museum); see also
 Bierbrier, *Who was Who*, pp. 173–4, and H. S. Smith, 'Edwards,
 (Iorwerth) Eiddon Stephen (1909–1996)', *Oxford Dictionary of
 National Biography*, 2004 (https://doi.org/10.1093/ref:odnb/
 70768).

5 British Museum, AES Ar.797, vol. 1, 61: Letter from Magdi
 Wahba to I. E. S. Edwards, 1 April 1967.

6 British Museum, AES Ar.797, vol. 1, 60: Letter from I. E. S.
 Edwards to H. F. Rossetti, Deputy Under-Secretary of State in the
 Department of Education and Science, 2 December 1966.

7 British Museum, AES Ar.797, vol. 1, 62: Letter from
 I. E. S. Edwards to Magdi Wahba, 11 April 1967.

8 John Beavan, 'Hamilton, Sir (Charles) Denis (1918–1988),
 newspaper editor.' *Oxford Dictionary of National Biography*, 2004
 (https://doi.org/10.1093/ref:odnb/40157).

9 The story is recounted in Edwards, *From the Pyramids to
 Tutankhamun*, p. 253 and in Edwards' 'Preface' to his departmental
 files, AES Ar.797, vol. 1, 7–8.

10 'Philip Taverner: Marketing director who pioneered "blockbuster
 exhibitions" with the 1972 Tutankhamun show in London'
 The Times, 4 March 2016, p. 59.

11 The National Archives (UK), FCO 39/1238, cited in Juliette
 Desplat, 'A trickle of pharaonic valuables', The National Archives
 blog, 5 February 2016 (https://blog.nationalarchives.gov.uk/
 trickle-pharaonic-valuables/).

12 The National Archives (UK), FCO 39/998 (Tutankhamun
 Exhibition London, 1972); see also Desplat, 'A trickle of pharaonic
 valuables'.

13 British Museum, AES Ar.797, vol. 1, 12 (Edwards, 'Preface').

14 British Museum, AES Ar.797, vol. 1, 87; memorandum by

Edwards on object selection. Exhibition catalogue for Japan: *Tut-ankhamun Treasures* [in Japanese]. Tokyo: Asahi Shimbun, 1965.

15 Catalogue number 73.

16 Catalogue number 14.

17 Catalogue numbers 266g, 266c–f.

18 Catalogue number 256a.

19 British Museum, AES Ar.797, vol. 1, 87: memorandum by Edwards on object selection.

20 Catalogue number 108.

21 Catalogue number 275c.

22 British Museum, AES Ar.797, vol. 1, 270: report by Lord Trevelyan on his visit to Egypt, date 24 March 1970.

23 Noblecourt, *La grande Nubiade*, pp. 33–4.

24 British Museum, AES Ar.797, vol. 2, 552–5: Plenderleith's report on the proposed exhibition in London, 13 January 1970; and 559–60, letter from Plenderleith to Edwards, 20 August 1971.

25 The National Archives (UK), FCO 39/997 (Tutankhamun Exhibition London, 1972), Annex A to treaty agreement signed 28 July 1971; see also British Museum, AES Ar.797, vol. 1, 216–18 (typescript of same).

26 British Museum, AES vol. 2, 497–503: Letter from James to Edwards, 14 November 1971.

27 Bierbrier, *Who was Who*, p. 502.

28 Catalogue number 289b.

29 British Museum, AES vol. 2, 503–6: Letter from James to Edwards, 15 November 1971.

30 Catalogue number 256dd.

31 Catalogue number 14.

32 Catalogue number 331a.

33 Catalogue number 266g.

34 British Museum, AES vol. 2, 512–14: Letter from James to Edwards, 25 November 1971.

35 Quoted in Desplat, 'A trickle of pharaonic valuables'.

36 British Museum, AES vol. 2, 592–3: Letter from Goulding to Edwards, 7 September 1971.

37 The National Archives (UK), FCO 39/998 (Tutankhamun Exhibition London, 1972); British Museum, AES vol. 2, 578: Unclassified telegram from Malcolm Holding in the FCO to Goulding at the British Embassy in Cairo, 25 October 1971.

38 Edwards, *From the Pyramids to Tutankhamun*, pp. 287–8 (but the

29 January 1972 date he gives for the arrival of the mask cannot be correct).

39 British Museum, AES Ar. 797, vol. 2, 707–10: Wingate & Johnston Limited confidential notes on transport, 20 January 1972.

40 British Museum, AES Ar. 797, vol. 3, 875: Notes of a meeting of the Main Working Party, 14 January 1972.

41 British Museum, AES Ar. 797, vol. 4, 1274: Press and TV visit to British Museum, 28 January 1972. See e.g. Peter Hopkirk, 'Tutankhamun secret air cargo', *The Times*, 29 January 1972, front page. Several newspapers and the major television news programmes carried the story, too.

42 Sam Heppner, 'Displaying Tutankhamun', *The Times*, 28 February 1972, p. 9; oral history interview with Margaret Hall, conducted by Claire Wintle, September 2018 and March 2019 (Collection: Interviews on World Cultures and Museum Practice).

43 British Museum, AES Ar.797, vol. 2, 403–17: Tutankhamun: Provisional budget, 12 May 1971.

44 British Museum, AES Ar.797, vol. 2, 776–7: Memorandum from Edwards for the Trustees of the British Museum, 4 September 1969.

45 British Museum, AES Ar.797, vol. 2, 400–2: Notes on a meeting held at the British Museum, 19 November 1969; see also The National Archives (UK), FCO 39/570, cited in Desplat, 'A trickle of pharaonic valuables' (n. 11).

46 British Museum, AES vol. 1 (EA/569/70/AMK): Letter from Edwards to Wolfenden, 29 May 1970.

47 Oral history interview with Margaret Hall, conducted by Claire Wintle (see n. 42), Track 2, 49:05.

48 Noel Streatfeild, *The Boy Pharaoh: Tutankhamen*. London: Michael Joseph, 1972.

49 Streatfeild, *The Boy Pharaoh*, p. 127.

50 British Museum, Central Archives, file 'Temporary Exhibition Records. Treasures of Tutankhamun': Letter from Michael Adeane to Trevelyan, 13 September 1971.

51 British Museum, Central Archives, file 'Temporary Exhibition Records. Treasures of Tutankhamun': Wolfenden to Adeane, 2 February 1972.

52 British Museum, AES Ar. 797, vol. 3, 988: Programme for the opening by the Queen, 22 March 1972.

53 The girl who presented the bouquet was the daughter of Mr
and Mrs Omran El-Shafei, in British Museum, AES Ar. 797, vol.
3, 989: Letter from Edwards to Mrs El-Shafei, 21 March 1972.
Copies of the Queen's speech are in British Museum, AES Ar.
797, vol. 3, 925–30: Holding to Edwards (covering note),
29 February 1972, followed by hand-corrected draft and, on
7 March, a draft with corrections incorporated.

54 British Museum, AES Ar. 797, vol. 4, 1265–71, mentioning the
Daily Telegraph, the *Guardian*, *Evening News*, *Evening Standard*
and *Observer*, plus *Birmingham Post*, *Reading Post*, *Luton Echo*,
Watford Echo, *Slough Mail* and *Bristol Daily Post*.

55 Peter Hopkirk, 'Golden mask of Tutankhamun thrills the boys
on first schoolchildren's day', *The Times*, 4 April 1972, p. 3. On
the Hull replicas, see Gabrielle Heffernan, '"Wonderful things"
in Kingston upon Hull', in Eleanor Dobson and Nichola Tonks
(eds), *Ancient Egypt in the Modern Imagination: Art, Literature, and
Culture*. London: Bloomsbury, 2020, pp. 13–28.

56 British Museum, AES Ar. 797, vol. 1 EA/8/806/72/IMS: Letter
from Edwards to Mukhtar, 2 August 1972.

57 British Museum, AES Ar. 797, vol. 1, EA/5500/72/IMS: Letter
from Edwards to Mukhtar, 31 May 1972.

58 Peter Hopkirk, 'Tutankhamun visitors not deterred by queues',
The Times, 15 April 1972, p. 4.

59 Anne Sharpley, 'Happy hours with King Tut's in-crowd', *Evening
Standard*, Tutankhamun Souvenir Edition, 2 June 1972, p. 17.

60 British Museum, AES Ar. 797, vol. 1 EA/1256/71/AMK:
Edwards to D. F. Allen (British Academy), 22 December 1971.

61 Hopkirk, 'Golden mask of Tutankhamun', *The Times*, 4 April 1972,
p. 3.

62 Christina Riggs, 'Visitor views', *Photographing Tutankhamun* blog,
18 June 2018 (https://photographing-tutankhamun.com/
2018/06/).

63 British Museum, Central Archives, file 'Temporary Exhibition
Records. Treasures of Tutankhamun': Letter from David Checketts
(Prince Charles' private secretary) to Wolfenden, 6 April 1972,
planning a visit on 14 April; Wolfenden replied the following day.

64 Penelope Fitzgerald, *The Golden Child*. London: Fourth Estate,
2014 [1977], p. 70.

65 Christopher McIntosh, 'Tutankhamun: A Lavish Tribute',
Country Life, 6 April 1972, pp. 848–9 (at p. 849).

66 Amelia Edwards, *A Thousand Miles up the Nile* (1877), p. 208 (with her sketch of the temple colonnade opposite).

67 Stereograph, 'Philae, the "pearl of Egypt", bathed by the sacred Nile', dated 1902 or 1903 (https://lccn.loc.gov/2002697272), and for the rescue of Philae, see Säve-Söderbergh, *Temples and Tombs of Ancient Nubia*, pp. 151–86.

68 Discussed in Carruthers, *Flooded Pasts*, Chapter 1 ('Irrigating Nubia').

69 Pierre Loti, *La mort de Philae*. Paris: Calmann-Lévy, 1908.

70 Säve-Söderbergh, *Temples and Tombs of Ancient Nubia*, p. 13.

71 Säve-Söderbergh, *Temples and Tombs of Ancient Nubia*, p. 166.

72 The National Archives (UK), FO 949/102, cited in Juliette Desplat, 'Antiquity versus modernity? Philae and the Aswan Dam', The National Archives blog, 8 February 2017 (https://blog.nationalarchives.gov.uk/antiquity-versus-modernity-philae-aswan-dam/).

73 British Museum, AES Ar. 797, vol. 1, 70: Letter from Edwards to K. H. Jeffery, Department of Education and Science, 16 December 1968.

74 The National Archives (UK), FCO 13/364, as expressed by Peter Hayman, Deputy Under-Secretary of State for Foreign and Commonwealth Affairs; quoted in Desplat, 'Antiquity versus modernity?' (n. 60).

75 British Museum, AES Ar. 797, vol. 2, 448: Letter from Säve-Söderbergh to Edwards, 7 November 1972.

76 British Museum, AES Ar. 797, vol. 2, 433–37: Correspondence between Hamilton and Wolfenden, November 1973; AES Ar. 797, vol. 2, 438–43: Edwards, 'Memorandum on *The Times*' claim for a Management Fee', with covering and follow-up notes, 17 January and 6 February 1974.

77 Peter Hopkirk, 'Exhibition netted £600,000', *The Times*, 3 May 1973 p. 4. When the exhibition accounts were finalized, the British Museum was able to send an additional £57,731 to the UNESCO fund. The National Archives (UK), OD 24/149, cited by Desplat, 'Antiquity versus modernity?' (n. 60).

78 The National Archives (UK), FCO 39/1238, cited in Desplat, 'A trickle of pharaonic valuables' (n. 11).

79 Ashmolean Museum, *Report of the Visitors, 1971–2*. Oxford: Oxford University Press, p. 58; see also Riggs, *Photographing Tutankhamun*, p. 221.

80 Held on 29 November 1972: British Museum, AES Ar. 797, vol. 2, pp. 464–7.

81 Peter Hopkirk, 'Honour for man who chose Tutankhamun treasures', *The Times*, 1 January 1973, p. 4.

82 The latter claim is made, without support, in Geraldine Norman, *Dynastic Rule: Mikhail Piotrovsky and the Hermitage*. London: Unicorn Publishing, 2016, Chapter 3 (unpaginated ebook).

83 Norman, *Dynastic Rule*, Chapter 2 (unpaginated ebook).

84 Antonova passed away in late 2020 from complications of Covid-19. Among her many obituaries: Rosalind P. Blakesley, *Apollo Magazine*, 14 December 2020 (online edition); Sophia Kishkovsky, *The Art Newspaper*, 1 December 2020 (online edition). For the transport of the objects and details of the Pushkin Museum run, see e-books.arts-museum.ru/ovi_books/tutankhamon/index.html and L. A. Zavorotnaya, 'The exhibition "Treasures of Tutankhamun's Tomb" at the State Museum of Fine Arts A. S. Pushkin, 1973–1974' [in Russian], available at https://pushkinmuseum.art/data/epublication/chronic/8690_file_pdf.pdf.

85 Catalogue number 29.

86 Obituary by L. I. Akimova, excerpted in English at www.orientalstudies.ru/eng/index (q.v. Personalia).

87 Andrey O. Bolshakov, 'Tutankhamun at the Hermitage' [in Russian], in *250 Stories About the Hermitage: 'Collection of Motley Chapters . . .', Book Three*. St Petersburg: The State Hermitage Publishers, 2014, pp. 135–40.

88 According to a blog post by G. Egorov, recounting his visit: 'To the exhibition of the treasures of Tutankhamun in 1974' [in Russian], posted 21 January 2018 (https://g-egorov.livejournal.com/635979.html).

89 Bolshakov, 'Tutankhamun at the Hermitage' [in Russian], p. 138.

90 Olena Romanova, 'Kyiv receives Tutankhamun: The exhibition "Treasures of Tutankhamun's Tomb" in Kyiv 6 January–14 March 1975', in V. M. Danylenko (ed.), *Ukraine in the Twentieth Century: Culture, Ideology, Politics*. Kyiv: Institute of History of Ukraine, National Academy of Science, 2018, pp. 298–318 [in Ukrainian].

6 *Land of the Twee*

1 The coffin may have been made for Horemheb, who succeeded Ay a few years after Tutankhamun's death: see Nicholas Reeves, 'The coffin of Ramesses II', in Alessia Amenta and Hélène

Guichard (eds), *Proceedings of the First Vatican Coffin Conference, 19–22 June 2013*, vol. 2. Rome: Edizioni Musei Vaticani, 2017, pp. 425–38.

2 Recounted in Hoving's memoir: Thomas Hoving, *Making the Mummies Dance: Inside the Metropolitan Museum of Art*. New York: Simon & Schuster, 1993; see also his obituaries in the *New York Times*, 10 December 2009, and the *Guardian*, 15 December 2009.

3 For Carter Brown's life and career, see Neil Harris, *Capital Culture: J. Carter Brown, The National Gallery of Art, and the Reinvention of the Museum Experience*. Chicago: University of Chicago Press, 2013.

4 Brown University Steering Committee on Slavery and Justice, *Slavery and Justice* report, 2006, esp. pp. 16–17 (https://www.brown.edu/Research/Slavery_Justice/documents/SlaveryAndJustice.pdf).

5 Giovanni Pagliarulo, 'Passions intertwined: Art and photography at I Tatti', in Carl Brandon Strehlke and Machtelt Israëls (eds), *The Bernard and Mary Berenson Collection of European Paintings at I Tatti*. Florence: Villa I Tatti and Officina Libraria, 2015, pp. 71–85.

6 For Carter Brown's education and travels, see Harris, *Capital Culture*, pp. 17–36.

7 Harris, *Capital Culture*, p. 10.

8 Ismail Fahmy, *Negotiating for Peace in the Middle East*. London: Croom Helm, 1983, pp. 50–7.

9 Bernard Gwertzman, 'Sadat's oil plea to Arabs termed result of pledge', *New York Times*, 30 January 1974, p. 3; Robert Holloway's review of Fahmy, *Negotiating for Peace*, in *Journal of Palestine Studies* 13.4 (1984), pp. 131–2.

10 For the Nixon anecdote, see Hoving, *Making the Mummies Dance*, p. 401, with more detail in Harris, *Capital Culture*, pp. 200–4. The diplomatic and political underpinning of the 1970s Tutankhamun tour in America is the focus of Melani McAlister, *Epic Encounters: Culture, Media, and US Interests in the Middle East, 1945–2000*. Berkeley: University of California Press, 2001, pp. 125–54; see also Melani McAlister, '"The common heritage of mankind: Race, nation, and masculinity in the King Tut exhibit', *Representations* 54 (1996), pp. 80–103. Harris, *Capital Culture*, pp. 189–218, explores the Tutankhamun tour from the vantage point of Carter Brown's involvement at the National Gallery of Art.

11 McAlister, *Epic Encounters*, p. 128, citing Hoving, *Making the Mummies Dance*, p. 401.

12 Meredith Hindley, 'When the boy-king was the hottest ticket in town', *Humanities* 36.5 (2015) (https://www.neh.gov/humanities/2015/septemberoctober/feature/king-tut-classic-blockbuster-museum-exhibition-began-diplom).

13 On the Seattle venue, see Eleanor Boba, 'Treasures of Tutankhamun exhibit opens at Seattle Center on July 15, 1978', *History Link*, 21 May 2018 (https://www.historylink.org/File/20564).

14 Säve-Söderbergh, *Temples and Tombs of Ancient Nubia*, pp. 168–9.

15 Hoving, *Making the Mummies Dance*, pp. 51–3, 58–63, 240–1; Harris, *Capital Culture*, pp. 198–200; Cyril Aldred, 'The Temple of Dendur', *Metropolitan Museum of Art Bulletin* 36.1 (1978).

16 Grace Glueck, 'Egyptian art glitters in capital', *New York Times*, 9 September 1976, p. 4; see also Hindley, 'When the boy-king was the hottest ticket in town' (n. 12). Brown held a follow-up press conference in October 1976, after a visit by Jehan Sadat, President Sadat's wife: Harris, *Capital Culture*, p. 202.

17 Grace Glueck, 'Are art exchanges a game of propaganda?', *New York Times*, 26 September 1976, p. 1; see also Harris, *Capital Culture*, pp. 205–7.

18 Hoving, *Making the Mummies Dance*, pp. 402–11.

19 Filmed oral history interview, 'Egyptologist Christine Lilyquist discusses her career', *The Ancient Egyptian Heritage and Archaeology Fund*, 23 January 2019 (https://youtu.be/w1U2HTzdsZo), from 24:19.

20 Hoving, *Making the Mummies Dance*, p. 404.

21 Catalogue numbers 29, 73.

22 Catalogue number 266.

23 Riggs, *Photographing Tutankhamun*, pp. 193–4.

24 Hoving, *Making the Mummies Dance*, p. 410, and podcast interview with Peter Solmssen for the Fine Arts Museums of San Francisco, 2010, when the De Young Museum hosted *Tutankhamun and the Golden Age of the Pharaohs* (https://www.famsf.org/blog/podcast-interview-peter-solmssen-about-first-king-tut-exhibition).

25 Francis X. Clines, 'About New York: Beholding the beholders of Tut', *New York Times*, 6 January 1979, p. 24.

26 Letter from Alan Gardiner to his mother, 17 February 1923, partial transcription at http://www.griffith.ox.ac.uk/discoveringTut/alt-accounts/4garope.html.

27 Henry Mitchell, 'Toasts and treasures', *Washington Post*, 16 November 1976, p. C1. On the opening night gala, see Harris,

Capital Culture, pp. 207–8.

28 John J. O'Connor, 'King Tut sits for TV portrait tonight', *New York Times*, 27 July 1977, p. 63.

29 Catalogue number 8.

30 Tom Buckley, 'The discovery of Tutankhamun's tomb' in *Treasures of Tutankhamun*. New York: Metropolitan Museum of Art, 1976, pp. 9–18 (quoted phrases at pp. 9 and 12).

31 Bierbrier, *Who was Who*, p. 390 for Muhammed's biography.

32 Wafaa El Saddik, *Protecting Pharaoh's Treasures: My Life in Egyptology*, transl. Russell Stockman. Cairo and New York: American University in Cairo Press, 2017, pp. 86–9.

33 See Challis, *Archaeology of Race*; Riggs, *Unwrapping Ancient Egypt*, pp. 70–6; Christina Riggs, *Egypt: Lost Civilizations*. London: Reaktion, 2017, esp. Chapter 7.

34 *Illustrated London News*, 3 July 1926, p. 18; almost identical wording in Howard Carter, *The Tomb of Tut.Ankh.Amen*, vol. II. London: Cassell, 1927, p. 113. See also Riggs, *Photographing Tutankhamun*, p. 136.

35 Clare Corbould, *Becoming African Americans: Black Public Life in Harlem, 1919–1939*. Cambridge, Mass.: Harvard University Press, 2009, pp. 57–87 (quoted passage is from p. 57, n. 2, a 4 July 1923 article in the *New York Amsterdam News*). For African-American engagements with ancient Egypt, see also Scott Trafton, *Egypt Land: Race and Nineteenth-Century American Egyptomania*. Durham, NC: Duke University Press, 2004.

36 Corbould, *Becoming African Americans*, p. 61, with n. 17.

37 Corbould, *Becoming African Americans*, p. 61.

38 Martin Bernal, *Black Athena: The Afroasiatic Roots of Classical Civilization*. Rutgers: Rutgers University Press, 1987 (vol. 1), 1991 (vol. 2), 2006 (vol. 3).

39 Eleanor F. Wedge (ed.), *Nefertiti Graffiti: Comments on an Exhibition*. Brooklyn: The Brooklyn Museum, 1976, pp. 53–9 (quoted passages at pp. 53 and 55).

40 On the emergence of Afrocentrism in the United States, see Algernon Austin, *Achieving Blackness: Race, Black Nationalism, and Afrocentrism in the Twentieth Century*. New York: New York University Press, 2006, pp. 110–29; Stephen Howe, *Afrocentrism: Mythical Pasts and Imagined Homes*. London: Verso, 1998; Clarence E. Walker, *We Can't Go Home Again: An Argument about Afrocentrism*. Oxford: Oxford University Press, 1989.

41 McAlister, *Epic Encounters*, p. 141, with n. 37 (copy of the resolution).

42 McAlister, *Epic Encounters*, p. 143, with n. 38 (quoting from the Scott-Gibson booklet, 'Tutankhamun and the African Heritage', caption to figure 11).

43 Richard F. Shepard, 'Three TV programs tied to Tut show', *New York Times*, 16 December 1978, p. 47.

44 McAlister, *Epic Encounters*, p. 144.

45 In the vast literature on this topic, Sally Price's incisive critique still stands out: *Primitive Art in Civilized Places*. Chicago: Chicago University Press, 1989 [2nd ed., 2000].

46 All quotes from Paul Richard, 'Thrilling instalment in the King Tut Story', *Washington Post*, 16 November 1976, pp. C1/C3.

47 Grace Glueck, 'Treasures of Tut glitter in Daylight', *New York Times*, 12 December 1978, pp. B1/B16.

48 Grace Glueck, 'The Tut show gives a Midas touch to almost everyone but the viewer', *New York Times*, 24 December 1978, p. 23.

49 Hoving, *Making the Mummies Dance*, pp. 406–8.

50 See Harris, *Capital Culture*, pp. 204–5, 215–16.

51 I. E. S. Edwards, *Tutankhamun: His Tomb and Its Treasures*. London: Knopf, 1976. This was a 256-page, clothbound book with 100 full-colour illustrations, retailing at $25. The official exhibition catalogue sold for a more modest $6.95: Katharine Stoddert Gilbert (ed.), *Treasures of Tutankhamun*. New York: Metropolitan Museum of Art, 1976. In addition, there was a special issue of the Metropolitan Museum of Art *Bulletin*, called *Tutankhamun*, vol. 34, no. 3, Winter 1976–7, and a spiral-bound history of the discovery, using Burton photographs: Polly Cone (ed.), *Wonderful Things: The Discovery of Tutankhamun's Tomb*. New York: Metropolitan Museum of Art, 1978. The books and other merchandise can be viewed in the *Treasures of Tutankhamun* sales catalogue, https://libmma.contentdm.oclc.org/digital/collection/p15324coll10/id/199533.

52 For sale at time of writing, https://www.etsy.com/uk/listing/660608761/treasures-of-tutankhamun-exhibit-isis, 14 August 2020. I am grateful to the owners of AnewAgain for discussing their stock of official 'Treasures of Tutankhamun' merchandise and ephemera with me.

53 Stanley Eichelbaum, 'L.A. has a new superstar – King Tut', *San Francisco Examiner and Chronicle*, 5 March 1978, p. 20 Scene.

54 Glueck, 'The Tut show gives a Midas touch' (n. 48).

55 Lynn Simross, 'Merchandising the many faces of Tutankhamun',
 Los Angeles Times, 28 January 1978, p. 61.

56 Glueck, 'The Tut show gives a Midas touch' (n. 48), and Boba,
 'Treasures of Tutankhamun exhibit opens at Seattle Center' (n. 13).

57 Glueck, 'The Tut show gives a Midas touch' (n. 48).

58 Grace Glueck, 'Where Tut money is going', *New York Times*,
 23 March 1979, p. 24.

59 For instance the reviews quoted and discussed in Harris, *Capital
 Culture*, p. 211.

60 Information courtesy of the AnewAgain Etsy shop (personal
 communication, September 2020).

61 Austin Scott, 'Carter pays a visit to Tut exhibit, says it's "so
 beautiful"', *Washington Post*, 13 March 1977, p. 32.

62 Eric Wentworth, 'The long slow line', *Washington Post*, 8 March
 1977, pp. C1, C4

63 Juan Williams and Jean M. White, 'Waiting for King Tut . . .',
 Washington Post, 16 March 1977, pp. B1, B6.

7 *Restless Dead*

1 Recounted in Carter, *Tomb of Tut.Ankh.Amen*, vol. 2, pp. 64–91,
 and see Carter's journal entries from 3 October 1925 onwards:
 http://www.griffith.ox.ac.uk/discoveringTut/journals-and-diaries/
 season-4/journal.html.

2 Carter, *Tomb of Tut.Ankh.Amen*, vol. 2, p. 81.

3 Entry for 31 October in Carter's journal (see link, n. 1).

4 Riggs, *Unwrapping Ancient Egypt*, p. 64, with further references.

5 The quotation is from Browne's 1658 essay *Hydriotaphia, Urn
 Burial*. On *mumia* consumption, see Philip Schwyzer, *Archaeologies
 of English Renaissance Literature*. Oxford: Oxford University Press,
 2007, pp. 151–74; Louise Noble, *Medicinal Cannibalism in Modern
 English Literature and Culture*. New York: Palgrave Macmillan,
 2011, esp. pp. 17–34; Richard Sugg, *Mummies, Cannibals, and
 Vampires: The History of Corpse Medicine from the Renaissance to the
 Victorians*. Abingdon and New York: Routledge, 2011.

6 Arthur Keith and Karl Pearson, 'The skull of Sir Thomas Browne',
 Nature 110.149 (1922) (https://doi.org/10.1038/110149c0).

7 W. G. Sebald, *The Rings of Saturn*, transl. Michael Hulse. London:
 Vintage, 2002 [1998], p. 19.

8 Both letters headed 'The New Museum at Cairo', *The Times*,
 29 May 1890, p. 12. See Riggs, *Unwrapping*, pp. 199–200.

9 'King Tutankhamen. Reburial in Great Pyramid. Sir Rider
 Haggard's Plea', *The Times*, 13 February 1923, p. 13 (Letters to
 the Editor). Reprinted in *New York Times*, 15 February 1923. On
 debates about reburying mummy, see Jo Marchant, *The Shadow
 King: The Bizarre Afterlife of King Tut's Mummy*. Boston: Da Capo,
 2013, pp. 45–7, and on the treatment of royal mummies more
 generally, Riggs, *Unwrapping Ancient Egypt*, pp. 198–202.

10 Marchant, *Shadow King*, p. 46.

11 Carter, *Tomb of Tut.Ankh.Amen*, vol. 2, pp. 106–40. Compare
 the synthesis, with links to diary entries, record cards, drawings,
 and photographs, prepared by the Griffith Institute in 2009
 and presented as 'Howard Carter's Account of the Examination
 of Tutankhamun's Mummy', at http://www.griffith.ox.ac.uk/
 gri/4mummy.html. For the unwrapping and rewrapping, see also
 Riggs, *Unwrapping*, pp. 27–9.

12 Carter, *Tomb of Tut.Ankh.Amen*, vol. 2, pp. 143–61. The personal
 notes that Derry kept during the examination are in the archives
 of University College London, where science writer Jo Marchant
 tracked them down. See Marchant, *Shadow King*, pp. 69–70.

13 Entry for 11 November in Carter's journal (see n. 1).

14 Carter, *Tomb of Tut.Ankh.Amen*, vol. 2, p. 137.

15 Catalogue number 255.

16 Entries for 14–15 November in Carter's journal (see n. 1) and
 Douglas Derry's personal notes, as discussed in Marchant, *Shadow
 King*, p. 70.

17 Catalogue number 256k.

18 Catalogue number 256dd.

19 Carter, *Tomb of Tut.Ankh.Amen*, vol. 2, p. 126.

20 Carter, *Tomb of Tut.Ankh.Amen*, vol. 2, p. 108.

21 Marchant, *Shadow King*, pp. 69–70, based on Derry's personal
 notes of the examination.

22 Entry for 18 November in Carter's journal (see n. 1), nearly
 identical to Carter, *Tomb of Tut.Ankh.Amen*, vol. 2, p. 111–13.
 See also Marchant, *Shadow King*, pp. 71–2; Riggs, *Photographing
 Tutankhamun*, p. 136.

23 *Illustrated London News*, 3 July 1926, p. 18, and in Carter, *Tomb of
 Tut.Ankh.Amen*, vol. 2, p. 31.

24 Noblecourt, *Tutankhamen*, p. 164, fig. 101; figs. 102 and 104 are
 also Burton photographs of the head.

25 Streatfeild, *Boy Pharaoh*, p. 65.

26 Entry for 10 October 1926, in Carter's journal: http://www.griffith.ox.ac.uk/discoveringTut/journals-and-diaries/season-5/journal.html.

27 'Tutankhamun's Trumpets', broadcast on the BBC Regional Programme, Sunday, 16 April 1939 at 5 p.m.: *Radio Times* 811 (14 April 1939), p. 21; 'To be heard on the wireless', *Illustrated London News*, 15 April 1939, p. 633. Available to listen at http://rex.keating.pagesperso-orange.fr/.

28 Catalogue number 253.

29 Catalogue numbers 266, 266a–g.

30 Catalogue number 317.

31 Derry's report appeared in Carter, *Tomb of Tut.Ankh.Amen*, vol. 3, pp. 167–9. See Reeves, *Complete Tutankhamun*, pp. 123–5.

32 Timothy Mitchell, *Rule of Experts: Egypt, Techno-Politics, Modernity*. Berkeley: University of California Press, 2002, pp. 19–53, 187–8.

33 Marchant, *Shadow King*, pp. 98–9.

34 R. G. Harrison, 'The Tutankhamun post-mortem', in Ray Sutcliffe (ed.), *Chronicle: Essays from Ten Years of Television Archaeology*. London: BBC, 1978, pp. 41–52.

35 Marchant, *Shadow King*, p. 97; Nevine El-Aref, 'Mummy scan furore', *Al-Ahram Weekly*, 26 July 2005 (printout online at http://www.egyptologica.be/news/pdf/mummy_scan_furore.pdf).

36 Traded under this name between 1925 and 1932 (https://archiveshub.jisc.ac.uk/data/gb133-gut/gut/1/9). See also Marchant, *Shadow King*, p. 95, and for the distribution of Siemens X-ray machines, Pierre-Yves Donzé, *Making Medicine a Business: X-ray Technology, Global Competition, and the Transformation of the Japanese Medical System, 1895–1945*. London: Palgrave Macmillan, 2018, pp. 23–4.

37 R. G. Harrison and A. Abdalla, 'The remains of Tutankhamun', *Antiquity* 46.1, 1972, pp. 8–14, at p. 10, and see Marchant, *Shadow King*, p. 101.

38 Harrison and Abdalla, 'Remains of Tutankhamun', p. 9.

39 Harrison and Abdalla, 'Remains of Tutankhamun', p. 11; F. Filce Leek, *The Human Remains from the Tomb of Tutankhamun*. Oxford: Griffith Institute, 1972, p. 17.

40 Air date 28 February 1971, announced in *Radio Times* issue dated 26 February, p. 15; air date 21 March 1972 announced in *Radio Times* issue dated 16 March, p. 41. For viewing figures, see

Karol Kulik, 'A short history of archaeological communication',
in Timothy Clack and Marcus Brittain (eds), *Archaeology and the
Media*. Walnut Creek: Left Coast Press, 2007, pp. 111–124, at
p. 120.

41 Marchant, *Shadow King*, pp. 105–107.

42 Marchant, *Shadow King*, pp. 109, 118–19.

43 Widely covered in the media, e.g. 'The mummy of Ramses II is
flown to Paris for treatment today', *New York Times*, 27 September
1976, p. 7; the body returned to Cairo on 10 May 1977. An urban
myth circulates on the internet, to the effect that the body was
issued with a passport. Scientific study: Lionel Balout, Colette
Roubet and Christiane Desroches Noblecourt, *La Momie de
Ramsès II: Contribution scientifique à l'égyptologie*. Paris: Éditions
Recherche sur les civilisations, 1985.

44 Rita Reif, 'Egypt pondering fate of its mummies', *New York Times*,
8 March 1981, p. 48

45 Shin Maekawa (ed.), *Oxygen-Free Museum Cases*. Los Angles:
Getty Conservation Institute, 1998, esp. papers by Shin Maekawa,
'Conservation of the royal mummy collection at the Egyptian
Museum', pp. 1–5 and Nasry Yousef Iskander, 'Controlled-
environment cases for the royal mummy collection', pp. 47–52.
Nasry Iskander held the same role at the Egyptian Museum that
his father Zaky Iskander once had.

46 For example, Tom Hundley, 'Mummies back on Egyptian public
scene', *Chicago Tribune*, 6 March 1994.

47 Samantha L. Cox, 'A critical look at mummy CT scanning',
The Anatomical Record 298 (2015), pp. 1099–1110.

48 Riggs, *Unwrapping Ancient Egypt*, esp. pp. 197–221.

49 See Marchant, *Shadow King*, for a full discussion, pp. 151–67.

50 Frank J. Rühli and Salima Ikram, 'Purported medical diagnoses
of Pharaoh Tutankhamun, c. 1325 BC–', *HOMO: Journal of
Comparative Human Biology* 65.1 (2013), pp. 51–63, at p. 60.

51 On which see Riggs, *Unwrapping Ancient Egypt*, p. 210, with
further references in n. 59, 60.

52 A. J. N. W. Prag and Richard Neave, *Making Faces: Using Forensic
and Archaeological Evidence*. London: British Museum Press, 1997;
Caroline Wilkinson, *Forensic Facial Reconstruction*. New York and
Cambridge: Cambridge University Press, 2009.

53 Obituaries: *New York Times*, 14 January 2020; *Washington Post*,
16 January 2020.

54	Zahi Hawass et al., 'Ancestry and pathology in King Tutankhamun's family', *Journal of the American Medical Association* 303.7 (February 2010), pp. 638–47.

55	Marchant, *Shadow King*, offers a detailed discussion of the *JAMA* article and critical responses to it, pp. 183–211. See also the exhaustive overview of proposed pathologies in Rühli and Ikram, 'Purported medical diagnoses (n. 50).

56	Zahi Hawass and Sahar N. Saleem, 'Mummified daughters of King Tutankhamun: Archeologic and CT studies', *American Journal of Roentgenology* 197 (2011), pp. W829–36 (web only).

57	Geoffrey Chamberlain, 'Two babies that could have changed world history', *Historian* 72 (2001), pp. 6–10; C. A. Hellier and R. C. Connolly, 'A re-assessment of the larger fetus found in Tutankhamen's tomb', *Antiquity* 83 (2009), pp. 165–73.

58	Philippe Charlier, Suonavy Khung-Savatovsky, and Isabelle Huynh-Charlier, 'Forensic and pathology remarks concerning the mummified fetuses of King Tutankhamun', *American Journal of Roentgenology* 198 (2011), p. W629 (web only).

59	Cottrell, *The Lost Pharaohs*, p. 167.

8 *Tourists, Tombs, Tahrir*

1	Reid, *Whose Pharaohs*, pp. 191–5; Hélène Morlier (ed.), *L'architecte Marcel Dourgnon et l'Égypte*. Paris: Publications de l'Institut national d'histoire de l'art, 2010.

2	Report by *Times* correspondent Arthur Merton, quoted in Thomas Hoving, *Tutankhamun: The Untold Story*. London: Simon & Schuster, 1978, p. 200. For 1920s 'Tutmania', see also Fryxell, 'Tutankhamen, Egyptomania, and temporal enchantment'; Paul Collins and Liam McNamara, *Discovering Tutankhamun*. Oxford: Ashmolean Museum, 2014; Frayling, *The Face of Tutankhamun*.

3	Carter's diary entry for 12 October 1923, setting out discussions he had with James Quibell (of the Antiquities Service) and the Ministry of Public Works: http://www.griffith.ox.ac.uk/discoveringTut/journals-and-diaries/season-2/journal.html.

4	For the Italian royal visit: Christian Orsenigo, 'Una guida d'eccezione per illustri viaggiatori: Pierre Lacau e i Savoia in Egitto', in Christian Orsenigo (ed.), *Da Brera alle Piramidi*. Milan: Scalpendi Editore, 2015, pp. 113–17.

5	See Riggs, *Photographing Tutankhamun*, p. 168, fig. 5.12; Colla, *Conflicted Antiquities*, pp. 206–7, with fig. 12.

6 N. F. Mansfield-Meade, *The Latest Pocket Guidebook to Luxor & Environments, including also Tut-Ankh-Amen*. Luxor: Gaddis Photo Stores, 1942 [4th ed.].

7 Mansfield-Meade, *Pocket Guidebook*, p. 78.

8 Howard Carter, 'Report on general work done in the Southern Inspectorate', *Annales du Service des antiquités de l'Égypte* 4 (1903), pp. 43–50.

9 Mitchell, *Rule of Experts*, pp. 196–9, 203–4.

10 Eli Avraham, 'Destination marketing and image repair during tourism crises: The case of Egypt', *Journal of Hospitality and Tourism Management* 28 (2016), pp. 41–8; David Fielding and Anja Shortland, 'How do tourists react to political violence? An empirical analysis of tourism in Egypt', *Defence and Peace Economics* 22.2 (2011), pp. 217–43.

11 A point that underlies L. L. Wynn, *Pyramids and Nightclubs: A Travel Ethnography of Arab and Western Imaginations of Egypt*. Austin: University of Texas Press, 2007.

12 Catalogue numbers 267g, h. Riggs, *Photographing Tutankhamun*, pp. 227–9.

13 Francine Marie David, *Bei den Grabräubern: Meine Zeit im Tal der Könige*. Zürich: Unionsverlag, 2011.

14 Hoving, *Untold Story*, pp. 76–7. For more details, see Christina Riggs, 'Water boys and wishful thinking', *Photographing Tutankhamun* blog, 20 June 2020 (https://photographing-tutankhamun.com/blog/).

15 Karl K. Kitchen, 'Mohamed Gorgar found King Tut', *Boston Daily Globe*, 13 April 1924, p. 38. I am grateful to Dr Sue Gattuso of the Swaffham Museum for first bringing this article to my attention.

16 Two recent examples: Zahi Hawass, *Tutankhamun: Treasures of the Golden Pharaoh, The Centennial Celebration*. New York: Melcher Media, 2018, preface; Blakeway Media, 'Tutankhamun in Colour', BBC4, National Geographic, France 5, air date June 2020 (made with the cooperation of the Griffith Institute, Oxford University).

17 John Romer and Elizabeth Romer, *The Rape of Tutankhamun*. London: Michael O'Mara Books, 1993; see also Kent Weeks, 'Tourism in the Valley of the Kings', in Richard H. Wilkinson and Kent R. Weeks (eds), *The Oxford Handbook of the Valley of the Kings*. Oxford: Oxford University Press, 2016, pp. 559–66.

18 Van der Spek, *Modern Neighbors*, pp. 45–52 for the 'Gurna' name and other names used for specific settlement areas, which do not

correspond to the site names used by Western archaeologists.

19 Hassan Fathy, *Gourna: A Tale of Two Villages*. Cairo: Ministry
of Culture, 1969; Hassan Fathy, *Architecture for the Poor: An
Experiment in Rural Egypt*. Chicago: University of Chicago Press,
1973. The latter was first published in French in 1969, and only
translated into Arabic in the 1980s. For further details of Fathy's
Gurna project, see Mitchell, *Rule of Experts*, pp. 186–212, and
Miguel Guitart, 'The failed utopia of a modern African vernacular:
Hassan Fathy in New Gourna', *Journal of Architectural Education*
68.2 (2014), pp. 166–77.

20 See van der Spek, *Modern Neighbors*, pp. xxv–xxvii, on Caroline
Simpson's efforts with the Qurna History Project and Qurna
Discovery initiative, and pp. 387–8, Appendix 5, a 1996 petition
from Gurna residents to the Egyptian government.

21 Van der Spek, *Modern Neighbors*, pp. 319–46, esp. at pp. 337–8.

22 See http://archive.arce.org/conservation/Qurna/qurna-overview.

23 Maria Golia, 'Luxor's chance for smart development', *Middle
East Institute* online, 19 December 2013 (https://www.mei.edu/
publications/luxors-chance-smart-development).

24 El Saddik, *Protecting Pharaoh's Treasures*, pp. 9, 141, and news
coverage: Andrew Bossone, 'Luxor residents evicted to make way
for tourists', *Egypt Independent* online, 30 November 2009
(https://egyptindependent.com/luxor-residents-evicted-make-
way-tourists/); Alexander Dziadosz, 'Bulldozers overhaul Luxor,
city of pashas and pharaohs', *Reuters*, 1 April 2010 (https://www.
reuters.com/article/us-luxor-egypt/bulldozers-overhaul-luxor-
city-of-pashas-and-pharaohs-idUKTRE6303Z420100401).

25 Karl Anthony Schmid, 'Doing ethnography of tourist enclaves:
Boundaries, ironies, and insights', *Tourist Studies* 8.1 (2008),
pp. 105–21.

26 Youssef M. Ibrahim, 'Egyptian Museum bombed', *New York
Times*, 17 March 1993, p. 12; Associated Press, 'Following style of
militants, bomb in Egypt hits tour bus', *New York Times*, 9 June
1993, p. 3.

27 See van der Spek, *Modern Neighbors*, pp. 17–20.

28 El Saddik, *Protecting Pharaoh's Treasures*, pp. 147–50.

29 Mario Schulze, 'Tutankhamun in West Germany, 1980–81',
Representations 141 (2018), pp. 39–58.

30 Catalogue number 266.

31 Biographical accounts and interviews with Hawass are not in short

supply, starting with his personal website, www.drhawass.com.
See also Ian Parker, 'The pharaoh: Is Zahi Hawass bad for
Egyptology?', *The New Yorker* 16 November 2009 (https://
www.newyorker.com/magazine/2009/11/16/the-pharaoh); and
Joshua Hammer, 'The rise and fall of Zahi Hawass', *Smithsonian
Magazine*, June 2013 (https://www.smithsonianmag.com/history/
the-rise-and-fall-and-rise-of-zahi-hawass-72874123/).

32 Robert Brookes, 'Basel hails success of Tutankhamun show',
 SWI Swiss Info, 1 October 2004 (https://www.swissinfo.ch/eng/
 basel-hails-success-of-tutankhamun-show/4125432).

33 Margaret Studer, 'The return of the king: Tut comes to Europe',
 Wall Street Journal, 26 March 2004 (https://www.wsj.com/articles/
 SB108024176231265516).

34 Robin Pogrebin and Sharon Waxman, 'King Tut as a business
 venture', *International Herald Tribune*, 3 December 2004, p. 9
 (also published in the *New York Times*, 2 December 2004, pp. A1/
 B6). The article mentions American entertainment conglomerate
 Anschutz Entertainment Group, of which AEI was then a
 subsidiary.

35 'Behind the mask: Tutankhamun's last tour', BBC Arabic,
 premiered 7 July 2020 (https://youtu.be/wQWVpskwQH8); see
 also Hannah McGivern, 'BBC investigation uncovers legal dispute
 over blockbuster Tutankhamun exhibition', *The Art Newspaper*,
 9 July 2020 (online).

36 Nevine El-Aref, 'Tutankhamun artefacts to go on display at
 Hurghada, Sharm museums', *Ahram Online*, 28 August 2020.

37 Heffernan, '"Wonderful Things" in Kingston upon Hull'.

38 Sally MacDonald, 'Lost in time and space: Ancient Egypt
 in museums', in Sally MacDonald and Michael Rice (eds),
 Consuming Ancient Egypt. London, University of London Press,
 Institute of Archaeology, 2003, pp. 87–99 (at pp. 93–4). See the
 attraction's website, https://www.tutankhamun-exhibition.co.uk/,
 and local news coverage e.g.: Meghan Hindley, '"It's strange to
 think that it is now 30 years since we created the Tutankhamun
 exhibition"', *Dorset Echo*, 28 May 2017 (https://www.dorsetecho.
 co.uk/news/15314106.its-strange-to-think-that-it-is-now-30-
 years-since-we-created-the-tutankhamun-exhibition/).

39 Umberto Eco, *Travels in Hyperreality: Essays*. London: Pan Books,
 1987, pp. 34–5.

40 Simon Connor and Eid Mertah, 'Des répliques dans une

exposition', in Simon Connor and Dimitri Laboury (eds), *Toutankhamon: À la recherche du pharaon oublié*. Lièges: Presses Universitaires, 2019, pp. 24–9.

41　Catalogue numbers 8, 14.

42　See http://www.griffith.ox.ac.uk/discoveringTut/burton5/ burtoncolour.html; the colourizations were also the subject of a television documentary, *Tutankhamun in Colour*, Blakeway Productions for the BBC, first aired in June 2019. On the historical questions raised by digital colourization of photographs, see Elizabeth Edwards, Review of Dan Jones and Marina Amaral, *The Colour of Time* (London: Head of Zeus, 2018), in *History of Photography* 43.3 (2019), pp. 331–2.

43　Extensive information about the Tutankhamun facsimile can be found on the website of the Factum Foundation at https://www. factumfoundation.org/ind/40/facsimile-of-the-tomb-of- tutankhamun.

44　Daniel Zalewski, 'The factory of fakes', *The New Yorker*, 21 November 2016 (https://www.newyorker.com/magazine/2016/ 11/28/the-factory-of-fakes).

45　Carter, *Tomb of Tut.Ankh.Amen*, vol. 2, p. 29.

46　Neville Agnew and Lori Wong, 'Conserving and managing the tomb of Tutankhamen', *Getty Magazine*, Winter 2019, pp. 8–11 (https://www.getty.edu/conservation/our_projects/field_projects/ tut/related_mats.html).

47　Nicholas Reeves, 'The decorated north wall in the tomb of Tutankhamun (KV62)', Amarna Royal Tombs Project, Occasional Paper no. 3, 2019, pp. 8–10.

48　Agnew and Wong, 'Conserving and managing', p. 10. For a scientific analysis of the painting technologies used in the burial chamber: Lori Wong et al., 'Examination of the wall paintings in Tutankhamen's tomb: Inconsistencies in original technology', *Studies in Conservation* 57 Suppl. 1, pp. S322–30.

49　Randy Kennedy, 'It's a long road from ancient Egypt', *New York Times*, 3 August 2010, pp. C1/C6.

50　El Saddik, *Protecting Pharaoh's Treasures*, pp. 9–11.

51　Summarized in Riggs, *Unwrapping Ancient Egypt*, pp. 7–9 with further references to news coverage and the responses of various professional bodies.

52　Catalogue number 175.

53　Catalogue number 296a.

54 Catalogue numbers 275c, e.

55 Nevine El-Aref, 'Missing artifacts from the Egyptian Museum retrieved', *Ahram Online*, 12 April 2011.

56 As recounted in David D. Kirkpatrick, *Into the Hands of the Soldiers: Freedom and Chaos in Egypt and the Middle East*. London: Bloomsbury, 2018. Kirkpatrick was the *New York Times* bureau chief in Cairo at the time.

57 Mohamed Elshahed, 'The case against the Grand Egyptian Museum', *Jadaliyya* ezine, Arab Studies Institute, 16 July 2011 (http://www.jadaliyya.com/pages/index/2152/the-case-against-the-grand-egyptian-museum); Ali Abdel Mohsen, 'Egypt's museums: From Egyptian Museum to "torture chamber"', *Egypt Independent*, 20 April 2011 (http://www.egyptindependent.com/news/egypts-museums-egyptian-museum-torture-chamber).

58 See now Ganzeer's website (https://ganzeer.com/V-Ankh-Amun), the Walls of Freedom Facebook site, and Basma Handy and Dan Karl (eds), *Walls of Freedom: Street Art of the Egyptian Revolution*. Berlin: From Here to Fame, 2012 (limited edition, preview on http://wallsoffreedom.com/preview/). For protests during the 2011 transition stage, see Lucie Ryzova, 'The battle of Muhammad Mahmoud Street in Cairo: Politics and poetics of urban violence in revolutionary time', *Past & Present* 247.1 (2020), pp. 273–317.

59 The reports of Human Rights Watch and Amnesty International make for sober reading: https://www.hrw.org/middle-east/n-africa/egypt; https://www.amnesty.org/en/countries/middle-east-and-north-africa/egypt/.

60 Kirkpatrick, *Into the Hands of the Soldiers*, p. 327.

CONCLUSION *The Museum of Dreams*

1 George A. Reisner, 'The dead hand in Egypt', *The Independent* 114, no. 3903 (21 March 1925), pp. 318–24 (at p. 318).

2 Catalogue numbers 486, 560, and others.

3 Catalogue numbers 80, 466.

4 Catalogue number 264.

5 Catalogue number 620.1.

6 Gareth Harris, 'Opening of Cairo's greatly anticipated $1 billion Grand Egyptian Museum delayed again because of coronavirus', *The Art Newspaper*, 7 April 2020; Nicholas Glass, "'Grand Egyptian Museum will be finished this year'": Behind the scenes of the giant $1 billion project', *The Art Newspaper*, 7 August 2020.

7 Further details at the architectural firm's website, https://
 www.hparc.com/work/the-grand-egyptian-museum.

8 This is the so-called 'second solar boat', the first having been
 discovered in 1954 and displayed in the Solar Boat museum that
 opened near the Khufu pyramid in 1984. For the current project,
 see Meredith Brand, 'Salvaging Khufu's second solar boat', *Nature
 Middle East*, 17 June 2017 (doi:10.1038/nmiddleeast.2017.109).

9 Figures as of 2017, from https://www.popcouncil.org/research/
 survey-of-young-people-in-egypt.

10 Facebook post, 20 August 2020 (https://www.facebook.com/
 gemcc/posts/1300878000087339?__tn__=K-R).

11 There was extensive news and social media coverage of the statue's
 move to the GEM, e.g. Kristin Romey, '3,000 year old colossal
 pharaoh statue moved to new home', *National Geographic*,
 25 January 2018 (online).

12 See William Carruthers, 'Spectacles of the past', *Jadaliyya*, 12 May
 2021 (www.jadaliyya.com/Details/42719/Spectacles-of-the-Past).

13 For further details, see https://www.jicagem.com/.

14 El Saddik, *Protecting Pharaoh's Treasures*, p. 210.

15 See http://www.unesco.org/new/en/culture/themes/museums/
 museum-projects/the-national-museum-of-egyptian-civilization/
 #c167609.

16 Announcement and press release: https://www.euneighbours.eu/
 en/south/stay-informed/news/european-union-supports-egypt-
 transformation-egyptian-museum-cairo.

17 'Tutankhamun: Egypt museum staff face trial over botched beard
 job', *BBC News* online, 23 January 2016 (https://www.bbc.com/
 news/world-middle-east-35392531).

18 'Egypt calls in Germans to fix pharaoh's beard', *The Local*
 online (in English), 28 October 2015 (https://www.thelocal.
 de/20151028/germans-called-in-to-fix-botched-tutankhamun-
 repair). Pending full publication of the results, further information
 and press links (in German and English) can be found on the
 Römisch-Germanisches Zentralmuseum website: https://
 web.rgzm.de/ueber-uns/presse/pressemitteilungen/pm/
 article/die-totenmaske-des-tutanchamun-restaurierung-und-
 technologische-untersuchung.html.

19 Julia Bertsch, Katja Broschat, Christian Eckmann et al.,
 Tutankhamun's Unseen Treasures: The Golden Appliqués. Cairo:
 DAI/RGZM, 2017.

20 Catalogue number 256k.
21 Catalogue number 403a, Temp. Inv. 2-3-60-1. Katja Broschat, Thilo Rehren, Christian Eckmann, 'Makelloses Flickwerk: Die gläsernen Kopfstützen des Tutanchamun und anderes', *Restaurierung und Archäologie* 9 (2016), 1–24.
22 Nicholas Reeves, 'Tutankhamun's mask reconsidered', *Bulletin of the Egyptological Seminar* 19 (2015), pp. 511–26, with Emily Teeter's observations on p. 515, n. 40. Gold discs may have covered the ear piercings when the mask was first found, but they were either not noticed by Carter or not replaced.
23 Catalogue number 207.
24 See Editorial in http://cipeg.icom.museum/media/docs/2017-07-cipeg-e-news.pdf; preliminary presentation and photographs at https://www.biancamadden.com/news/icom-cipeg-tutankhamun-shrine-project/.
25 Letter from Burton to Winlock, 26 December 1932 (Metropolitan Museum of Art, Department of Egyptian Art archives, Harry Burton file 1930–35).
26 Colonial mimicry, and the 'double vision' it produces, is among the arguments set out by postcolonial thinker Homi Bhabha, collected in his book *The Location of Culture* (London: Routledge, 1994); see also Homi Bhabha, 'Of mimicry and man: The ambivalence of colonial discourse', *October*, vol. 28, Spring 1984, pp. 125–33.

Timeline

1 In order: Washington DC, Philadelphia, New Haven, Houston, Omaha, Chicago, Seattle, San Francisco, Los Angeles, Cleveland, Boston, St Louis, Baltimore, Dayton, Toledo, New York plus World's Fair, Toronto.
2 In order: Washington DC, Chicago, New Orleans, Los Angeles, Seattle, New York, San Francisco.
3 In order: Los Angeles, Fort Lauderdale, Chicago, Philadelphia, London, Dallas, San Francisco, New York, Melbourne.
4 In order: Vienna (*Tutankhamun and the World of the Pharaohs*), Atlanta, Indianapolis, Toronto, Denver, St Paul, Houston, Seattle.

Illustration Credits

p. 168 UNESCO rescue operations at Abu Simbel. *Keystone-France/ Contributor/Getty.*

p. 177 Opening of the 1967 Paris show. *Keystone-France/Contributor/Getty.*

p. 196 Mask of Tutankhamun in London, 1972. *Guardian News & Media Ltd 2021/Jane Bown Archive.*

p. 201 The Queen at the British Museum opening, 1972. *The Print Collector/Alamy.*

p. 206 British Museum queues. *Evening Standard/Stringer.*

p. 210 Philae island. *Library of Congress.*

p. 217 Installing the mask in Moscow. *The Pushkin State Museum of Fine Arts.*

p. 232 Hoving, Nawawy and Brown with mask. *Bettmann/Contributor/Getty.*

p. 236 Hoving with Selket replica. *The Washington Post/Getty.*

p. 240 Elizabeth Taylor at start of 1970s American tour. *National Gallery of Art, Washington, DC, Gallery Archives.*

p. 260 Shroud and floral wreaths on coffin. *INTERFOTO/Alamy.*

p. 266 Preparing to unwrap the royal remains. *Hulton Archive/Staff/Getty.*

p. 311 Aumonier with replica statues. *Hulton Archive/Staff/Getty.*

PLATES

1. Tutankhamun miniature coffin (left). *Chesnot/Contributor/Getty.*

2. Tutankhamun miniature coffin (right). *Allentown Morning Call/ Contributor/Getty.*

3. Carter's painting of Queen Seniseneb. *Sepia Times/Contributor/Getty.*

4. Sheet of linen. *Metropolitan Museum of Art.*

5. Floral wreath. *Metropolitan Museum of Art.*

6. Painted wooden head. *Robert Harding/Alamy.*

7. Portrait of Howard Carter. *Hulton Archive/Getty.*

8. Guardian statue. *Chesnot/Contributor/Getty.*

9. Alabaster vase. *Imagedoc/Alamy.*

10. Harpooner statue. *Agefotostock/Alamy.*

11. Dendur temple in Nubia. *Granger Historical Picture Archive/Alamy.*

12. Dendur temple in the Metropolitan Museum of Art. *Iain Masterton/ Alamy.*

13. Evening Standard supplement (left). *Tony ALS/Alamy.*

14. Evening Standard supplement (right). *Tony ALS/Alamy.*

15. Tomb facsimile. *Jackie Ellis/Alamy.*

16. Egyptian soldiers with mask. *UPI/Alamy.*

17. Conservation of outermost coffin. *Khaled Desouki/Contributor/Getty.*

18. Egyptian street art. *Alain Guilleux/Alamy.*

Index

Page numbers in *italics* indicate illustrations

Credit: Andy J. Crouch

CHRISTINA RIGGS is Professor of the History of Visual Culture at Durham University and an expert on the history of the Tutankhamun excavation. She is the author of several books, including *Photographing Tutankhamun* and *Ancient Egyptian Magic: A Hands-on Guide*.

PublicAffairs is a publishing house founded in 1997. It is a tribute to the standards, values, and flair of three persons who have served as mentors to countless reporters, writers, editors, and book people of all kinds, including me.

I. F. STONE, proprietor of *I. F. Stone's Weekly*, combined a commitment to the First Amendment with entrepreneurial zeal and reporting skill and became one of the great independent journalists in American history. At the age of eighty, Izzy published *The Trial of Socrates*, which was a national bestseller. He wrote the book after he taught himself ancient Greek.

BENJAMIN C. BRADLEE was for nearly thirty years the charismatic editorial leader of *The Washington Post*. It was Ben who gave the *Post* the range and courage to pursue such historic issues as Watergate. He supported his reporters with a tenacity that made them fearless and it is no accident that so many became authors of influential, best-selling books.

ROBERT L. BERNSTEIN, the chief executive of Random House for more than a quarter century, guided one of the nation's premier publishing houses. Bob was personally responsible for many books of political dissent and argument that challenged tyranny around the globe. He is also the founder and longtime chair of Human Rights Watch, one of the most respected human rights organizations in the world.

· · ·

For fifty years, the banner of Public Affairs Press was carried by its owner Morris B. Schnapper, who published Gandhi, Nasser, Toynbee, Truman, and about 1,500 other authors. In 1983, Schnapper was described by *The Washington Post* as "a redoubtable gadfly." His legacy will endure in the books to come.

Peter Osnos, *Founder*